THE GOLDEN AGE OF COUTURE

Paris and London 1947–57

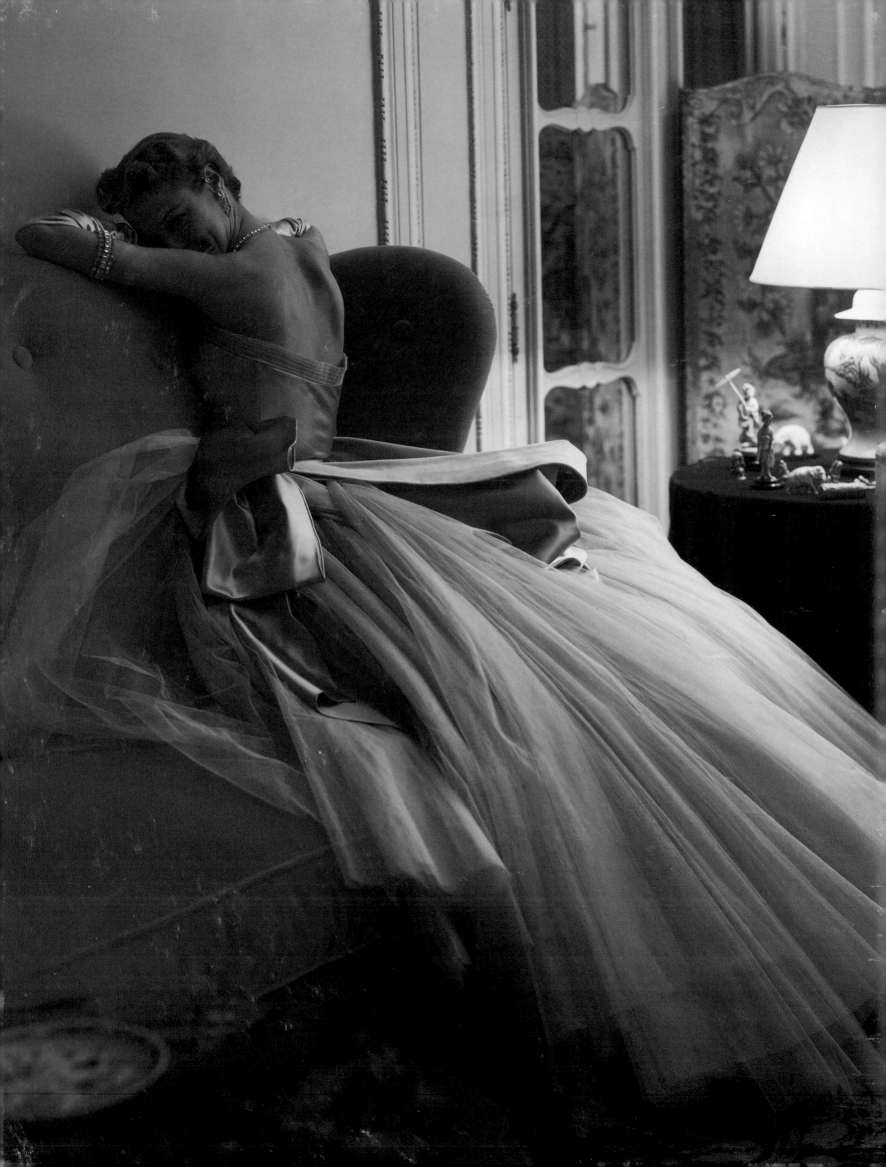

THE GOLDEN AGE OF COUTURE

Paris and London 1947–57

EDITED BY CLAIRE WILCOX

V&A PUBLICATIONS

First published by V&A Publications, 2007
V&A Publications
Victoria and Albert Museum
South Kensington
London SW7 2RL

Distributed in North America by Harry N. Abrams, Inc., New York

Hardback edition
ISBN 978 1 85177 520 0
Library of Congress Control Number 2007924500

10 9 8 7 6 5 4 3
2011 2010 2009 2008 2007

Paperback edition
ISBN 978 1 85177 521 7

10 9 8 7 6 5 4 3 2 1
2011 2010 2009 2008 2007

A catalogue record for this book is available from the British Library.

Designer: Nigel Soper
Copy-editor: Catherine Blake
Indexer: Vicki Robinson
New V&A photography by Richard Davis, V&A Photographic Studio

Printed in Singapore by C.S. Graphics

V&A Publications
Victoria and Albert Museum
South Kensington
London SW7 2RL
www.vam.ac.uk

Front jacket/cover illustration:
Cocktail dress by Christian Dior
(London). Organza, 1957.
Illustration created for the
V&A by David Downton
© David Downton

Back jacket/cover illustration:
Evening dress by Christian Dior,
modelled by Wenda Rogerson.
L'Opéra, Paris, 1948. *Vogue*
(British edition), February 1948.
Photograph by Clifford Coffin

Frontispiece:
Evening dress by Jean Dessès,
modelled by Jeannie Patchett.
1950. Photograph by Norman
Parkinson

Page 8
Christian Dior house models
wearing the Spring/Summer
1957 collection. Photograph
by Cecil Beaton

CONTENTS

List of Contributors

Christopher Breward is Acting Head of Research at the V&A and a Professorial Fellow at London College of Fashion, University of the Arts, London. He was co-director, with David Gilbert, of the ESRC/AHRC 'Cultures of Consumption' Research Project: 'Shopping Routes: Networks of Fashion Consumption in London's West End 1945–1979' and co-edited the accompanying books, *Swinging Sixties* (2006) and *Fashion's World Cities* (2006). Other recent publications include *Fashion* (2003) and *Fashioning London* (2004). He was also co-curator of the Museum of London exhibition *The London Look* (2004–5).

Amy de la Haye is Reader in Material Culture and Fashion Curation at London College of Fashion, University of the Arts, London. Much of her curatorial and published works have focused on London fashion. Formerly Curator of Twentieth-Century Dress at the V&A, she curated the exhibition *The Cutting Edge: 50 Years of British Fashion* (V&A, 1997). She is currently co-authoring a V&A book about London couturier Lucile, curating an exhibition about the Women's Land Army and co-authoring a book on fashion curation.

A graduate of the Institut d'Etudes Politiques de Paris, with a doctorate in history of art, **Catherine Join-Diéterle** has been Curator-in-Chief of the Musée de la Mode et du Costume de la Ville de Paris since 1989.

Eleri Lynn is Assistant Curator of the V&A's exhibition, *The Golden Age of Couture: Paris and London 1947–1957* (2007). Previously she assisted with the exhibition *International Arts and Crafts* (V&A, 2005) and the V&A's Medieval and Renaissance Galleries project. She also coordinated the V&A's *Fashion in Motion* series in 2005.

Lesley Ellis Miller is Senior Curator of Textiles at the V&A. She has published extensively on eighteenth-century French luxury textiles, and is co-editor of the academic journal *Textile History*. A much-revised second edition of her 1993 monograph on the Spanish fashion designer Cristóbal Balenciaga will be published to coincide with the V&A exhibition, *The Golden Age of Couture: Paris and London 1947–1957* (2007).

Alexandra Palmer is Senior Curator, Textiles & Costume, at the Royal Ontario Museum where she has curated numerous exhibitions including *Elite Elegance: Couture Fashion in the 1950s* (2003). Her book *Couture and Commerce: the transatlantic fashion trade in the 1950s* (2001) won a Clio award for Ontario history. Her publications include *Old Clothes, New Looks: Second Hand Fashion* (2005) and *Fashion: A Canadian Perspective* (2004), as well as contributions to the exhibition catalogues *RRRIPP!! Paper Fashion* (Benaki Museum, Athens, 2007), *Christian Dior et le Monde* (Musée Dior à Granville, 2006) and *Un Secolo di Moda* (Villa Medici, Rome, 2003).

Sonnet Stanfill is Curator of Twentieth-Century and Contemporary Fashion at the V&A. She curated the V&A display *Ossie Clark* (2003) as well as *New York Fashion Now* (2007), for which she also edited the accompanying book. She has contributed to *Fashion's World Cities* (2006) and *The Fashion Reader* (2007).

Abraham Thomas is Curator of Designs at the V&A. He was curator of *Paper Movies: Graphic Design and Photography* at Vogue and Harper's Bazaar, *1934–1963* (2007). He co-curated *On The Threshold: The Changing Face of Housing* (2006) and *Alternating Currents*, a V&A season of events looking at Islamic architecture (2005).

Hugo Vickers wrote the authorized biography of Cecil Beaton (1985), and also edited two volumes of Beaton's diaries, *The Unexpurgated Beaton* (2002) and *Beaton in the Sixties* (2003). He serves as Cecil Beaton's Literary Executor, and has lectured about Beaton in England, Europe, Australia and the US. His most recent major work is a biography of the Queen Mother, *Elizabeth, The Queen Mother* (2005).

Claire Wilcox is Senior Curator of Twentieth-Century and Contemporary Fashion at the V&A and curator of the exhibition, *The Golden Age of Couture: Paris and London 1947–1957* (2007). She curated the V&A's major exhibitions *Vivienne Westwood* (2004), *Versace at the V&A* (2002) and *Radical Fashion* (2001) and edited the accompanying books. She also devised the V&A's *Fashion in Motion* series which has been running at the Museum since 1999. Other publications include *Bags* (1999) and, with Valerie Mendes, *Modern Fashion in Detail* (1998).

Acknowledgements

THIS PUBLICATION, which accompanies the V&A's major exhibition, *The Golden Age of Couture: Paris and London 1947–1957*, has been made possible with the assistance and support of a great number of people.

I would especially like to thank the Assistant Curator, Eleri Lynn, for her tremendous dedication, enthusiasm and support. Eleri and I have worked very closely together to realise this book and exhibition, and collaborated with staff across the Museum.

Firstly, I would like to thank the Director of the V&A, Mark Jones, for his support of new acquisitions that have enhanced both the exhibition and the permanent collection. I am immensely grateful to colleagues who have shared their expertise with us, in particular Lesley Miller and Christopher Breward. Special thanks are due to Christopher Wilk, Sarah Medlam, Sonnet Stanfill, Sue Prichard, Suzanne Smith, Daniel Milford-Cottam and Louisa Collins of the Department of Furniture, Textiles and Fashion, and also to Alexia Bleathman, Clare Phillips and Abraham Thomas, whose advice on twentieth-century photography was invaluable. I would like to thank the staff of the Collections Services and Conservation departments, especially Richard Ashbridge, Matthew Clarke, Robert Lambert, Sandra Smith and Nick Umney.

Presenting an exhibition and book with such a predominance of V&A objects would not have been possible without the skill, patience and enthusiasm of the staff of the V&A Textile Conservation Studio: Cynthea Dowling, Lara Flecker, Frances Hartog, Marion Kite, Roisin Morris, Debbie Phipps and Natalia Zagorska-Thomas. Thanks to Ken Jackson of the V&A Photographic Studio for accommodating all our urgent requests, and to Richard Davis for his beautiful photography. From the departments of Exhibitions, Design, Press, Marketing, Development, Learning and Interpretation and V&A Enterprises, many thanks are due to: Amelia Calver, Olivia Colling, Annabelle Dodds, Jane Drew, Kat Herve-Brazier, Poppy Hollman, Debra Isaac, Abigail Jones, Annabel Judd, David Judd, Abbie Kenyon, Jane Lawson, Cathy Lester, Linda Lloyd Jones, Nicole Newman, Lucy Trench, Lisa Smith, Rebecca Smith, Rebecca Ward, Damien Whitmore and Cassie Williams. I would also like to acknowledge the valuable contributions of Danielle Sprecher, Latoya Lee and Charles Villeneuve de Janti. Many thanks to Carolyn Sargentson and all those within the Research department, for providing the supportive environment in which this project could come to life.

My sincere thanks to our Exhibitions team, Stephanie Cripps and Elodie Collin. For their creative exhibition design, I am grateful to Land Design Studio: Robin Clark, Peter Higgins, Simon Milthorp and Jona Piehl, and to Lol Sargent of Studio Simple. Thanks also to Mike Cook of DBA and Mark Greenway and Jamie Kessack of Greenways for managing the project.

I am also indebted to colleagues in the international museum community for opening up their collections and archives. I wish to thank the following people: Rosemary Harden and Eleanor Summers at the Museum of Costume, Bath; Edwina Ehrman and Nickos Gogolos at the Museum of London; Joanna Marschner at Kensington Palace; Dr Miles Lambert at the Gallery of Costume, Platt Hall; Clare Lamkin at the Bradford College Textile Archive; Sandrine Bachelier, archivist at Bucol-Holding Textile Hermès; Beatrice Salmon, Pamela Golbin, Caroline Pinon, Marie-Helene Poix and Eric Pujalet-Plaà at the Musée de la Mode et du Textile; Catherine Join-Diéterle, Laurent Cotta, and Sylvie Lécallier at the Musée de la Mode de la Ville de Paris; Miren Arzalluz, Aberri Olaskoaga Berazadi, Mariano Camio and Igor Zubizarreta at Fundación Cristóbal Balenciaga; Betty Long-Schleif at the Maryhill Museum of Art; Andrew Bolton and Shannon Bell Price at The Costume Institute, The Metropolitan Museum of Art; the National Trust, for allowing us access to Osterley House; and to Toni-Lynn Frederick of the University of Reading.

I am highly indebted to the following people for their assistance and support: John Galliano, Philippe le Moult, Olivier Bialobos and Soïzic Pfaff at Christian Dior; Marie-Louise de Clermont-Tonnere, Marika Gentil, Nathalie Guibert and Elodie Poupeau at Chanel; Sigrid Delepine at Balenciaga; Ian Garlant at Hardy Amies; Lindsay Evans Robertson; Stephen Jones; Marie-Andrée Jouve; Svetlana Lloyd; Valerie Mendes; Kerry Taylor; Hamish Bowles; Frederic Bourdelier and Vincent Leret at Christian Dior Perfumes; June Kenton and Laure Day at Rigby and Peller; Elaine Sullivan, Ines de la Fressange and Bruno Frisoni at Roger Vivier; Geoffroy Medinger at Van Cleef and Arpels; François Broca at the Ecole de la Chambre Syndicale de la Couture Parisienne; and to La Droguerie, Paris.

Very special thanks are extended to Hubert de Givenchy, François Lesage and Percy Savage, who shared their memories with us. I am also grateful to the family of Lady Alexandra, in particular Mrs Xenia Dennen, for allowing us to study her mother's personal papers and photographs. I would like to thank Lady Thomas of Swynnerton, the Dowager Duchess of Devonshire, Lady Diana Herbert, Mrs Virginia Surtees, and the Sekers family for their generosity and kind assistance in helping to identify the recent V&A acquisition, 'Zemire' by Christian Dior.

Special thanks are due to the V&A Publications team, in particular Mary Butler, Monica Woods, Asha Savjani, Clare Davis and Geoff Barlow, and to copy-editor Catherine Blake and book designer Nigel Soper.

I would like to express my gratitude to all those who contributed to the book (listed opposite), whose expertise and knowledge have enriched this publication, and the accompanying exhibition. To those many couturiers who made the 'Golden Age' what it was, I can only express my admiration.

Thanks, as always, to my family.

CLAIRE WILCOX

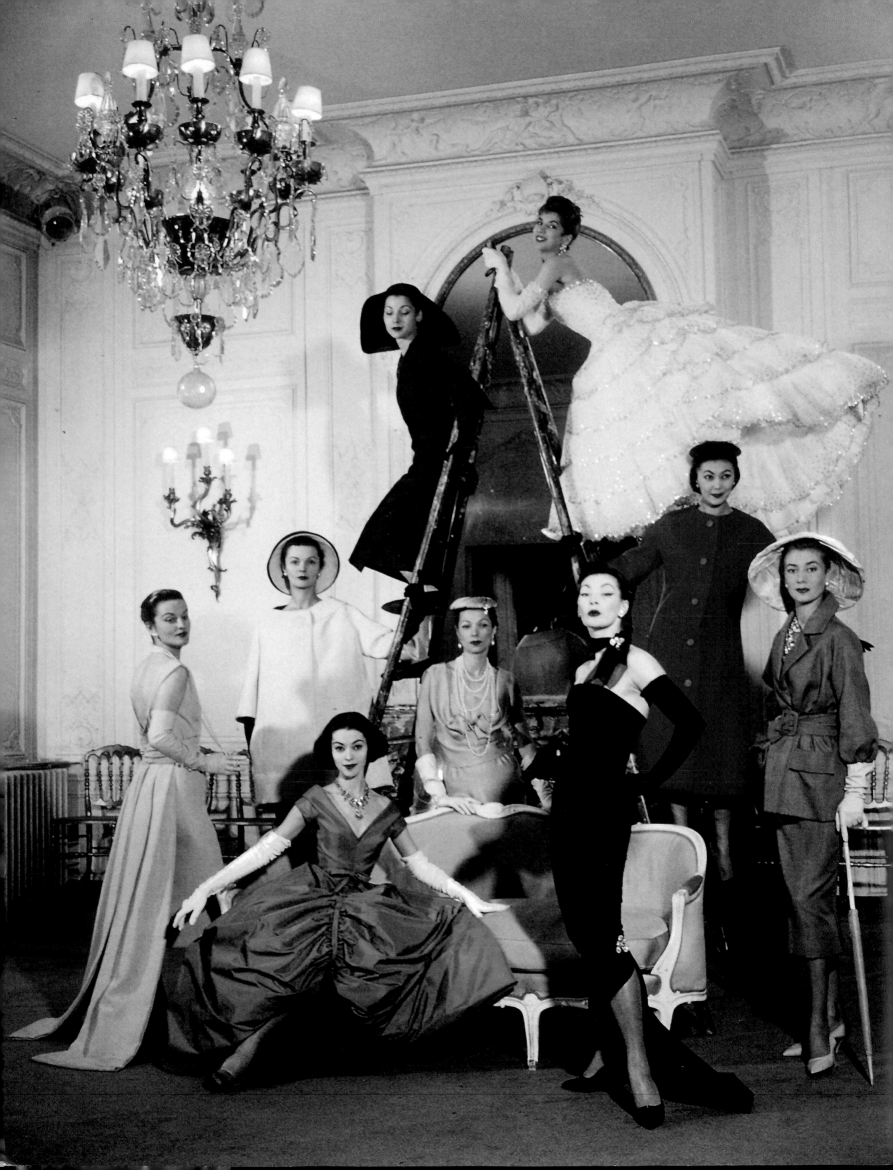

Foreword

The Golden Age of Couture: Paris and London 1947–1957 celebrates an important decade in fashion history that began with the launch of Christian Dior's famous New Look in 1947 and ended with his death in 1957. Couture thrived during these years, and Paris enjoyed renown worldwide for the luxurious creations that its fashion houses produced. Designers such as Cristóbal Balenciaga, Pierre Balmain and Hubert de Givenchy dominated the headlines but their London counterparts such as Hardy Amies, John Cavanagh and Norman Hartnell also excelled.

The V&A possesses one of the finest collections of fashionable dress in the world and we are proud to be able to feature evening gowns, cocktail dresses and suits by many of the leading designers of the time, accompanied by fashion photography and illustration from our own superb archive. Indeed, 95% of the exhibits come from the V&A's own collections. They have been specially conserved and photographed for this exhibition and book, and carefully displayed to accentuate the meticulous handcraft that each custom-made piece required.

Many of the Museum's most significant couture garments were acquired by Cecil Beaton for his exhibition at the V&A, 'Fashion: An Anthology' (1971). Sourced from the high society of the day, including members of the royal family, they provide a unique window onto post-war Paris and London couture. The V&A's Director at the time, John Pope-Hennessy, called the collection an 'incomparable enrichment of the Museum's resources'. New acquisitions for this exhibition – including a striking evening ensemble by Dior and a blue silk cape by Givenchy, identical to that worn by Audrey Hepburn in the 1957 film *Funny Face* – add to our understanding of the golden age of couture, and testify to the fruitful relationship between the V&A's exhibitions programme and the enhancement of the permanent collection.

Christian Dior described the post-war years as a 'golden age', and this exhibition recognizes his central contribution to the era. Dior and his contemporaries set the highest of standards for creative design and impeccable workmanship and their legacy continues to this day.

MARK JONES
Director of the Victoria and Albert Museum

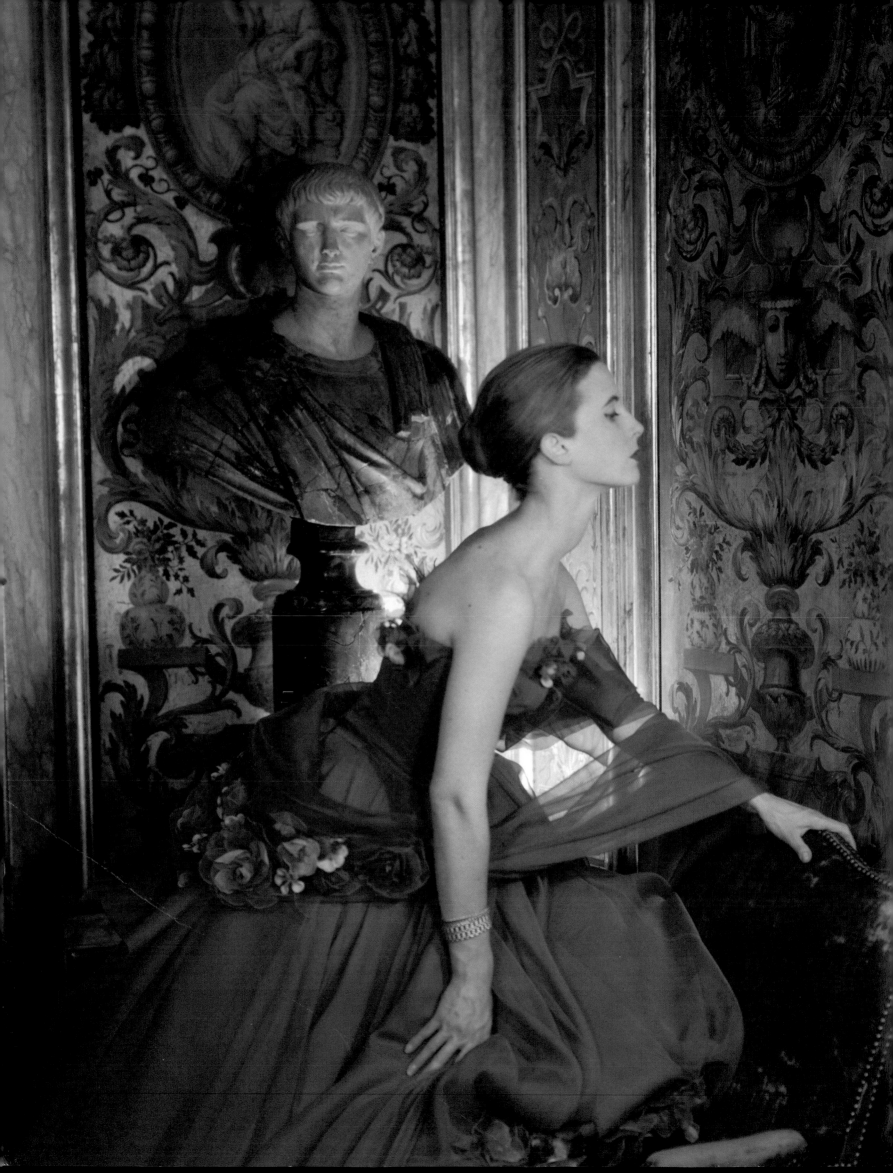

1

INTRODUCTION

CLAIRE WILCOX

'The model he imagines is, first and foremost, a beautiful object, excellently made and finely sewn; so that if, years afterwards, it were discovered at the back of some cupboard, although the fashion which inspired it has long gone out of date, it would still inspire astonishment.'[1]

CELIA BERTIN

THE SUBJECT OF THIS BOOK IS COUTURE 'excellently made and finely sewn' in Paris and London between 1947 and 1957. This was the zenith of French couture, when designers such as Cristóbal Balenciaga, Pierre Balmain and Jacques Fath dominated fashion, and headlines in New York were held for the latest news from Paris. However, in the history of fashion, this decade belongs to Christian Dior, for he launched his new house in 1947 with the defining 'New Look' and died 10 years later, having created one of the most successful fashion houses of the twentieth century.

Paris was renowned worldwide as the centre for the creative design and skilful production of luxurious high fashion. It was founded on a system established by the British-born dressmaker Charles Frederick Worth, who opened his prestigious fashion house in Paris in 1858 with the aim of unifying design and fabrication under one roof. Almost entirely a handcraft industry, the production of couture was based on a division of labour, with separate in-house workshops for dressmaking (*'flou'*) and tailoring (*'tailleur'*) supported by a luxury trade in trimmings and accessories supplied by specialist ateliers all over France. Feathers, floral accessories, embroidery, beading and ribbon work were created by hand in small workshops, much as they had been since the eighteenth century, while entire streets were devoted to glove makers, shoe makers and furriers. The poet Stéphane Mallarmé described Paris at the turn of the century as

1.2 Evening dress by Rahvis.
Grosvenor Square, London.
Vogue (British edition), June 1947.
Photograph by Clifford Coffin

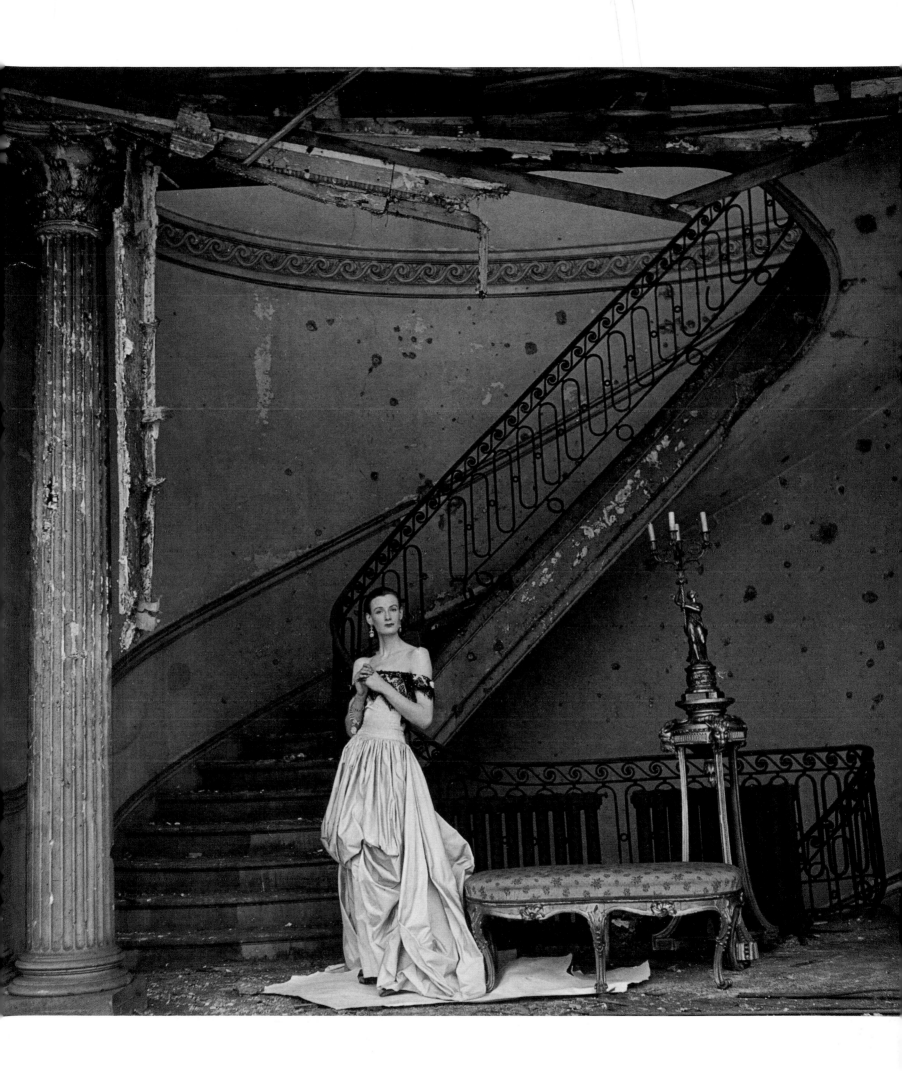

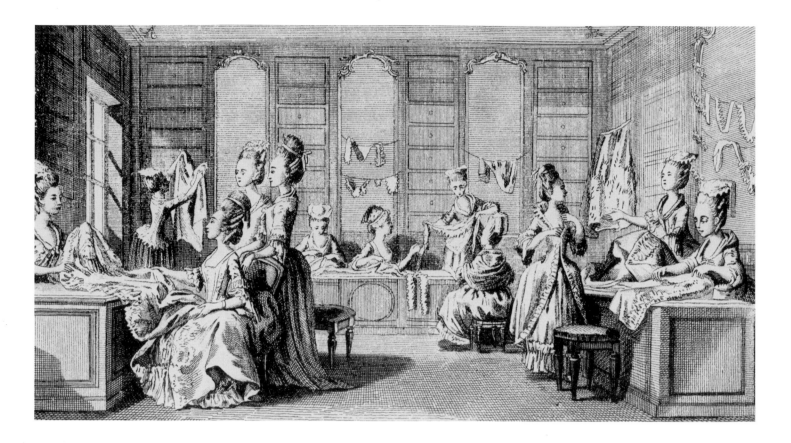

a bustling marketplace, 'as much a museum... as a bazaar: nothing strange but what it accepts; nothing exquisite which it does not sell.'[2]

The reputation of this flourishing trade in couture depended on its high quality and the Chambre Syndicale de la Couture Parisienne was formed to regulate the increasing number of houses; each member had to apply annually for admittance and conform to a set of regulations, such as number of employees and designs for each collection.[3] By 1939, there were 70 registered houses varying in status and importance, each distinguished by the personality and taste of their designer.[4] Paris fashion attracted an international clientele, but the bedrock of the house was the high social value placed upon fashion by French women. 'Sometimes wealthy but more often only well-to-do, the Parisian lady achieves her renowned chic less with money than by intense concentration on her clothes,' stated American *Life* magazine on 25 April 1949.

Although the term 'haute couture' has often been appropriated, it was regarded emphatically by Parisians as a phenomenon that was impossible to relocate to another city. Lucien Lelong, president of the Chambre Syndicale, famously defied the German occupiers – who intended to transplant the production of couture to Berlin and Vienna during the Second World War – by claiming: 'It is in Paris or it is nowhere.'[5] This sense of ownership extended beyond the city into the provinces and regions, and became a matter of national pride: 'a Paris gown is not really made of cloth, it is made with the streets, with the colonnades... it is gleaned from life and from books, from museums and from the unexpected events of the day. It is no more than a gown and yet the whole country has made this gown.'[6] It was particularly important for France to reaffirm its

1.3 Denis Diderot, illustration of fashion trades from *L'Encyclopédie, ou Dictionnaire raisonné des sciences, des arts et des métiers*, Paris, 1751

position in the post-war years, for sales to the highly valued American market had ceased during the war and, as the balance of economic power shifted from the old world to the new, Paris's dominance was challenged. In February 1948 French *Vogue* asserted couture's renaissance, opening with a 23-page advertising *cahier* of photographs of magnificent couture houses, superimposed on a street map of Paris (see pl.3.5). This sense of pride continued to be reflected in the settings in which couture was photographed, from grand Parisian salons, to the Opéra and in front of topographical maps of eighteenth-century Paris (pl.1.4).

In the post-war period, increased material and labour costs and higher taxes put pressure on Paris couturiers who, despite government subsidies, knew that commercial survival could only be assured by establishing rich new markets. The second chapter in this book, 'Dior's Golden Age', places the recovery of couture in the context of Christian Dior's brief but immensely influential reign. Although the creation of exclusive, made-to-measure garments for private clients was the mainstay of French couture's identity, Dior and his contemporaries' strategic development of the international export market and establishment of boutique and ready-to-wear lines repositioned French couture at the centre of the international fashion business. Sales to American department stores, manufacturers and wholesalers became increasingly significant after the war while several designers created lines specifically tailored to the American consumer. As Alison Settle, British journalist and editor of *Vogue*, wrote, 'New York is a great copying centre but has never been a creating centre. Paris was the home of ideas – for fabrics, lines, accessories.'[7]

'The fashion houses were rather awe-inspiring… the atmosphere was always a little bit like going into a high-class museum or a church… there was a silence'.[8] All couture activity in Paris revolved around the individual houses, which contained a honeycomb of workshops and studios that supported custom-made dressmaking. Many customers got no further than the boutique – an ante-chamber for perfume and accessories – but Alexandra Palmer, in her chapter 'Inside Paris Haute Couture', takes us deeper into the interior, from the luxurious salon and fitting rooms to the secretive workrooms.[9] From initial sketch to selection of textile, embroidery and trimmings, cutting, fitting, showing and finally delivery of the long-awaited garment, Palmer traces the process of dressmaking and conveys the meticulous care that went into the creation of a garment, for as Ginette Spanier, Balmain's *directrice* remarked, 'If a seam is not quite right, that is a matter of

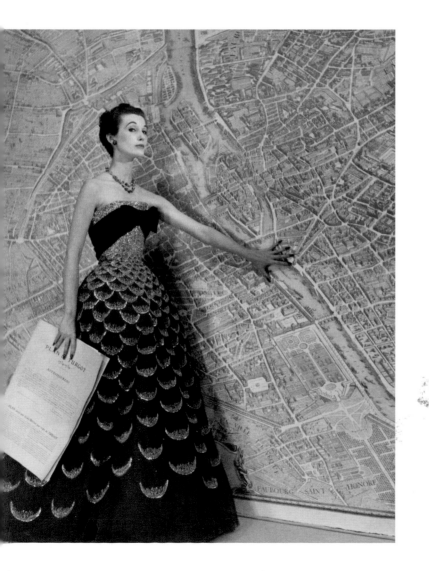

1.4 Evening dress by Christian Dior, modelled by Mary Jane Russell, against Turgot's 1739 map of Paris. *Harper's Bazaar* (US edition), October 1951. Photograph by Louise Dahl-Wolfe

life and death'.[10] Each employee had a clearly defined role within the hierarchy to achieve this creation, a phenomenon that writer Celia Bertin described as 'people work[ing] together to create what they understand by beauty, using a common language because they have a common aim and a common craft'.[11]

In her chapter 'Material Evidence: London Couture 1947–57', Amy de la Haye reflects on the British couture and archival collections in the Victoria and Albert Museum, recounting the individual histories of garments from a decade that saw such national celebrations as the Festival of Britain in 1951 and the 1953 Coronation. The Paris couture system set a template for London couturiers and with the creation of the Incorporated Society of London Fashion Designers in 1942 the small community of fashion houses – 12 as opposed to 47 in Paris in 1943 – gained increasing recognition.[12] Many London couturiers trained in Paris; John Cavanagh worked with Edward Molyneux in London and Paris during the 1930s, and then with Pierre Balmain from 1947 to 1951, before returning to establish his London business (see p.110). British women relied on such couturiers' understanding of etiquette, commissioning Mayfair dressmakers such as 'couturier-royal' Norman Hartnell, who dressed royalty and aristocracy, to create formal dresses and traditional debutante gowns that nodded to fashionable style without being unseemly.[13] A comparison of British and French *Vogue* in the late Forties and Fifties reveals that the French edition was larger and more glamorous, filled with stylish photographs, extensive fashion features and perfume advertisements, while British *Vogue*'s emphasis was on ready-to-wear, dress patterns, society portraits and, naturally, the latest news from Paris.

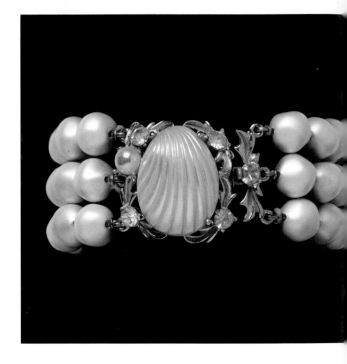

1.5 Bracelet by Elsa Schiaparelli. Artificial pearls with gilt metal clasp, c.1958. V&A: M.39-1986

Alison Settle described London couture in the late Forties as 'clothes which have social confidence… but lack superb drama'.[14] While never competing with Paris in terms of glamour, London's Savile Row enjoyed a reputation as the home of bespoke tailoring, and couturiers such as Charles Creed and Hardy Amies created elegant, precision-tailored ensembles for women, for town and country (pl.1.7). British tailoring even attracted Parisian attention; the very grand, luxurious establishment of Lanvin Castillo added a menswear department in Paris in the early Fifties and formed a reciprocal relationship with the tailoring firm Henry Poole in Savile Row. Percy Savage, who worked in Paris as a press officer for first Nina Ricci then Lanvin recalled, 'We had an arrangement… They would send some of their young apprentices to Lanvin to learn what we did in France, and we sent some of our young apprentices to Savile Row… they had beautiful fabrics and they made beautiful clothes. Savile Row really was top of the market everywhere.'[15] The London couturiers' understanding of the social mores of mid-century British society, the quiet confidence of their clothes and their early willingness to adapt to ready-to-wear ensured this small band survived the decade.

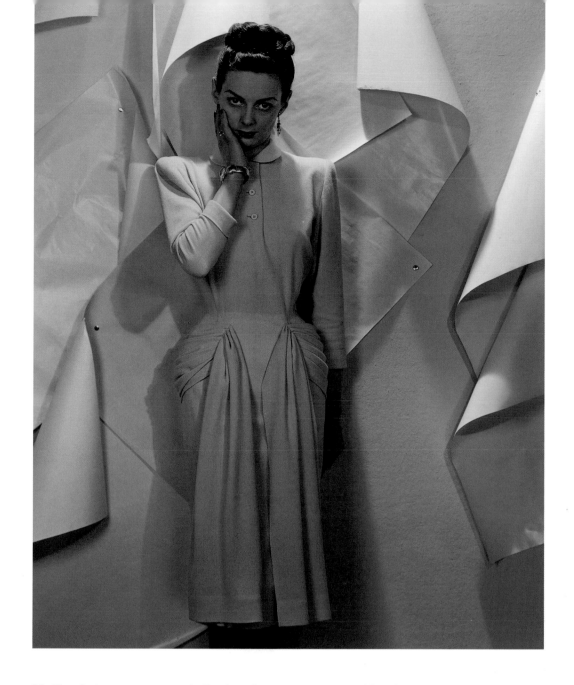

1.6 Dress by Peter Russell. Unused shot for *Vogue* (British edition), 1946. Photograph by Cecil Beaton

Unlike their counterparts in Paris, who were supported by the state, London houses were largely self-financed. The need to create small, saleable collections gave London couture its character and emerging designers such as Ronald Paterson and Michael Donéllan – the 'Balenciaga of London' – its distinction.

The Paris dressmaking schools, Les Ecoles de la Chambre Syndicale de la Couture Parisienne, were established in 1929 to train a skilled workforce for France's vast fashion industry, but few designers rose from the ranks of the workrooms to lead their own houses; Jacques Griffe was an exception. In contrast, London's success as a fashion capital was underpinned by an art school system which from the first encouraged innovative design as well as technique. The opening of the fashion faculty at the Royal College of Art in 1948 was inspired by Christian Dior. Its first professor was Madge Garland, previously editor of British *Vogue*; Savage recalled '…she went to Paris in 1947, saw the Christian Dior collection, the New Look, came back, and said that they had to have a fashion department'.[16] 'What seemed once a feminine frivolity is now dignified by University status', wrote *Picture Post* on February 19, 1949.

Settle stated in 1941, 'The importance of the fabric trade was always kept in the

1.7 New Look coats by Hardy
Amies and Edward Molyneux,
modelled by Wenda Rogerson
and Barbara Goalen, London,
March 1949. Photograph by
Norman Parkinson

background, never allowed to become too apparent'.[17] This neglect is redressed in Lesley Ellis Miller's analysis of the symbiotic relationship between fabric producer and fashion house in 'Perfect Harmony: Textile Manufacturers and Haute Couture 1947–57'. Celia Bertin observed that 'after a fashion opening, the makers of cloth and embroidery feel that they have contributed to the couturier's creation. And his imagination has undoubtedly been influenced by their suggestions.'[18] Textile suppliers from Lyons, Switzerland and Britain brought satins, lace and wools and even new synthetics to Paris to flourish in front of the couturiers; the visceral quality of this stage in the creative process is conveyed by Hubert de Givenchy, who said 'the smell of silk is unique…the fabric is alive'.[19] The textile manufacturers did not only supply fabrics; 'Every year the silk producers used to send envelopes full of silkworm eggs, and the girls would wear them under their black pullovers to keep the eggs warm until they hatched… Those young girls were sent to Paris to learn about couture so that they could eventually get a job in the fashion world in Paris, which was considered more upmarket than working in a silk mill in Lyons.'[20]

The multiplicity of designers in Paris and the quality of their collections gave the city a confidence which attracted private clients and trade buyers from all over the world. Although many smaller houses have disappeared without trace, two left a lasting legacy. In her chapter 'Dior and Balenciaga: A Different Approach to the Body', Catherine Join-Diéterle compares the temperament, practice and style of these two giants. Christian Dior's career fascinated both press and public, and his publicity was as well tailored as his fashions. First an art dealer then freelance designer, Dior worked at Piguet and Lelong before setting up his own house to great critical acclaim. Soon outgrowing Paris, branches of Christian Dior emerged in New York, London and eventually Canada, Australia and South America. Cristóbal Balenciaga's long career spanned 1918 to 1968. He opened workshops in Spain under the name of Eisa, before relocating to Paris in 1937 following the Spanish Civil War, attracted, like many of his compatriots, by the city's cultural liberalism. Balenciaga's Paris house was the grandest and most exclusive in the city and the esoteric qualities of his tailoring led him to be regarded by many, including Dior, as 'the master'.[21] The different working practices of Balenciaga and Dior had a profound effect on the character of their fashion and influenced those designers who worked closely with them – Pierre Cardin and Yves Saint Laurent for Dior and Ungaro and Courrèges for Balenciaga, who also mentored Hubert de Givenchy. The photographer and diarist Cecil Beaton wrote: 'Whereas Dior's dresses are most ingeniously and beautifully evolved from sketches, Balenciaga uses fabrics like a sculptor working in marble. He can rip a suit apart with his thumbs and remake or alter his vision in terms of practical, at-hand dressmaking.'[22]

It was said of Beaton: 'He had an unerring instinct for what was chic and fashionable: he knew whom to cultivate. He was the right kind of snob. He had his stethoscope on the heart of society and when there was a change in the beat, he wanted

to know why.'[23] Many of the V&A's most significant couture garments were acquired for the Museum by Beaton and shown in his exhibition 'Fashion: An Anthology' (1971). Sourced from leading figures of the day whom Beaton flattered and cajoled into donating, they provide a unique window into post-war London and Paris couture; the Museum's Director at the time, John Pope-Hennessy, called the collection an 'incomparable enrichment of the Museum's resources'.[24] Many of the donors were photographed by Beaton, or mentioned in his diaries, and as he was one of the most perspicacious social commentators of the day, his insight adds depth and context to the significance of the garments. In his chapter, 'Cecil Beaton and his Anthology of Fashion' Hugo Vickers, Beaton's biographer, situates the V&A's garments in the social milieu of their time in his analysis of the clients, friends and designers who gave up their treasured gowns to the Museum. Vickers takes as his template the book which Beaton wrote in tribute to the designers and clients who 'made a triumph of the evanescent', *The Glass of Fashion* (1954).[25]

Further research for this book has been undertaken by Eleri Lynn into the dynamics of patronage and the conventions of formal dress. The role of British ambassador's wife was one of the most visible in Paris and the diaries of Lady Gladwyn, wife of the British Ambassador in Paris 1954–60, reveal the investment and effort couture clients made in commissioning their wardrobes; an adherence to specific dress codes remained one of the characteristics of the well-dressed. Although both London and Paris provided a source of grand gowns, Lady Gladwyn chose custom-made Paris dresses for most important occasions. The unpublished memoirs of Lady Dacre (then wife of the Naval Attaché to Paris, 1948–50) shed light on the close relationship of trust between client and designer. The Parisian couturier Jacques Fath often lent dresses to society women for state occasions; Lady Dacre was described on one occasion as 'outstanding in a full-skirted dress of orchid coloured tulle with a strapless top'.[26] London's relationship with Paris remained close. Christian Dior – an Anglophile who dressed in Savile Row suits – was invited to stage several special shows in the presence of Princess Margaret, the most high profile of British couture clients, in Paris in 1951 and at Blenheim Palace in 1954, the year in which he also opened his London branch. At one of the most important diplomatic occasions of the decade, the Queen's state visit to Paris in 1957, many of the British clients wore Paris couture. Cecil Beaton's gift to the V&A included several gowns worn on this occasion – including a floral Balmain design for Diana Cooper, wife of the previous British Ambassador, and a ball gown in lilac lace by Fath for Lady Gladwyn. The Queen, however, wore a spectacular British-made gown by Norman Hartnell called 'Flowers of the Fields of France' (see pls 4.15 and 7.8).

In his chapter, 'Intoxicated on Images: The Visual Culture of Couture', Christopher Breward examines the representation of fashion through the perspective of French philosopher Roland Barthes' near-contemporary commentaries on the subject, as well

as through the couturier's sketch and the impressions of the professional image-makers. The soft pastels of Christian Bérard, René Gruau and Eric (Carl Erickson) typified the style of fashion magazines of the late 1940s, which prioritized mood over accuracy, while the lucid quality of Richard Avedon's and Irving Penn's photography mirrored the sharp silhouettes of the following decade. Key journals of the day, such as *Vogue* and *L'Officiel de la Mode et de la Couture*, covered every couture collection and fashion magazines played an increasingly important role in introducing new styles to the growing mass audience (pl.1.8). The selection of a dress for the front cover could increase sales dramatically and this growing interdependence between fashion photography and publishing was acknowledged by Carmel Snow, editor-in-chief of American *Harper's Bazaar*, who reflected: 'The editors must recognize fashions while they are still a thing of the future. The dressmakers create them, but without these magazines, the fashions would never be established or accepted.'[27]

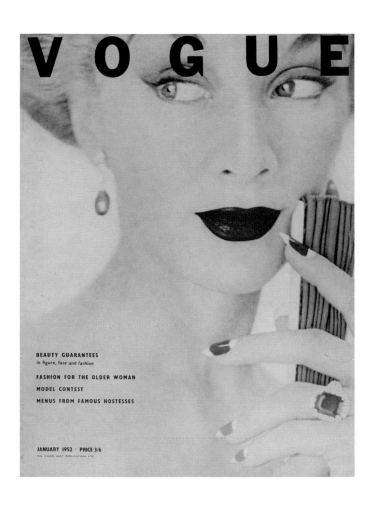

1.8 *Vogue* (British edition), January 1952. Photograph by Clifford Coffin

Couture differed from ready-to-wear in many aspects, but its distinguishing characteristic was that each garment was a one-off, made from start to finish by a particular workshop which derived great pride in its creation. However, once shown, the garment was subjected to photographic sessions and daily presentations until the next collection began, and, once out of date, might be sold as an ex-model at a reduced price. Most couture garments exist as versions of the original, chosen and amended to perfectly fit the private client's shape and needs. In 2006, the V&A acquired a striking evening ensemble of jacket, skirt and bodice, found in a damp cellar by the Seine – an interpretation of Dior's 'Zemire' from the Autumn/Winter 1954–5 'H-Line'.[28] A plethora of labels give clues about its identity and history and include a hand-written tape indicating that the dress was made for the wife of the leading British textile manufacturer Miki Sekers (pl.1.9). This was clearly a special order, for the startlingly bright cellulose acetate fabric was advanced for its time. Descendants of the Sekers family recall that Agota Sekers was often persuaded to commission clothes that would publicize the company's innovative fabrics.[29] An image in the Dior archive demonstrates that the original outfit – in silver-grey satin by Brossin de Méré with mink-trimmed cuffs – was one of the selection presented to Princess Margaret at Blenheim Palace in 1954.[30] A postage stamp sized piece of the fabric survives on the couture house chart which also documents its maker (Christiane) and the model who wore it (Renée). Interestingly, 'Zemire' was not only an important design which received at least one private client commission, but was also

1.9 Interior of bodice showing
silk lining and labels, 'Zemire'.
Christian Dior, Autumn/Winter
1954–5. V&A: T.24–2007

successful in terms of commercial reproduction – it can be fleetingly glimpsed in some
seconds of promotional film produced by Dior in 1954, and was featured in several
magazines. An advertisement in *Vogue* (British edition) in November 1954 shows an
identical copy of the skirt and bodice (without jacket) by the British ready-to-wear
company Susan Small, priced at 22 guineas (pl.1.11).[31] Christian Dior also created
designs for the theatre and an outfit made for Vivien Leigh by Angels & Bermans, the
theatrical costumiers, bears a striking resemblance.[32] Zemire is one of Dior's most
consciously historical designs. The 'riding' jacket and full skirt have a distinctly
eighteenth-century flavour, and are made using traditional construction techniques.
Edna Woolman Chase, editor-in-chief of American *Vogue* from 1941 to 1952, said of
Dior: 'His clothes gave women the feeling of being charmingly costumed; there was a
faintly romantic flavour about them.'[33] The attraction and paradox of Dior and many
of his contemporaries is that although they established a modern identity for couture
between 1947 and 1957, its practice and philosophy were rooted in the past.

The chapters in this book map the creative, economic and social forces that shaped
couture after the war. Two images, from London and Paris, illuminate something of its
status. In his salon, Jacques Fath puts the finishing touches to his elegant wife's outfit,
while a floor polisher skates over the wooden floor (pl.1.13). In the second, a Hartnell
model in full evening dress stands motionless while a figure in the background wields a
vacuum cleaner (pl.1.14). These juxtapositions reflect the paradoxical yet perfect
construct of couture, for the production and sale of luxury fashion relied on a clear
division between elite and non-elite. However, while couture remained unattainable for
most people – the closest they came to it was in glossy magazines or on the silver screen
– the sale of ideas and an increasingly powerful media created a ripple effect that
engaged and captivated an ever-growing audience. Even the BBC capitulated just

1.10 'Zemire' by Christian Dior,
shown without jacket, modelled by
Nancy Berg. *Vogue* (French edition),
September 1954. Photograph by
Clifford Coffin

Overleaf
1.11 Ready-to-wear copy of
'Zemire' by Susan Small. Silk satin.
Vogue (British edition), November
1954

1.12 'Zemire' modelled by Dior
house model Renée. Paris, 1954.
Photograph by Regina Relang

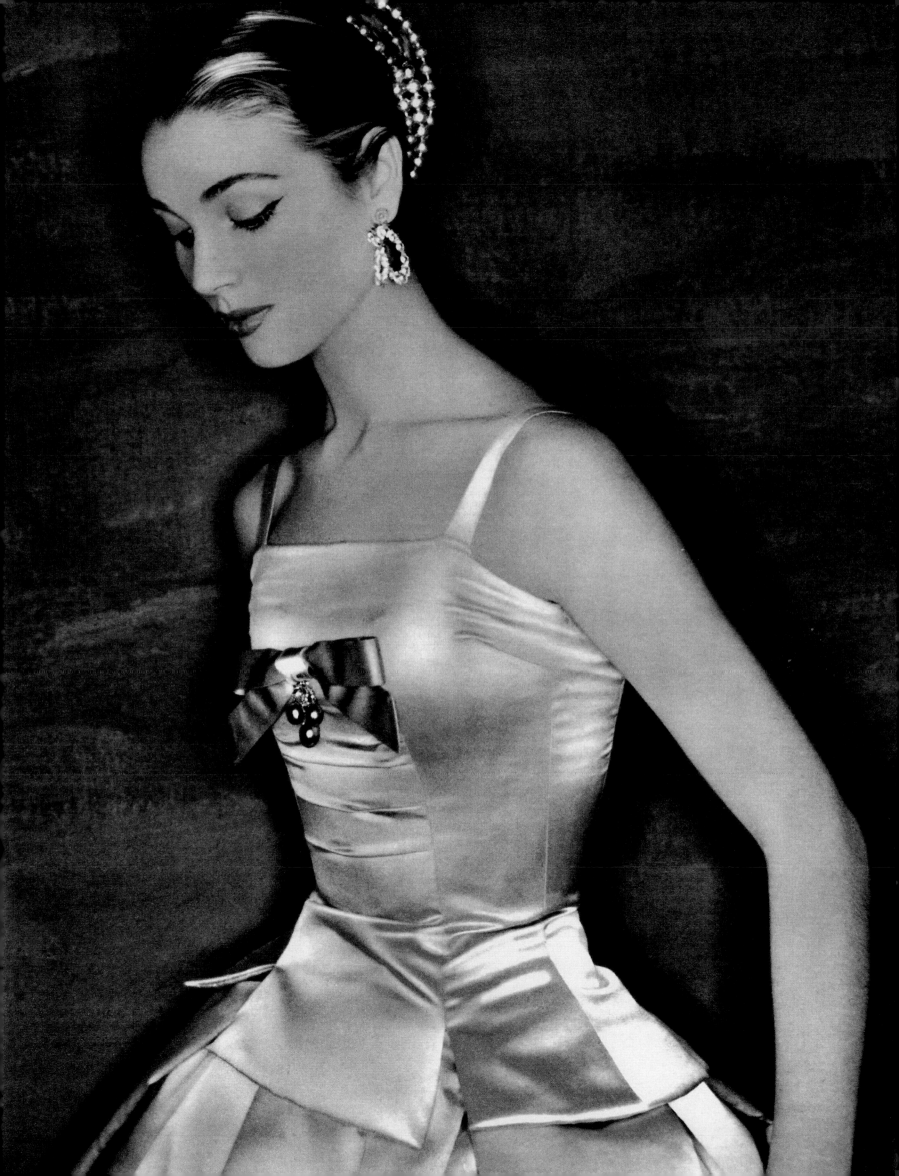

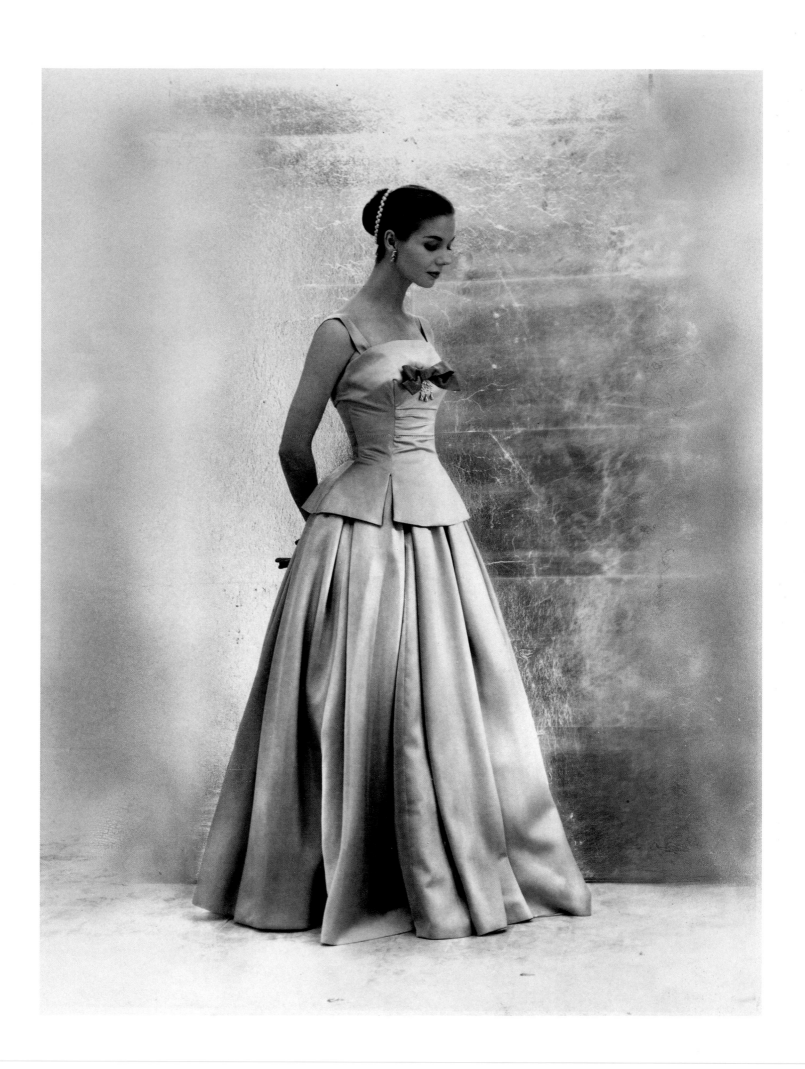

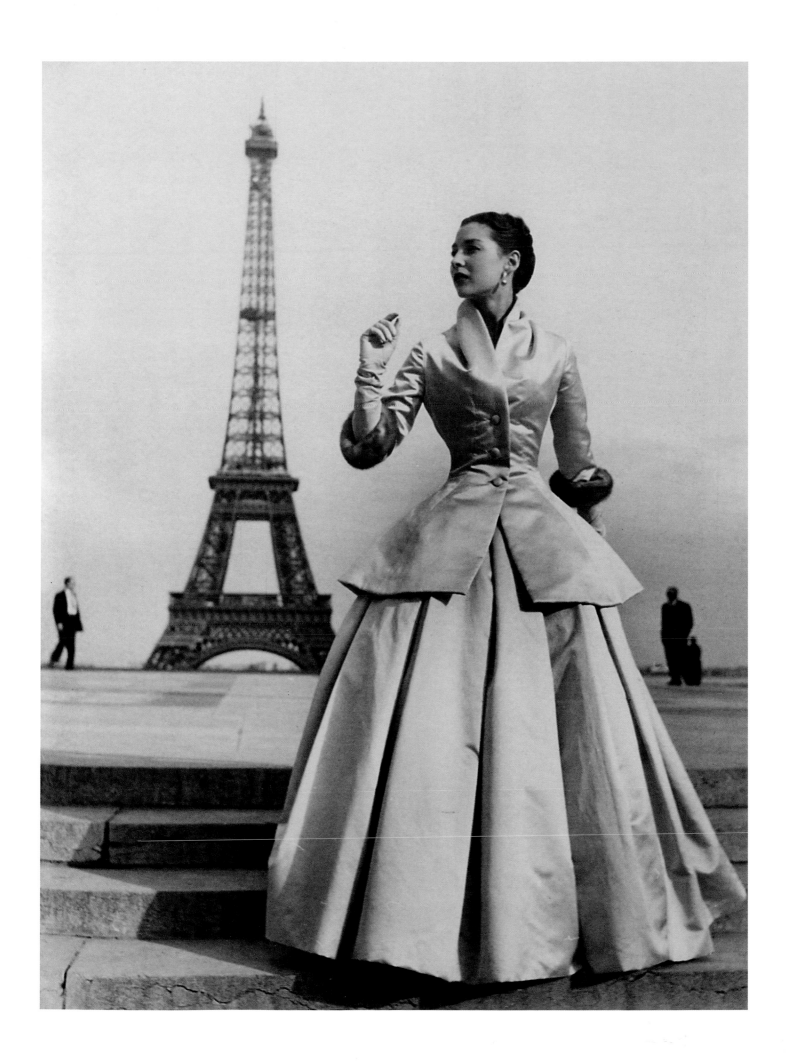

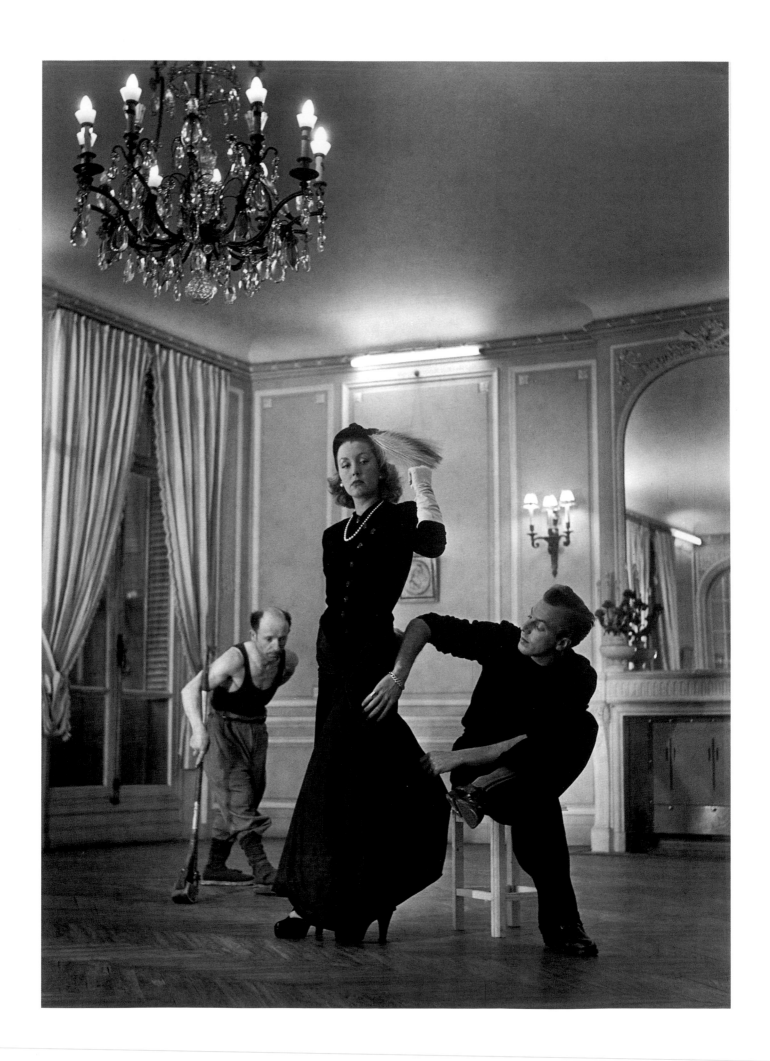

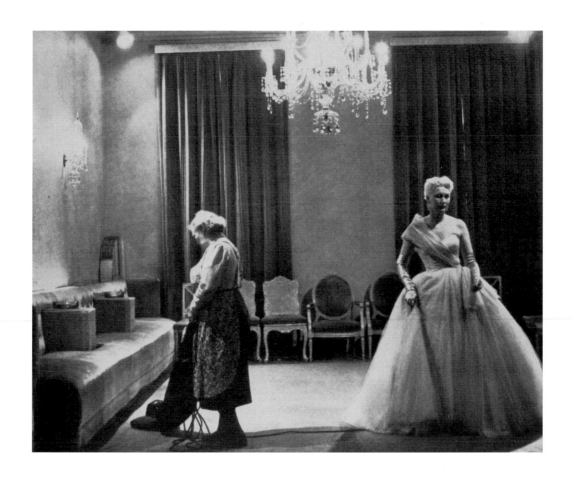

1.13 Jacques and
Geneviève Fath, 1946

1.14 Lana, a house model
at Norman Hartnell,
February 1955

after the war, with a television series devoted to the great French couturiers, presented by V&A curator and historian James Laver.

Although cultural and economic changes in society in the 1950s and the changing patterns of consumption eventually displaced couture, its fragile existence today remains a symbolic if not financially profitable commitment to personal aspiration, national identity and extraordinary and time-consuming handcraft. Its legacy is clear in modern fashion which, faithful to fashion's eternal preoccupation with both past and future, frequently mirrors the styles and manners of this elegant age.

———————

This book is published in conjunction with the exhibition 'The Golden Age of Couture: Paris and London 1947–1957' at the V&A (22 September 2007–6 January 2008).

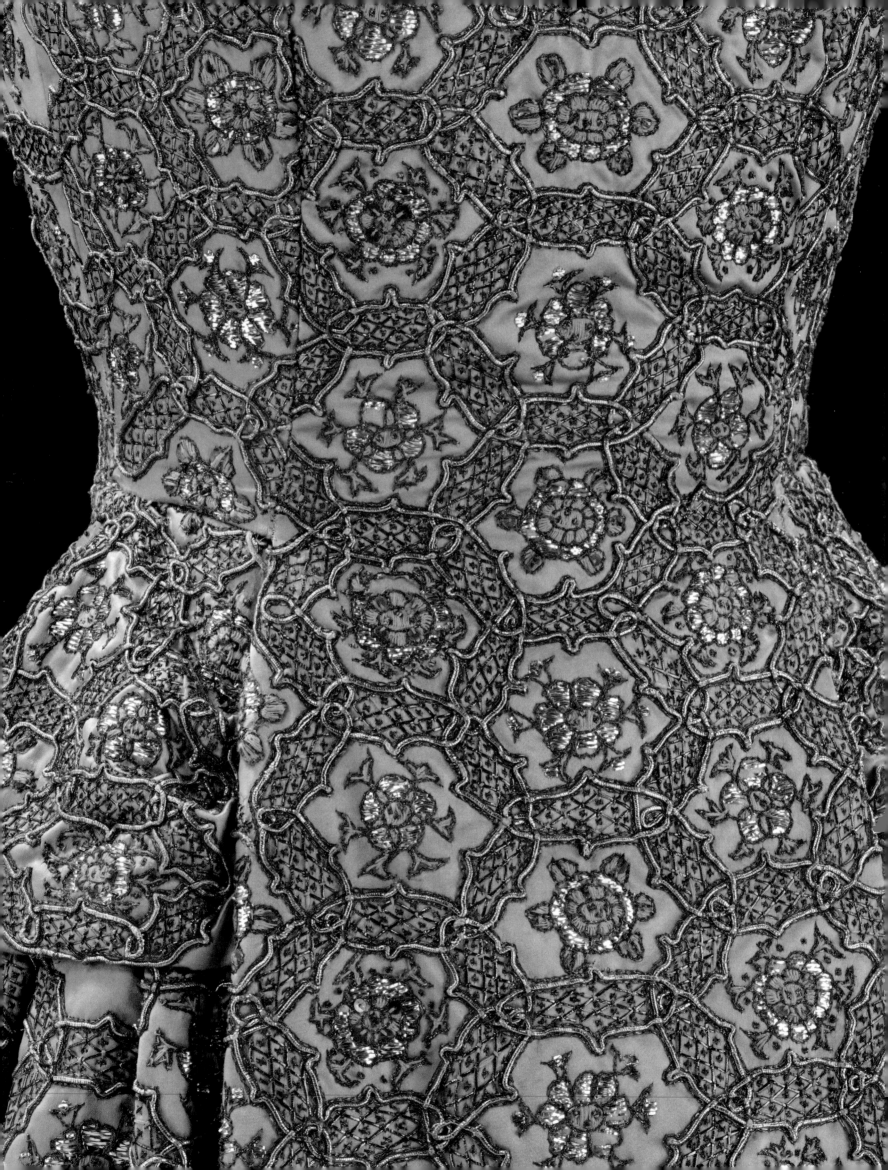

2

DIOR'S GOLDEN AGE
The Renaissance of Couture

CLAIRE WILCOX

'A golden age seemed to have come again. War had passed out of sight and there were no other wars on the horizon. What did the weight of my sumptuous materials, my heavy velvets and brocades, matter? When hearts were light, mere fabrics could not weigh the body down.' [1]

CHRISTIAN DIOR

PARIS WAS THE UNDISPUTED CENTRE of fashion in the years leading up to the Second World War. In 1937, there were numerous haute couture houses, among them the grand establishments of Chanel, Lanvin, Lelong, Mainbocher, Molyneux, Patou and Schiaparelli, as well as newcomers Jean Dessès, Jacques Fath and Cristóbal Balenciaga. The ebb and flow of seasonal fashion collections drew an international audience of wealthy private clients from Europe, the United States and South America (an increasingly important market), who arrived every season to commission new wardrobes. Equally important were the professional buyers who flocked to Paris, eager to pick up ideas and buy the latest fashions for reproduction across the world. However, the Second World War and the occupation of Paris by German troops between 1940 and 1944 disrupted the economy of haute couture and threatened its survival. In 1946, while Paris fashion was still struggling to recover, Christian Dior launched his new house on avenue Montaigne and became an overnight sensation with his first collection: 'unknown on the 12th of February, 1947, famous on the 13th,' wrote *L'Express*.[2]

Although a good number of houses had survived the war, and a few even opened during it, such as Marcelle Chaumont in 1940, Dior was regarded by many as the saviour of haute couture. His romantic vision created a mood of optimism after the gloom of the previous years, while the complex artistry of his gowns drew on skills unique to Parisian couture, providing employment for numerous *premières* (atelier supervisors)

The inscription on the building reads:

Vetustissima Templariorum Porticu
Igne consumpta
An 1678
Nova Hæc
Sumptibus Medij Templi extructa
An 1681
Gulielmo Whitelocke Arm Thesaur

and seamstresses. For a decade Dior's collections, with their endless supply of ideas, provided headlines and fuelled the growing market in ready-to-wear, particularly in the US, while still maintaining Paris's traditional status as a creative source for innovative fashion. This chapter traces couture's revival in the post-war period in the context of Dior's brief but immensely influential reign.

Paris 1939–45

Just days before the outbreak of the Second World War the weekly US magazine *Time* informed its American readers that 'reports from the opening of Paris fashion shows have grated on Nazi ears for the past fortnight as Schiaparelli followed Mainbocher, and Paquin, Patou and Balenciaga demonstrated that, whoever runs the world, Paris intends to go on making his wife's clothes (pl.2.3).'[3] The couturiers' defiance was a question of both national pride and economic necessity, and reflected an underlying concern about control of the fashion markets, threatened as they were by the storm clouds on the horizon. Within months of the outbreak of war, travel restrictions began to affect overseas orders as fewer international buyers attended the collections and private clients began to disperse. Edna Woolman Chase, who was editor-in-chief of American *Vogue* from 1941 to 1952, wrote in her memoirs: '*Vogue*'s role in the first few months of war was a gratifying if complex one. The couture suddenly became strangely dependent on us. The most cogent questions from the Paris office were: 'How does the wind blow on Seventh Avenue? Are the wholesalers profiting by war to push American design?'[4] This anxiety was not unjustified. Cecil Beaton noted in his diary how horrified he was that Paris's fall to the Germans was hailed with delight by the American press 'as a means of getting at Paris fashions quick'.[5]

Although the September 1940 issue of American *Vogue* cried 'What will America do without Paris fashion?',[6] home-grown designers such as Hattie Carnegie, in tune with New World sensibilities and the desire for informal, youthful styles, were gaining confidence and saw an opportunity to challenge French dominance of the lucrative and expanding ready-to-wear market. In terms of production France could not compete, for the US was now an industrial giant, mass-producing clothing as well as cars. Paris's strength was in innovative design, but as the war progressed several important designers relocated to New York until the war was over, upsetting the established balance of power. The American-born Mainbocher, couturier and former editor-in-chief of French *Vogue*, set up on 57th Street next to Tiffany's, stating 'America was working hard to make New York the world centre of fashion,'[7] while British journalist Alison Settle remembered: 'They had French émigré couturiers like Schiaparelli to help them.'[8]

By 1941 ration cards had been introduced in Paris as clothing shortages increased, caused by German requisitions and the difficulty of transporting supplies between the occupied and unoccupied French territories. Home dressmaking and couture were both hampered by lack of supplies, from thread to pins, scissors and needles. In March 1943

2.3 Ensemble by Cristóbal Balenciaga. Paris, 1941. Photograph by Seeberger

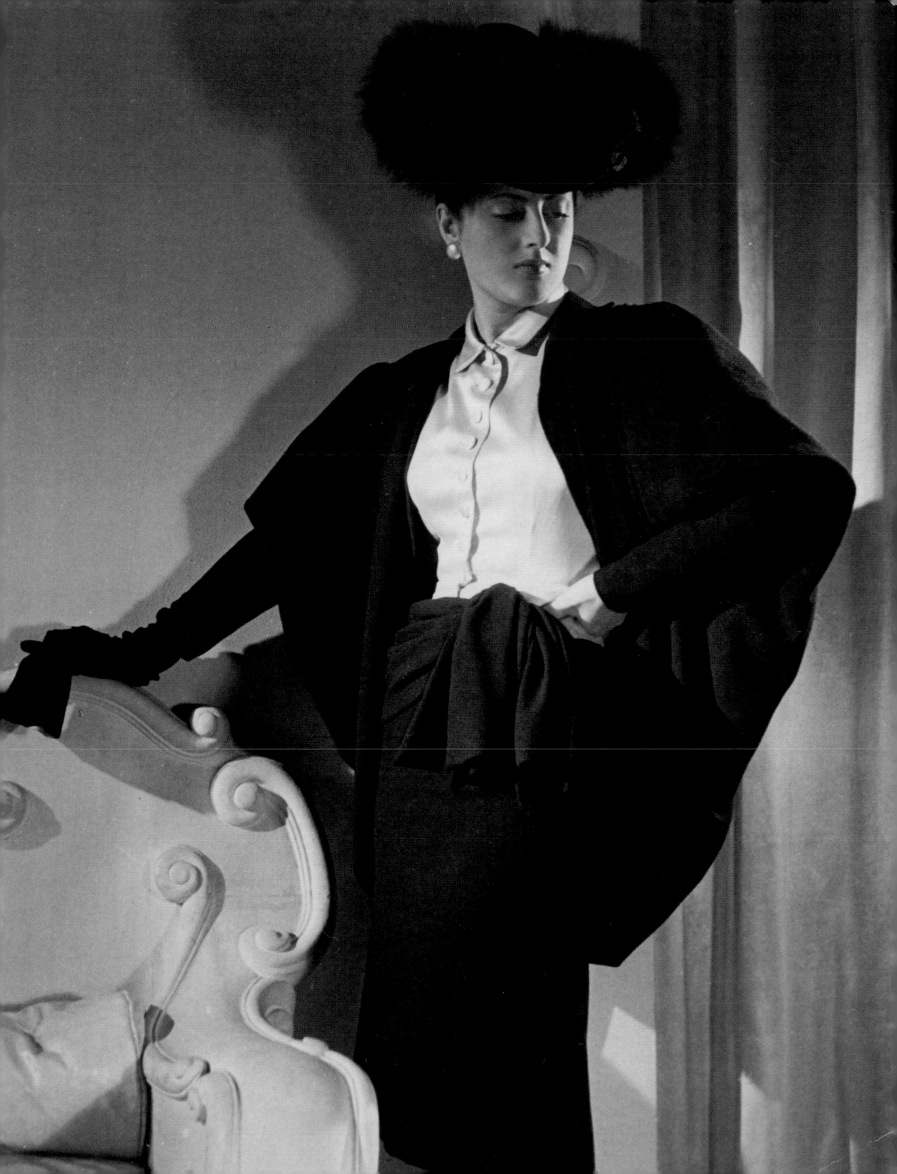

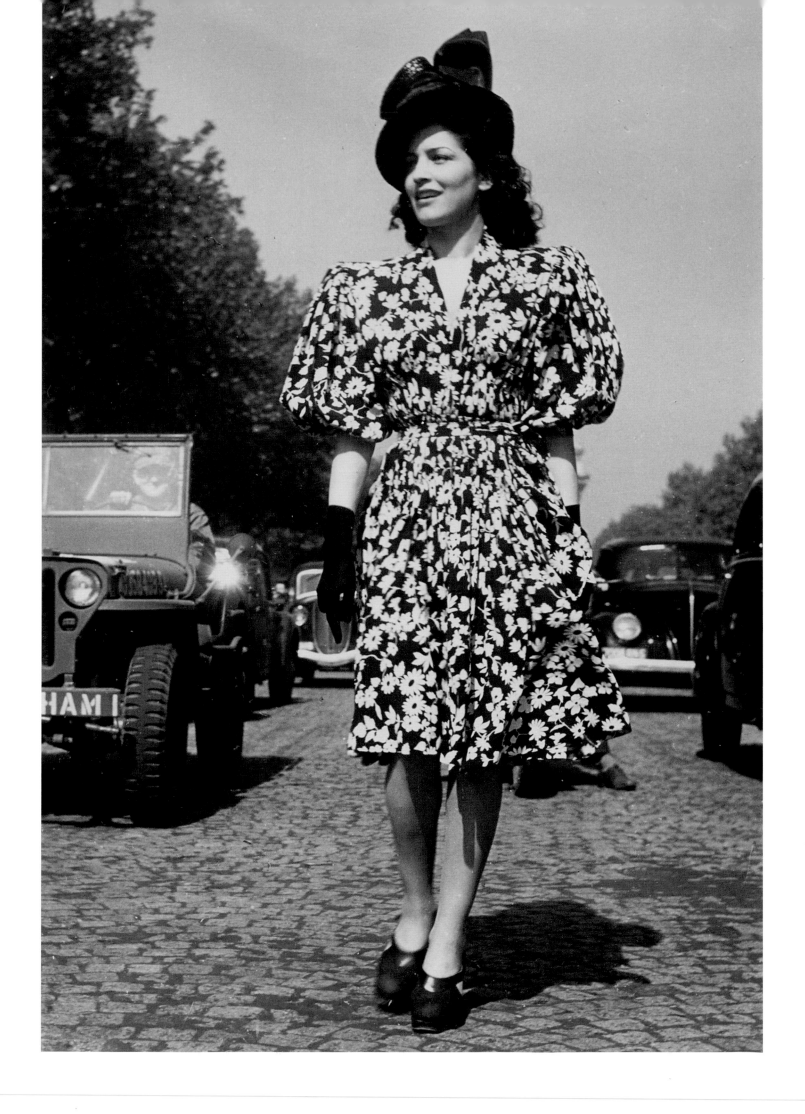

British *Vogue* published an article entitled 'How we live in France' by Elizabeth Hoyt, an American living in Paris, which stated that 'clothing rations are so meagre that it is impossible to dress comfortably – or even adequately – without recourse to "Black Markets" at enormous prices. Fortunately I had a pre-war wardrobe and have been gradually wearing this to shreds.'[9] The historian Dominique Veillon described how, in the face of dwindling overseas visitors, the Chambre Syndicale encouraged French women to continue to buy couture, with publicity drives in the press that defended couture's cultural importance, arguing that 'stylishness was an economic weapon'. A ration card was issued for couture clients and buyers, and a limited number of authorized couture houses were given an allowance of materials, while regulations were imposed on the number of designs produced. Some couturiers, such as Balenciaga and Grès, continued to make elaborate evening gowns in defiance of restrictions and were temporarily closed down. Some responded to the new conditions of war with practical outfits for cycling and travelling by metro.[10]

Post-war Paris

Paris's liberation in August 1944 abruptly exposed its wartime fashions to the world press (pl.2.4). Much was made of the cyclists' outfits and extravagant hats. As the first sightings began to emerge, *Time* magazine reported 'poke bonnets of brilliant-coloured straws, some 18 inches tall'.[11] Cecil Beaton, in Paris as one of the party of Winston Churchill's 1944 official visit, noted the 'Durer-esque headgear, suspiciously like domestic plumbing, made of felt and velvet' and the 'wide, baseball-players' shoulders, and heavy sandal-clogs, which gave the wearers an added six inches in height but an ungainly, plodding walk'. He added: 'Unlike their austerity-abiding counterparts in England these women moved in an aura of perfume.'[12]

Hermetically sealed from the rest of the world for four years, French high fashion seemed extravagant to British taste, for designers such as Digby Morton and Hardy Amies had been expected to conform to Utility restrictions on fabric quantities, skirt lengths and even number of buttons. The arrival in London in 1945 of the French ambassador's wife Mme Massigli in a tight-waisted jacket, full skirt and large hat was greeted with amazement, for Londoners still looked as they had in 1939.[13] 'We have only to look at the flippant and over-lavish designs, quite out of keeping with present times, which emanated from Paris before and after its liberation to understand the advantage that the restraint of utility clothing has given to Britain,' wrote Morton.[14] In their defence, Paris couturiers argued that they made fewer dresses with the available material rather than stint on quality of design.[15] Alison Settle, one of the first correspondents to arrive in Paris after the liberation, noted that the tendency towards full skirts had been necessary to conceal the poor quality of available fabrics, such as *fibranne* (spun rayon), and to compensate for lack of raw materials for underpinnings.[16]

In the face of the barrage of disapproval aimed at anyone suspected of collaboration,

2.4 'V-day' day dress by Maggie Rouff. Paris, 1944. Photograph by Seeberger

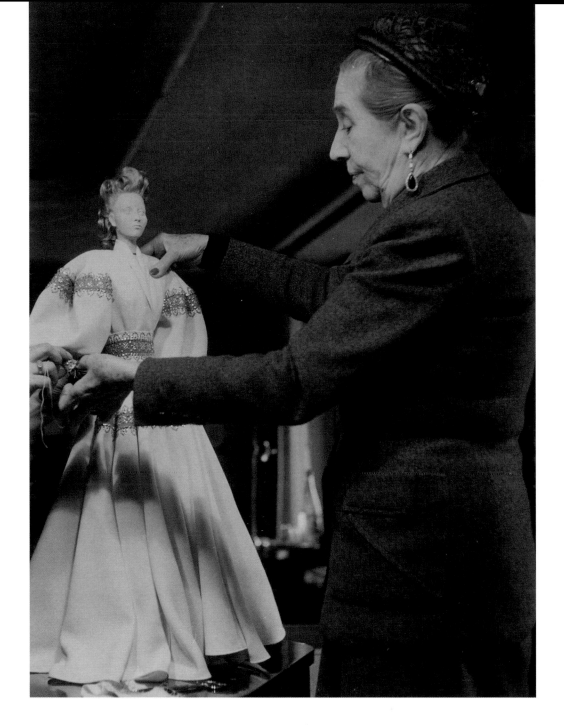

2.5 Jeanne Lanvin with one of her Théâtre de la Mode dolls, 1946. Photograph by Seeberger

Lucien Lelong, President of the Chambre Syndicale, requested an interview with Settle. 'He wanted to explain that he had not been co-operating with the Germans but fighting a rearguard battle to retain the Paris couture and its skilled workers and designers in Paris and not have them deported to Berlin as the Germans planned.'[17] However, *Time* magazine was outraged. In its opinion, Lelong had persuaded the Germans to let couture stay in Paris 'on the grounds that post-war German Europe would not otherwise be able to compete successfully against US designers. Thus 60 Paris dressmakers, employing directly 15,000 *midinettes* [seamstresses] and indirectly a million makers of dress materials were allowed to fashion style in full freedom.'[18]

Wealthy clients such as the Duchess of Windsor began to return to Paris, and it was reported that she bought two Schiaparelli pieces from the first post-war collections, 'a green taffeta formal gown with a full skirt, and a tailored black moiré suit, with the low-cut neck line forming draped sleeves.'[19] Nevertheless, in an effort to revive trade further, the Chambre Syndicale organized a promotional drive – the miniature 'Théâtre de la

Mode', a touring exhibition of nearly 200 dolls exquisitely dressed in miniature fashions by the French couturiers (pls 2.5 and 2.6). The quarter-lifesize dolls were arranged in painted sets representing Paris created by artists such as Christian Bérard and Jean Cocteau. The co-operative effort that the Théâtre inspired brought together a community that even as late as 1946 was still suffering privation: 'Beautiful models huddled around little stoves. Skilful *midinettes* bulged with sweaters… there was still not enough electric current to run all the machines or to burn the lights long.'[20]

Beaton, commissioned for a photo shoot by French *Vogue's* recently reopened Paris studio, summed up the contradictions: 'Balenciaga's line is very medieval and pregnant – nothing to do with the present-day travelling in métros so overcrowded that one has to be pushed into the train by porters – but so rich and luxurious that it is stimulating just to see.' He continued, 'the vegetables I asked for as props to these pictures were of great interest to those in the studio who still know hunger.'[21]

The vignettes of the Théâtre charmed first Europe, and then, in an updated version with Spring 1946 outfits, New York and San Francisco. Many of the dolls survive to this day, in the Maryhill Museum of Art, Goldendale in Washington, and provide an insight into the sheer number of French houses in operation (many now long forgotten) and a unique view of the transitional styles of the immediate post-war period. Although Mainbocher had shown tight-waisted gowns and created corset designs for Warner's of New York in 1939[22] and Marcel Rochas introduced a strapless bustier dress in 1942, the growing trend for a more curvaceous figure had been suspended during the war years in favour of more masculine styles. In 1945, Balenciaga became one of the first to increase skirt lengths and soften the ubiquitous padded shoulder, and this feminization is clear in the Théâtre de la Mode dolls that he dressed. One other doll stands out as particularly elegant – Lucien Lelong's, which was dressed by his chief assistant, Christian Dior.

2.6 Théâtre de la Mode dolls by (from left to right) Lucile Manguin, Marcelle Chaumont, Manguin and Jeanne Lafaurie, 1946. Maryhill Museum of Art

 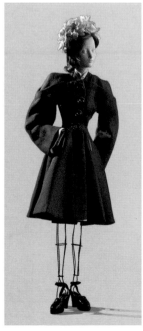 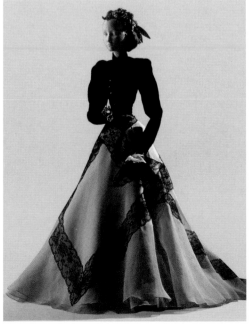 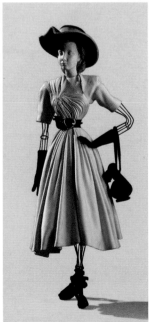

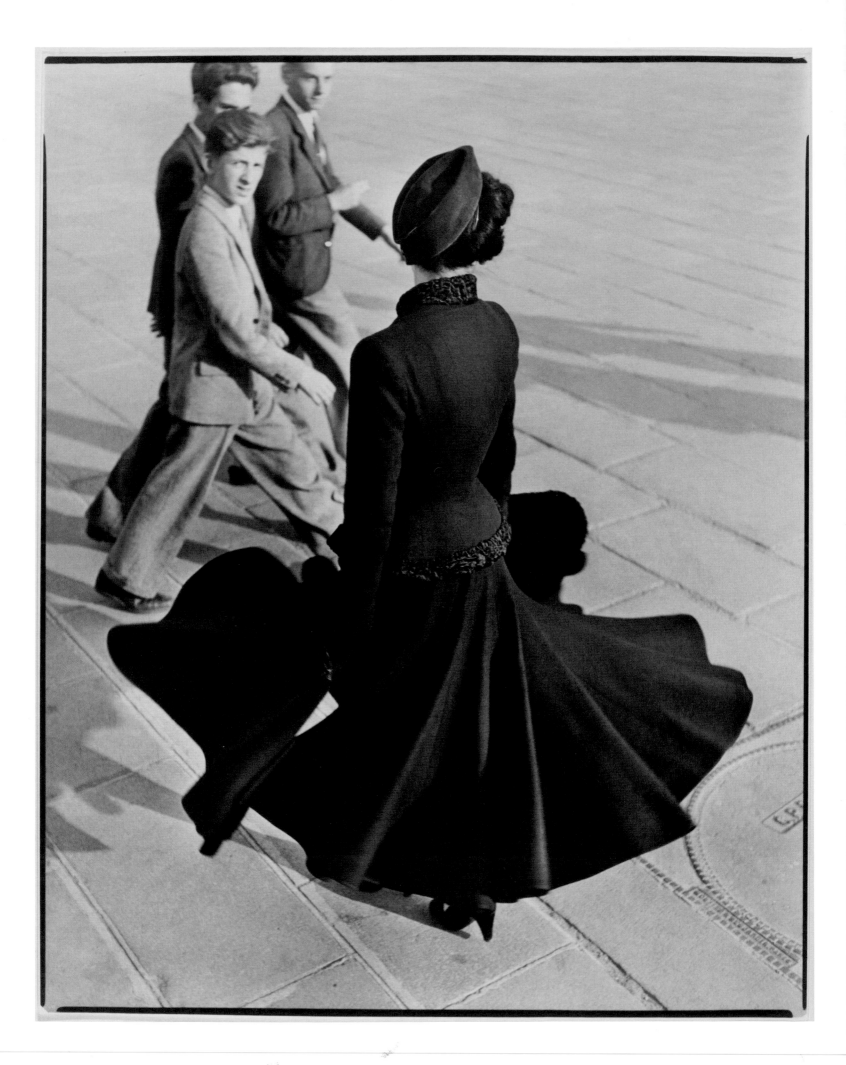

The New Look

'In December 1946, as a result of the war and uniforms, women still looked and dressed like Amazons. I designed clothes for flower-like women, with rounded shoulders, full feminine busts, and hand-span waists above enormous spreading skirts.'[23] CHRISTIAN DIOR

French *Vogue* announced the launch of Christian Dior's new fashion house with a modest paragraph in its social pages on 'La Vie de Paris'. In the same edition, sketches of the prevailing fashions explained that Dior's designs were based on two organic forms, the 'Corolle' – the whorls of petals of a flower – and the loops of the 'figure 8'. The caption explained '*La taille doit être très, très mince*'[24] – the waist must be very, very small. Although *Vogue* led with Dior's designs, the magazine gave no suggestion of the fervour with which his first collection had been received – of which Bettina Ballard, American *Vogue*'s fashion editor, wrote: 'I was conscious of an electric tension I had never before felt in couture… We were witnesses to a revolution in fashion.'[25] Previously, Dior had had a life of peaceful anonymity working first for Robert Piguet, then for Lucien Lelong for 10 years. However, in 1946 he negotiated a partnership with the Boussac Group (textile magnate Marcel Boussac was head of the Comptoir de l'Industrie Cotonnière, or CIC) who provided $500,000 and administrative support to create an entirely new house.[26] The relationship between textile producer and fashion designer was an intimate one, but rarely had a house been directly supported in this way, and it gave Dior's launch both credibility and assurance. Although suggestions have been made that the 'Cotton King' encouraged the generous use of fabric in order to revive textile sales, Dior explained in his autobiography *Dior by Dior* (1957) that he had simply picked up on the Zeitgeist, propelled by the fashionable world's distaste for any style reminiscent of uniforms. 'We were just emerging from a poverty-stricken, parsimonious era, obsessed with ration books and clothes-coupons: it was only natural that my creations should take the form of a reaction against this dearth of imagination.'[27] Notably, Dior chose models who were not too tall, to emphasize their well-fed, fertile shapeliness, in contrast with the lean wartime silhouette. Mme Marguerite, Dior's *directrice technique* (head of workrooms) described altering a dressmaker's dummy to fit Dior's vision, saying, 'I even rounded the abdomen, as on Greek statues, and there at last was a voluptuous figure to pin the muslin shape to, and ready to express the New Look.'[28] London-based couturier John Cavanagh described the new styles as 'a total glorification of the female form'.[29]

Dior was born in 1905, into an affluent family, and his historicist sense of fashion was informed by childhood memories: 'I thank heaven that I lived in Paris during the last years of the Belle Epoque – nothing will ever be able to equal the sweet memory of those days.'[30] Dior nurtured a predilection for nineteenth-century touches, using fabric knots, fringed bows and artificial flowers as finishing touches on garments of stiff taffeta, duchesse satin and wool, which were as firmly structured as those of Worth, the founder of haute couture. Dior wrote that 'an ethereal appearance is only achieved by elaborate workmanship: I wanted to employ quite a different technique in fashioning my clothes,

'*I designed clothes for flower-like women, with rounded shoulders, full feminine busts, and hand-span waists above enormous spreading skirts.*'

CHRISTIAN DIOR

2.7 New Look suit by Christian Dior, modelled by house model Renée. Place de la Concorde, Paris, 1947. Photograph by Richard Avedon. V&A: PH:74–1985

from the methods then in use – I wanted them to be constructed like buildings. Thus I moulded my dresses to the curves of the female body, so that they called attention to its shape. I emphasised the width of the hips, and gave the bust its true prominence; and in order to give my models more "presence" I lined nearly all of them with cambric or taffeta, thus reverting to an old tradition.' [31]

Although quite out of step with developments in contemporary art and design, Dior's nostalgia paid dividends. Far from creating clothes that competed with those of American designers such as Claire McCardell, who devised a uniform of simple, interchangeable components for the modern age, he revived a specifically Parisian form of dress with layers of underpinnings and 'wasp waists – achieved by seaming, by corsets (both separate and built-in)' (pls 2.8 and 2.9). [32] Edna Woolman Chase recalls: 'His look was one of unforced femininity – a polished continuation of the rounded line, which had been seen in Paris since the first post-war collections, but with the fabric so worked, the silhouette so gently handled that there was no look of heaviness or stricture.' [33] Dior's idealized vision of femininity was loved by the public but vehemently criticized by some other designers. Chanel, who reopened in 1954 after an absence of many years, said 'elegance in clothes means freedom to move freely'. [34] The complexity of Dior's clothes, with their elaborate fastenings, was questioned by Balenciaga for whom simplicity of form was a vocation. The minute snap-fasteners, buttons and zips on Dior's gowns meant that a woman required assistance to dress; Lady Gladwyn (wife of the British Ambassador to France between 1954 and 1960) wrote in her diary in 1947 that Lady Hulton, wife of publishing magnate Sir Edward Hulton, 'was late appearing for her own dinner because she was having difficulty getting into her new Paris dress – a tremendous creation the effectiveness of which depended on her wearing a real old-fashioned corset to tighten her waist.' [35]

One of the key aspects of Dior's look was that its doll-like shape was unmistakable in silhouette, with its lavish ballerina skirts, smooth fitted bodices and moulded jackets. Despite the complexity of the original designs the look was copiable and, significantly, commercial. 'Bar', one of the most important designs of Dior's first collection, combined tailoring and corsetry to create an armature upon which a silk jacket with padded hips and pleated wool skirt floated despite its heavy (8lb) weight (see p.60). Although Dior employed traditional corsetry techniques for the underpinnings, developments in new synthetics made corset-dependent fashions possible for all women (although as Settle noted, while rationing was still in place, corsets were forbidden in the UK except on doctor's orders), while full bell-like skirts could be cheaply achieved with nylon petticoats rather than Dior's multiple layers of taffeta and net. The blatant defiance of austerity regulations required by such dresses was controversial, and the British Government tried to prevent the New Look from catching on. Settle recalled: 'We were forbidden by the Board of Trade to mention his styles in case they engendered a desire for more fabrics, pretty styles, some trace of elegance. Dior's "New Look" was supposed to be

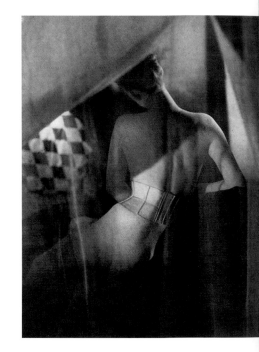

2.8 Waspie by Robert Piguet. *Vogue* (French edition), January 1947

2.9 Corsetted underdress, 1950s. Photograph by John French. V&A: AAD

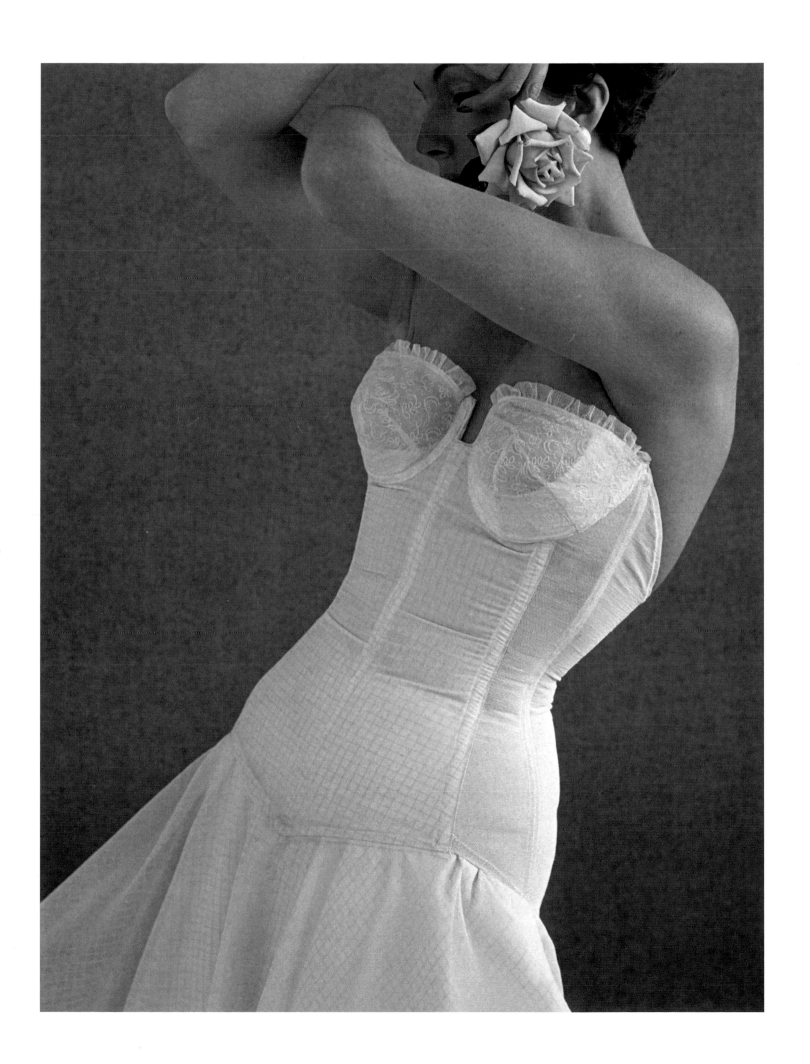

> *'I was conscious of an electric tension I had never before felt in couture… We were witnesses to a revolution in fashion.'*
>
> BETTINA BALLARD

completely unknown in Britain.'[36] However, the New Look proved unstoppable – despite shortages of fabric, which precluded even wealthy British clients from commissioning new clothes, skirts were lengthened with strips of fabric, shoulder pads removed and jackets taken in. In April 1947 Lady Gladwyn wrote: 'the dressmaker came and altered the jacket of my very ancient coat and skirt, nipping it in at the waist in the approved new fashion, and thereby, I hope, enabling me to wear it this season.'[37]

Dior's overnight success was most evident in his reception by the American press. Carmel Snow, editor-in-chief of *Harper's Bazaar* in New York, called the collection 'the New Look'. In his autobiography Dior refers to the fortuitous publicity coup of being photographed by the American weekly magazine *Life* as he prepared his first collection. However, he also consciously targeted the American market early on, employing Yvonne Minassian as head of export sales. She recalled: 'I was wearing a Legroux hat and in my pocket was my ticket with the dollar currencies for my trip. We got on from the word go, and at the end of the interview I had signed a contract. Dior offered to make me three dresses for my visit and I went off on a troop-carrier (all there was available in 1946) to announce the opening of the Maison Dior to the New York fashion world.' She wrote to Dior 'I'm not at all sure they [the buyers] will come.'[38] Although by the time of his launch early in the following year many Americans had already placed their season's orders and left Paris, after reading Carmel Snow's reports they returned, to be followed in subsequent seasons by European, South American, Australian and eventually even Japanese buyers.

The emergence of Christian Dior's fashion house dispelled any hopes entertained by critics in the US, who had felt that American designers could compete with a weakened Paris. Dior was awarded a Neiman Marcus Oscar by the renowned department store for his 1947 collection, becoming the first French couturier to be so honoured, and went in person to Dallas, Texas, to collect it (Norman Hartnell also received an Oscar on the same occasion). He then toured the US in the midst of protests about excessive skirt lengths, all of which gave added publicity to the New Look. By 1948 he had obtained premises on Manhattan's Fifth Avenue and signed up a team of American assistants to produce a line of dresses that would be a digest of the Paris collections, to wholesale 'at $59.75 and up' under the name of 'Christian Dior New

2.10 'Green', day dress by Christian Dior. Green and white silk, Spring/Summer 1947. *Vogue* (French edition), Spring 1947. See V&A:T.115–1974

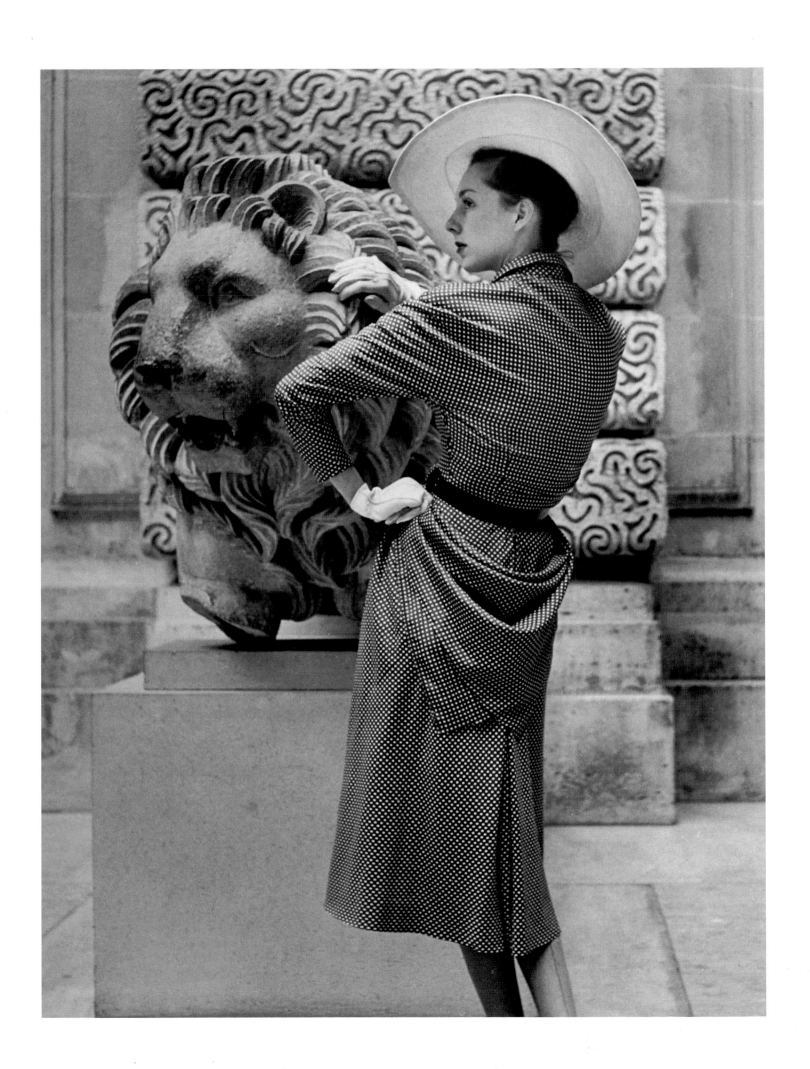

York'. 'The dresses will be a "conservative evolution" of his Paris models, designed with one eye on US tastes and the other on the limitations of machine production,' wrote *Time* magazine on 16 August 1948.[39] Dior was as astute commercially as he was artistically; he was well aware that maintaining a knowledge of the American way of life was 'indispensable for every denizen of the twentieth century'.[40]

Dior's departure from the hothouse of the private client market and his launch into wider commercial fields was not without precedent. Jacques Heim had introduced his 'Jeunes Filles' line in 1936 for younger women and from 1950 the 'Heim-Actualité' ready-to-wear collection, but his house – complemented by sports and casual wear shops in the South of France – did not enjoy the status of the grand old establishments (pl.2.13). He was described by *Women's Wear Daily* as 'basically an innovator in business. He didn't want to be called a designer, but rather an editor of clothes'.[41] Dior, however, maintained an equilibrium between the status and tradition of French high dressmaking and new commercial opportunities, taking the old world to the new. His prescience ensured the survival and reputation of his brand in an ever more competitive world, paving the way for haute couture to take full advantage of the rise of consumerism in the 1950s.

2.11 Cocktail dress by Christian Dior (London). Organza, 1957. Given by Mrs William Mann, V&A: T.235–1985

2.12 Hat by Aage Thaarup. Velvet, 1950s. Worn by Mrs Blair Cook and given by Mrs B. Church. V&A: T.255–1985

2.13 Jacques Heim, paper patterns with labels and fabric swatch

2.14 Shoe by Roger Vivier for Christian Dior, 1954. Given by Roger Vivier, V&A: T.148–1974

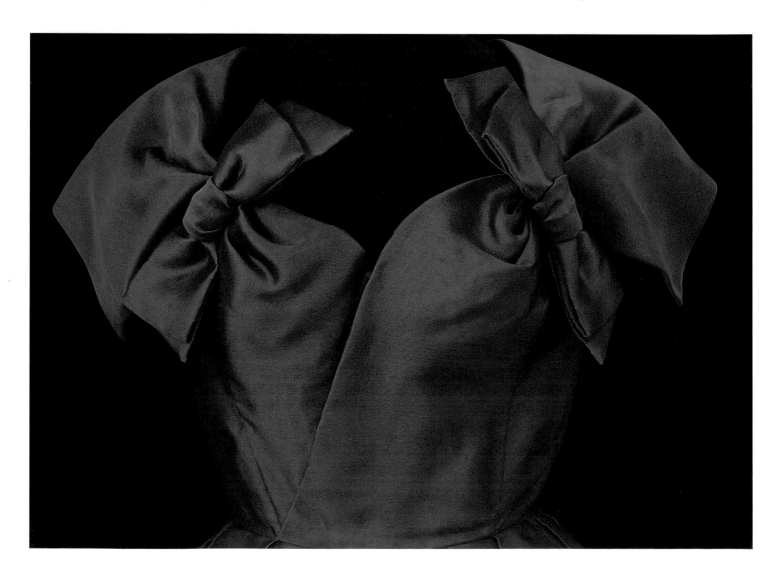

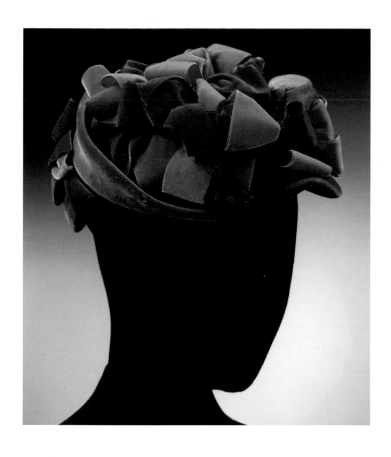

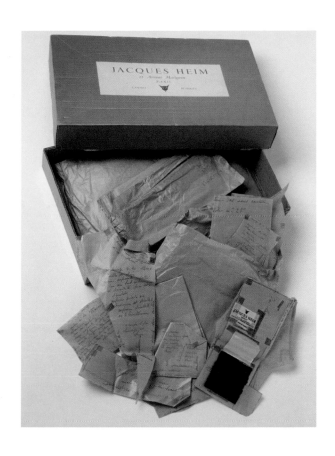

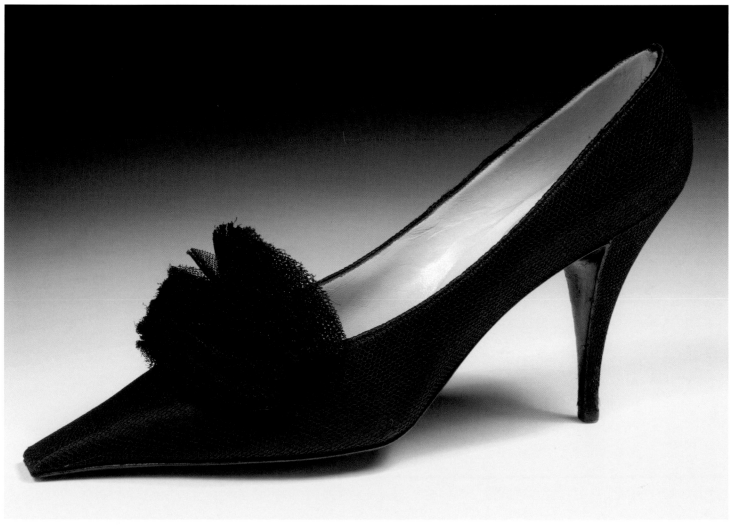

1950–57

The wider political changes and reshaping of Europe through the Marshall Plan (an American financial aid programme which ran from 1948 to 1952 to repair war damage and support regeneration) and the encouragement of American purchases of European goods benefited the couture industry. Despite this support, and textile subsidies by the French government, by the mid-1950s the number of Paris couture houses had declined from 70 in 1937 to 52. Many of the great establishments had closed; Lelong retired in 1948, Molyneux in 1950, Piguet in 1951, Rochas in 1952 and Schiaparelli in 1954, while Worth (under Paquin's ownership since 1954) closed its doors in 1956 after a century in business. The economic viability of couture changed irrevocably as increased material and labour costs in the post-war period put pressure on Paris couturiers and textile manufacturers, who realized that commercial survival could be ensured only by continuing to develop new markets abroad. Accelerating modes of communications meant that fashions could be disseminated ever more quickly, while international travel became part of a way of life for the couturiers who sought new markets. Although Givenchy would later suggest that the jet plane dealt couture one of its death blows, in its early commercial stages the development of air travel and its increasing availability meant that couturiers could put on fashion shows all over the world rather than relying on buyers coming to Paris. Air France advertised flights to 35 destinations in French *Vogue* in 1948, and in her autobiography *Flying Mannequin* (1958), 'Freddy', a leading British model of the time, even recalled modelling a fashion show during a flight.[42] London couturiers such as Digby Morton also increased their export sales – he went to Paris in 1950 with the idea that American visitors could order a 'real London tailor-made' and collect it on a flying visit to London, while Hardy Amies became the first London couturier to show in New York in 1952. In the same year, even the reclusive Balenciaga travelled to the US to discuss licensing and distribution.

Although *Time* magazine said of Christian Dior, 'He's Atlas, holding up the entire French fashion industry', several important houses shared Dior's international stage.[43] Pierre Balmain, who had opened shortly before Dior, in 1945 (having also worked at Lelong), showed a collection in Australia in 1947, opened a branch in New York in 1951 with biannual collections adapted to American taste, and also opened boutiques in Brussels in 1952 and Caracas in 1954. By 1956 he had 600 employees, 12 couture workrooms and in-house fur and millinery ateliers.[44]

Other old established houses were rejuvenated by taking on new chief designers, such as Lanvin, which unusually was renamed Lanvin Castillo following the appointment of Antonio Canovas del Castillo in 1950. This very grand, luxurious establishment, arranged over six floors, had 600 employees and a mainly private clientele, and was described by *Time* magazine as the place where Parisiennes would go 'if they wanted to be sure they would not be mistaken for Americans'.[45] At the time of writer Celia Bertin's 1956 survey of Parisian couture, three-fifths of French women

'He's Atlas, holding up the entire French fashion industry.'

TIME MAGAZINE

2.15 Evening dress by Pierre Balmain. Printed silk, 1957. *L'Officiel*, March 1957. See V&A: T.50–1974

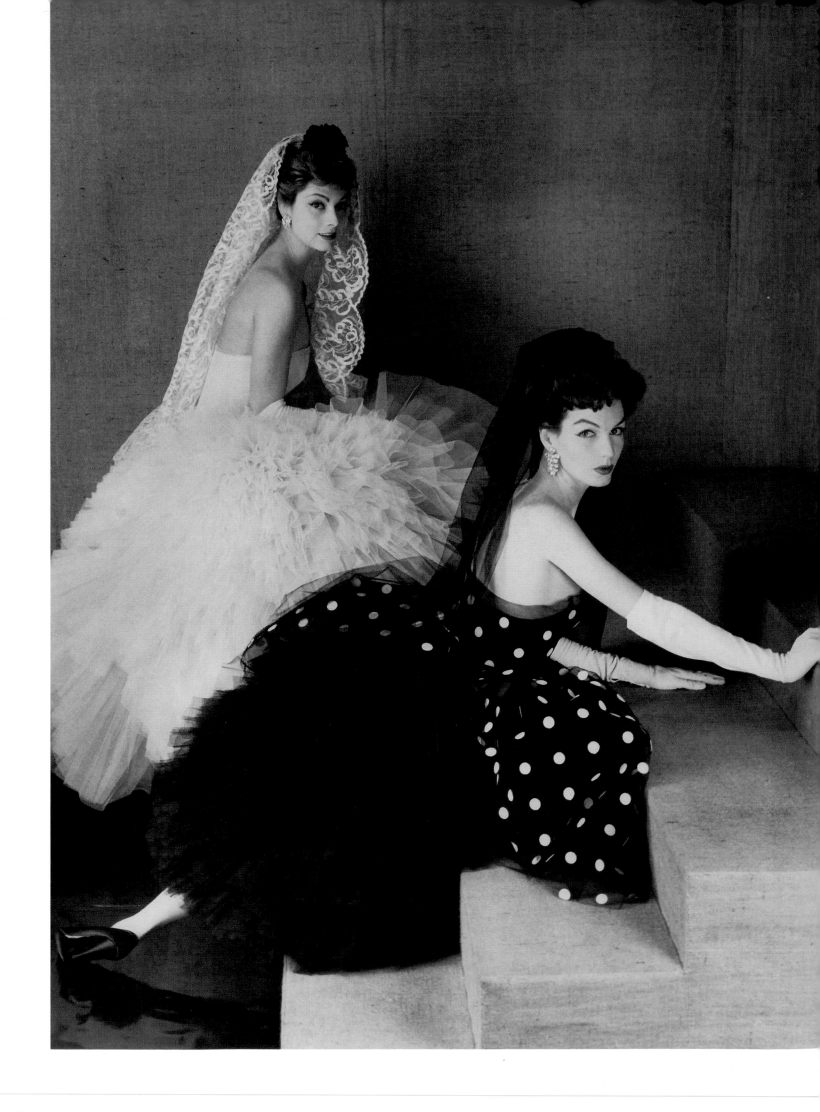

2.16 Cocktail dresses by Lanvin Castillo. *Vogue* (French edition), April 1957. Photograph by Henry Clarke. For the black and white dress, see V&A: T.52–1974

2.17 Evening dress by Digby Morton. Draped jersey, 1954. Given by Lady Howard Robertson, V&A: T.278–1975

still wore clothes made by dressmakers (although not necessarily couture) rather than ready-to-wear.[46] For Dior, custom-made dresses still accounted for over 50 per cent of his total dress sales, but *Time* magazine claimed that for every $400 dress, he made only a profit of $30;[47] in some cases, profit was abandoned totally for the sake of publicity. On 8 March 1950, Lady Gladwyn noted in her diary, 'Mme Massigli was in a tremendous Dior dress, Mme Auriol in one from Fath which I preferred; I have no doubt that neither paid for their dresses but wore them as advertisement.'[48] French employment regulations made it difficult for couturiers to cut the cost of time-consuming hand labour and the situation was compounded by the loss of Eastern European markets and a reduction in European and South American sales because of currency and import restrictions; many clients had problems during the Fifties and even into the Sixties, according to fashion publicist Percy Savage, because they could not get their money out of the country.[49] The wealthy still looked to Paris for direction but increasingly

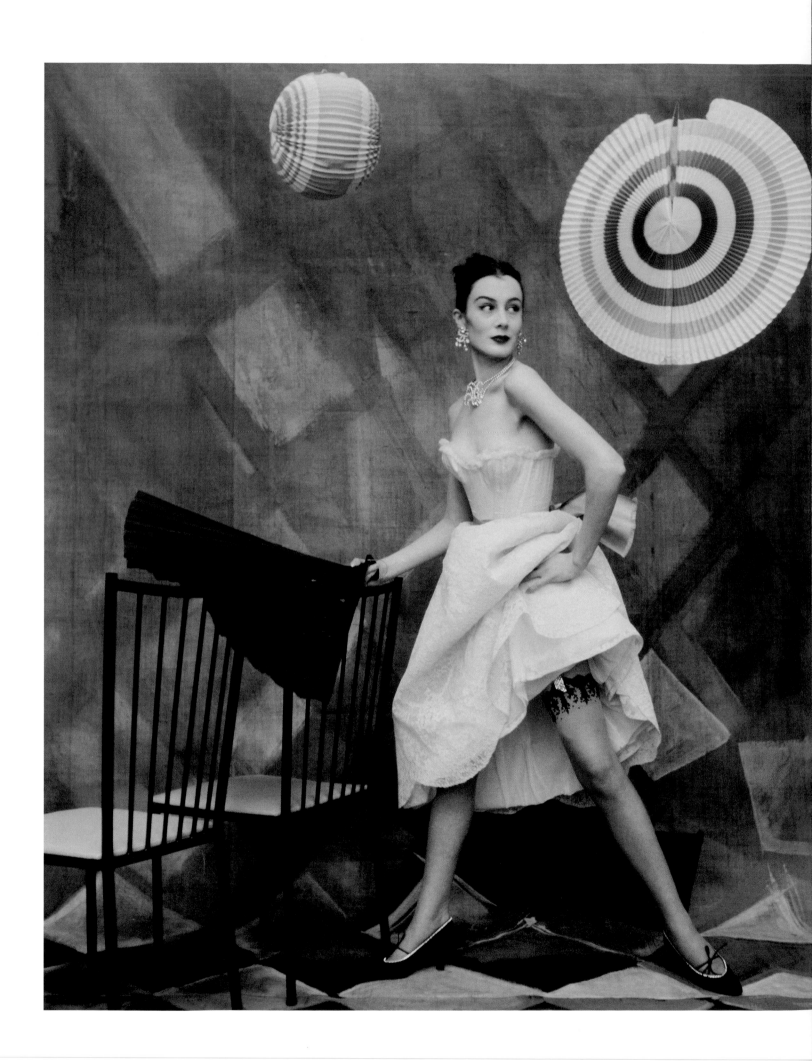

did not buy: Cecil Beaton reported that the Duchess of Argyll 'admitted her clothes are a result of inordinate care and thought, that she buys them in New York because they're better value, but goes to Paris to keep her eye in',[50] while Evangeline Bruce, one of Dior's most loyal clients, began to buy American copies of his garments. 'They were labelled "Monsieur X", but everyone knew. You couldn't tell the difference,' said one New York store executive. The issue was also one of a changing social climate; couture client Mme Fabre-Luce said: 'I couldn't face interminable fittings. Of course there was an undoubted aesthetic loss. You rarely see anyone in the street who rises above the ordinary now.'[51]

A recurring theme in all the couturiers' autobiographies of this period was the issue of intellectual copyright and uncontrolled copying. Savage described how a major client of Balenciaga 'used to come to London after she had bought from Balenciaga, and go to a little couturier in Beauchamp Place, who would copy stitch for stitch and bead for bead the jackets and suits and dresses... she told everybody that she did it, everyone knew that she had copies of them'.[52] Although copying on this level may have been tolerated if not appreciated, professionally organized plagiarism forced designers into *prêt-à-porter* in an attempt to control market forces. Savage recalls 'word would get back to the house... perhaps one unhappy manufacturer who had bought a lot would see that somebody else had used the name of Lanvin when they weren't allowed to... we would eventually speak to them, or sue the other house. That happened fairly regularly... The Americans were reasonably good, and they paid a lot of money so we let them get away with murder.'[53] Despite a law passed in 1952 that copyrighted a couture collection for one season,[54] leading couturiers filed dozens of lawsuits a year in an attempt to prevent fraud, but much of it was too complex to pursue. Settle wrote: 'Paris gave them [the buyers] the ideas and inspiration for scores of models which they did not buy but "carried in the eye".'[55]

'Avenue Pierre 1er-de-Serbie is my street in Paris, in the heart of the haute couture quarter. Seventh Avenue is its American translation into wholesale terms,' observed Jacques Fath in *Fodor's Women's Guide to Paris* in 1956. Of the same two streets, he wrote, 'the two get on fabulously well together for very sound reasons. They respect and need each other.'[56] Fath launched his house in 1937 and in 1949 'freely admitted' to have 'already sold 41 million francs worth of custom-made dresses'.[57] He was, from the American perspective, one of the three giants of post-war Paris fashion alongside Christian Dior and Pierre Balmain, although his name is less familiar today because of the closure of his house following his untimely death in 1954. Like Dior, Fath travelled to the US regularly from 1948, having branched into the American market with a ready-to-wear line with the American clothing manufacturer Joseph Halpert. The designs were sold in numerous cities in Lord & Taylor, Magnin and Neiman Marcus stores. Fath learnt quickly from the American wholesalers; his ready-to-wear line of 1953, 'Université', was backed by press and textile magnate Jean Provost and utilized mass-production and sizing methods developed in the US. Fath's versatile designs were tailor-made for the American way of life, even determining the type of materials employed: 'lightweight

2.18 Boutique stockings by Jacques Fath, 1954. Photograph by Henry Clarke

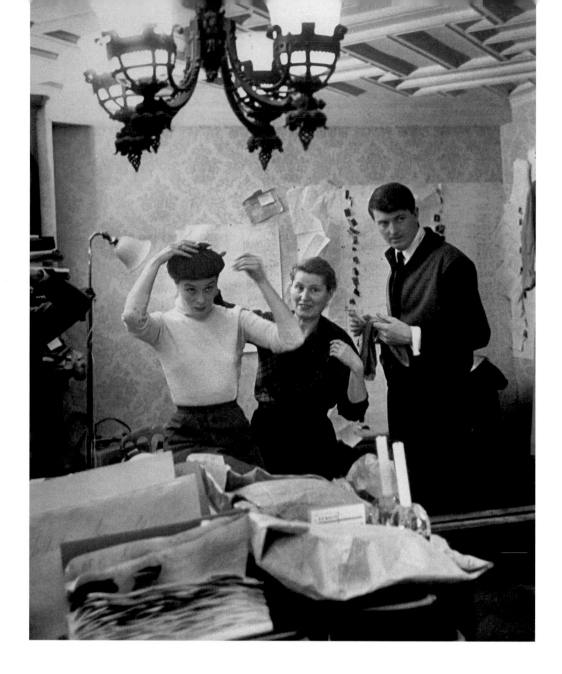

2.19 Hubert de Givenchy, model Bettina and her fitter prepare for Givenchy's first collection in 1952

2.20 Audrey Hepburn in a dress by Hubert de Givenchy for the 1954 film *Sabrina*

American fabrics are used for our New York collections, while heavy tweeds, velvets, and woollens are indispensable to Paris styles'.[58]

The post-war transformation of the fashion houses was reflected in the consolidation of the boutique, which catered for a more popular market for lower-priced goods such as perfume and accessories. By the mid-1950s, perfume, stockings, scarves and millinery sales constituted 36 per cent of Fath's takings (pl.2.18).[59] The breakdown of formal dressing reflected a new spontaneity and individualism in dress style, with the boutique becoming a forerunner for the concept of *prêt-à-porter*. The young Hubert de Givenchy was instrumental in shaping this more youthful approach to dressing in the post-war era by incorporating the spirit of the boutique with the quality of couture. Like many couturiers he learnt through placements at various houses, from Fath to Piguet, Lelong and then Schiaparelli for four years, where he designed 'separates' for her pioneering boutique. This breakdown in demarcation of couture practice and the simultaneous emergence of the modern career woman were reflected in the weekly magazine *Elle*'s decision to feature a cotton blouse from Givenchy's first couture collection of 1952 on their front cover. [60]

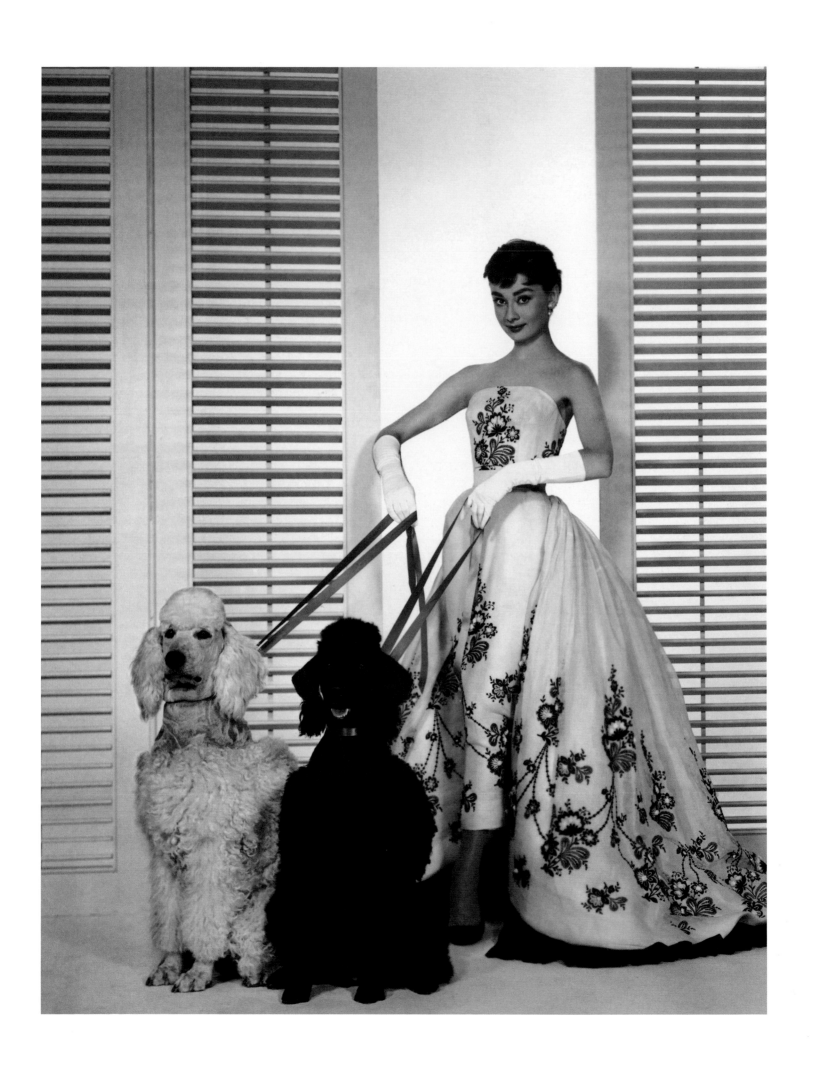

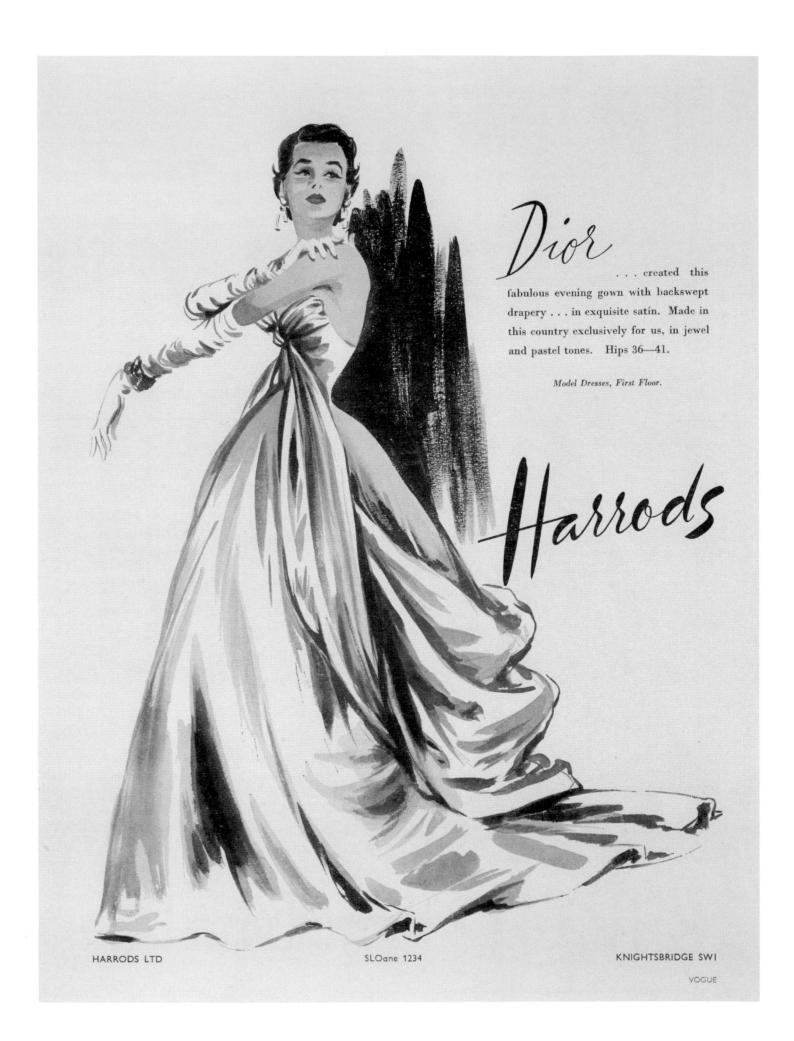

Dior

. . . created this fabulous evening gown with backswept drapery . . . in exquisite satin. Made in this country exclusively for us, in jewel and pastel tones. Hips 36—41.

Model Dresses, First Floor.

Harrods

HARRODS LTD　　　　　　　SLOane 1234　　　　　　　KNIGHTSBRIDGE SW1

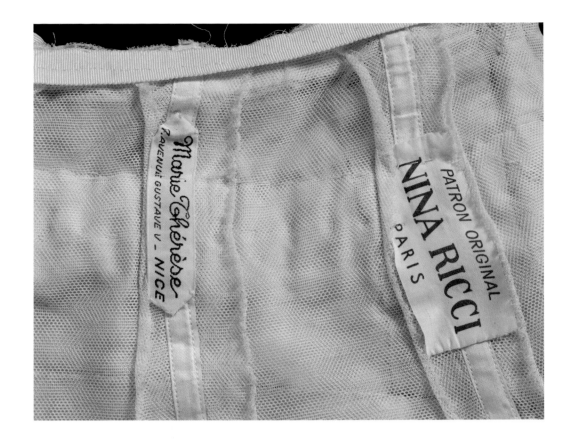

2.21 Advertisement for Harrods dress department. *Vogue* (British edition), November 1956

2.22 Interior of a Nina Ricci licensed copy. Satin, 1955–9. V&A: T.639–1995

2.23 Invitations to Christian Dior (London) fashion show at Harrods, 1957. Harrods Archive

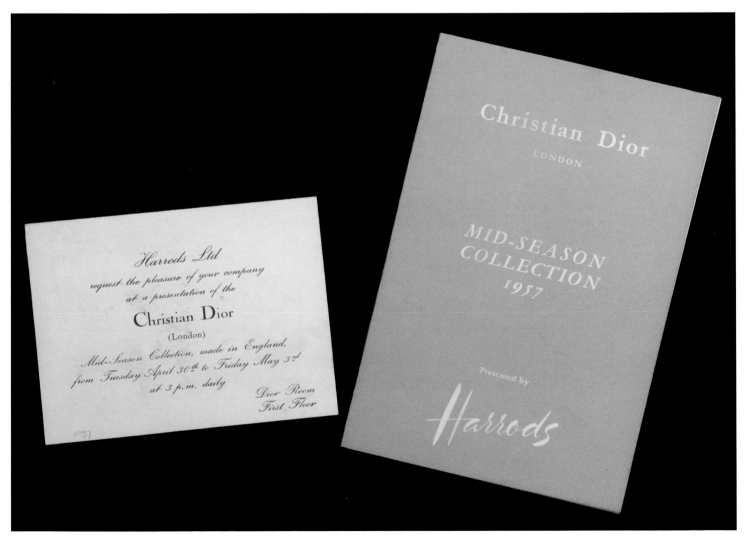

> *'He has gone, and ten years of taste, of daring, of invention, have gone with him. It is to Dior that haute couture owes the recovery of its empire when it was most threatened. He is irreplaceable.'*

<div align="right">

VOGUE (FRENCH EDITION)

</div>

By the mid-1950s, Dior's annual turnover was $18 million, according to *Time* magazine, and his workforce had increased more than tenfold, from 85 in 1946 to a total of 1,200. There were branches in London and Caracas, an accessory line, perfume company, hosiery, gloves and men's ties, designs for Scottish cashmere and bathing suits for California, while on avenue Montaigne seamstresses made 12,000 dresses a year with $1,000,000-worth being sold abroad, more than half of all Paris couture's exports.[61] The historian Valérie Guillaume argues that one reason for the demise of Jacques Fath's empire, despite his fame and prosperity, was that he did not form independent companies abroad but entered into agreements, such as the provision of couture patterns for *Vogue*.[62] In contrast, Dior owned eight 'Christian Dior' companies, while 16 firms made Dior products under franchise, an economic strategy that ensured the house's survival. As Savage explained, 'Dior had a very strong commercial sense, and went out, made contracts which bound certain people to them for years to come. So that when Christian Dior died, there were many international contracts that they had to respect.'[63]

'He has gone, and ten years of taste, of daring, of invention, have gone with him. It is to Dior that haute couture owes the recovery of its empire when it was most threatened. He is irreplaceable.'[64] *Vogue* (French edition), November 1957

Dior's sudden death in 1957 threatened an international business empire. The fashion trade was of vast importance to the French economy, and its recovery after the war was helped immeasurably by Dior's success, both in the Parisian and international markets. It was essential to keep the house going, for as Marie-Louise Bousquet, editor of French *Harper's Bazaar*, stated: 'If the colossus of Dior had crumbled, it would have shaken French fashion to its foundations.'[65] Yves Saint Laurent's appointment as chief designer at the age of 21 presaged a shift in taste as the decade drew to a close and his 1958 triangular 'trapeze line' was hailed in the US as 'the first big change in female fashions since the New Look in 1947'.[66] Other designers had begun to emerge who made Dior's

2.24 Yves Saint Laurent at Christian Dior's funeral. Paris, 1957

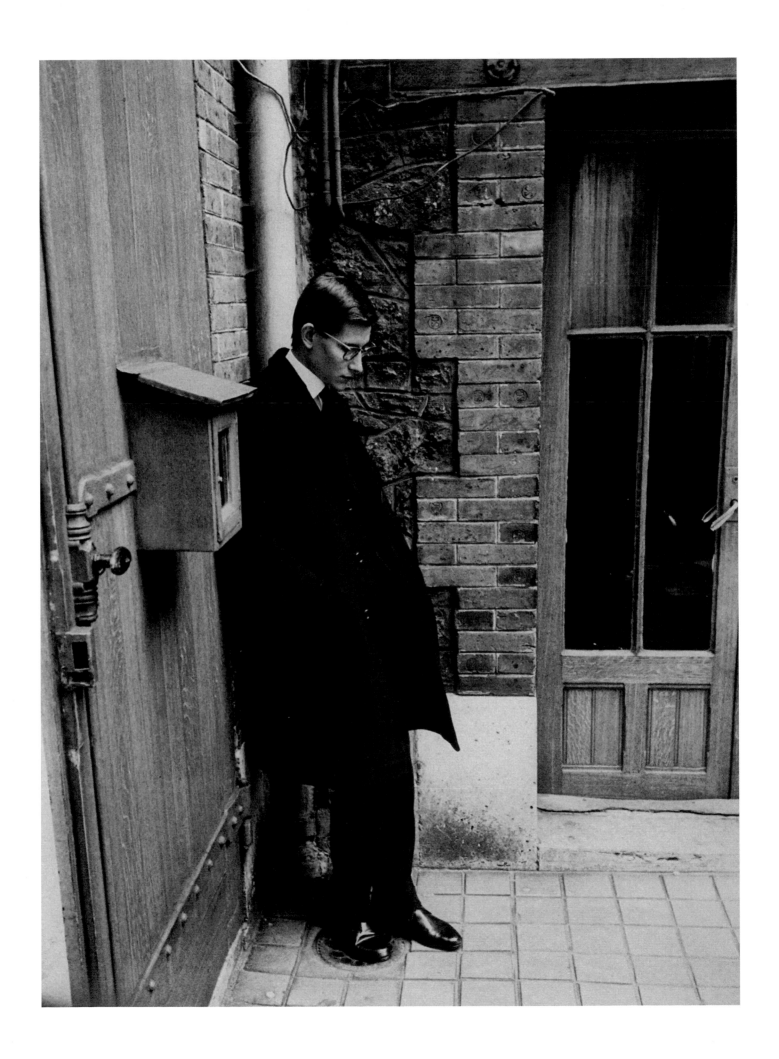

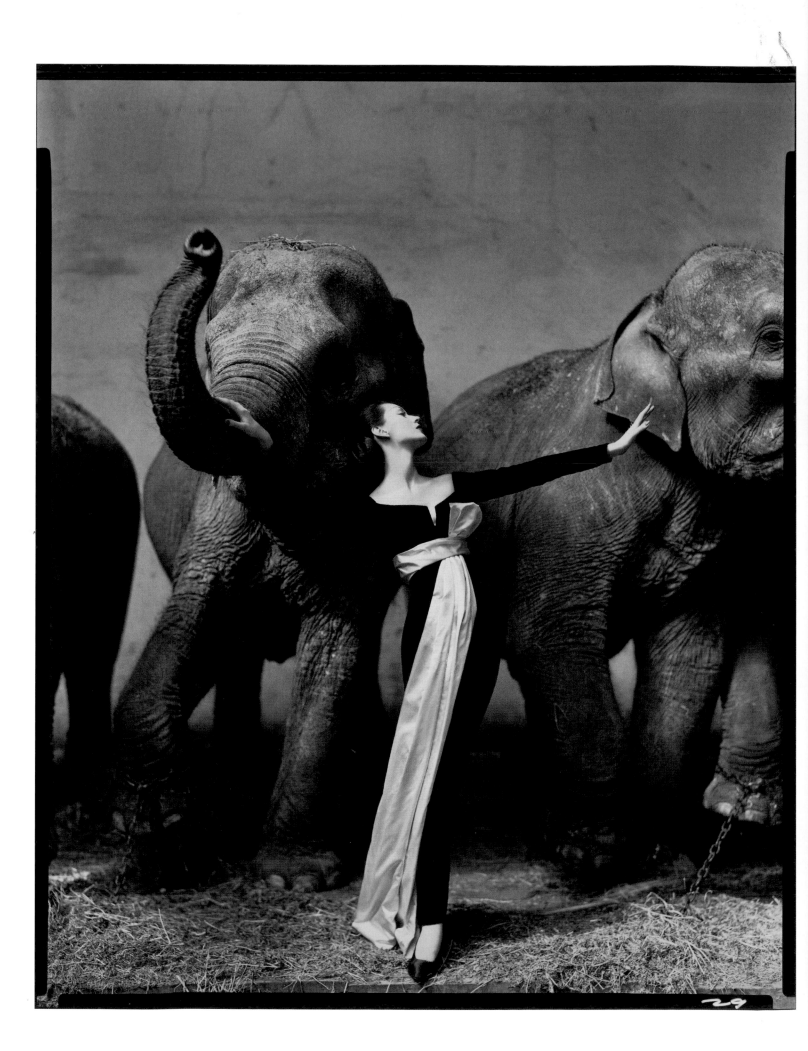

> *'If the colossus of Dior had crumbled, it would have shaken French fashion to its foundations.'*
>
> MARIE-LOUISE BOSQUET

designs seem old-fashioned; one such was Pierre Cardin, head of Dior's *tailleur* atelier in 1947, who founded his own house in 1950 and began his haute couture and ready-to-wear collections in 1953. Chanel relaunched in 1954 after an absence of 15 years, showing suits, easy skirts and pleated day dresses 'for women over 30'. Despite hostility from the French press her casual elegance began to gain momentum.[67] Bettina Ballard, who defended Chanel and took her designs to the US, pinpointed her underlying threat to the very fabric of couture. 'As a dress designer, she was virtually nihilistic, for behind her clothes was an implied but unexpressed philosophy: the clothes do not really matter at all, it is the way you look that counts.'[68] Balenciaga began to enter his most abstract and distinctive phase; his restrained aesthetic, echoed by his disciples Ungaro, Courrèges and Givenchy, anticipated a fashion that finally found resonance with movements in contemporary design in an aesthetic shift from nostalgic to avant-garde.

The wartime conditions that preceded Dior's launch threw his utopian vision and desire to bring back 'the neglected art of pleasing' into sharp relief.[69] For a decade his collections gave clear direction to journalists, clients and trade buyers, a clarity of vision matched only by the efficient business model he created. Although many of the older fashion houses did not survive the harsh post-war climate, for Dior and his contemporaries in both Paris and London the decade was indeed a 'Golden Age' in terms of prosperity and creativity. This is reflected in the beauty of those sumptuous gowns and sharply tailored suits that are preserved in museums and private collections all over the world. When Dior first went to the US in 1947, he expressed a desire 'to plant one foot in America, while keeping the other in the Old World'.[70] Despite the tensions between singular design and the demands of the mass market, Parisian haute couture inspired and co-existed with a new global trade in fashion. It established a blueprint that moved fashion from the couture house of Dior's early days, with its 'heavy velvets and brocades',[71] to the boutique with its versatile, youthful designs, setting in place a process whereby fashion could reflect and adapt to the defining changes of the second half of the twentieth century.

2.25 'Soirée de decembre', evening dress by Yves Saint Laurent for Christian Dior, modelled by Dovima. Spring/Summer 1955. Photograph by Richard Avedon. V&A: PH.26–1985

The New Look

CLAIRE WILCOX

In her diary entry for 27 February 1947, Cynthia Gladwyn wrote: 'Went to Heywood Hill's bookshop after lunch hoping to see Nancy [Cunard], and I found her there, in a wonderful Paris hat, such as might have been worn about 1905. She gave most disquieting news about the fashions that are being shown there, for I can't think how we can ever achieve such a complete change of silhouette on our coupons – long skirts for day wear, either hobble or crinolines, sloping shoulders, hair parted in the middle and looped over the ears.'[1]

The long 'crinolines' and sloping shoulders that Lady Gladwyn described were part of a fashion movement begun before the war that incorporated nineteenth-century elements. However, it was Christian Dior who successfully crystallized this in the first collection of his new fashion house in 1947. He wrote, '... it happened that my own inclinations coincided with the tendency of the times', and he countered the scanty, masculine silhouette of war fashions with 'rounded shoulders, full feminine busts, and hand-span waists above enormous spreading skirts'.[2] The 'Corolle' line, as it was originally named, alluded to the ring of petals of a flower, but it was rechristened on the spot by Carmel Snow, editor of American *Harper's Bazaar*, as 'the New Look'.

So complex was the inner construction of Dior's New Look garments that in July 1947, *Harper's* published technical diagrams. Dior later explained that he 'revived traditional techniques of construction using solid fabrics whose weight was reinforced with

taffeta or cambric linings. Firm underpinnings in the form of underwired bustiers and girdles and tulle and horse hair petticoats, padded hips and bust created a smooth womanly figure.' In Dior's 'Bar' suit the narrow waist was achieved by corsets (both separate and built-in) and the hip pockets added width. The long pleated black wool skirt, lined with cambric, is exceptionally heavy. 'Bar' cost 59,000 francs for private clients in 1947. The amount of fabric required to create New Look garments – typically 15 yards in a woollen day dress, 25 yards in a short taffeta evening gown – caused outrage, for rationing was still in place.

The New Look required a complete change of accessories. Neat hairstyles replaced the flowing hair and complex millinery of the war years. Shoes changed from clumpy wedges to slim, elegant courts with narrow toes and high heels supported by steel rods. Couture fashion shows were traditionally staid affairs, but Dior encouraged his models to move like dancers, as Ernestine Carter of *The Sunday Times* described: 'Arrogantly swinging their vast skirts, the soft shoulders, the tight bodices, the wasp-waists, the tiny hats bound on by veils under the chin, they swirled on, contemptuously bowling over the ashtray stands like ninepins. This new softness… was positively voluptuous.'[3]

Although Dior went on to design many other important collections, the New Look caught the public imagination, and the long, full-skirted ballerina look continued to be part of the vocabulary for popular fashions right up to the 1960s.

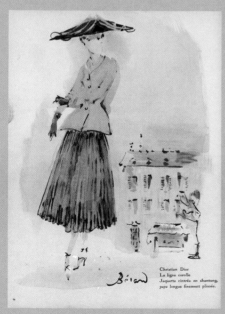

2.26 'Bar', suit by Christian Dior. *Vogue* (French edition) May/June 1947. Illustration by Christian Bérard

2.27 'Bar' (detail). Shantung silk. Given by Christian Dior, V&A: T.376–1960

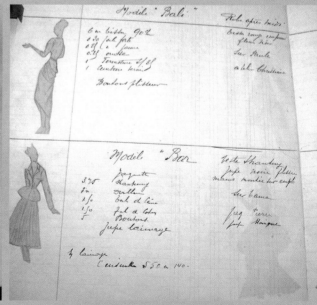

2.28 The technical specifications for 'Bar' in Dior's notebooks. Christian Dior Archive

2.29 'Bar', later modelled by Renée. Photograph by Willy Maywald, 1955

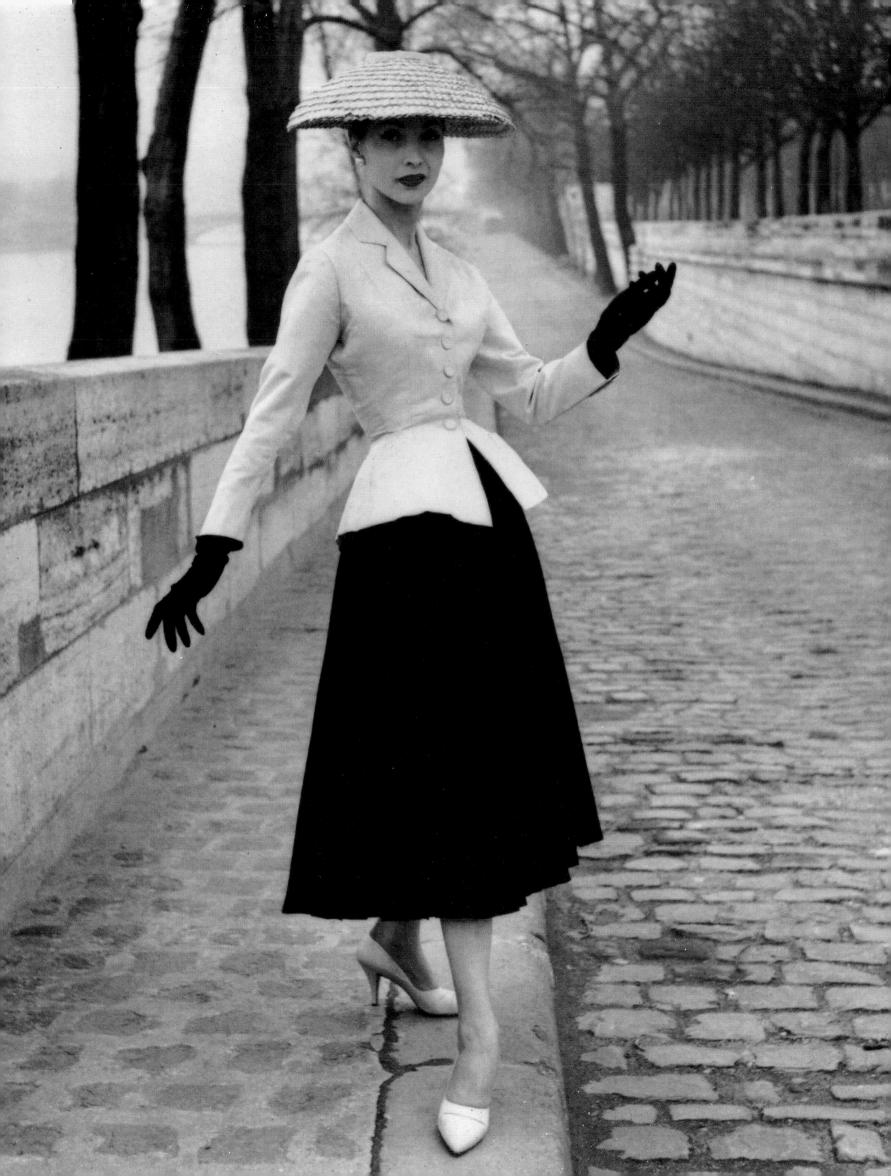

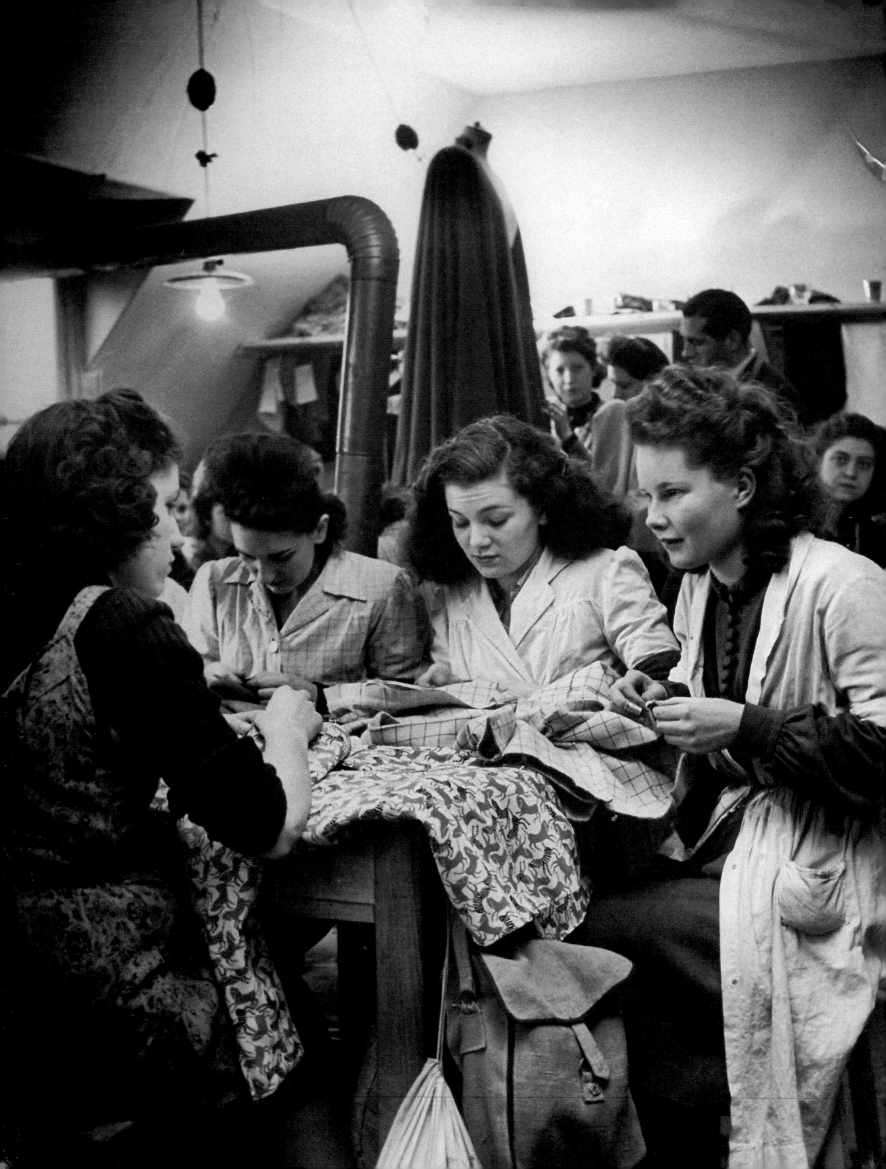

3

INSIDE PARIS HAUTE COUTURE

ALEXANDRA PALMER

3.1 *Petites mains*
in the *flou* atelier
at Pierre Balmain,
*c.*1948–9

'... *the rustle of silks and satins, the variegated perfumes carried thither by the clients, the murmuring voices of saleswomen and dressmakers like the droning bees and the sound of whispering from neighboring booths and smothered laughter.'*

PAUL GALLICO

'A PARIS DRESS makes one feel capable of charming a pearl out of an oyster,' wrote Jean Dawney, a model for Christian Dior.[1] In the 1950s it was understood that fashions that bore a Paris couturier's name were impeccable in design, taste and fabrication. One client wrote: 'A dress signed by a great couturier that fits like a glove, immediately invests one with enormous self-confidence. When I wear my foulard dress I feel like an important person... nothing will alter the fact that it is a dress by the great X, and because it is by X nobody can possibly speak ill of it.'[2] Haute couture and Paris were inseparable. Yet, while the romantic associations of Paris haute couture gowns were perpetuated by clients, journalists and the couture industry itself, the actual mechanics of sustaining the luxury craft relied upon a complex infrastructure rooted in French geography and history. A close examination of the French couture system explains why and how the post-war years are recognized as the 'golden age' of Paris haute couture.[3]

The custom dressmaking business, haute couture, was formally founded in 1868 and called the Chambre Syndicale de la Couture Parisienne. This agency was a legal governing body that dealt with labour, marketing and copyright issues for individual couture houses as a collective. Membership was reviewed annually and based upon strict rules that covered location, creation, fabrication, presentation and dissemination of haute couture designs. The key concern was to protect France's historic reputation as

3.2 'Les Muguets', evening dress by Hubert de Givenchy. Organza with sequins and beads, 1955. Given by Viscountess de Bonchamps, V&A: T.223–1974

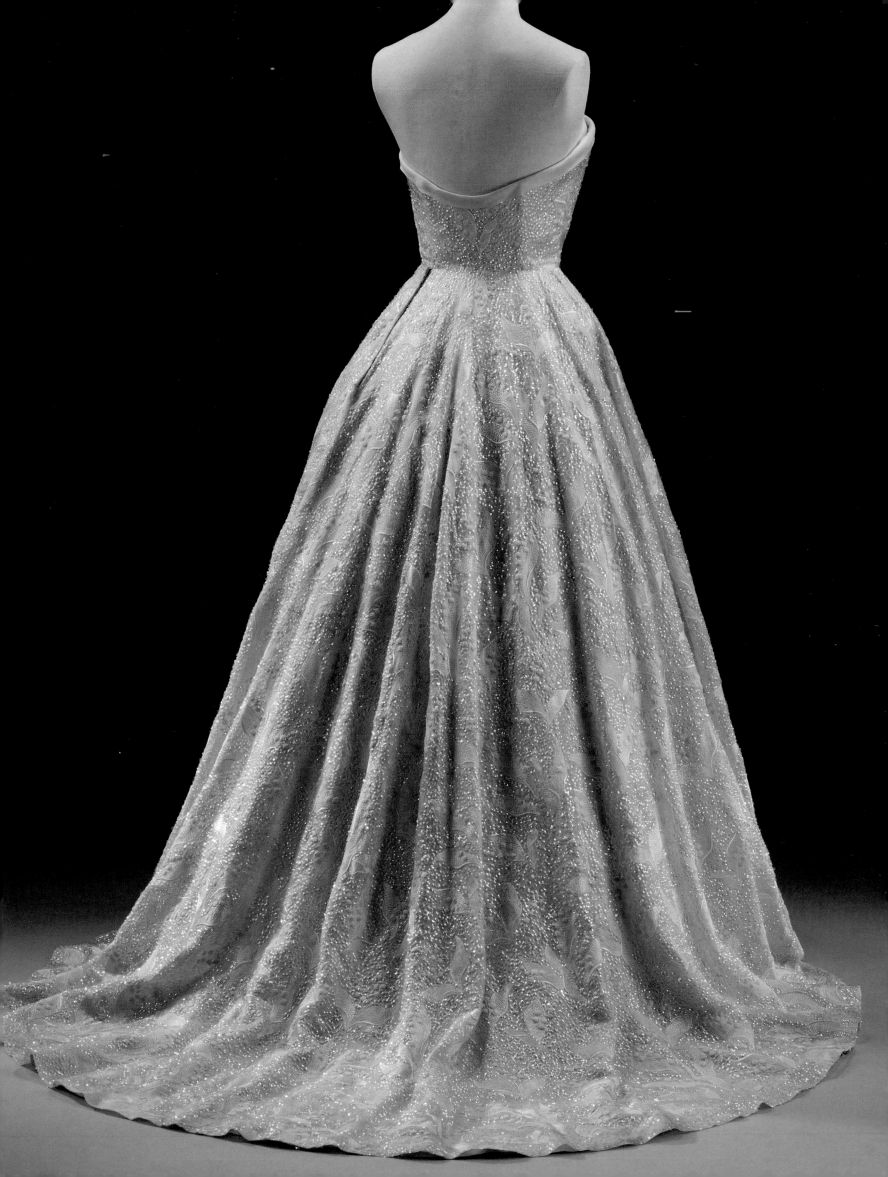

the crucible for modern, innovative and original fashion design as well as its artisanal skills. Thus, haute couture was not only an artistic oeuvre but also an important cultural product that was part of French patrimony. It was also an important business that, before the Second World War, accounted for over 300 million francs in French exports, an important point that is usually ignored in favour of more glamorous and artistic promotion.[4]

The years immediately following the war brought rapid renewal and change. The Paris couture industry was faced with the prospect of keeping alive its centuries-old traditions and skills by marrying them with the reality of a new post-war economy and changing clientele. In 1945 the Chambre Syndicale introduced new regulations that British fashion journalist Alison Settle noted were imperative, since 'you cannot divorce trade and creative art'.[5] Indeed, 'the costing of each dress is all that really matters in the final analysis… so many hours of electric light burned, so many hours of work girls' time, so many yards of material, so much for embroidery, …for the zipper, …for a button, …the wages of the man and the petrol for the van to deliver it… the cardboard boxes and the tissue paper… (masses of tissue paper)… and so on… and so on.' A Paris couture house operation was a 'strange mixture of theatre and commerce, showmanship and business'.[6]

The regulations for membership of the Chambre Syndicale applied to all aspects of the business. The couturier had to maintain 'suitable' premises in Paris. Each collection had to comprise a minimum of 75 original designs created by the couturier or by *modélistes* (assistants) who were employed full-time by the house. Collections had to be shown twice a year, in the spring and autumn, on dates set by the Chambre Syndicale. The designs had to be made-to-measure, and shown in a *passage* on three models at least 45 times a year in the Paris house. The rules also covered the technical execution of the original designs and the repetitions that had to be made to measure for clients (stipulating a minimum of three fittings at each stage). In order for the house to achieve this, it needed at least 20 full-time employees, comprising seamstresses (*petites mains*) and saleswomen (*vendeuses*). These stringent regulations help explain why opening a couture house was a complex and serious financial investment, unlike that of a custom dressmaker who could work from home and hire workers as needed, thereby reducing overheads. They ensured that haute couture retained the type of practices that could not devolve into mass production, particularly at a time when they seemed to be obsolete and in danger of disappearing.[7]

Architecture and Décor

During the late seventeenth century, the organization of French couture had been based on a successful network of luxury manufacturers and ancillary industries located in the suburbs and provinces, who produced 'textiles, beading, feathers' and included, 'shoemakers, milliners, furriers, leather merchants, makers of buttons, belts, buckles,

3.3 Gloria Swanson leaving Jacques Heim at 15 avenue de Matignon, Paris, 1955

handbags, flowers, umbrellas; purveyors of ribbons and laces and sophisticated laces; hairdressers, embroiderers, jewellers'. These trades were in constant contact with Paris merchants, who let them know what the customers were requesting and buying. A location within Paris, the traditional shopping centre of France, was essential for a true *maison de la haute couture* (pl.3.3).[8]

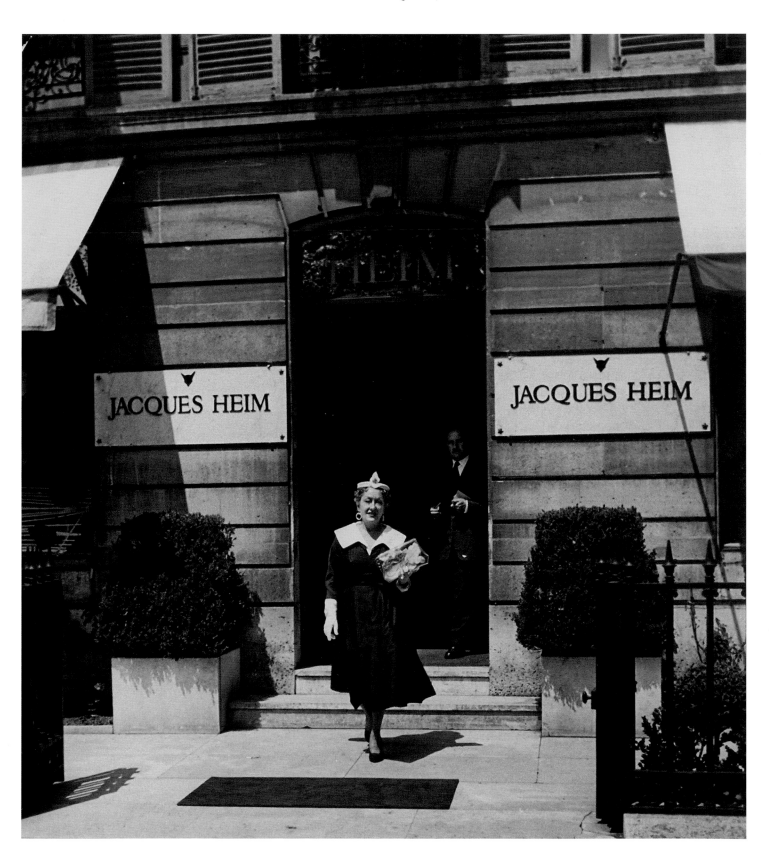

Post-war, the most fashionable address for a couture salon changed. Previously this had been the rue de la Paix, but when Alix reopened as Maison Grès, at 1 rue de la Paix, her business was described as 'the newest house on an old-fashioned street'. The newly fashionable streets emanated from the Rond Point des Champs-Elysées, and housed 'more dressmakers and milliners than any other in Paris'. Among these were the new house of Pierre Balmain, which first opened in 'two small decorated salons on an upper floor of the building at 44 rue François I – in the Georges V quarter of Paris', and Jacques Fath, whose 'swank house, formerly in a private residence' was on avenue Pierre I^er de Serbie. Jean Dessès's new salon on the corner of avenue Matignon and rue Rabelais was notable, since it was previously the home of Alexandre Eiffel – with 'proportions [that] reflect the tower itself', it was most impressive.[9]

A couturier had to present a collection in a fashionable, tasteful interior suitable for receiving clients who were used to luxury. Both locations and settings did not go unnoticed. The house of Manguin on place François I^er, for example, was reported to be indicative 'of the post-war tendency of Paris dressmakers to establish themselves in plushy residences of the nineteenth century, and to decorate them in a style that reflects the taste of the original period'. Each couturier's establishment was a deliberate expression of his or her taste. At Molyneux, a client found 'The salons... decorated in gray, are light and spacious, being meant to serve as inconspicuous settings for the clothes. These things reflect the personality of the head of the house, who has pleasant easy manners, [and] wears Savile Row clothes.'[10]

Before opening his house Christian Dior had clear ideas of what he thought would be appropriate. 'I did not want an authentic Louis XVI interior; I wanted a 1910 version of Louis XVI, a notion most [decorator friends] would have considered complete folly.' Dior hired Victor Grandpierre, who had been 'brought up in the right tradition' and who created the 'salon of my dreams: all white and pearl grey, looking very Parisian with its crystal chandelier, discreet light brackets and a profusion of quintias palms...'(pl.3.4). The business location and décor were so key to presentation and sales that the look and ambience of Paris salons were emulated internationally by department stores and luxury boutiques.[11]

However, the circumscribed setting could make rapid expansion difficult. The house of Givenchy opened in February 1952 at 8 rue Alfred de Vigny, near the Parc Monceau, with 22 employees, and by 1956 had 250. In six years the house of Christian Dior had taken over five buildings, ran 28 workrooms and needed a thousand employees to accommodate the rapidly expanding Dior empire that had begun with a single house, three workrooms and 85 staff. A Paris couture house was a unique space that united the ambience of a private residence in the salons (complete with dressing rooms for intimate fittings) with an artist's studio, workrooms or ateliers and storerooms, as well as business offices for press, financial affairs and record keeping. In this way the dual public and private faces of haute couture were housed under one roof.[12]

3.4 Christian Dior collection, February 1951, shown in the grand salon

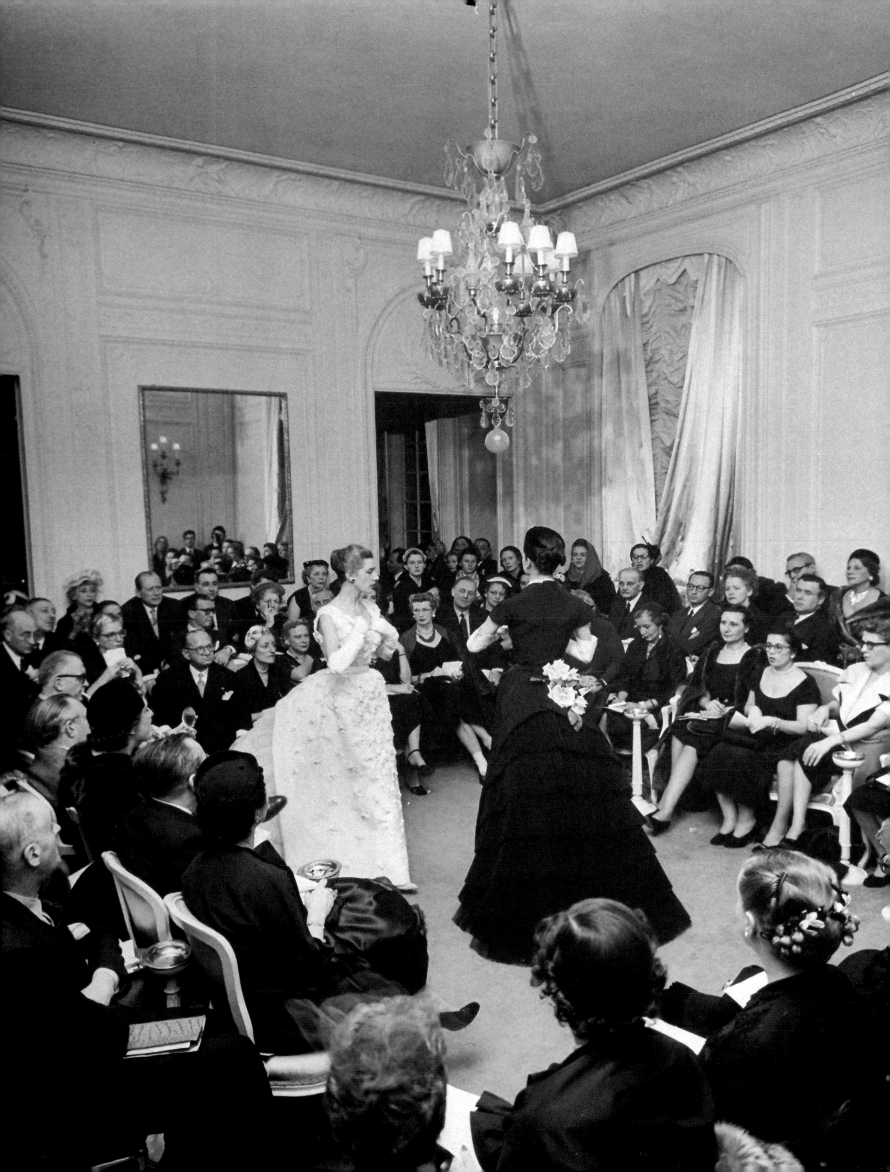

Creation within Hierarchy: Studio and Ateliers

An haute couture house was an inherently hierarchical organization that ensured fluid teamwork between the interior workings of design studio, workrooms, models and the public showing and selling of the garments in the salons. This system stemmed from French medieval guilds that were abolished during the Revolution in 1791. Historically, cutting the textile, a more potentially ruinous and expensive craft, was a skill only learned by men through apprenticeship to a tailor. Women were seamstresses or sewers and did not learn how to cut complex tailored shapes. It was not until the late 17th century that they were allowed to form their own guild and began to professionalize their trade and expand their skills, though they were still forbidden from making fitted and formal dress.[13] The hierarchy began with the couturier who was considered to be 'an artist who can be influenced in a direction which he considers to be the line of the day but who cannot be dictated to. Each of the great dress houses of Paris has at its head a man who is himself either a designer, or, as it were, the conductor of an orchestra of designers.'[14] The couturier represented the entire house and his or her name was on the label.

An haute couture garment was first and foremost the fruit of many hours of craftsmanship. The first stage was creating the *modèle* (design), either through sketching or draping cloth directly on a model (pl.3.6). Jacques Heim explained that innovation was a subtle thing: 'We do not expect the couturier to show us new dresses each season, but a conception of woman as well, for whom the dresses have been designed.'[15] A couturier could employ *modélistes* to help with the design, but could not buy outside designs, as was allowed before the war.[16] This permitted different approaches to designers in the house, as well as the continuation of the business when the founding couturier retired or died.

Once the designs were conceived the textile had to be selected and ordered from the manufacturer in the amount required (see Chapter 5). This stage was followed by the choice of buttons, trims and all findings that had to be sourced and ordered. Like a beehive, the couture house received and sent out for external suppliers. As Dior famously described, the textile producers came 'from Paris, London, Roubaix, Lyons, Milan and Zurich… bringing with them the wealth of the Low Countries and the richness of the Orient'.[17] Two months in advance of the collections the suppliers showed samples to the couturiers. Each textile manufacturer or embroidery house designed their collection in response to the current cultural sensibilities of the season, in the hope of selling between 50 and 75 per cent of their line. Once sold, the design was exclusive to that couture salon.[18] However, couturiers would often place design samples on hold while they created their collection, which meant that suppliers could not show a design to another couturier until it was firmly declined, usually at a

3.5 Part of an advertising feature sponsored by the Chambre Syndicale de la Haute Couture Parisienne. *Vogue* (French edition), February 1948

3.6 Jean Dessès in his studio, *c.* 1950

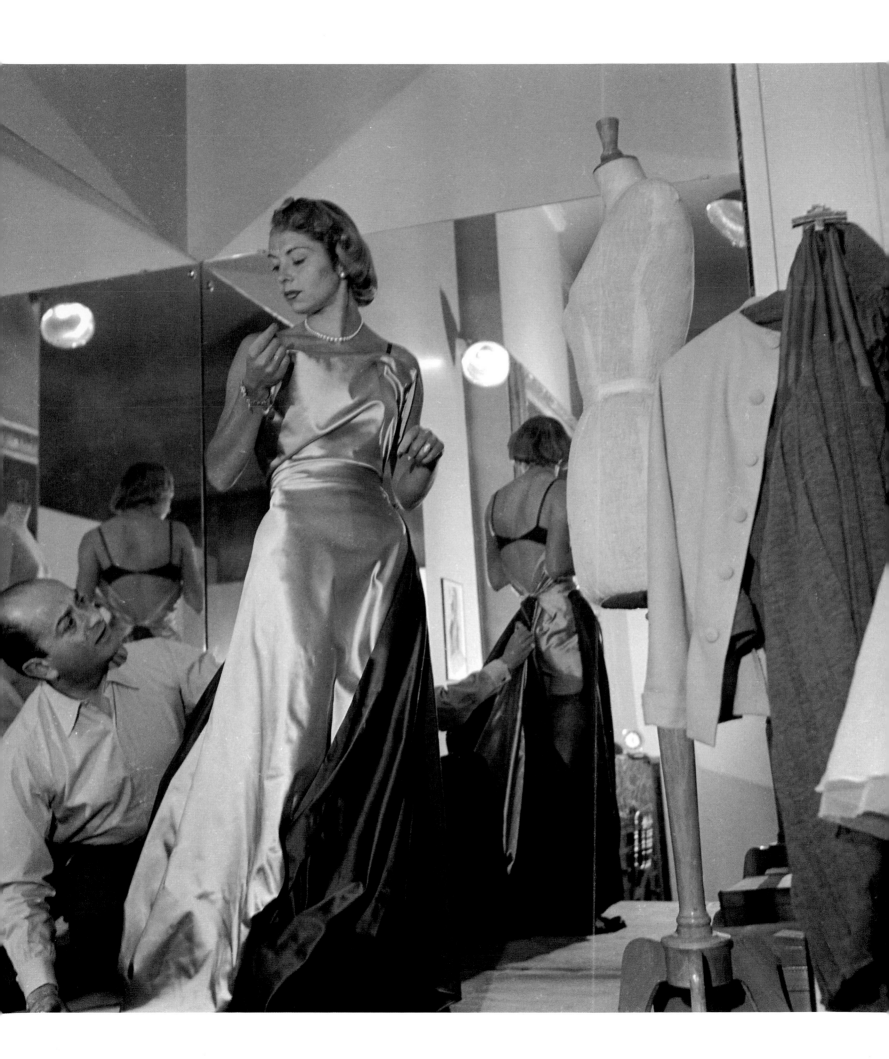

time too late for showing it to another potential client or producing it. Consequently, suppliers were forced to create many designs knowing that a proportion would never be ordered.

Any distinctions between the design of the garments, the creators of the textiles and any embellishments that were used were subsumed under the couture house name. This was a symbiotic arrangement, since the suppliers relied upon orders from the couture houses as much as the couturiers relied upon the suppliers. During the 1950s there were around a dozen embroidery houses in Paris. They purchased the ground for their samples from the textile manufacturers, so in turn were responding to and relying on textile manufacturers' designs and colours. The major embroidery houses of Lesage and Vermont produced 180–300 samples a season, which they showed in December and June. In order to try to appeal to the tastes of as many couturiers as possible and ensure sales, Jean Vermont always bought a variety of textures and weights, such as light gauze, stiff satin, organza, tulle and always velvet for winter. François Lesage remarked that embroidery houses proposed, rather than imposed, their creations.[19]

The number of designs produced by each couture house depended upon the scale of the couture house operation. In order to cover the full range of social occasions and events a client might have to attend, each collection encompassed morning, afternoon and evening designs. The moderate-sized salons of Griffe and Dessès designed around 110–170 garments a season, while Dior presented between 230–250, of which approximately 48 would eventually be eliminated, either because they were acknowledged as unsatisfactory to the couturier or buyer, or because they served only to generate publicity. There were often more Spring/Summer designs than Autumn/Winter, as these were generally less expensive to produce. In sum, it was estimated that the Paris couture houses collectively showed around 6,000 new designs a season during the mid-1950s.[20]

Once designed, the nascent *modèle* was made up in one of two types of workshop – the *tailleur* (tailoring) atelier, or the *flou* (dressmaking) atelier – depending on the hand skills that the materials and shapes required. Seamstresses, called *petites mains*, were specialists in the techniques of tailoring or draping, and by constantly working with particular materials perfected their art (pl.3.7). The design would initially be given to the *première d'atelier* in charge of a workroom, who would decide which seamstress was best suited for the individual design. The *première* was the liaison between the design studio and atelier, and also between the salon and the atelier. Each *première d'atelier* had two assistants: one who gave out the work and another who looked after the supplies of materials.

Seamstresses worked around tables in small groups and each became an integral part of the creation (pl.3.1). They were categorized and paid according to their technical abilities and experience, but all started out as *arpettes* (apprentices), learning finishing skills and observing workroom operations. After two or three years they either left the trade or began

as a second hand, called a *deuxième main débutante*. They would then graduate to the position of *deuxième main*, and finally *deuxième main qualifiée*. Each promotion was based upon an assessment of a piece of work. Some women progressed to the next stage, the *première main*. They then began as a *première main qualifiée*, and could become a *première main deuxième échelon*. After around 10 years, a seamstress could become a *première main hautement qualifiée*. If she worked in the *flou*, only then was she entitled to work on a new *modèle* and had full responsibility, from cutting it out to its final completion. In the *tailleur* atelier, the *seconde* cut and the *tailleur* was responsible for the complex sewing.[21]

All couture house staff, whether apprentices, seamstresses or saleswomen, usually came through referrals from friends or relatives. Paule Boncourre began at the house of

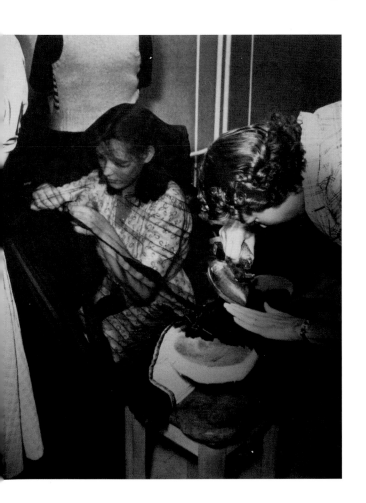

3.7 The *flou* atelier at Christian Dior, *c.*1947. Christian Dior Archive

Christian Dior as a 15-year-old apprentice in October 1947, through an introduction from a relative who was working for another couture establishment. She steadily worked her way up through the echelons of the *flou* during her 40 years' experience. As an *arpette* she developed basic sewing skills by over-casting seams, covering buttons and findings. During her first year she also attended a technical college one day a week, working towards the Certificate of Professional Aptitude (C.A.P.), the accreditation established by the Chambre Syndicale for workroom employment in a couture house. She passed, and worked for one more year as an apprentice hand. She then became a *deuxième main* and 10 years later a *première main hautement qualifée*. She favoured working with *mousselline*, tulle and georgette, lightweight and slightly stiff fabrics that are difficult to handle because they can shift as you work. She said that in haute couture sewing, 'Everything is in the technique: the reverse must be as beautiful as the face.'[22]

Once the sketch or draped piece had been delivered to a workroom, it was used as the basis for making the *toile*, the design made up in unbleached cotton.[23] The *toile* was marked up in ink and red tape ribbons or threads, so that it could be taken apart and used as the basis for the pattern. It was then fitted to one of the in-house models, who were each measured as carefully as a 'gold bar being put into the Bank of England'. Only when a *toile* was judged to be 'perfection' was it made up in cloth, thus becoming a *modèle*.[24] The pattern pieces were cut from the specified textile by the *première main hautement qualifiée*, who assigned the parts to the appropriate workers. If the dress required embroidery it would be sent out at this stage, either already cut or marked for cutting. François Lesage usually allowed two weeks from the order date for the embroidering of a design.[25]

Fittings on models were part of the development of the designs and were likened to 'what the chrysalis is to the butterfly. Raw material and scissors take charge.'[26] Models

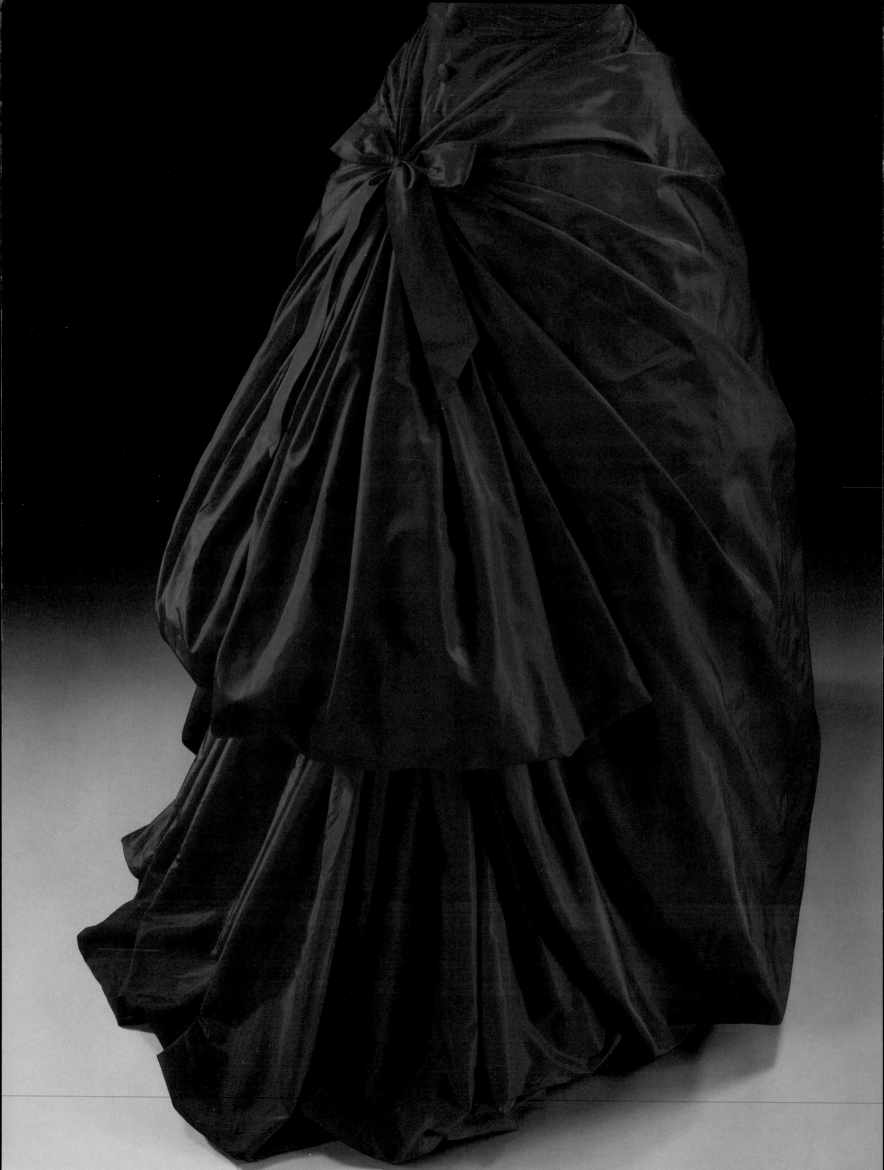

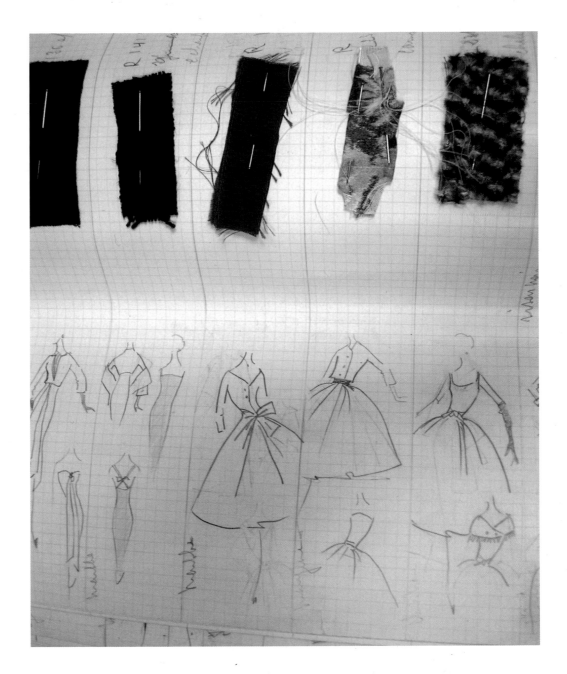

3.8 Evening dress by Cristóbal Balenciaga (detail). Silk, 1955. Given by Miss Caroline Coombe, V&A: T.427–1967

3.9 The charts at Dior clearly show the organization of the couture house. Each design is listed in the order shown in the collection and the notes detail the model for the dress, the sources for textiles and trims, and who made the garment. Details for 'Ecarlate', Autumn/Winter 1955–6 (see pl.6.11) are shown in the centre. Christian Dior Archive

worked long hours before a collection was launched, an experience Dior described as 'an endurance test' since the girls were on their feet from 10am till evening.[27] Each member of the couture team, from the *arpette* to the *première* and the model, became attached to the designs they worked on.[28] While the *premières* were intent on the nuances of adjusting a dress, the models became an inanimate form – for the *premières* were 'not dressing a girl; they are simply allowing a body to be put inside *their* dress'.[29] The famous model Bettina described the tension at the house of Jacques Fath:

> The foreman (*première*) would crouch on the ground with her eyes glued to the hem and make me revolve, very slowly, inch by inch, on my heels. …she would cry if she thought she had muffed a dress, the mannequins would weep when a dress that was destined for them was given to another girl, and the second-in-command would arrive in floods of tears because a dress had a mark on it.[30]

The entire atelier became invested in a design that could take as many as 200 hours to make, while a whole collection could require over 100,000 hours.[31]

When all the *modèles* were finished, the collection was finally ready to be shown. The dresses entered the public sphere, to be worn by the models in the salons in front of clients for the first time. Collections were presented in a specific order that moved from day to evening wear and traditionally ended with a bride.

The Couture Salon

The Paris couturier served two different groups in the salon. The private client was vital in order to continue the traditional role of the house, which was required to produce made-to-measure designs in order to remain an haute couture establishment. The private client distinguished the couture house from that of a mere commercial design source. The second client, the commercial buyer, represented both small and large retailers and manufacturers who purchased *modèles* for resale and promotion, and as design sources to be copied. Thus, couture houses had the seemingly impossible job of catering for two different market demands simultaneously.

Admittance to view an haute couture collection was strictly controlled. The first to see the latest designs were not private clients but the international press and commercial buyers, who had to apply to the Chambre Syndicale every season for admission. The domestic proportions of the salons required each house to repeat their showings to meet demand. At a large house such as Dior, the showings lasted a week. The first to be invited

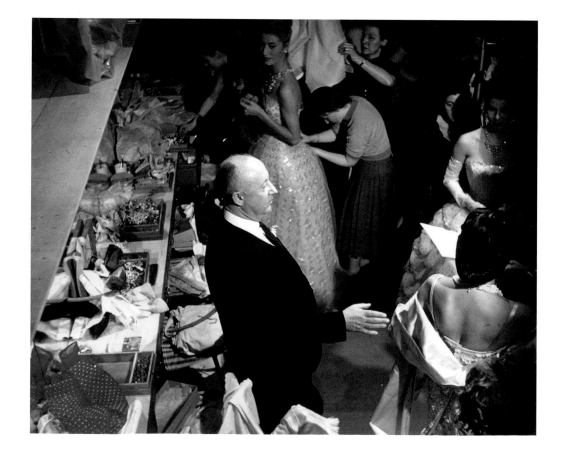

3.10 Christian Dior in the *cabine* with staff at a rehearsal for the presentation of a new collection. Paris, 1957

into the salons were the press, then the North American commercial buyers, followed by the Europeans and finally the French commercial clients, a precedence based upon prestige.

The launch of a collection, or *passage*, was the unification and culmination of all house activities into one moment. The models dressed in *la cabine des mannequins*, which one author described as 'a mixture between a harem and a bathhouse'.[32] This area also housed the jewellery, hats, shoes, umbrellas and gloves that were part of each costume. *Habilleuses*, or dressers, assisted several models at once to dress and undress while others ironed, organized and hung up ensembles (pl.3.10). The show lasted for several hours, with press and buyers in their assigned places, while invited celebrity guests and the couturier's friends added to the excitement. 'Cameras and their lights… Flowers: perfume: and no air. Windows firmly shut. Girls come on, whirl around, disappear, numbers being called in French, then English… End and rush for doors.'[33] Descriptions of the presentations repeatedly recall these key factors.

As soon as the *passage* was over, the press and their press agents, the buyers and their *vendeuses* all scrambled to inspect the *modèles*. Buyers wanted to know what the press was shooting and the press wanted to know what the buyers were buying, so that each could capitalize on their markets. Amongst the *vendeuses* there was stiff competition as often they were trying to show and sell the same garment. The press requested garments for photography and sketches. Leonora Curry, editor of British *Harper's Bazaar* between 1953 and 1956, recalled that she saw two collections and about 400 garments in one day. Immediately following a showing she would try to secure specific designs for a photo shoot, but noted that her American counterpart, Carmel Snow, 'ruled because shops would buy the design if they knew it had been photographed'.[34] At the same time, buyers also wanted to see the garments before placing orders. Store buyers were trying to find key pieces that no one else had ordered so they could achieve exclusivity, while commercial buyers wanted designs that would be the season's 'Ford'.

After the collections were seen and orders placed, there was a hiatus. For three weeks the press was not allowed to release any sketches or photographs and buyers had to wait for their orders. To prevent the dissemination of couture designs during this lull, the Chambre Syndicale set an official release date, upon which all international buyers received delivery of all haute couture *modèles* at the same time. Commercial buyers had around 30 days upon receipt of their orders to make up their copies in secret. Then the press was allowed to release the photographs and sketches (around 30 days after the openings).[35]

Thus, Paris haute couture was a paradox. It was a specialized custom-order trade that was compelled to produce thousands of repetitions within three weeks, a time-frame determined by the commercial market it first supplied. This created a trickle-down effect for all the ancillary trades. Embroidery houses would have to have hundreds of designs made up in a few weeks to fill the commercial orders. In addition to the staff

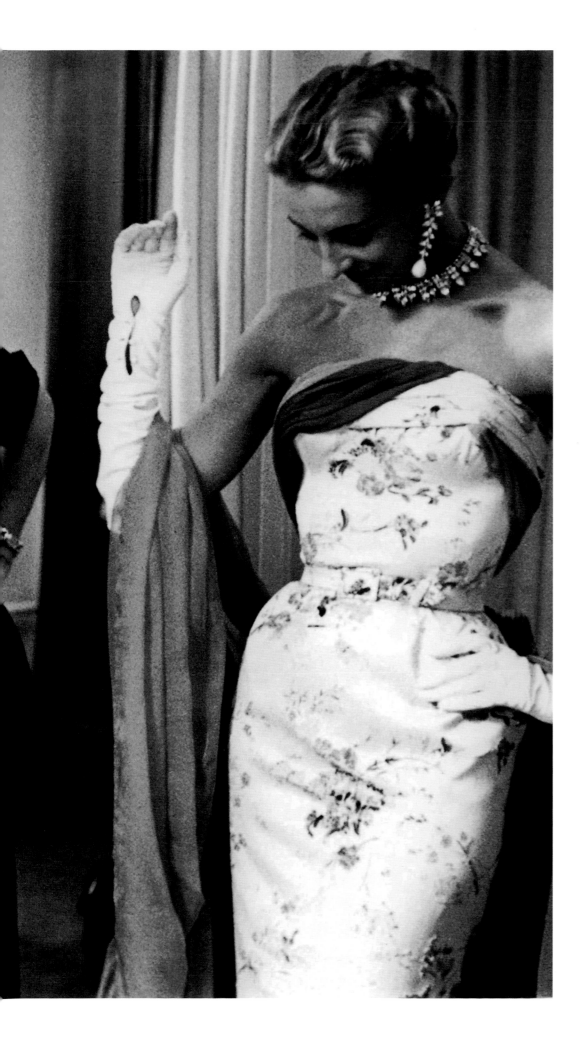

3.11 Ginette Spanier, the *directrice*
at Pierre Balmain, shows an evening
gown from the Autumn/Winter
1953–4 collection to a commercial
buyer and fashion editor, 1953

of 20 he employed in his Paris atelier, François Lesage would hire over 100 women, all working in small ateliers that specialized in beading, embroidery or *passementerie*, in the towns of Lunéville, Nancy, and Baccarat in Lorraine. Jean Vermont employed more of these same workers, and travelled back and forth from Paris to the provinces with his embroideries by car and train. This outsourcing also enabled him to avoid paying benefits and dealing with French employment regulations for small businesses with 50 or more employees (he never hired more than 49 workers for his Paris atelier).[36]

The numbers of Paris haute couture repetitions made in such a short time were indeed impressive and make it clear that an haute couture dress is rarely unique, but rather one of a few. In fact the more fashionable and successful the design the more it was reproduced in the original and subsequent versions. In one year, 1954–5, at the average-sized house of Jacques Griffe, 1,650 repetitions were produced. The smaller house of Jean Dessès produced 1,494, whereas Christian Dior made over 5,000. It was estimated that 'Two out of five [workers] in France are gainfully employed in… needle, textile, or allied trades… that includes… dressmaking and millinery, textile workers, manufacturers of accessories, notions and all types of soft goods.'[37] Thus, although it is difficult to know exactly how many of a particular *modèle* were made, it is clear that Paris haute couture designs were reproduced in their thousands each season.

The commercial orders were exported by land and air to manufacturers, department stores, boutiques and provincial dressmakers around the world, where the latest Paris haute couture designs would be shown in fashion shows, sold, copied and modified, and sketches and photographs of the *modèles* disseminated. Sydney Blauner, buyer for the New York firm Suzy Perette, put it bluntly: 'If you don't come to Paris, you're missing the boat. There are more ideas in a thimble here than in all of America.'[38]

The Domestic Couture Salon and the Private Client

One month after the first showings and delivery of commercial orders, private clients entered the Paris haute couture salons. 'Here indeed was woman's secret world... the battlefield where the struggle against the ravages of age was carried on with the weapons of the dressmaker's art and where fortunes of money were spent in a single afternoon.'[39]

Just as social contacts facilitated an employee's entrance to the couture house, so too did these influences apply to the client. A woman who wanted to buy haute couture at a Paris salon gained entrance by referral. This was often through a friend or relative, who would provide the name of her *vendeuse*, or else the *directrice* of the couture salon would assign a *vendeuse* to a new client. A *vendeuse* would also develop relationships with the concierges of prestigious hotels, who would pass along her name to guests in need of an introduction to a particular house. In this way the haute couture salon was part of the wealthy tourist's Paris experience in the tradition of the Grand Tour.

Reminiscing about the house of Balenciaga, Bettina Ballard, fashion editor of American *Vogue* (1946–54), remarked: 'It is a brave woman who walks in unknown and unheralded to spend her money. There is no place where it is more flattering to be received as an habitué and friend, and there is no place that can seem more impenetrable if one is not known.'[40] Paul Gallico's charming 1957 novel, *Mrs 'Arris Goes to Paris*, tells the story of a working-class English woman whose dream it is to own an haute couture dress. He describes Mrs 'Arris's reaction when she finally entered the house of Dior:

> She was almost driven back by the powerful odor of elegance that assailed her once she was inside. It was the same that she smelled when Lady Dant opened the doors to her wardrobe... it was compounded of perfume and fur and satins, silks and leather, jewelry and face powder. It seemed to rise from the thick gray carpets and hangings, and fill the air of the grand staircase before her. It was the odor of the rich...[41]

Private clients made appointments through their *vendeuse* to see the private fashion show that was held daily from 2.30 to 5pm. The salon was set with lavish floral arrangements and the house perfume would be sprayed in the air. A client would be seated in the salon on an elegant gilt chair, and given a programme so that she could make notes on the pieces that were of interest. After the *passage* the client could request to see the garment again, either on the model or at close hand, by trying it on in a dressing room (pl.3.14).[42]

The job of the *vendeuse* was to guide the client's taste, ensuring that she was perfectly attired. It required a great degree of social skill. Hardy Amies recognized that '[a] good *vendeuse* will know the family history of her client, her lifestyle and the size of her fortune. She will anticipate the customers' requirements.' Once a garment was

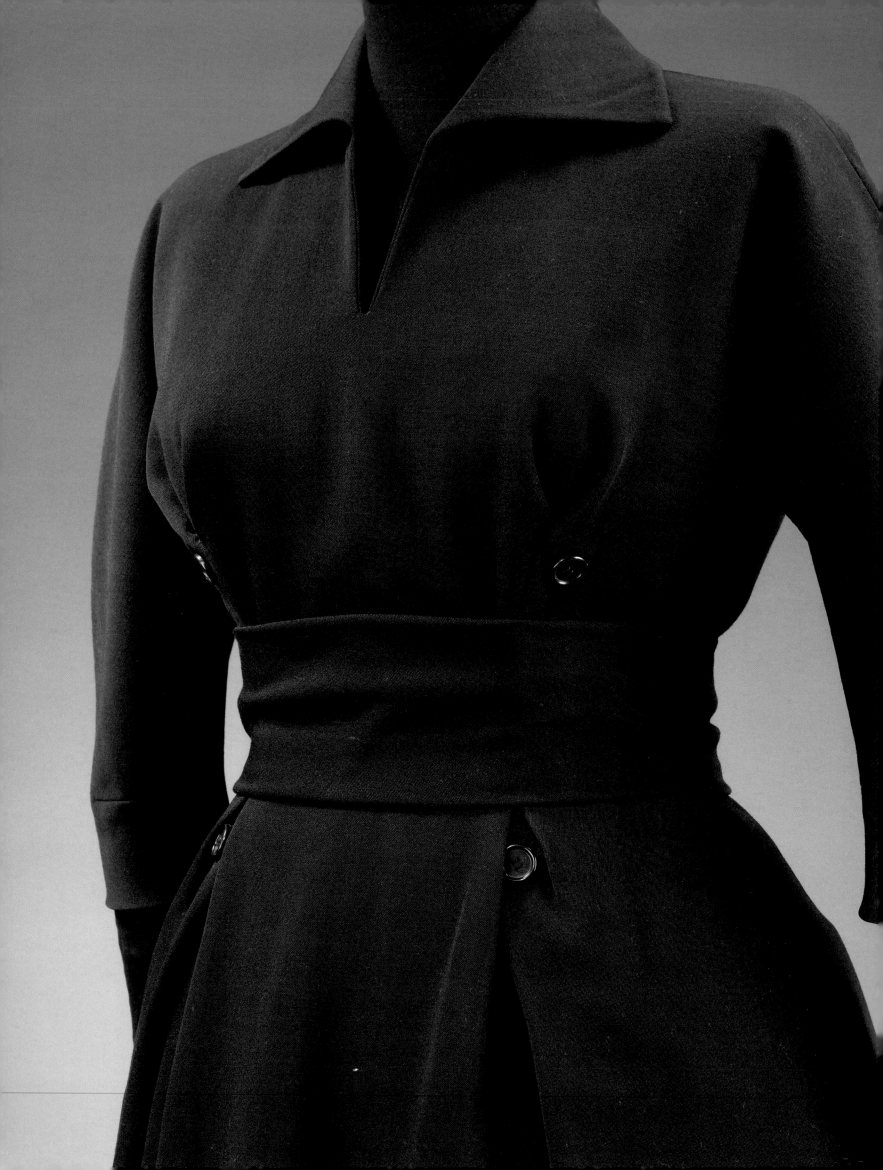

ordered, it was the *vendeuse* who was the liaison between the house, the workroom and her client, and who arranged for the three fittings and delivery.[43]

The *vendeuse* Sophie Gins described her career at Christian Dior, which began when she was 19. She was referred by her mother, who was working in the office of Marcel Boussac, the textile manufacturer who had helped Dior establish his house. Her first job was as a telephone operator for the four phone booths available to clients in the salon. Within a few months, Madame Lanciene, one of the 22 *vendeuses*, asked her to become her *seconde*. Her duties included obtaining the requested *modèles* for the client after the shows, and being responsible for the related paperwork that tracked the progress of the garments to and from the atelier and salon for fittings. She later became a full *vendeuse* and worked for the house of Dior for 20 years.[44]

An haute couture *modèle* was only really successful once it had been ordered. It was conceived to be worn outside the couture house, and this was the real measure of its success, aesthetically and financially. Only then was the couturier's skill recognized and confirmed. At this point the design also began to take on a romantic significance for the client that went beyond the material, workmanship, design and expense. It began to symbolize future pleasures to be experienced as an elegant woman wearing the garment. It represented the private haute couture client's entire experience of consumption – from her reception in the salon to seeing the collection, selecting a design, being fitted and finally wearing the haute couture garment that had already required hours of her time. She was completely invested in the purchase. Paul Gallico described this memory for Mrs 'Arris:

3.14 Private clients watch the *passage* at Christian Dior. *Harper's Bazaar* (American edition), March 1956. Photograph by Louise Dahl-Wolfe

…it was but a flash for her to be back in the hive of the cubicles, a part of the delicious atmosphere of woman [*sic*] world compounded of the rustle of silks and satins, the variegated perfumes carried thither by the clients, the murmuring voices of saleswomen and dressmakers like the droning bees and the sound of whispering from neighboring booths and smothered laughter.[45]

The same garment, even if never again worn, could later also recall wonderful memories of its acquisition and wearing. It was a clear reminder and physical expression of the client's successful assertion of her own personal taste and identity. Although Mrs 'Arris's recollection was fiction, the real and complex experience of purchasing a Paris haute couture *modèle* was conveyed in a thank-you note to the house of Pierre Balmain, from a private client upon receipt of her new dress:

3.13 'Batignolles', day suit by Christian Dior. Worsted, Spring/Summer 1952. Worn by Mrs Opal Holt and given by Mrs D.M. Haynes and Mrs M. Clark, V&A: T.110–1982

It gave me a taste for life again. Never mind the dress: its sheer arrival was enough, carried by a man in uniform, in its enormous new cardboard box, surrounded by pounds of tissue paper. When I signed for it I felt everything was worth while, that life was exciting again. Thank you …[46]

Jean Dessès

SONNET STANFILL

Jean Dessès opened his Parisian atelier in 1937, two years before France went to war. In a report published in French *Vogue* on the state of fashion as war began, Dessès announced that his atelier 'still remains open, creating designs in harmony with real life'.[1] In 1946 Dessès moved to the Champs-Elysées, into the stately mansion previously owned by architect Alexandre Eiffel. In this post-war period, when restrictions on materials and shifting client fortunes might have threatened his young business, Dessès found great success. He designed the wedding outfits for Princess Sophia of Greece to Prince Juan Carlos, and his many clients included the Hon. Mrs J. J. Astor and Viscountess Waverly, both of whom donated dresses to the V&A. The luxurious textiles and skilled construction techniques seen in these gowns suggest the high level of quality and workmanship that French couture houses managed to maintain during the period of France's recovery.

Dessès's career-long preoccupation with draping and form resulted in gowns defined by their femininity, technical complexity and use of sheer fabrics that required skilful handling. Although he was born in Alexandria, Egypt, in 1904, his ancestry was Greek, and his signature pieces – columnar, draped and pleated evening gowns created in silk chiffon – alluded to classical antiquity. In his early designs, Dessès's evening wear is characterized by a subtle colour palette of creams, beiges and pale pinks, but later he introduced vibrant reds, often employing two similar shades in the same dress but softening their intensity by using matt chiffon fabric. A strapless red evening dress from around 1953 highlights Dessès's virtuoso pleating. The skirt's delicate drapery envelopes the wearer in softly gathered swags, and a long tie crosses over at the neck, falling to the back. The intricate pleating across the bodice is an example of a construction technique Dessès favoured for both early evening and formal occasions. Although the bodice appears to be soft and unstructured, it features the sewn-in boning common at the time.

Further evidence of Dessès's precise pleating can be seen in a 1951 cocktail dress. The bodice's composition of curving pleats with a pattern suggestive of waves fits closely to the body; the dress then tapers to a narrow waist, and swells into a full skirt of soft pleats. Referencing the colouring of a sailor's uniform, Dessès chose royal blue for the dress and white cotton piqué to trim the collar and cuffs of the silk chiffon over-jacket (not illustrated).

A dusty brown cocktail dress from around 1955 illustrates Dessès's artful construction. The cobweb-like skirt is crafted from 21 lace-trimmed squares, each suspended from a point at the waist and falling to a handkerchief hem. By stitching each square to the next in a carefully plotted pattern, Dessès created a skirt of graceful volume and movement. The criss-cross placement of lace on the bodice draws attention to the *décolletage* of this otherwise demure dress.

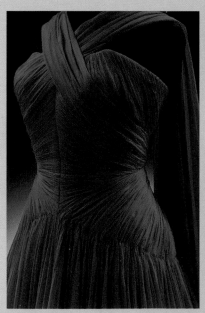

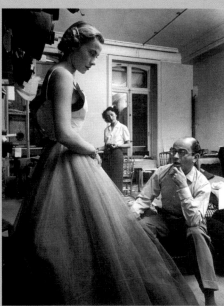

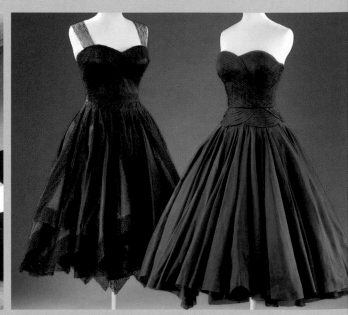

3.15 Evening dress by Dessès. Chiffon, c.1953. Worn by Mrs Opal Holt and given by Mrs D.M. Haynes and Mrs M. Clark, V&A: T.105–1982

3.16 Jean Dessès with model Christiane Richard, 1950. Photograph by Nat Farbman

3.17 Cocktail dresses by Jean Dessès. Left: silk and lace 'handkerchief' dress, 1954–5. V&A: T.34–1988. Right: silk pleated dress, 1951. Given by Princess Margaret, V&A: T.237–1986

3.18 Dress by Jean Dessès. Chiffon, 1953. Photograph by Seeberger

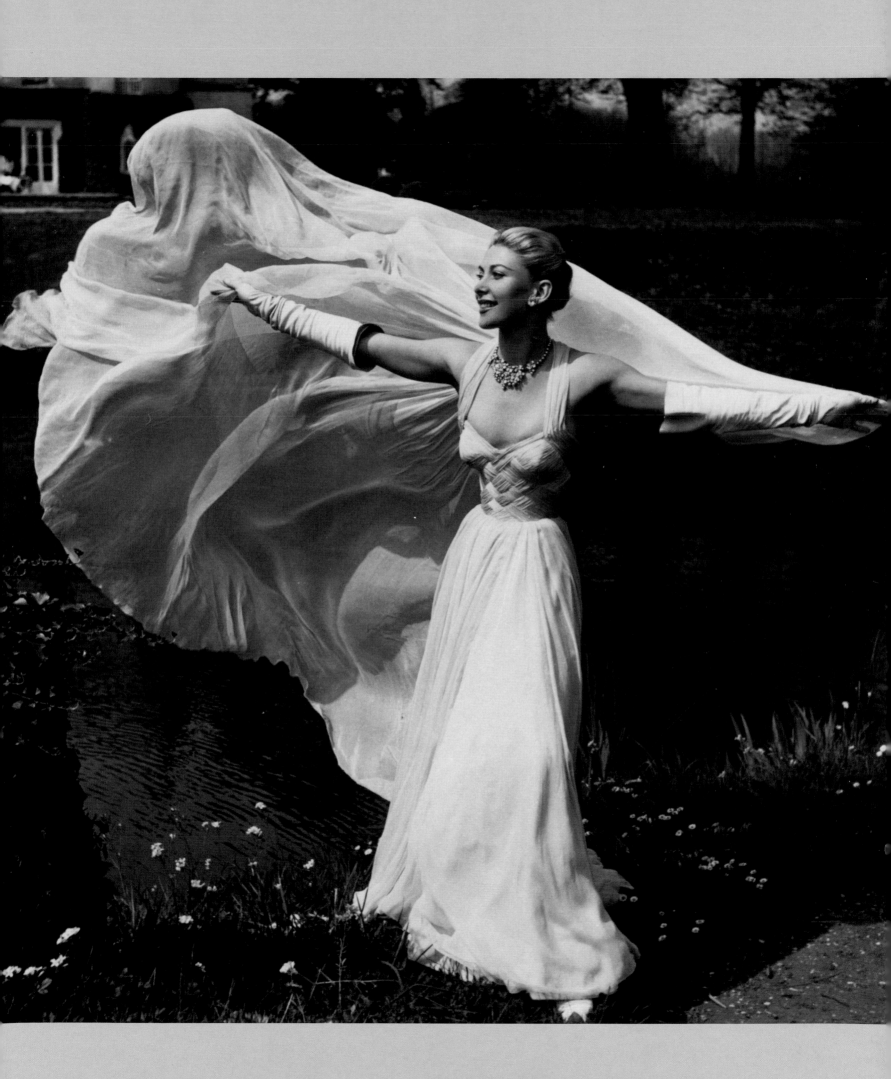

Jacques Fath

ELERI LYNN

Jacques Fath was born in 1912, just outside Paris. Self-taught, he had a flair for youthful, headline-grabbing designs, and a skill for what would become increasingly important to the world of fashion – publicity. Fath had tremendous personal appeal and he promoted his own image with care. In his opinion Balenciaga was too severe and, although he admired Dior, he was known to tease him about his '*bourgeois sérieux*' manner. Unlike his fellow couturiers, Fath was held up as a model of style: articles appeared in men's magazines describing how to emulate his 'masculine elegance', along with photographs of the couturier showing off his matinée-idol looks or smiling engagingly at the camera. His was a delightful dandyism that made him a darling of the press and his clients (whom he would address individually as '*mon poulet*'). Celia Bertin wrote of first meeting him: 'He had a showy elegance, this splendid young man with the charm of an "*enfant terrible*"... I couldn't take my eyes off him the whole evening.'[1]

Fath would often appear in the company of his wife, Geneviève, who was his business partner, model and best advertisement. She dressed immaculately in his designs, and always captured press attention. For a promotional tour to the United States in 1948, Mme Fath's $12,000 wardrobe consisted of 35 outfits and dozens of accessories, which filled 12 large trunks.[2] The trip was a runaway success, quadrupling sales at the Paris salon. Describing her as Fath's 'walking show window', *Life* magazine commented: 'At receptions in seven US cities both Mme Fath and her clothes have been enthusiastically received. So, also, was her husband's comment that many American women do not show off their figures enough.'[3]

Fath invested in the creation of a glamorous world. Even in the years directly after the war it was rumoured that he would spend $3,000 a year on champagne for his collection launches, which were described as a mixture of a Hollywood première and an opening night at the opera. He regularly attended celebrity events such as the Cannes film festival, and threw dinner parties at his villa in the Midi, or dined at restaurants, his presence attracting huge crowds. The greatest events of the calendar were, however, Fath's own celebrity-studded parties, lavish themed balls for clients, buyers, press and friends at his chateau at Corbeville. The photographer André Ostier, one of Fath's friends, recalled how 'all Paris dreamed' of being invited.[4] Fath's self-promotion and publicity campaigns were hugely successful, but at their core were chic and feminine designs, a thriving ready-to-wear business with the American firm of Halpert, and a devoted clientele. The dissemination of the Fath look and lifestyle resulted in haute couture sales that were second only to Dior's at the time of his death in 1954. His very public and apparently boundless *joie de vivre* made his early death seem all the more tragic. Celia Bertin found the idea unthinkable: she preferred to imagine 'that he was working incessantly, that he was travelling – that he had been to a party'.[5]

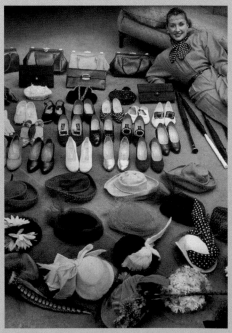

3.19 Jacques Fath as the Sun King with his wife, Geneviève. Venice, 1951

3.20 Jacques Fath, 1950

3.21 Geneviève Fath with her accessories for an American tour, April 1948

3.22 Jacques Fath with a model and a client, 1951

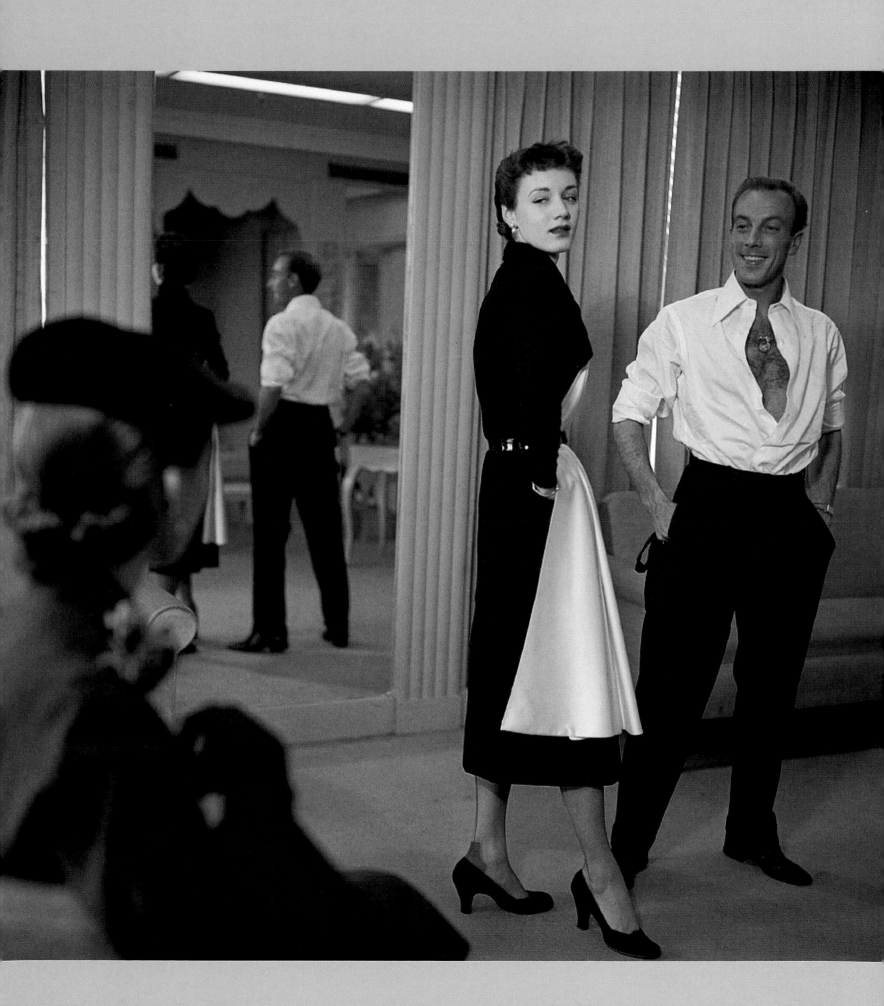

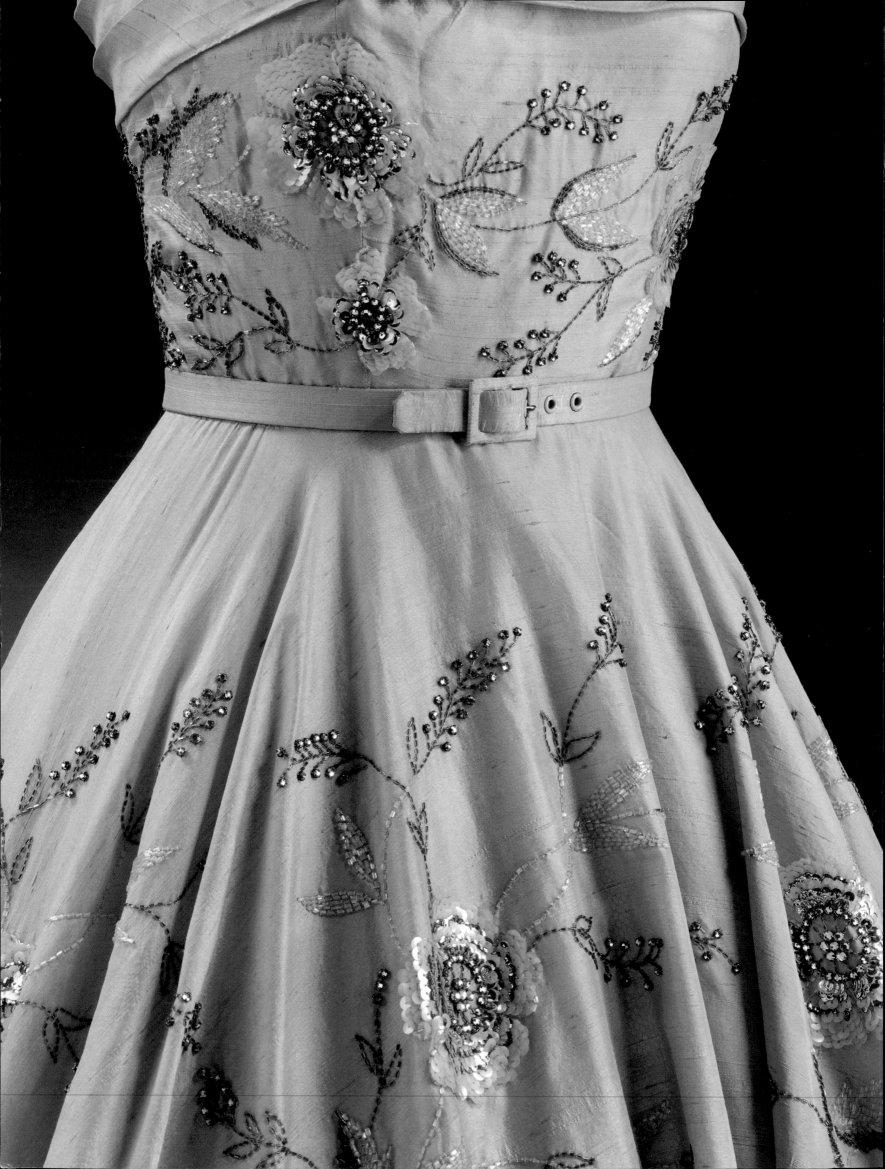

4

MATERIAL EVIDENCE
London Couture 1947–57

AMY DE LA HAYE

4.1 Evening dress
by Worth (London),
see 4.10

'In London, the fashion point is woven into
a wearable design... these clothes are good
mannered; they seldom trumpet their
qualities; but they are clothes that elegant
women everywhere love to possess'[1]

VOGUE (BRITISH EDITION)

THIS CHAPTER CONSIDERS couture in London and the garments designed between 1947 and 1957 that now form part of the V&A's Dress Collection. It assesses how representative of each couturier's work these surviving garments are, and sites them in relation to prevailing fashion trends. As far as evidence is available, it also documents couture purchasing patterns and the biography of the occasionally worn garment, which sometimes culminated in its being presented to the Museum. These luxurious clothes bear testimony to the couturiers' creative expression and the craft skills of their own and ancillary workshops.

London's couture industry became established after the First World War. Previously, wealthy women had been dressed primarily by London's court dressmakers, who created etiquette-correct garments – styled along the lines of Paris fashions – for the social life of the British elite, which revolved around the monarchy and the Season. Although the term 'haute couture' has never been strictly defined and regulated in Britain (as it is in Paris), London's couturiers distinguished themselves from the court dressmakers by presenting seasonal collections of directional designs. Norman Hartnell opened his couture house in 1923, Lachasse followed in 1928, Peter Russell in 1931, Victor Stiebel and the London branch of Molyneux in 1932, Digby Morton in 1933 and Mattli in 1934. During the 1930s Anglo-American couturier Charles James worked in

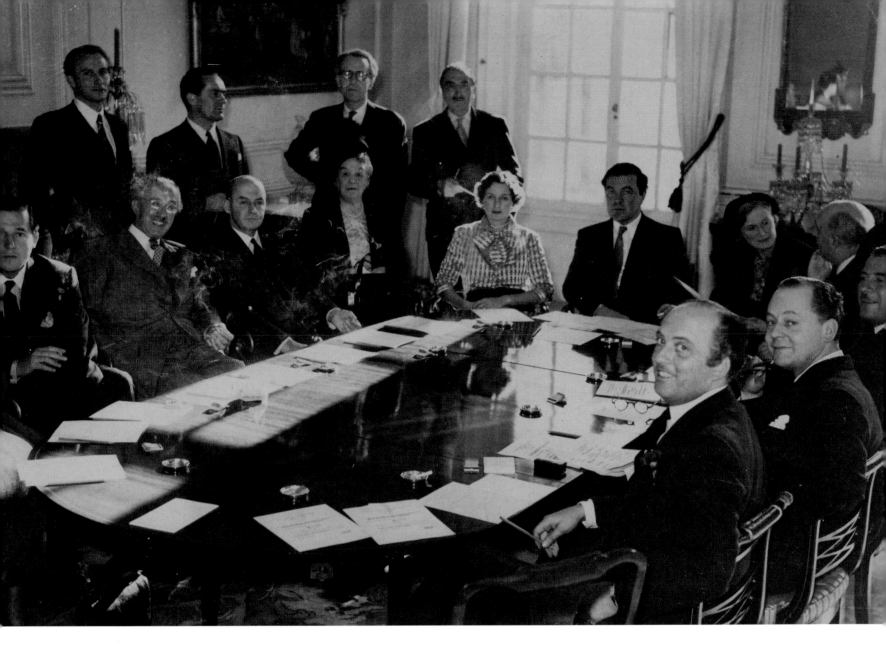

4.2 The members of INCSOC, October 1949. Standing, from left to right: Michael Sherard, Giuseppe Mattli, Victor Stiebel and Peter Russell. Seated, from left to right: Hardy Amies, William Haigh (National Wool Textile Export Corp.), Colonel Crawford (Bianca Mosca), Mrs C. Mortimer (Worth), Viscountess Rothermere, Norman Hartnell (Chairman), Miss Lilian Hyder (Organizing Secretary), Sir Raymond Streat (Cotton Board), R.A.G. Barnes (Lace Federation), Digby Morton and Charles Creed. V&A Archives

London but subsequently moved to New York. From the mid-1940s, London's couture industry expanded: Angèle Delanghe opened in 1944, Hardy Amies, Charles Creed, Michael Sherard and Bianca Mosca each opened a house in 1946, Ronald Paterson in 1947, John Cavanagh in 1952 and Michael Donéllan in 1953. London's couture industry was centred on Mayfair.

The early years following the Second World War proved challenging for London's couturiers. Rationing continued until 1949, the Utility Clothing Scheme remained in force until 1952, and, whilst luxurious fabrics were available for export, they were in short supply for the home market. Taxes introduced by the new Labour government adversely affected the couturiers' home clientele, and the devaluation of the franc in 1948 rendered London a relatively expensive market abroad. Nonetheless, export sales – critical for the commercial survival of many houses – remained high. In 1950 the Annual Report of the Incorporated Society of London Fashion Designers (INCSOC) declared that 'The main aim of the Society is to promote the London Fashion Designers and British fabrics at home and overseas. Because of present-day conditions the Society's activities are confined almost exclusively to developing the dollar market overseas [pl.4.2].'[2]

Some insight into the internal workings of a London couture house can be obtained

from publications of the day. In 1946 *The Strand* magazine documented that the staffing of an 'average' house included two *vendeuses*, who earned about £6 (equivalent to about £162 in 2006) a week plus commission. As in Paris, London's couture workrooms were divided between tailoring and dressmaking. Each workroom was headed by a tailor or dress fitter: women in this position earned between £10 and £20 and the men a few pounds more. *Secondes*, who earned about £2 a week, distributed work to 'the hands' who in turn passed work on to juniors. These girls, of whom there were between 40 and 60, earned £2–4 a week. Whilst some houses had full-time models, *The Strand* stated that on average there were two models, who earned £3–5, provided their own shoes and cosmetics, and were often laid off at slack times.[3]

With the exception of Hartnell, who had his own embroidery workrooms, couturiers sent their cut work to a specialist company such as Paris House (in London) to be embroidered (see Chapter 5 and p.136). The couturiers also made use of specialist pleating houses, furriers and glove-, belt-, bag-, shoe-, button- and artificial flower-makers. Ann Scory was London's leading maker of artificial flowers, created in silk, chiffon, velvet and feathers, for the couture houses, and also made flowers for the Queen. To complete their ensembles they regularly commissioned creative milliners, including John Reed Crawford, Eric, Otto Lucas, Simone Mirman, Rudolf, Aage Thaarup and Madame Vernier, whose trade union organization was the Associated Millinery Designers of London. From 1956 these craftspeople and companies could apply for Associate Membership of INCSOC.

Unlike their Paris colleagues, throughout this period London's couturiers received little support from the state or backing from fabric manufacturers. However, building upon relationships forged during the Second World War, INCSOC worked collaboratively with textile organizations such as the International Wool Secretariat (IWS) and the Cotton Board to publicize the couturiers' work. Some London couturiers secured modest licensing contracts, but did not enjoy the lucrative deals offered to top Paris designers. Nor did they earn major revenue from perfume sales. Their wage bills were also higher. An article appearing in *The Economist* in 1951 compared the couture industries of the two cities, stating that 'Paris, with its tradition of *couture*, is rich in trained and experienced people; in London they have a scarcity value. The London house, moreover, has to pay purchase tax at the rate of 22 per cent on each quarter's sales.'[4] It is perhaps surprising, therefore, that London couture in 1951 was competitively priced: a Parisian dress might cost £300 (equivalent to £6,525 in 2006) whilst a comparable London model cost about half this amount at £152.10s., including tax for the home market.[5]

In 1952, leading London couturiers Norman Hartnell and Hardy Amies employed 400[6] and 200[7] workers respectively, whilst Michael Sherard operated with a small team of just 40.[8] By contrast, a leading Paris house employed between 500 and 850 workers and showed some 150 designs in January and July, as well as offering mid-season collections.[9] Amies' collections were less than half this size: he showed 60 ensembles, of

which 20 were day dresses (some with coats or jackets), 20 suits (some shown with overcoats) and 20 evening dresses (including cocktail and party dresses).[10] Amies stressed: '[E]very model in my collection has to do a job, the job of taking orders. Only rarely can I allow myself the extravagance of making one to do the job of making publicity.'[11]

London's couturiers necessarily created small collections of eminently wearable clothing for the social elite. This was made explicit by the fashion editors at *Vogue* and *Harper's Bazaar*, who presented the London collections in contexts specific to a particular occasion, identifying stylish and appropriate garments for the Royal Garden Party, Goodwood, Wimbledon, Ascot, Cowes, coming-out dances and summer balls, which were followed by winter months in the country (pl.4.3). This was given further endorsement through features picturing couture clients and their debutante daughters in their magnificent houses and grounds. London's most high-profile couture clients were the British royal family, and the 1953 Coronation provided an international showcase for the couturiers' designs (see p.110).

Tailoring

Most of the couture garments described here were ordered by the client, made to fit perfectly and worn for social events. They were subsequently carefully packed away and some sufficiently valued (in terms of provenance, design and perhaps as mementoes

4.3 'Days in Town', tailored suits by (from left to right) Hardy Amies, Michael Donéllan and Charles Creed, with hats by Vernier and Rudolf. *Vogue* (British edition), September 1953. Illustration by René Bouché

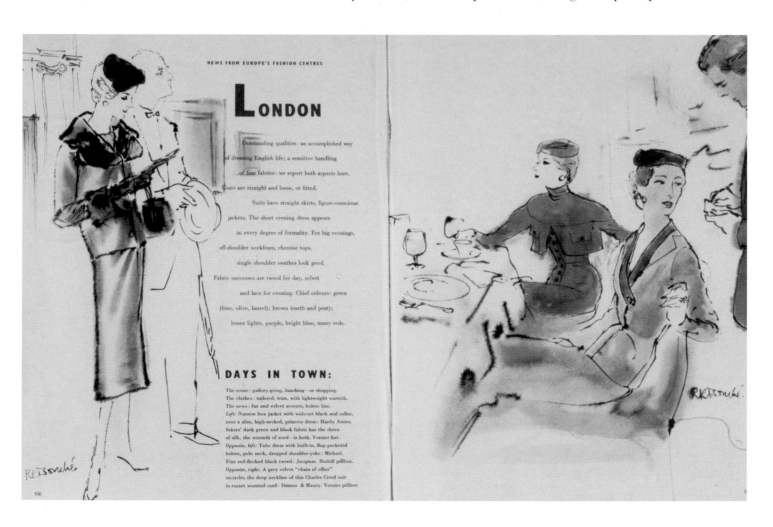

of special occasions – the intrinsic value of clothing is rarely financial) to be offered to the Museum for posterity. The couture client often possesses an extensive wardrobe of little-worn clothing, which explains why these garments – especially the tailored clothes, which would normally endure most use – are in good condition, although some have been altered during the period of their wear. The V&A's collection of couture tailoring from this time includes garments by Digby Morton, Hardy Amies, Norman Hartnell, Lachasse, Charles Creed and Michael Sherard.

Digby Morton trained as an architect before taking up a career in fashion. In 1928 he was appointed designer for the newly opened House of Lachasse. Hardy Amies, his successor at Lachasse, observed:

> Morton's philosophy was to transform the suit from the strict *tailleur*, or the ordinary country tweed suit with its straight up and down lines, uncompromising and fit only for the moors, into an intricately cut and carefully designed garment that was so fashionable that it could be worn with confidence at the Ritz.[12]

Morton continued to specialize in tailoring in his own salon. Quite typical of his designs is an ensemble made from green, beige and brown checked worsted which dates from 1947–8, and was worn and given to the V&A by Mrs Benita Armstrong (pl.4.5). The styling and colours were highly fashionable and entirely characteristic of Morton's preference for muted tones. The jacket was made by Morton's tailor, Roger Brinès, whilst the pleating of the matching dress involved the skills of an external workshop. A specialist company such as Ciment or Gilbert would have pleated the quarter circles of sun-ray pleats on the skirt (an expensive process which cost about £12),[13] and the fine green leather belt, which matches the dress perfectly, would have been ordered from an exclusive leather company such as Madame Crystal. What is perhaps unusual about this ensemble is the absence of distinctive pockets – Morton adored pockets, and he used them imaginatively and profusely.

Another suit by Digby Morton, named 'Chesterfield' after the velvet-collared coats worn by the trend-setting Earl of Chesterfield in the 1830s and 1840s, features cuffed pockets which emphasize the curve of the hips (pl.4.4). Dating from 1954, when black-and-white checks were the height of fashion, this lean-cut, shapely suit is accessorized with a small, fringed, bow-shaped scarf in matching tweed, which is lined with black silk velvet. Morton advised the client – Mrs Opal Holt – that, teamed with a discreetly checked blouse, this ensemble was ideal to wear at the races.

Hardy Amies was an astute businessman as well as a talented designer. In his autobiography *Just So Far* (1954) he describes his early career at Lachasse and Worth and explains how he developed his own couture business at home and abroad. To keep his business afloat Amies needed to sell 2,000 garments a year.[14] His clients generally

'Morton's philosophy was to transform the suit… into an intricately cut and carefully designed garment that was so fashionable that it could be worn with confidence at the Ritz.'

HARDY AMIES

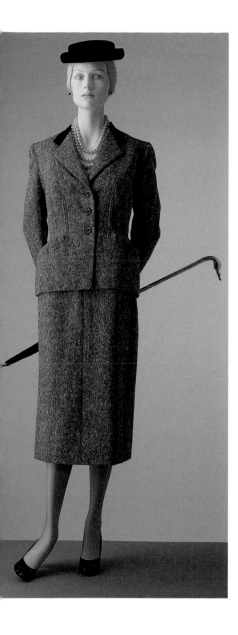

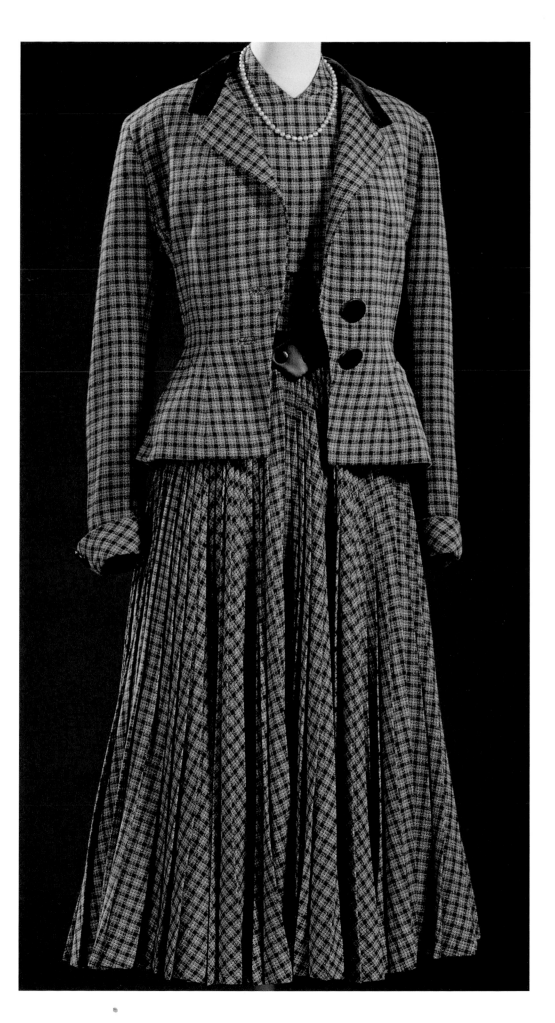

4.4 'Chesterfield', suit by Digby Morton. Wool tweed, 1954. Worn by Mrs Opal Holt and given by Mrs D.M. Haynes and Mrs M. Clark, V&A: T.101–1982

4.5 Suit by Digby Morton. Tweed with velvet trim, 1947–8. Given by Mrs Benita Armstrong, V&A: T.37–1966

ordered one or two dresses or suits each season, together with '…a series of little ready-made dresses bought extremely cheaply, often under a branded name'.[15] In order to compete in this expanding market, some couturiers – including Amies – opened boutiques, where they sold ready-made clothes or simplified designs that required just one fitting (rather than the usual two or three for a couture garment), along with cashmere knitwear and exclusive accessories.

By 1947 Norman Hartnell had a thriving business dressing society ladies, actresses and – very importantly – British royalty, whose patronage greatly increased his clientele and business. Although he was best known for his romantic evening dresses (pl.4.13), Hartnell was also capable of stylish restraint. A fine black wool coat with asymmetric buttoning and a sloping waistline was ordered by Lady Cassel in 1948 and subsequently donated to the Museum.[16]

Mr Owen – known as 'Owen at Lachasse' – was designer at Lachasse from 1953, when Michael Donéllan left to open his own house. Owen designed a claret-red wool suit chosen by Mrs Dent.[17] The jacket has distinctive wedge-shaped double pocket flaps and the skirt, knife-pleated in the back, was shortened during the course of its wear. The suit was worn with a red and black jersey hat from Lachasse and an embroidered and fagotted blue-grey crêpe-de-chine blouse labelled 'Givans'. The V&A originally dated this suit to around 1949 but research in the sales ledgers of the Lachasse archive reveals that it was in fact purchased in May 1954. (Stylistically it could have been designed at either time.) These fascinating ledgers document the purchasing patterns of Lachasse's clientele and reveal the prices they paid. The suit cost £58.6s (about £1,200 by 2006 prices) and the hat £10.10s (about £200). The ledgers show that Mrs Dent and her daughter placed regular orders for coats, suits, dresses and hats, and also had several alterations undertaken between 1938 and 1955.

Before working in his family couture house, Creed, in Paris (established 1870), Charles Creed was taught practical tailoring skills in Vienna and learned about the properties of fabric at Linton Tweeds; he gained commercial experience working in New York's fashion retail and wholesale industries. During the war Creed designed for the exclusive London store Fortnum & Mason, and shortly afterwards opened his own salon at 31 Basil Street, taking two fitters from Fortnum's with him (such staffing moves were common in the industry and clients would follow a valued designer or fitter). Creed specialized in tailoring: when he did make evening dresses they were usually slim and tailored. His unusually masculine Knightsbridge premises had dark panelled walls upon which he hung cavalry hats, and the salon displayed his collection of colourful miniature Napoleonic soldiers. Creed's passion for military uniform was translated into his couture collections: garments trimmed with frogging, braiding and piping, capes, tricorn hats (Simone Mirman and Renée Pavy regularly made hats for Creed) and fobs in place of buttons became Creed signatures. After closing his house in 1966 Creed gave the V&A some model garments, including a mustard-coloured wool suit with decorative black

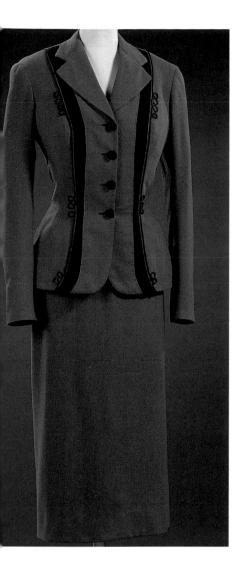

4.6 'Toffee', suit by Charles Creed.
Wool with silk braid, 1953.
Given by Mr Charles Creed,
V&A: T.63–1966

4.7 Suit by Michael Donéllan.
Worsted, 1954. Given by Mrs
Vivienne Cohen, V&A: T.52–1997

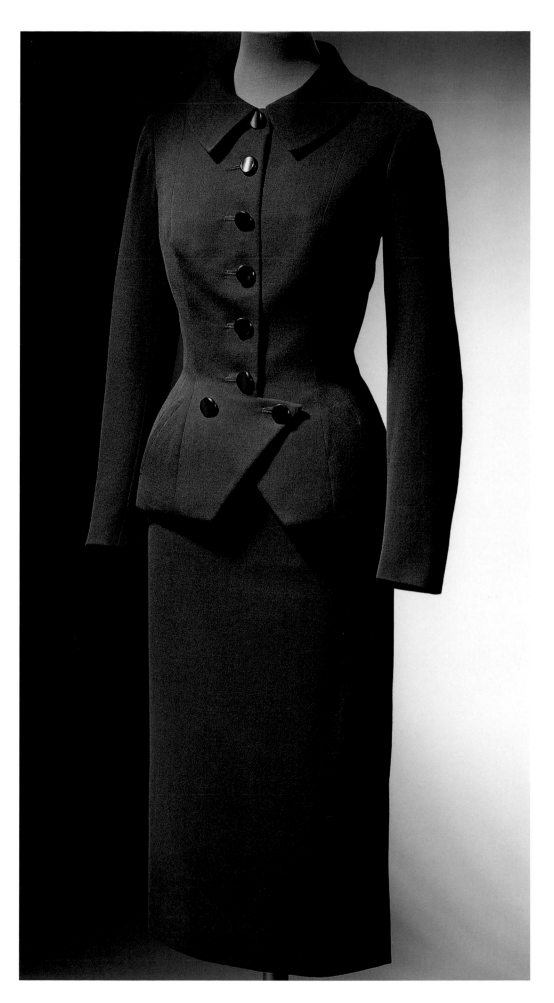

braiding from 1953, which retains the original tape, bearing the model number 1523 and the name 'Toffee' (pl.4.6). The suits epitomize the elegant, elongated lines for which Creed was known, and presumably he decided they would well represent his work to future generations.

Giuseppe Gustavo (Jo) Mattli was best known for his fluid, draped dresses and soft, feminine tailoring. Mattli studied tailoring in London and worked with Premet in Paris before establishing his London house. In 1955 his house went into liquidation and he subsequently moved to Basil Street to share Creed's premises.

In 1937, at the age of 18, Ronald Paterson won first prize for a tailoring design and second prize for a dress design when he entered a competition judged by the innovative Parisian couturier Elsa Schiaparelli. Much encouraged, he developed his skills at the Piccadilly Institute of Design and then worked in Paris. In 1947 Paterson opened a house in Albemarle Street. London's youngest couturier, he stated that he never looked to the past for inspiration;[18] his 1955 'flying saucer hats' (Rudolf regularly made his millinery) were uncompromisingly modern. The V&A has a Paterson suit from the late 1950s made in a heavy beige and brown checked wool.[19] The fashionable boxy jacket has a deep collar which can be worn in a variety of ways. Paterson regularly used checked and textural tweeds and was known for his light handling of bulky materials. The suit, along with a bold yellow precision-cut wool coat also by Paterson, was worn by Mrs C. Nattey and given to the V&A by her mother.

Michael Donéllan, another talented designer who started his career at Lachasse, opened 'Michael', his Carlos Place house in 1953. In spring 1954 Londoner Dr Vivienne Cohen ordered a black worsted suit from him (pl.4.7). The jacket has an unusual Peter Pan collar and curved pockets, and is softly moulded to accentuate the hips. Particularly distinctive is the buttoning, which becomes double-breasted just below the waist.

Victor Stiebel trained with the court dressmaker Reville before opening his own salon at 21 Bruton Street. From the outset, Stiebel aligned himself with the vogue for historical revival styles, and he used striped fabrics imaginatively. During the war, Stiebel's business was run by the Jacqmar organization. He subsequently became Jacqmar's Director of Couture (the label was 'Victor Stiebel at Jacqmar') and the house was located at 16 Grosvenor Street. In 1958 Stiebel became independent of Jacqmar and opened his own house in Cavendish Square.

Evening and wedding dress

As evening dresses and wedding gowns often are our most 'special' clothes, generally worn just once or twice for important occasions and rites of passage, these are the garments that are generally presented to the Museum. From this period, the V&A's collection includes couture evening dresses by Victor Stiebel, Hardy Amies, Norman Hartnell, Worth, John Cavanagh and Digby Morton.

For his Autumn/Winter 1947–8 collection, Victor Stiebel designed a yellow-green

4.8 Evening dress by Victor Stiebel at Jacqmar. Embroidered silk satin, 1950s. V&A: T.172–1969

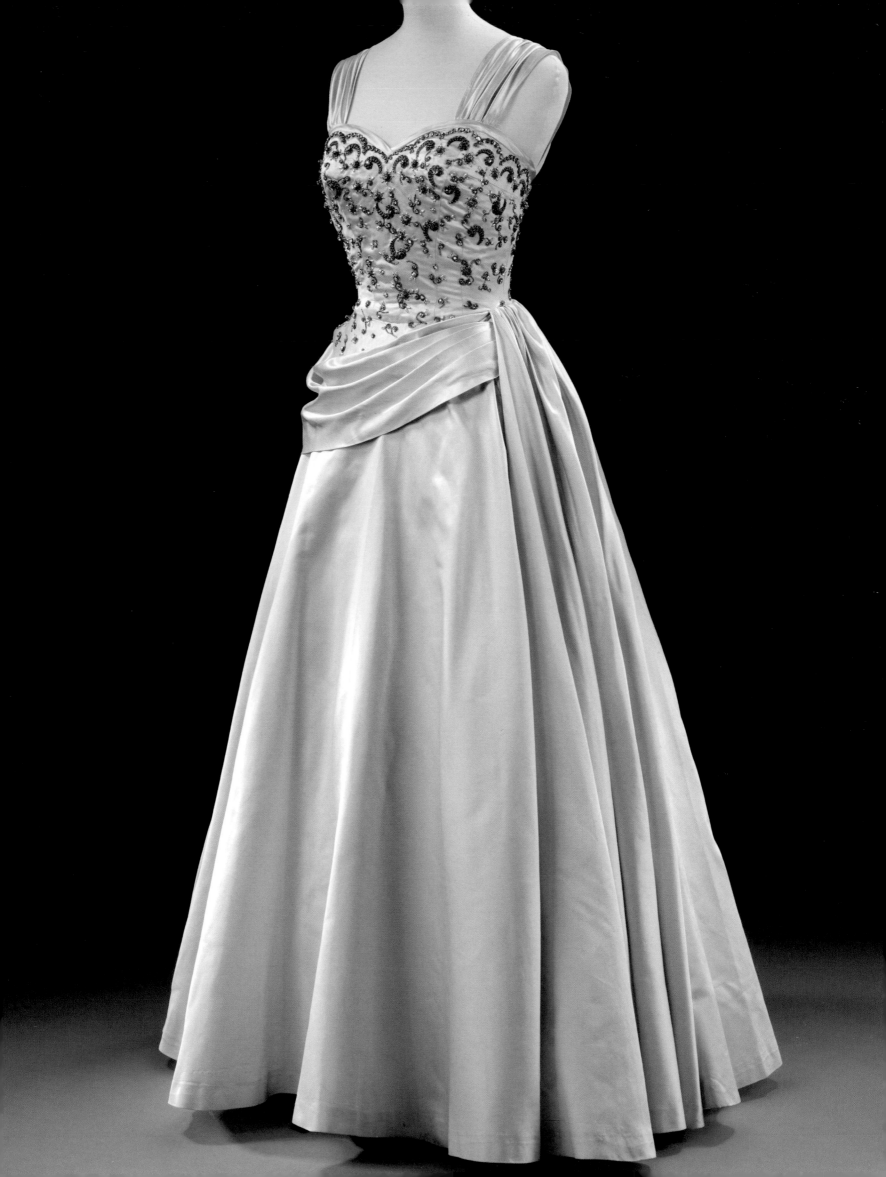

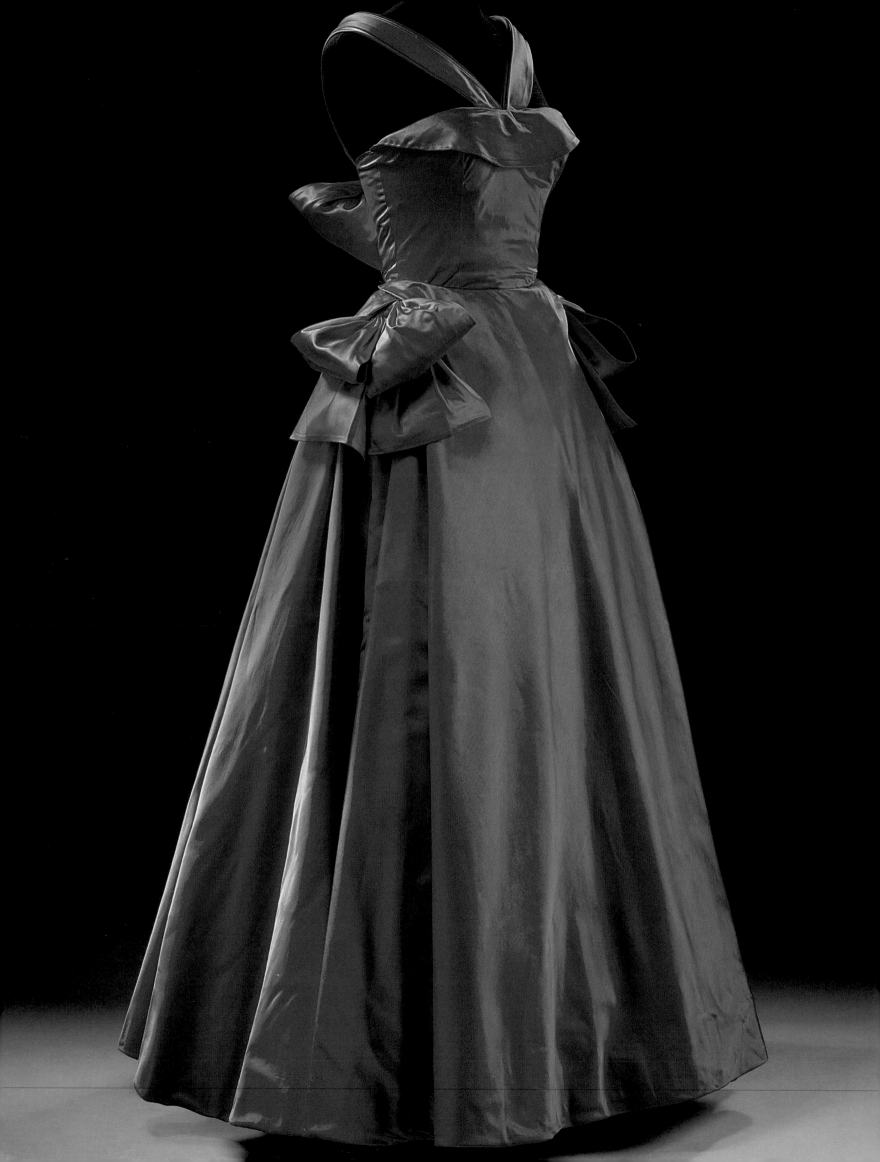

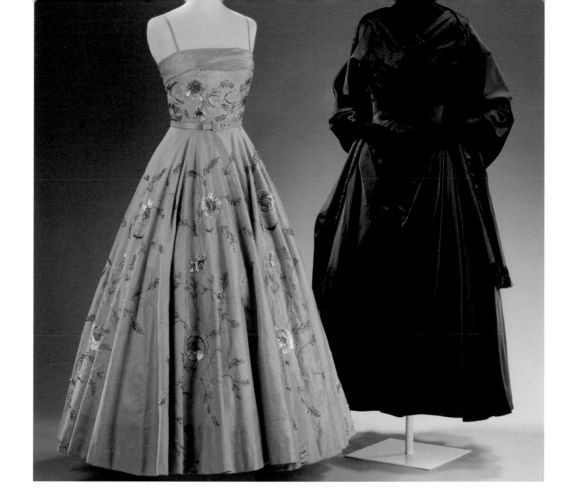

4.9 Evening dress by Hardy Amies. Satin, *c.*1950. V&A: T.86–2001

4.10 Evening dresses by Worth (London). Left: embroidered wild silk dress, 1955. Given by Mrs Roy Hudson, V&A: T.214–1973. Right: silk dress and stole, 1950s. V&A: T.18–2006

striped late-afternoon dress in silk grosgrain with a distinctive bustle bow which was worn and given to the V&A by Lady Cornwallis. It was a stylish and ingenious interpretation of the New Look.[20] When fabric was no longer scarce, Lady Templer purchased a cream silk satin evening gown, decorated with pearlized beads, rhinestones and silver beads, directly from a Stiebel show; since her shoulders were narrow, his studio added the straps (pl.4.8). The Hardy Amies evening gown that Mrs Lister Bolton chose, executed in crimson silk satin without embellishment, makes an altogether bolder statement (pl.4.9).

In the early 1900s the Paris couture house Worth opened a London branch, which merged with Reville in 1936. Clients were offered designs by Elspeth Champcommunal, a former Parisian designer and editor of British *Vogue*, alongside Parisian ones. In 1953 Owen Hyde-Clark, who had worked with Maggy Rouff in Paris and Bradley's in London, was engaged to design Worth's boutique range. About the same time the Parisian couture house Paquin bought Worth and in 1954 sold the name to Sydney Massin, who launched Worth (London) Ltd. One client, Mrs Roy Hudson, was a friend of Miss Whistler, Worth's head *vendeuse*. She purchased Worth's gowns between 1947 and 1962. Dating from *c.*1955, when Hyde-Clark was also responsible for couture, are two pink silk evening dresses worn by Mrs Hudson, one long and the other in the fashionable shorter length that was acceptable for all but the most formal occasions. Worth was known for delicately embroidered dresses in shades of champagne and rose, and these dresses are typical of the house's output (pl.4.10). However, the V&A also recently acquired a plain navy satin evening dress with matching stole. Worth (London) Ltd closed in 1967.

Bianca Mosca, one of London's two women couturiers, designed accessories for Schiaparelli and managed Schiaparelli's Paris boutique before moving to Paquin's London branch. When Paquin closed during the war, Mosca accepted a position at Jacqmar to design under her own name using their fabric. In 1946 she opened her own house at 22 South Audley Street. The June 1949 issue of *Vogue* observed that Mosca was the perfect model for her own designs (pl.4.11). The magazine published three portraits of her taken by Cecil Beaton, in which she wore a satin house coat with a printed design of pink and black wings, a rust and purple striped tweed suit and a pale grey brocade evening gown woven with tiny butterflies. Bianca Mosca died in 1950, just two months after she had seen the scheme she originated – for a group of five top level British fabrics manufacturers, including Sekers, to form the Associated Haute Couture Fabrics Company – open their Paris office (see p.119).

London's other woman couturier was Angèle Delanghe. In 1948 she presented formal silk gowns with panniers and pretty cotton evening dresses patterned with birds and leaves. By 1950 Delanghe had closed her house at 12 Beauchamp Place, but she reopened at 13 Bruton Street some eight years later.

Peter Russell told author and INCSOC secretary Lilian Hyder that he learned to draw by tracing models from *Vogue* magazine.[21] During the 1930s Russell contributed to the neo-classical revival, presenting evening dresses with accordion and fan-tail pleating, the latter of which he applied to his tailored jackets for his Summer 1950 collection. He was also known for his magnificent formal evening gowns: for the same collection, he presented an oyster-coloured silk satin gown that swept to the floor in unpressed pleats, with a tiny bodice held by a halter neck, embroidered by Paris House. Russell closed his salon at 2 Carlos Place in 1954 (see pl.1.6).

When Michael Sherard, who originally trained as a painter, realized that fashion was his vocation, he approached couturier Peter Russell to undertake an apprenticeship (making Russell the first London couturier to take on an articled pupil, for a premium of £100).[22] In 1946 Sherard opened his house at 24 Connaught Street, where his first collection, shown in February 1947, included evening dresses in cotton and more formal designs in silk, many decorated with a beautiful floral corsage, some of which appeared to be dappled with dew. Sherard worked extensively with lace; the V&A has a black Swiss lace evening dress with raised, self-fabric flowers, designed by Sherard in 1957 for his acclaimed Spring 1958 collection (pl.4.12). The couturier presented this dress to Cecil Beaton for the exhibition 'Fashion: An Anthology' (1971) at the V&A. Sherard closed his salon in 1964.

Norman Hartnell's salon and workshops were located in an eighteenth-century house at 26 Bruton Street, which he had adapted by architect Gerald Lacoste. The

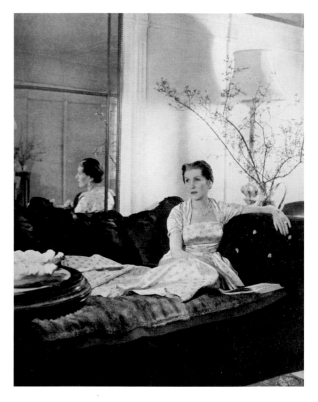

4.11 Bianca Mosca wearing a dress of her own design. *Vogue* (British edition), June 1949. Photograph by Cecil Beaton

4.12 Cocktail dress by Michael Sherard. Lace with appliqué lace flowers, Spring 1958. Given by Mr John Fraser and Mr Michael Sherard, V&A: T.403–1974

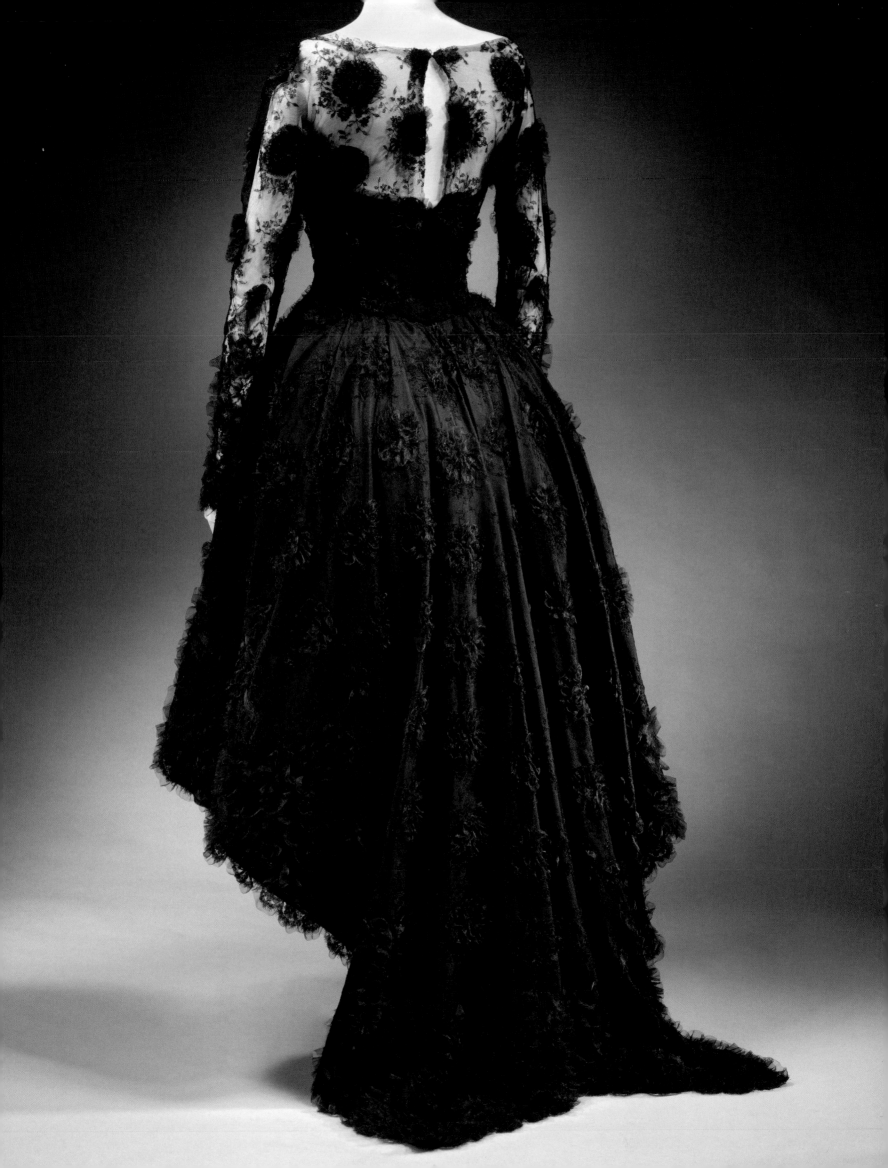

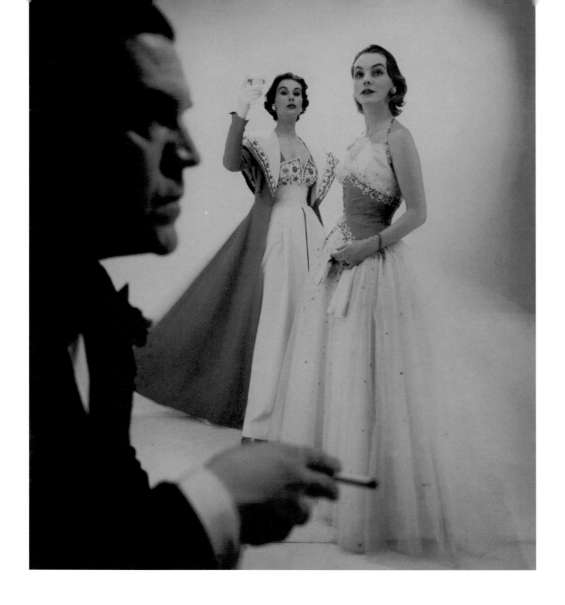

4.13 Norman Hartnell with models. Unused shot for *Vogue* (British edition), 1953. Photograph by Norman Parkinson

interior was decorated by Norris Wakefield. The walls were painted in 'Hartnell green' (green with a silvery-grey hue), the entrance hall was mirrored, and the salon was lit by magnificent, fantasy chandeliers, including one that was fashioned like a galleon. Hartnell's fitters and saleswomen were all dressed in the same soft green-grey. There was never any music played in the couture salons. In 1952 Lilian Hyder wrote that, when entering Hartnell's premises:

> Madame Jeanne will receive you. Her white hair has a violet rinse, she is always dressed in Parma violet colour, and she always wears a large posy of Parma violets. At the far end of the salon is a flood-lit entrance where the mannequins stand for a second before stepping into the large room...[23]

Hartnell was most famous for his romantic, full-skirted evening gowns twinkling with ornate – often raised – embroidery. In his autobiography *Silver and Gold* (1955), Hartnell described his creative process: first he sketched his designs, next he coloured them with paint and then he pencilled on embroidery patterns. He also painted a full-scale motif for his embroiderers to work from. From this period, the V&A houses evening dresses by Hartnell dating between *c*.1948 and 1955. These are mostly full-skirted, sleeveless evening gowns made in cream silk satin and lavishly embroidered, often with

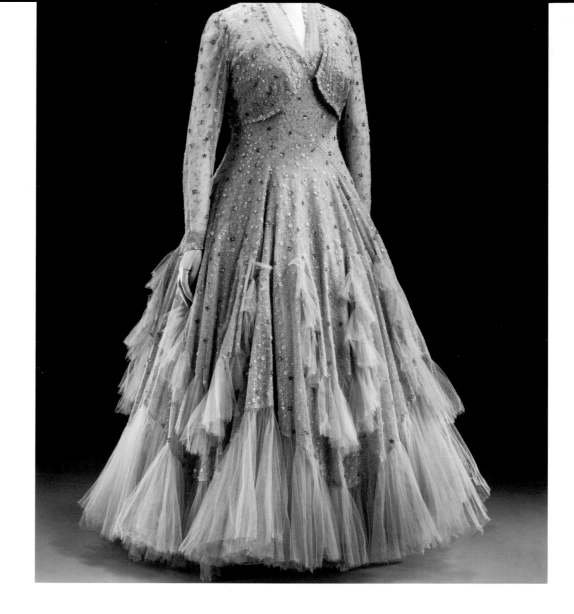

4.14 Evening ensemble by
Norman Hartnell. Tulle with
embroidery and sequins,
c.1948. Given by Mrs Fisher,
V&A: T.192–1973

colourful, raised, floral motifs. The earliest, however, an ensemble worn by Mrs Fisher,
comprises a dress of lilac-coloured tulle, with scalloped panels trimmed with grey tulle,
embroidered with flower-shaped sequins, and a matching long-sleeved bolero jacket.
It has a light, ethereal quality not always associated with Hartnell (pl.4.14).[24]

Wedding dresses formed a significant part of the couture houses' business, and
these are well represented in the Museum's collections. Former model and *Vogue* editor
Pat Cunningham chose Molyneux to design the dress for her marriage to couturier
Charles Creed in 1948.[25] Molyneux trained as a painter and worked with Lucile before
opening his Paris salon in 1919. His sister, Miss Kathleen, ran the London business which
opened in 1932. Molyneux was known for his refined designs, purity of line and lack of
extraneous decoration. Molyneux closed his house in 1950, but briefly reopened a new
fashion business in 1964.

In 1951 Norman Hartnell designed a wedding dress of cream-coloured duchesse
satin, embroidered with pearls, crystals and sequins on the shawl collar and in sweeping
bands on the skirt. It was worn and subsequently donated to the Museum by Mrs H. S.
Ball. Lindsay Evans Robertson, who worked with John Cavanagh, recalls 'it was a
couture workshop tradition to leave a blue bow, a pin, a silver coin and a spot of
blood from a virgin in the workroom inside a wedding dress': a single pin remains in
this gown.[26]

...ress

...amous wedding gown of this period was the dress that Hartnell designed for
...Elizabeth's marriage to Lieutenant Philip Mountbatten in 1947. Hartnell first
...d the Princesses Elizabeth and Margaret in 1935 as bridesmaids and received his
...warrant to Queen Elizabeth in 1940. In 1950 Hardy Amies received a royal order
to make clothes for Princess Elizabeth to wear on her state visit to Canada, and he
successfully applied for a royal warrant five years later. Throughout the period, members
of INCSOC arranged private showings for their royal clientele, including a presentation
of tweed clothes arranged in association with the International Wool Secretariat in 1948.
Whilst much royal dress is housed at Kensington Palace, the V&A has its own examples
of fashionable dress worn by royalty, as well as one magnificent ceremonial gown, all
designed by Hartnell.

Hartnell designed an elegant black evening dress for Princess Margaret in the early
1950s, made in ottoman silk with a fitted bodice and full skirt that has a scalloped hemline.
Apart from mourning dress, it was unusual for the royal family to wear black. As Hartnell
observed: 'As a rule, ladies of the Royal Family wear light coloured clothes because such
colours are more discernible against a great crowd, most of which will be wearing dark
everyday colours.'[27] Princess Margaret gave this dress to the V&A in 1986 (pl.4.16).

In 1953 Hartnell designed the Queen's Coronation dress, and in the same year he
was appointed a Member of the Victorian Order. In 1957 he designed a splendid dress
for the Queen to wear on her state visit to Paris. Whilst following general fashion trends,
ceremonial dress primarily complements ambassadorial, political and authoritative roles.
Called 'Flowers of the Fields of France', this dress is embellished with dazzling
embroidery which depicts poppies, *fleurs-de-lys*, wheatsheaves and bees (Napoleon's
symbol of industry), designed to compliment the host nation (pl.4.15). One of the
embroiderers who spent three weeks working on the gown (behind curtained windows
to avoid advance publicity) was Maureen Markham. She joined Hartnell in 1954 and
remained with him for the next 25 years; she recalls: '[Flowers of the Fields of France]
was so elaborate. We just hoped that she always sat on plush chairs so that the
embroidery did not get squashed!'[28] Three years later the Queen wore the dress again,
this time to the Royal Opera House in London. It was acquired for the V&A by Cecil
Beaton and displayed in the exhibition 'Fashion: An Anthology' in 1971 (see pl.7.8).

By 1957, international demand for couture clothing was in decline and a number
of London houses – amongst them Angèle Delanghe, Molyneux, Digby Morton, Bianca
Mosca and Peter Russell – had closed. From this point on, it was the modish, ready-to-
wear fashions offered by Mary Quant and a group of newly art-school-trained designers
that captured not only London but also international fashion headlines. Thenceforth
London possessed a dual fashion identity that incorporated both the couturiers who
continued to design luxurious yet wearable clothing for the social life of the British elite,
and the iconoclastic designers of fun, irreverent youth fashion.

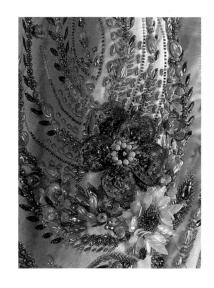

4.15 'Flowers of the Fields of France',
evening gown by Norman Hartnell
(detail). Duchesse satin with pearls,
beads, brilliants and gold thread, 1957.
Given by HM The Queen,
V&A: T.264–1974

4.16 Cocktail dress by Norman
Hartnell. Silk with diamanté straps,
early 1950s. Given by Princess
Margaret, V&A: T.238–1986

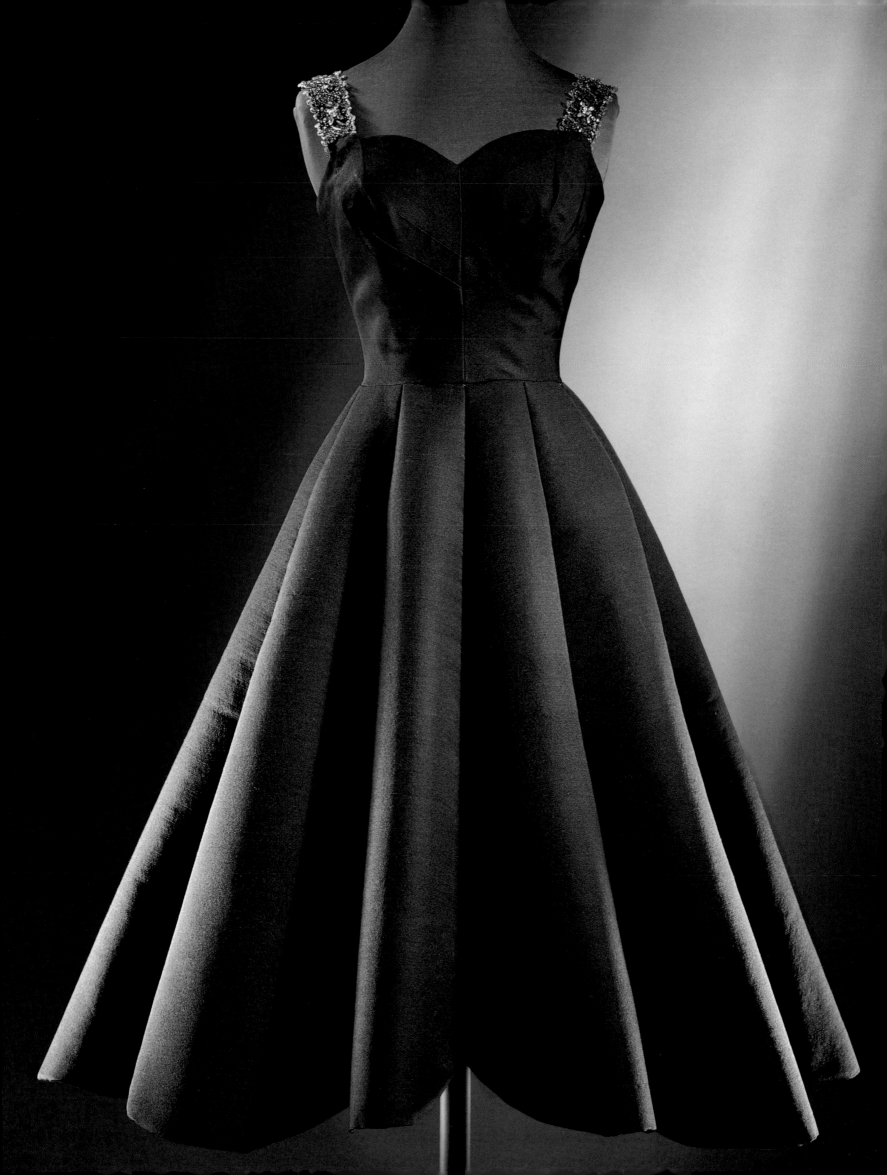

Miss Virginia Lachasse

AMY DE LA HAYE

Miss Virginia Lachasse was created in 1954 in London and became the star attraction in a touring exhibition of dressed dolls to raise money for the Greater London Fund for the Blind. Each firm who contributed donated £5 or more to the appeal, and additional funds were raised everywhere it toured.

Miss Lachasse is a perfect scale model of her namesake, Virginia Woodford, the leading model at the couture house of Lachasse in Mayfair. Two heads were cast in wax, each featuring brilliant blue painted eyes with false eyelashes and a wig fashioned by Steiner – one with long, flowing hair, the other gamine-short. Miss Lachasse's fully accessorized wardrobe provides a fascinating insight into the type and variety of fashionable couture dress appropriate for winterwear in 1954. The ensembles were designed by Owen at Lachasse and lingerie and accessories were custom-made by suppliers with whom the house regularly worked. Each piece is labelled and impeccably crafted from luxury materials to the standard of the full-size product, including fully fashioned nylons believed to be the smallest ever made. Miss Lachasse was recently donated to the Museum of Costume, Bath.[1] Her wardrobe comprises:

- For travelling, a suit and top coat of Rankine Hamilton's 'Dream Touch' tweed in lavender-green, with leather buttons made by Donbar. Worn with a blue silk chiffon, pin-tucked blouse.

- A grey day dress with pleated skirt in fine wool by Sweetingburgh, with patent shaped leather belt by Donbar.

- A black-and-white tweed suit with tie belt, accessorized with a gold metal, jewelled, leaf-shaped brooch.

- A blue silk dress with matching coat, the latter with bright pink lining.

- A gold and blue brocaded cream silk suit comprising a long, waisted jacket and a narrow skirt.

- A cocktail dress in spotted blue on black silk by Bradford & Perrier.

- A formal evening gown in white silk satin by Jacqmar, embroidered with pearls and diamanté, a tiara with matching earrings and necklace, and a flat-linked gold metal chain necklace, bracelet and earrings. Embroidery and jewellery all by Paris House.

- A sleeveless, sequinned evening sweater embroidered with gold thread made by Blind Knit-wear.

- A dyed and finely stranded mink coat by furrier A. Francke & Son, valued at £150.

- Millinery by Lachasse: one hat in grey silk jersey, one in black glazed straw, another decorated with pink velvet flowers.

- A black lace and tulle boned corselette with matching belt and brassière and cream tulle and embroidered satin lingerie. All made by Warners.

- Stockings by Aristoc

- A pair of high-heeled, gold leather sandals by Russell & Bromley.

- Soft leather gloves for day and evening, hand-sewn by Lachasse glove-maker Mrs Kershaw.

- A brown leather travel case by Finnigans containing toiletries by Yardley.

- A fine blue-grey leather handbag by Asprey, with mirror and purse.

- Printed cotton handkerchiefs by Tootal.

- Cigarette-holder, minuscule cigarettes and lighter by Dunhill.

- A Swan biro pen and stationery by Chelsea Bank.

- Silver metal coat-hangers.

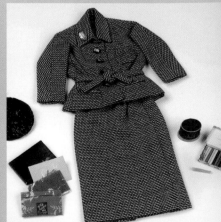

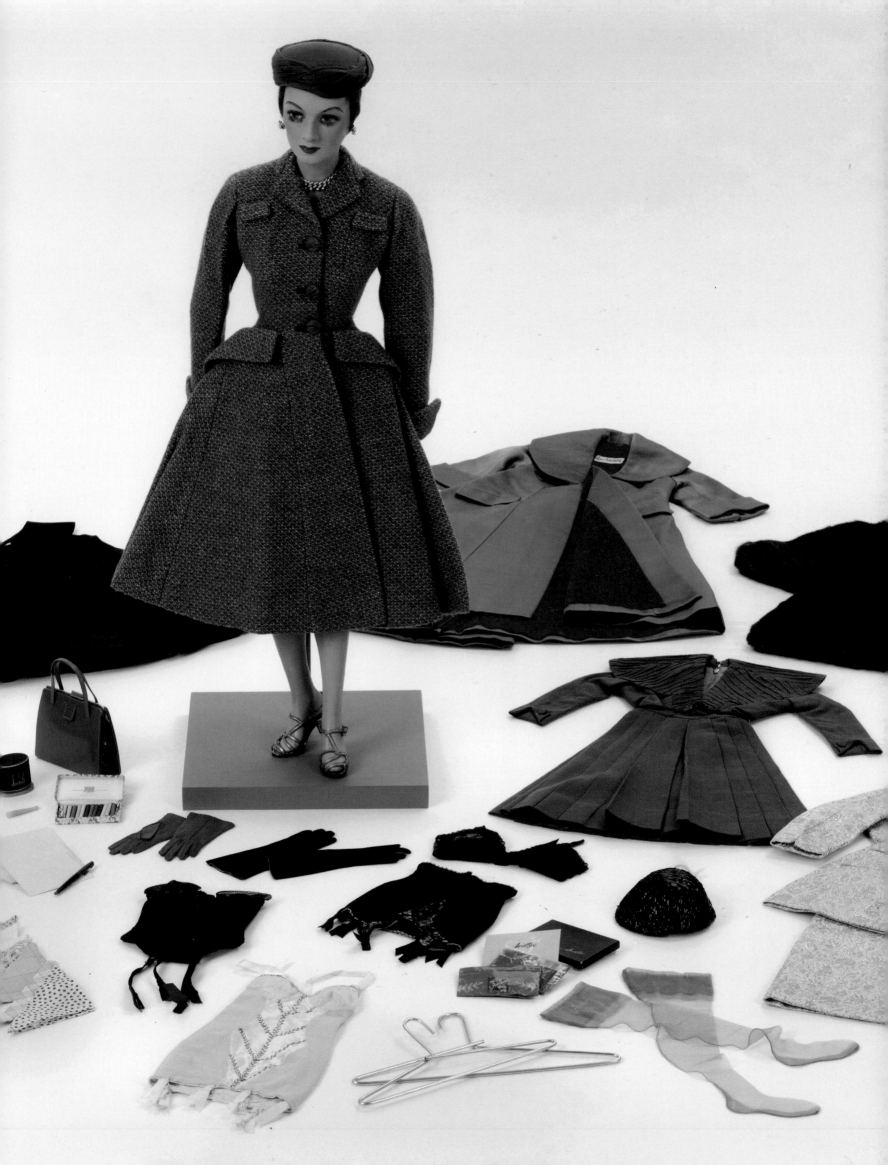

John Cavanagh

AMY DE LA HAYE

John Cavanagh trained with Edward Molyneux in London and Paris during the 1930s, served as an officer during the Second World War, and then worked with Pierre Balmain in Paris from 1947 to 1951. He opened his refined, all-white couture salon at 26 Curzon Street, London W1, in 1952. This magnificent evening gown formed part of Cavanagh's summer 1953 collection. It was ordered by Lady Cornwallis (née Esme Ethel Alice d'Beaumont, 1901–1969) to wear for the Coronation celebrations in June.[1] Although Cavanagh had been in business for just one year, he had already secured a reputation as a talented and innovative designer.

Lady Cornwallis's gown is made of an ivory-coloured silk, richly brocaded in a design of semi-naturalistic orchids woven in oyster, pale-pink and green silk enriched with glistening gold threads. The fabric was designed by Oliver Messel, who was then Britain's foremost costume and set designer, and was commissioned by Nicholas 'Miki' Sekers, a member of a Hungarian silk-weaving family, who owned the West Cumberland Silk Mills (founded in 1938). Sekers had an acute fashion sense and sold fabrics to Dior and Balenciaga, as well as to London's couturiers. He often commissioned designs from creative people who were not involved with textiles. Messel's sister Anne, Countess of Rosse, ordered a dress very similar to this from John Cavanagh.[2]

In 1961 Cavanagh engaged Lindsay Evans Robertson as his personal assistant. Mr Lindsay, as he became known, was still in his final year at the Royal College of Art's Fashion School, whose students were often taken by Professor Janey Ironside to see the couture and wholesale shows in Paris and London. The Cavanagh show was a revelation to him: 'It was Paris in London. There was a lightness of touch, a feminine delicacy, a fragility unlike the work of any of the other London couturiers.' Evans Robertson spent five years at Cavanagh and recalled:

'I learnt so much. The showroom staff and fitters had remarkable pedigrees. Individually, they had worked for such legendary names as Ricci, Molyneux, Lucile, Peter Russell. Cavanagh's sense of colour was exceptional. The palette was delicate. Yellows were pale but sharply juxtaposed with clear pinks. Greens were never unflattering. Cavanagh was a master of soft, feminine tailoring ... Endless thought would be put into which navy crêpe would be fresh, which colours would look new and flattering. Simplicity of line was an essential element, just as it had been for Molyneux.'[3]

Later in his life Cavanagh considered his French influence: 'I hope my work reflected my Paris training – I had lived and worked there and it is perhaps inevitable that my clothes looked more French than British.'[4]

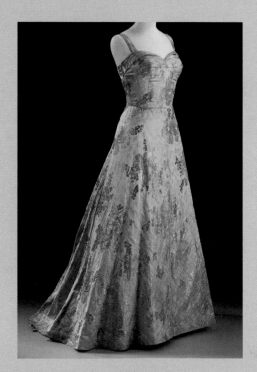

4.17 Evening dress by John Cavanagh. Silk brocade, Spring 1953 (the 'Coronation Collection'). Given by Lady Cornwallis, V&A: T.294–1984

4.18 Textile chart featuring the Sekers textile used in Lady Cornwallis's dress. Given by John Cavanagh, V&A: Cavanagh Archives

4.19 John Cavanagh, sketch. Spring 1953. Given by John Cavanagh, V&A: Cavanagh Archives

4.20 Evening dress by John Cavanagh for the same collection, 1953. Photograph by John French. V&A: AAD

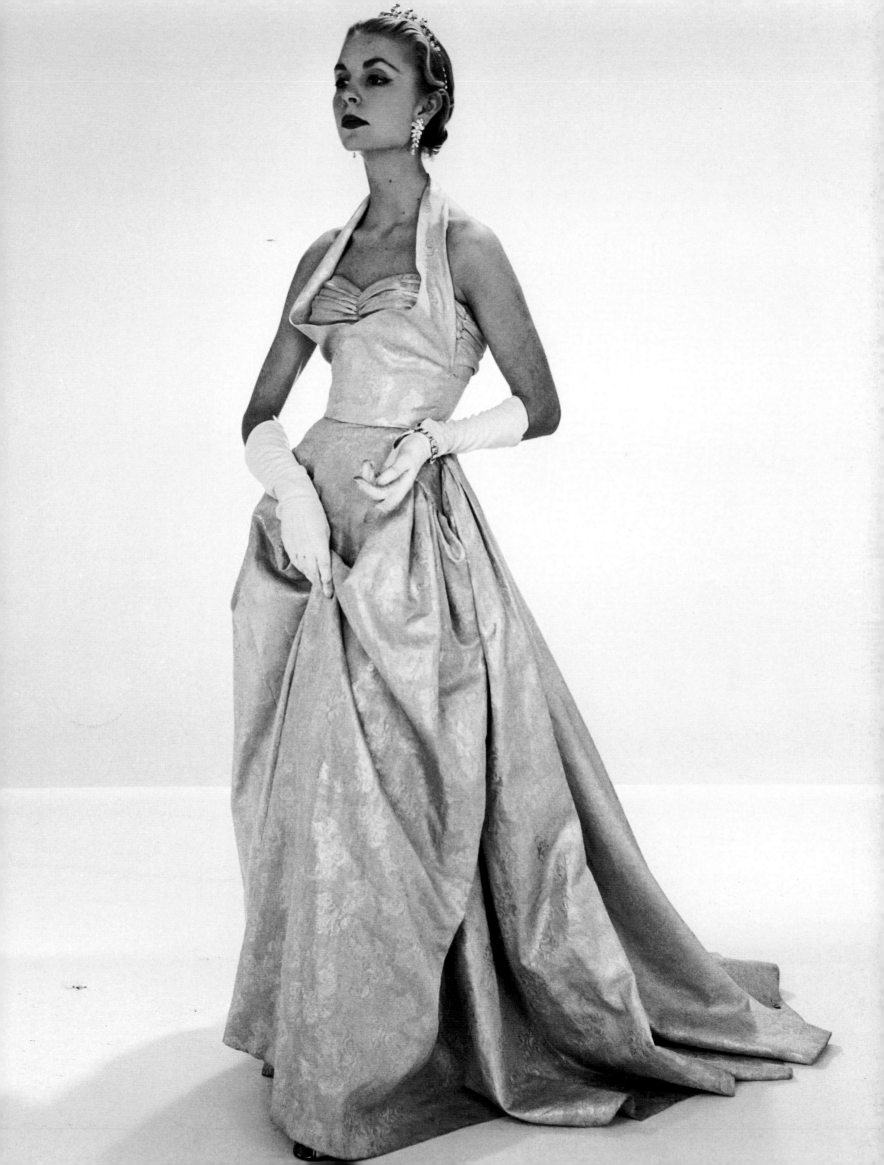

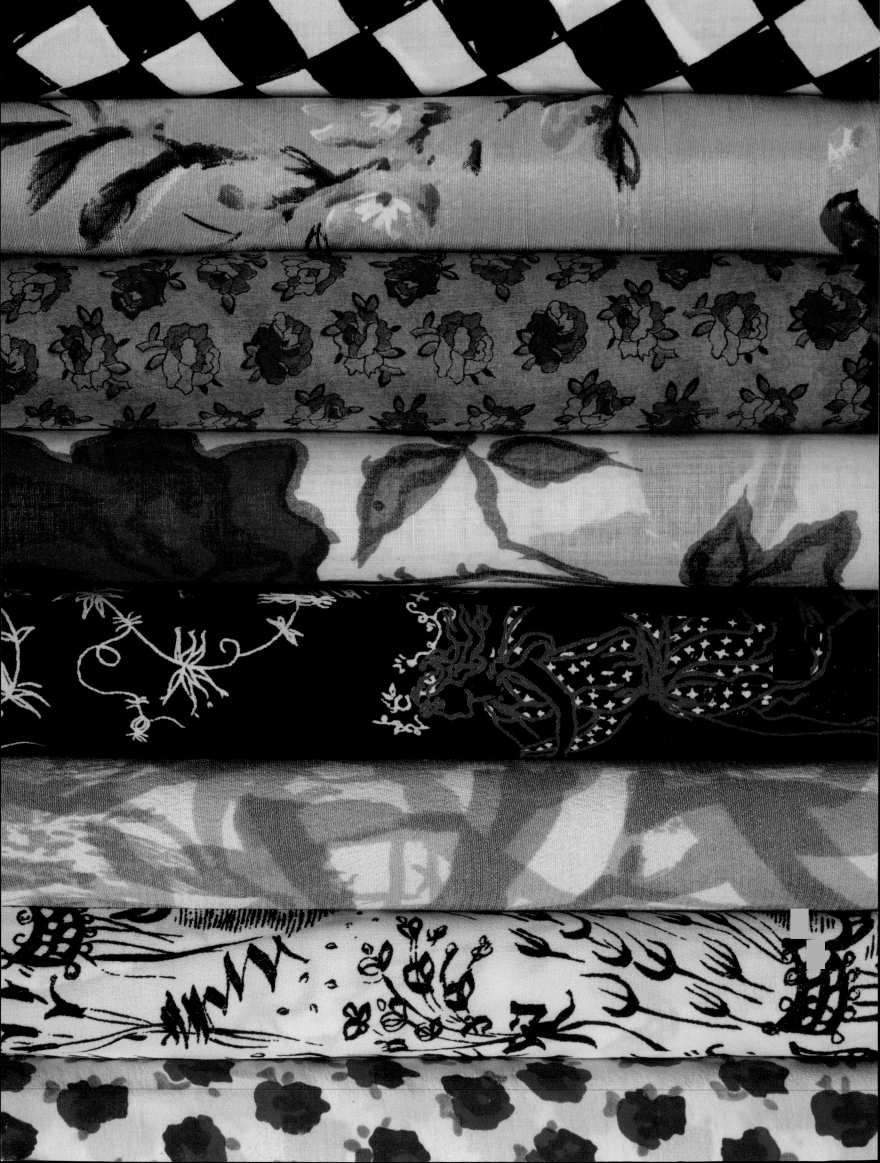

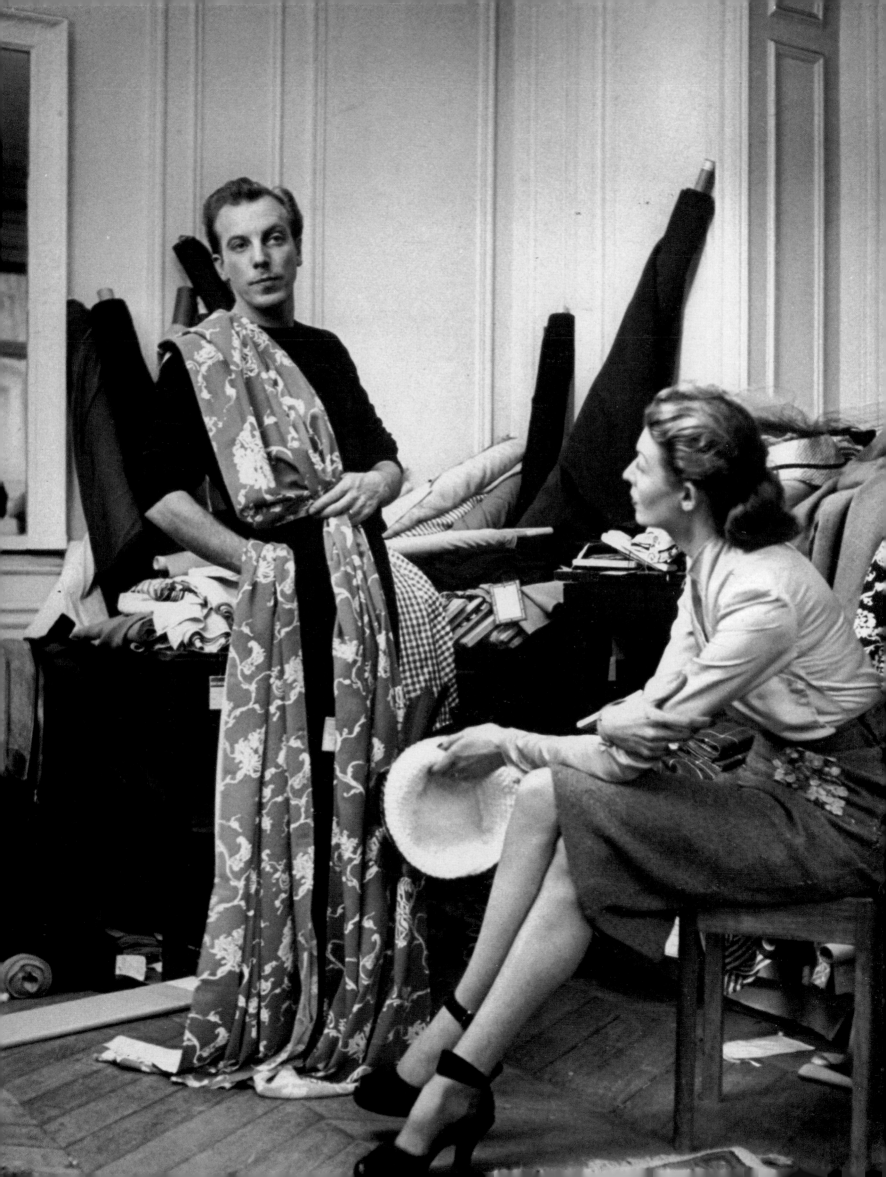

corner, in the middle ground an embroidered or brocaded silk hung seductively across the back of a chair, and artificial flowers lay in boxes on the floor (pl.5.3). Centre stage, the couturier was in the process of draping his model Sylvie in a luxurious, stiff, dove-grey satin, presumably to ascertain how effective that silk would be if cut into one of his highly constructed gowns. The composition captures the sumptuous and expensive veneer of haute couture at this time. Jacques Fath's notion of draping the fabric over himself while his wife Geneviève watched, offered an alternative, youthful, twist to this classic pose, and also favoured a textile of a very different type – a flowing, printed silk with a bold design (pl.5.2).

The plain textiles pictured behind Dior are indicative of the textile staples that couturiers used and thus kept in stock, and suggest the couturier's delight in such quality textiles after years of deprivation during the Second World War. The hand-embroidered fabric and the hand-made artificial flowers are also typical of the traditional luxury embellishments added after the construction of the dress (see p.136). Such surface decoration evolved from season to season in both its textural effects and its motifs, bringing extra novelty to new styles. Machine embroidered and printed patterns were an alternative, screen-printing having freed designers to create painterly surfaces which – after a spell out of fashion – returned as much-valued assets in the couturiers' repertoire from the early 1950s. During this decade, in fact, a huge variety of materials was used for couture garments. This essay reflects on their journey from manufacture to atelier, into the collections and on to the backs of the models, introducing the textiles produced for French haute couture, the relationship the manufacturers had with the Parisian couturiers, and the wider context in which manufacturers and couturiers worked.

Little has been published on these textiles, as fashion historians have tended to concentrate on the cut and style of

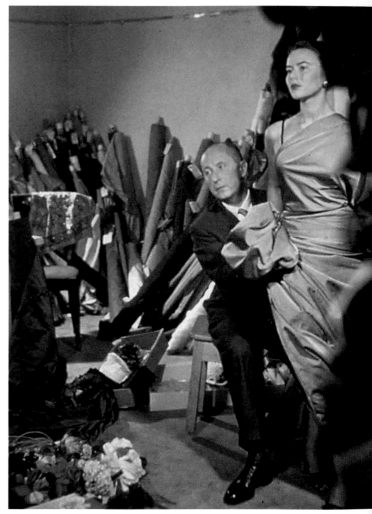

5.3 Christian Dior with model Sylvie. Christian Dior Archive

dress without giving due consideration to its material components.[3] The weight of the most accessible firsthand evidence has perhaps hindered them, for, while couturiers of the 1950s were anxious to publish their memoirs, textile manufacturers were less forthcoming. Moreover, until relatively recently, few museum collections have had strong holdings of mid-twentieth century couture garments or the textiles made for couture. Without accounts from both couturiers and textile manufacturers or documentation of firsthand examination of the textiles and how they functioned in the garments, it is difficult to assess how – or whether – couturiers achieved 'perfect harmony' in the marriage of their design with manufacturers' materials. Fortunately, recent interviews

have brought to the fore the perspective of the manufacturers and the ways in which they worked with and for couturiers. Research in various museum collections and in company and textile archives is beginning to offer some perspective on the textiles themselves.[4]

An exploration of the role of textiles in couture, embracing their makers as well as their users, merits attention in a book on couture for several reasons. First, the nature of the materials demanded that couture houses cultivate different skills for cutting and manipulation. Two different types of workshop housed those skills – the tailoring (*tailleur*) and dressmaking (*flou*) workshops, the first for the cutting and moulding of stiff and heavy fabrics, the second for the draping and sewing of supple fabrics (see Chapter 3). Secondly, the quantities of material used in each couture garment were large, partly because fashionable styles at this time were voluminous, partly because couture garments were generally lined and interlined, with generous hems and seams. Moreover, if the pattern comprised checks or stripes, or the fabric had pile, extra allowance was necessary to make sure that the checks matched at the seams or that the direction of the nap was consistent. British journalist Alison Settle, writing in 1948, noted the opportunities that the French couturiers gave their textile industry:

> The 'New Look' was launched last year to sell dresses employing up to 30 or
> even 40 metres of fabric disposed in swirling, swinging skirts, the width pointed
> up by tightly-corsetted bodies... the 'New Look' spring fashions of 1948...
> have turned the swirling skirts into skirts which flute. In place of the 30-metre
> hemlines of last year no more than ten metres are now used. But these ten, of the
> finest textured materials, are mounted over a stiffening of light tailoring canvas.
> Backing the stiffening is an equivalent ten metres of satin or taffeta lining:
> beneath goes at least an equivalent amount of fabric in the shape of a rustling,
> flounced petticoat. In all, the amount of material used is no less than in the swirl-
> line skirt. The French textile industry has been given the task of speedily and
> greatly increasing its exports.[5]

The red evening ensemble 'Zemire', from Dior's Autumn/Winter collection of 1954, confirms this extravagance: its skirt has a circumference of 3.5 metres, a length of 85 centimetres; below the outer layer of crimson cellulose acetate, layered and gathered tulle adds width on each hip, while the skirts are held out by two underskirts, one comprising no less than five layers of tulle, the second comprising silk organza and nylon net panels (see pl.1.9).[6]

As both Alison Settle's description and this garment suggest, the materials that fed demand ensured that this was an intriguing decade, because advances in the production of different qualities and combinations of natural and man-made fibres (cellulose and synthetic) blossomed. The long-lived staples of couture – fine silks and woollens – faced

serious competition as textile manufacturers and pressure groups promoted their wares ever more vigorously, using couture as a vehicle for publicity.[7] The couturiers' choice of textiles could therefore affect the fortunes of textile manufacturers, and consequently the large and hidden workforce that laboured far from Paris.[8] Manufacturers could use sales of high-fashion textiles to couturiers as a springboard from which they could leap into export and domestic markets (comprising high-class ready-to-wear manufacturers as well as professional and home dressmakers). If manufacturers found success with couture houses, they demonstrated their standing in the fashion world and received the orders that helped them to cover their production costs. The fashion and trade press, the sampling houses based in Paris and the fibre-specific lobbying organizations all offered information services to the wider world.[9]

Continuity and Change

Between 1947 and 1957, particular socio-political circumstances pertained in France, some based on a long tradition of state support for the luxury industries, some based on the effects of the German Occupation and some on post-war reconstruction, which embraced valued craft skills and flexible specialization, as well as promoting industrial modernization.[10] In common with most of Europe, France had suffered shortages and rationing in the 1940s, while the Nazis restricted communication with the outside world. Starved of raw materials, French cotton, woollen and silk manufacturers received instructions on the production of man-made fibre from the German administration. After the war, advances in the production of rayon and *fibranne* (spun rayon) were beneficial initially to the woollen industry, which had access locally to old and new raw materials, while the silk industry – not a priority for the modernizers – continued to suffer. Only from about 1948 was there consistent access to raw silk supplies, good-quality colouring agents for dyeing and printing, and power for factory machinery. By 1949, as the impact of monetary aid through the American Marshall Plan was finally felt in France, traditional luxury textile industries stabilized.[11]

During this time, France undoubtedly benefited from its centuries-old reputation for high fashion. This reputation had grown as the result of the state sponsorship of luxury trades since the late seventeenth century, and the formal establishment of haute couture from 1868. Sponsorship had originally focused on the silk and fine woollen manufactures. While France boasted a royal or imperial court in the eighteenth and nineteenth centuries, the state supported the manufacture of luxury goods through the imposition of protective barriers and reductions in import duties, and by providing a platform for the public display of French goods. The French fashion press were willing accomplices in asserting French superiority.[12] This tradition of support surely encouraged the luxury sector to turn to the state in times of hardship. It is unsurprising, therefore, that in 1950, Raymond Barbas, chairman of couture's governing body, the Chambre Syndicale de la Couture Parisienne, proposed a plan that would help both haute couture

'I let the fabrics guide me, and my imagination goes to work as soon as I have put them down'[13]

HUBERT DE GIVENCHY

and the French textile industry. A government subvention would cover the shortfall between the couturiers' investment in new designs and their sales. To qualify for aid, couturiers had to guarantee that 90 per cent of the textiles in their collections would be of French manufacture. In its first year, 1952, textile aid covered 50 per cent of the costs of textiles used in haute couture; from that date until the scheme ended in 1959, it averaged about 30–40 per cent.[14] Significantly, protection for native industries was formally articulated just as foreign imports began to increase: in 1950, the year of Barbas's initial petition, British manufacturers reported with glee a breakthrough in sales of their textiles to French couturiers.[15]

The French fashion press did its best to back native couture and manufacturers. French *Vogue*, for example, remained extremely patriotic in its editorial space well into the 1950s, exclusively featuring the products of the French textile industries. In Spring 1947 the *Cahiers des tissus d'été* ('Notebook of Summer Textiles') was specifically a 'little panorama summarizing the creations of the major French silk and woollen merchants'.[16] In the winter of 1948, when shortages were still an issue, eight woollen merchants and six silk merchants featured in *Vogue*; by 1952, there were 22 in total; by the following year 29; and by 1957, 40.[17] Rogue British and Swiss manufacturers infiltrated this French stronghold after 1953 – in particular, Czech-born textile converter Zika Ascher of London and Hungarian-born textile manufacturer 'Miki' Sekers of West Cumberland Mills, both major creative forces in British textiles, and Abraham and Burg of Switzerland. All were cosmopolitan in their outlook, and had already supplied some couturiers for several years before *Vogue*'s editorial eye alighted upon them.[18] Indeed, Sekers had spent a fortnight in Paris introducing his fabrics to the leading couture houses in December 1949 and predicted both additional work and more exports.[19]

Even before *Vogue*'s editorial space admitted the good quality foreign manufacturers, the magazine accepted advertising revenue from overseas companies. The number of foreign advertisements increased over this decade as textile industries in other countries grew stronger: the British company Jacqmar regularly advertised immediately after the war, and from the end of 1947, textiles from Parenti & Veneroni of Milan, suppliers of the Italian *alta costura*, appeared. In later years, their compatriots Gaetano Marzotto & Figli and Tessito Galtrucco also made a bid for French custom.[20]

While manufacturers advertised independently in *Vogue*, they also engaged in 'tie-ins' with couturiers. In spreads that grew in ambition and number, photographs of particular dresses from named couture houses in textiles from named manufacturers appeared at the beginning of a magazine, sometimes on several consecutive pages. Often the text was simple, merely indicating the name of the couturier, and the name of the textile and its manufacturer. For example, in Autumn/Winter 1949, in the same advertisement Dior and Balenciaga used self-coloured velvet and faille from the silk manufacturers Bianchini Férier of Lyons for two evening dresses (pl.5.4). A black evening dress, 'Cygne Noir' ('Black Swan'), in Dior's Autumn/Winter collection of

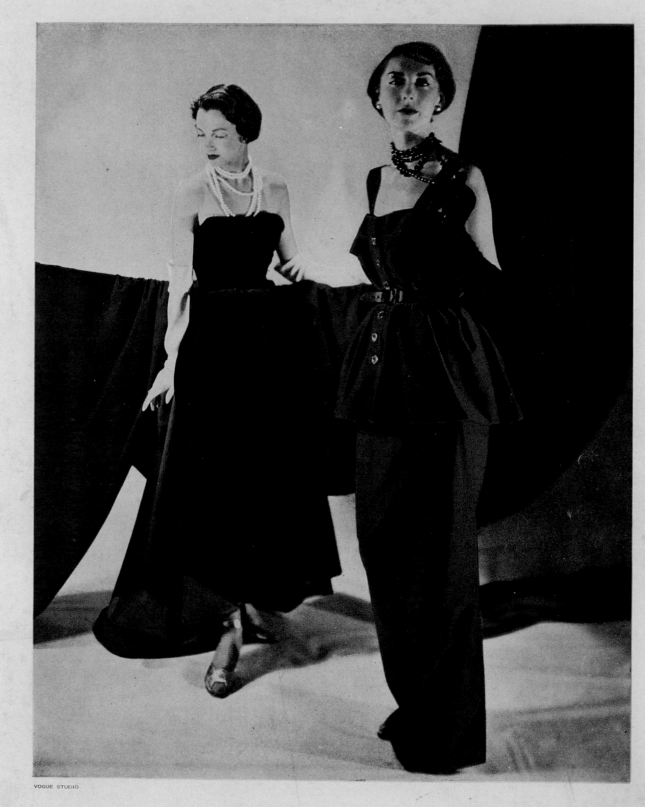

VOGUE STUDIO

Robe du soir de Balenciaga *Robe du soir de Christian Dior*

Velours de Lyon de Bianchini Férier

3

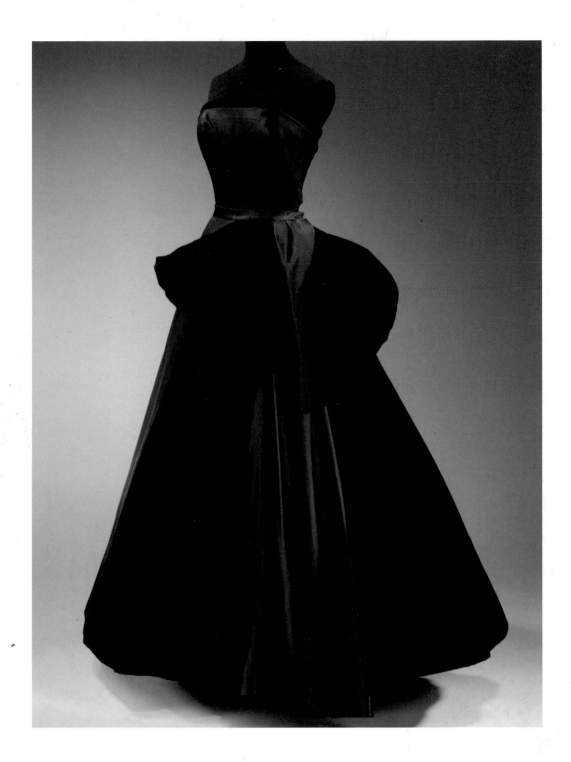

5.4 Advertisement for velvet by Bianchini Férier of Lyons, modelled in different colours in designs by Christian Dior and Cristóbal Balenciaga. *Vogue* (French edition), November 1949

5.5 'Cygne Noir' ('Black Swan'), evening dress by Christian Dior. Faille and velvet, Autumn/Winter 1949–50. Given by Baroness Antoinette de Ginsbourg, V&A: T.117–1974

1949–50, is surely made from silk velvet and faille from these manufacturers and reveals the glorious crisp quality of the textiles (pl.5.5). It contrasts with an elaborate Dior evening gown, in machine-embroidered velvet by the Swiss firm of Abraham et Cie., which appeared in British *Vogue* in 1958 (pl.5.16).[21]

It is impossible to gauge the impact of the official French initiatives and commercial propaganda. For French textile manufacturers, subsidies were an encouragement but not full protection against international competition. For smaller French couture concerns, they probably facilitated survival, but only for a short period, since after the introduction of subsidies the number of couture houses continued to fall – from 60 in 1952 to 36 in 1958.[22] This decrease must have affected textile manufacturers, who were

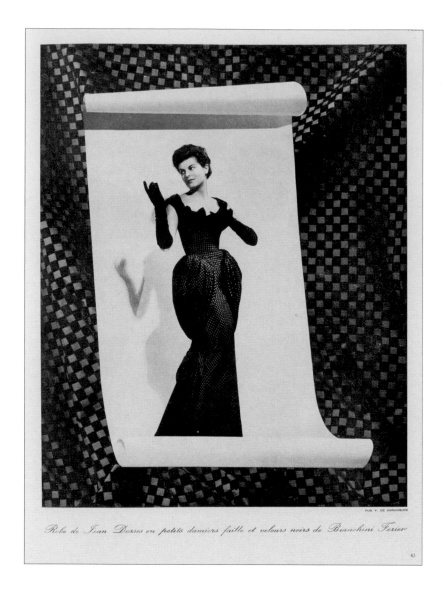

Robe de Jean Dessès en petits damiers faille et velours noirs de Bianchini Férier

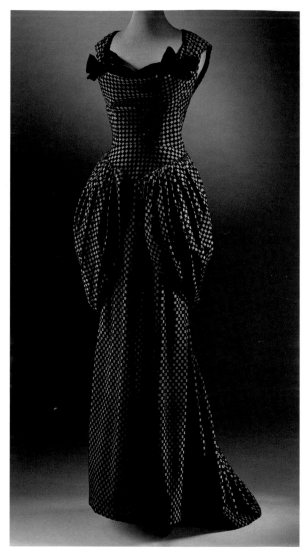

also experiencing the effects of increased foreign competition because major French couturiers clearly chose textiles wherever they found what suited their standards of excellence and vision. Balenciaga, Dior and Fath, for example, bought from France, Britain and Switzerland, and from the United States.[23]

A Symbiotic Relationship

On the surface, then, in the fashion press, couturiers and manufacturers worked harmoniously, hand-in-glove. The reality of their working relationship was rather more complex. Some couture houses had an intimate relationship with manufacturers: Chanel owned Tissus Chanel, while the textile manufacturer Marcel Boussac sponsored Dior.[24] In most cases, however, manufacturers (employing skilled craftsmen) worked independently. Both parties seem to agree that the role of the textile manufacturer was proactive: that manufacturers designed their textile collections 18 months to two years ahead of the creation of the couture collections, basing their ideas on what had worked in previous collections, their prediction of how fashion would evolve, and, importantly, on their knowledge of a particular couturier's taste.[25] Two months or so before the couture

5.6 Advertisement for checkerboard patterned velvet and faille by Bianchini Férier, modelled in an evening dress by Dessès. *Vogue* (French edition), October 1948

5.7 Evening gown by Jean Dessès. Velvet and faille, Autumn/Winter 1948–9. Given by the Hon. Mrs J.J. Astor, V&A: T.113–1974

collections, their representatives approached couture houses to entice the couturiers into buying from their collections. From this interaction emerged a variety of possible agreements between the relevant parties and, over the years, numerous collaborations developed.

Rapport with the couturiers was fundamental, as firms that restructured too fast discovered. Bianchini Férier, for example, a major supplier of silks before the war and keen advertiser in *Vogue* post-war (pl.5.6), restructured in 1944 and 1948. The departure of familiar faces meant that the company no longer had a secure entrée into Parisian couture houses. In the words of the couturier Pierre Balmain, in a letter to Bianchini Férier's management in 1960, for some years 'it seemed that the house of Bianchini Férier had become rather administrative and impersonal and no-one knew exactly what they could expect in terms of a relationship with the house'. Bianchini Férier had to win back their privileged relationship and did so by inviting the main couturiers into their renovated Parisian showrooms in the late 1950s. They also initiated special deals with key names: just before Dior's death in 1957, they agreed to reduce their prices on the understanding that the house would buy a significant number of their high-fashion textiles for the Spring season of 1958.[26] Dior's successors honoured this agreement.

5.8 Feature on summer fashions, here by Lucile Manguin, Madeleine de Rauch, Hermès and Marcel Rochas, in wool, linen, cotton and the synthetic Cracknyl by Rodier, Staron, Sinclair and Bucol. *Vogue* (French edition), June 1949. Illustrations by Tom Keogh

Dior wrote eloquently of how textile suppliers approached his house:

Two months before I have even roughed out my first sketch for the new
collection, I have to make my preliminary selection. For that is when they arrive
to see me – the silk merchants, the wool merchants, the lace-makers, men of
consequence imbued with strong traditions, who come from all over the world,
from Paris, London, Roubaix, Lyons, Milan, and Zurich, bringing with them the
wealth of the Low Countries and the richness of the Orient…. It is like receiving
an embassy. Rising to our feet to greet the ambassadors, we solemnly shake
hands, and in order not to get on to the subject of the materials piled up in the
corridor too quickly, we chat politely about the preceding season.
We recall those stuffs which have 'gone well', we give an account of
the sales of the models which were made from them, exactly as if
we are mutual friends imparting news of other friends whom they
have not seen for some time.

The showing of the new fabrics then followed. The men that Dior dubbed
the 'Eastern Potentates' travelled in style, accompanied by a number of
trunks containing dress lengths of fabric, while other merchants, 'like
spivs selling bootlaces in the street', produced 'tiny samples… the size of
postage stamps'.[27] Interestingly, Dior adopted the postage-stamp system
in order to keep a record of his designs and the fabrics in which they were
made (see pl.3.9).

All suppliers were, of course, on tenterhooks, awaiting the reactions
of the couturier. The atmosphere of each couture house was different. Dior's
welcome sounds cordial in comparison with Balenciaga's. Courteous, but
silent, the Spanish couturier treated the textiles with connoisseurial respect
and the manufacturers with distance, only occasionally whispering his
impressions in Spanish to his associate – in other words, in a language and
tone his supplier probably did not understand. While some manufacturers found it hard to
read Balenciaga's reactions, Pierre Ducharne, a textile printer and supplier of woollens,
could deduce what interested him and what did not: Balenciaga handled the former
carefully, but passed over the latter with barely a glance. Ducharne also notes that certain
couturiers had preferences with regard to colour:

5.9 'Kilcardie', mohair/nylon bouclé
samples by Ascher Ltd of London,
1957. V&A: T.199A to I–1988

… from the point of view of colour, Balenciaga, Balmain were the two houses
that I thought about most. I always had close to me the favourite colours of
Balmain and the favourite colours of Balenciaga; it was this red not that one,
this yellow not that one. There were colours that those couturiers didn't like:
you learnt to know this, when you put down something else.[28]

Through this exchange, season on season, understanding and collaboration between couturiers and manufacturers grew. Sometimes couturiers directly commissioned designs or suggested themes, or involved themselves in the design process. Schiaparelli was renowned before the war for her close collaboration with artists, as well as with the designer Sache, who converted her artwork into designwork; she also had a close working relationship with the silk houses of Bianchini Férier, Colcombet and Ducharne, and even went so far as to colour in the patterns that the textile printer submitted to her.[29] Givenchy, who – unlike Dior – had always taken inspiration from the fabrics, generally bought 'off the shelf', but on occasion made changes, or suggested 'sources such as books and reproductions of ancient and modern art, by providing sketches or simply advising manufacturers.'[30] Some manufacturers believed they knew their clients so well that they could prepare particular collections for them. Abraham of Zurich claimed that by 1953, five years after beginning to sell to Balenciaga, he could create ranges of textiles specifically for his house. By the late 1950s he was confident enough in his knowledge of other couturiers' tastes to provide them with particular 'packages' of textiles for their collections.[31] Geographic distance between couturiers and their suppliers did not prevent the development of close working and personal relationships. Indeed, the wardrobes of textile manufacturers' wives may well have benefited from these professional friendships: certainly, Lady Sekers wore Dior (see p.21), while Mrs Zumsteg (of Abraham) was photographed being fitted for a garment by Balenciaga.[32]

Some attempts at building a relationship were not so felicitous. The acerbic fashion journalist Lucien François recounted with glee the fate of the American velvet manufacturer who provided both Dior and Balenciaga with a sample from which to work. Balenciaga rang Dior, lamenting the deficiencies of the velvet, and the two couturiers colluded in rejecting it. Might the manufacturer in question have been the American manufacturer of synthetic fibres, DuPont? Certainly, the company had continued to lobby Parisian couturiers since the mid-1920s, in the belief that their endorsement swayed even the most recalcitrant women into buying certain textiles. Post-war, DuPont's Fabric Development Program promoted nylon under a variety of trade names (Orlon, Dacron and Antron). The department designed textiles to show the fibres to their best advantage and, in 1955, their magazine noted that the Paris shows had incorporated at least 14 fabrics containing DuPont fibres.[33] Competition in France came from Bucol, 'one of the foremost textile manufacturers' to develop nylon for rainwear and winter sports. The company was, at ready-to-wear level, to a large extent responsible for 'its steady development and the many varieties now seen everywhere and used extensively for all types of garments, from the finest lingerie to the more utilitarian dress, shirt and coat weights'.[34]

5.10 Samples from Ascher Ltd of London. Top and bottom right: mohair/nylon bouclé, 1958. V&A: T.200 and 203–1988. Left: chenille, 1958. V&A: T.75–1985

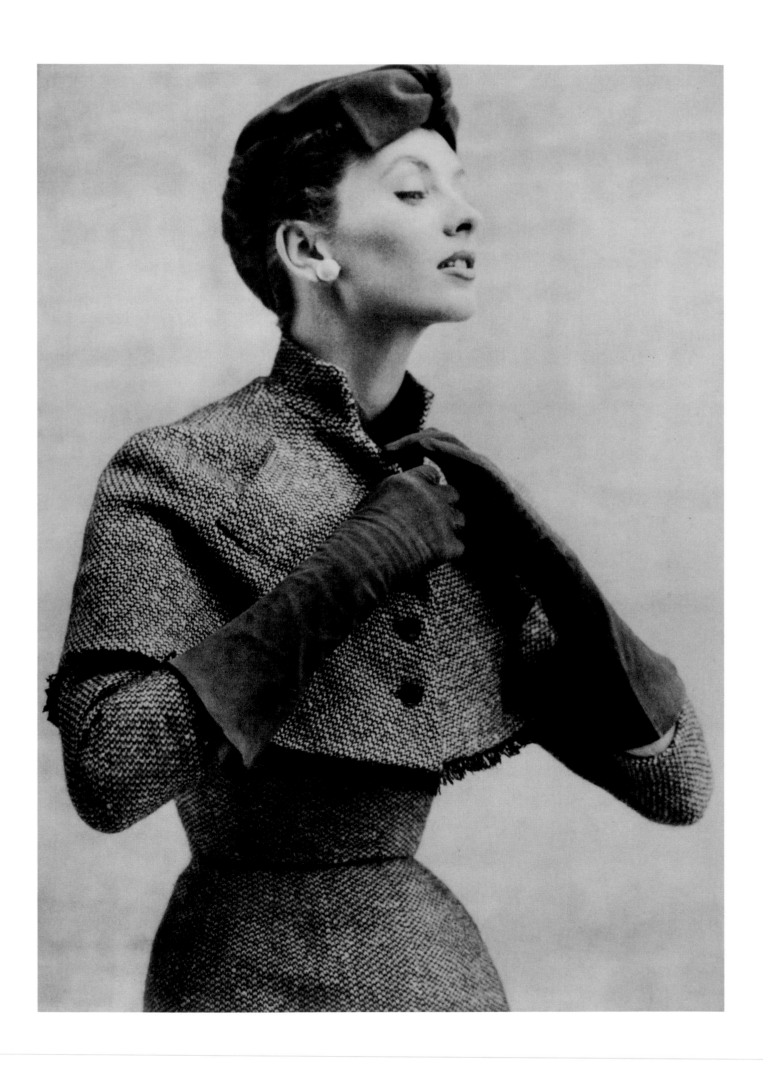

Seasonal encounters between couturiers and manufacturers resulted in contracts or sales, but also involved risks. Mostly couturiers wished to buy a small quantity of material, enough for one garment (on average 3–3.5 metres, just to see if it worked for them); some were so skilled they could calculate the length they required to the nearest 5 centimetres.[35] Sometimes they wanted to retain exclusivity for a limited period (about six months).[36] Working to commission or providing a short length was risky, as a couturier might decide at the eleventh hour not to use the fabric. In these circumstances, specially commissioned pieces were often too distinctive to sell on and, as was the case with regular pieces from the manufacturer's own collection, were less likely to attract custom since they had not been blessed with the free and prestigious publicity attached to the fabric's use in the couture show. The manufacturer was left with the problem of ridding himself of the longer piece of cloth that he had made up in order to justify the expense of setting up his looms. Ducharne explained that he had to sell a piece of cloth 30 metres in length in order to recoup the costs of creating and putting a new design into production – in other words, to cover labour, materials and plant.[37] These were expensive textiles, the printed ranges often using many more colours than those used for mass-market goods.[38]

The risk factor may explain why leading manufacturers were potentially useful to couturiers (certainly Dior expressed the view that they provided the best quality, colour and design).[39] Such firms had the means to sustain potential losses. Many of them also had the means to keep up commercial branches in Paris in the area around avenue de l'Opéra – prestigious addresses in the luxury district, close to the couture houses.[40] They thus had immediate access to shifts in couturiers' taste, and could respond to their whims. In the same streets were the premises of the important retailers/wholesalers such as Labbey, who stocked fine textiles from around the globe and often sold to the couturiers. Their names hid the identities of suppliers, often meaning that a manufacturer found out relatively late in the day that his textile had been used in the couture.[41] A dozen or so major French manufacturers also had branches in London, propitiously located in the same neighbourhood as the British couturiers, court dressmakers and textile manufacturers, around Savile Row and Regent Street.[42] They also often had offices in other fashion capitals and sold through department stores.[43]

And the couturiers bought…

Couture garments comprise 'visible', 'semi-visible' and 'invisible' (hidden) textiles, as Alison Settle so rightly intimated in 1948 (see p.117). The 'visible' fabrics combined one or more of the 'marks of distinction' recently highlighted by Lou Taylor in her analysis of the hierarchy of fashion textiles in the West.[44] The fibre or cloth type was often rare and expensive, and therefore redolent of luxury. The composition of the fabric in terms of fibre, yarn, colour and patterning was novel – and often also complicated to produce. Some were particularly delicate and so needed to be treated with care, on or off the body. Their manufacture or embellishment was associated with elite designers or elite

5.11 Fringed cape and matching dress by Jacques Fath. Falweed (tweed) by Rodier. *Vogue* (French edition), September 1953

manufacturing firms with familiar names and reputations based on their refined craft or manufacturing skills. Alternatively, the textiles were associated with a particular country or region that was already famed for high-quality goods of a particular genre (such as Scotland for tweeds, England for woollens and worsteds, France for silks, Switzerland for machine embroidery and lace). The promotion of the textiles targeted elite markets for particular social circles and particular social customs or events (such as the races at Ascot or Longchamp, or receptions at Buckingham Palace or Versailles).

In this decade, adhering to tradition, couturiers assigned the visible textiles a particular purpose. In other words, not only was there a 'hierarchy of textiles' but there was also an 'etiquette of textiles'. That etiquette observed the season (Autumn/Winter, Spring/Summer), the time of day (morning, afternoon, evening) and the wearer's age, as well as the nature of the event, including important rites of passage (such as christenings, marriages, funerals). Fibre, colour, structure and embellishment all played a part. In *A Guide to Elegance*, Geneviève Antoine Dariaux, *directrice* of Nina Ricci, explained not only what garments, but also what colours and textiles suited various times of day and different social events – naturally, her recommendations tallied perfectly with what the fashion magazines advised. Her preference was for the traditional natural fibres rather than man-made. In winter, tweed suits in brown, autumnal shades were suitable for morning (not black) (pl.5.11), and a woollen suit in a solid colour (not black or brown) for lunch, a wool dress and contrasting town coat in a vivid colour for afternoon. Only from six o'clock in the evening did black become acceptable. A wool or crêpe dress could be worn for early evening, and a silk, velvet or coloured brocade cocktail outfit for theatre openings and black-tie dinner parties.

In Spring different textiles and colours were in order, although garments in certain textiles could straddle seasons: the morning tweed suit for Spring had to be in a soft, delicate shade; the lunchtime suit was lightweight wool or linen with a lightweight wool coat (preferably in grey flannel, red, green, white or beige, all colours that could be worn all year round); at six o'clock, a navy or black or printed silk two-piece; and for black-tie dinners, a beaded dress or a black crêpe dress worn with a white coat. Finally, the most luxurious garments were evening dresses and coats that might be worn all year round, if black and velvet were avoided. The Northern European climate obviously informed her view, and she was biased in favour of plain textiles, perhaps because she believed in longevity for certain outfits (five years was not an unreasonable life expectation for a classic suit). Patterned textiles only entered the equation in morning tweeds (usually mottled combinations of colours rather than definite patterns), afternoon two-pieces and dressy evening gowns.[45]

Cotton – the only easily washable fibre – was traditionally associated with summer and with informal use, although in the early 1930s some couturiers had begun to use it for formal wear, and it was increasingly promoted in the 1950s for a variety of purposes. In the year of the New Look, Schiaparelli launched her first post-war cotton evening

gown, and Ascher was influential in persuading Dior to use this fabric for the same purpose for the first time in his Summer collection of 1948. By the following year, Ascher was supplying Balmain, Fath, Griffe, Dessès and Piguet, too.[46] In general, however, cotton sat best for sporty, summer dresses or for blouses and lingerie (pl.5.8). It continued to be associated with youth, and it was usually a light colour, sometimes printed.

Dariaux barely mentioned man-made fibres. Yet both rayon, the first established man-made fibre, and nylon, the 'new kid on the block', played a major role in post-war high fashion, usually combined with natural fibres. Couturiers experimented with what manufacturers offered them. Exotic trademarks, a form of copyright protection, drew attention to such new textiles as Bucol's Cracknyl, Rhodavyl and Tergal. New materials also entered the vocabulary of decoration: plastic ornament vied with traditional glass beads and metal sequins in embroidered patterns, and lurex offered an alternative to gold and silver yarns. Until the mid-1950s the metallic threads used for brocading were still made of strips of silver gilt, which were wound round a silk or cotton core. In woven fabrics, these threads could be used only as wefts, a disadvantage to the manufacturer. The advent of Lurex, a synthetic core with aluminium coated strip, revolutionized the trade, since it could be used for warp and weft. It created the potential for extremely showy products.[47] In 1956 an international exhibition held in New York and London

5.12 Advertisement for the International Lurex Exhibition featuring an evening coat by Fath. *Vogue* (French edition), October 1956

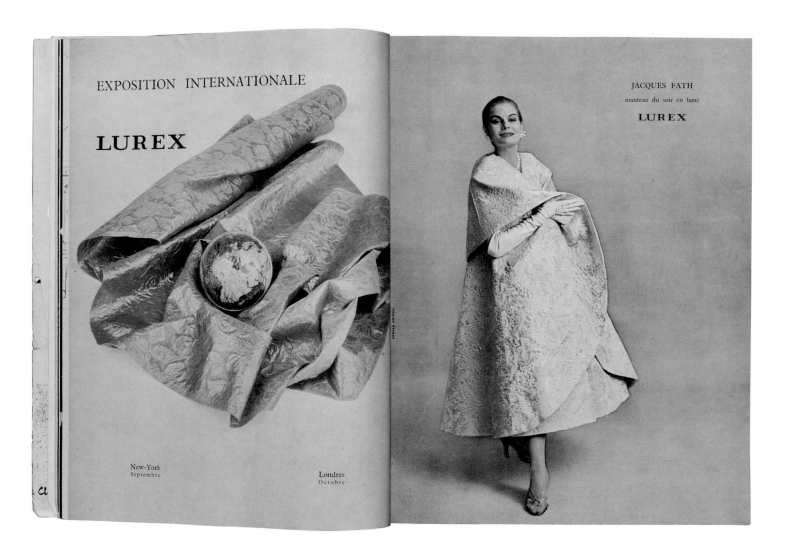

testified to its wonders, with fine examples of couturiers' designs to support the claims (pl.5.12).[48]

Fibre was only one component that differentiated traditional and novel couture textiles; texture and pattern were others. The former was generally achieved through the combination of different yarns during weaving, their relative fineness, and the openness of the woven, knitted or netted structure into which the yarns were incorporated. Thus, silk or cotton might convert into a fabric that was transparent and floated ethereally, or was opaque, firm but supple, or could be made into lace. Patterning was created either during or after construction. Lace and brocade effects were created during construction, while the surface of a finished textile could be printed or embroidered afterwards. Initially, after the war, couturiers evidently valued plain rather than patterned textiles, partly because they were used to wartime printed patterns that deliberately obscured the poor quality of the base fabric. From 1946, they sought out fabrics that had some 'body' or 'handle', usually those with dense woven structure. The satin in the photograph of Dior (pl.5.3) belonged to this type of textile, as did the faille and velvet of his black evening gown (pl.5.5), and the taffeta of many of the puffed and draped ball gowns of the early to mid-1950s.[49]

There was a variety of woollen textiles that also met couturiers' exacting criteria for quality: knitted jersey and woven textiles such as tweed, flannel, and wool crêpe. By the late 1940s woollen manufacturers were already combining (sheep's) wool with other animal hair, such as angora, alpaca or mohair, yarns that made the end product lighter-weight, a desirable characteristic for the North American market (always important to Parisian couturiers). 'Chiffon tweeds' and 'crêpe tweeds', much praised in the press, were the culmination of a quarter-century of developments that the war had brutally interrupted.[50] They led logically to the 'froth' of pure mohair and mohair and nylon mixes which, according to the British press, took Paris by storm in 1957. The French press was more restrained in their commentary. Zika Ascher's examples were the result of his collaboration with Scottish mills over the preceding year. Lanvin Castillo unveiled them heroically in a range of huge coats, with romantic names: 'Elsinore', 'Mailcoach', 'Cariolan' and 'McDuff' (pls 5.9 and 5.10).[51]

Pattern entered the equation in woollens in a variety of checks – houndstooth, Prince of Wales, shepherd's plaid and tartans. They were particularly associated with winter and the colour ranges varied from season to season, with *Vogue* evoking particular themes. Fittingly, an article entitled 'Les Grands Crus', which was published in winter 1953, featured these stalwarts of the fashion trade, each colour range associated deftly with the finest wines and spirits: for example, 'noted for that very important evening dress, "Sable d'or", double voile lamé. Lamés from Bucol. Sparkling like champagne'; or 'Noted for travelling, "Silweed", two-toned tweed. Rodier wools with warm glints of old brandy' (pl.5.13).[52] Spots and stripes were perennial favourites, whether woven or printed.

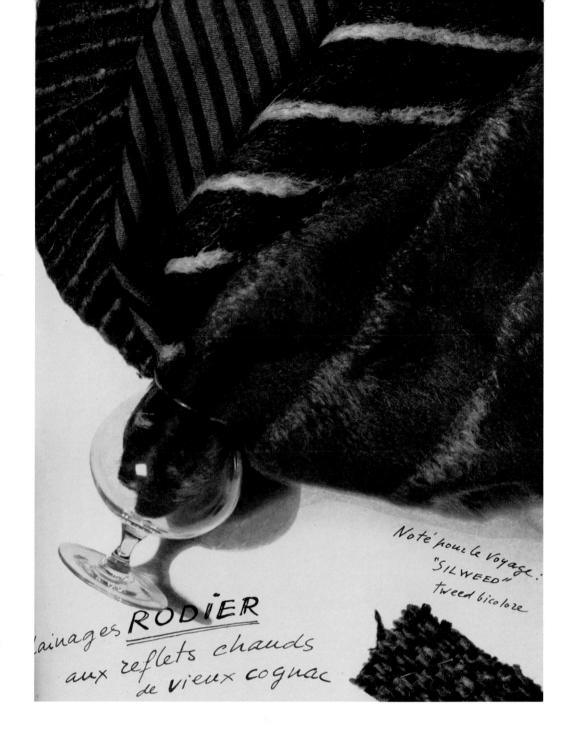

5.13 Wool by Rodier, presented in the editorial feature 'Les Grands Crus' ('The Great Vintages'). *Vogue* (French edition), September 1953

Overleaf
5.14 Cocktail dress by Christian Dior. Silk chiné, Spring/Summer 1956. Given by Mrs Laurie Newton-Sharp, V&A: T.216–1968

5.15 Evening dress by Marcelle Chaumont. Hand-painted organza, Spring/Summer 1949. Given by Mrs Loel Guinness, V&A: T.92–1974

Undoubtedly, as Dior suggested, Spring/Summer was the season for prints. What differentiated couture prints from cheaper products once dyestuffs were readily available was often the number of colours used or the quality of the base fabric on which the colours were printed. Silk, cotton and rayon were the usual base fabrics for printing. While many of the patterns were small in scale, and generally floral, geometric or figurative, truly painterly designs on a grand scale became popular from about 1952. The glorious floral concoctions of chiné roses made for the couture houses by Ascher, Ducharne and Staron, amongst others, epitomize this strain, and remained popular with couturiers till the end of the decade (pl.5.14 and see pl.2.15). There were variations on the theme, the hit of summer 1953 being the 'Blue Bird', a pattern created by Ascher in 1953. It incorporated exotic branches of blossom and diving swallows (pl.5.1).[53]

As mentioned above, these 'visible' materials were the tip of the iceberg, as couture garments are constructed using many 'hidden assets' that are often made of fabric – linings (many were, in fact, visible, and deliberately so), interlinings, padding and

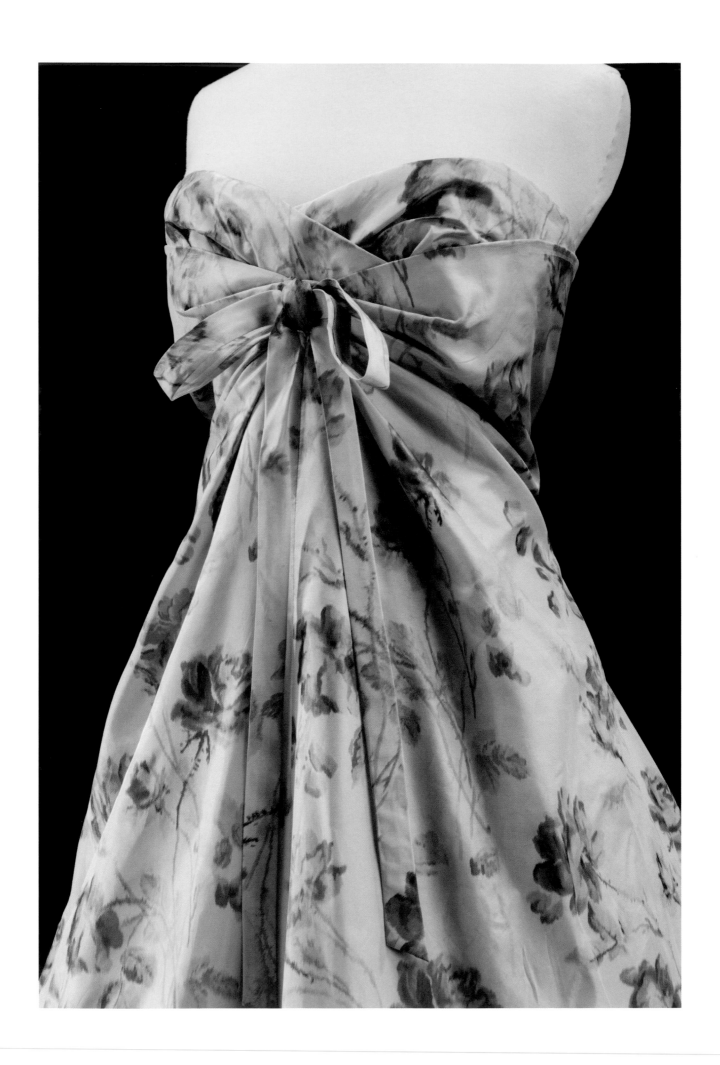

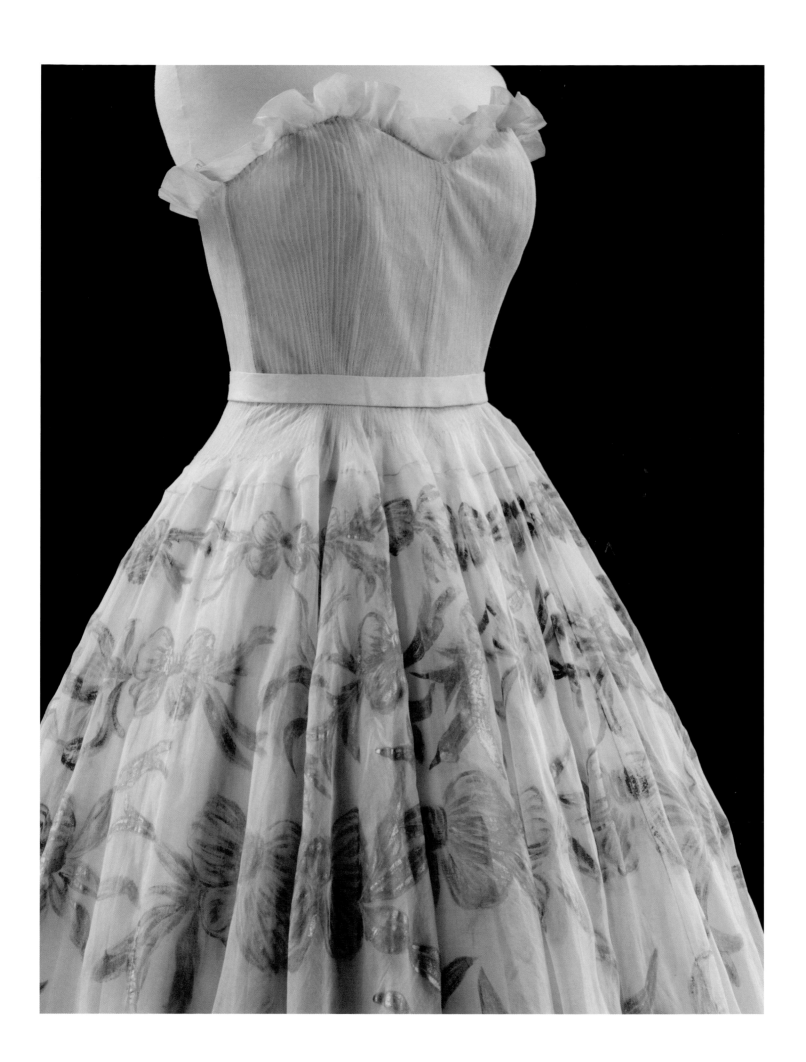

underwear, which by the end of the Fifties was as likely to be made in nylon as in the traditional cotton or silk. As Dariaux observed in the early Sixties, 'No more tortuous whalebones, no more hot rubber materials hugging you affectionately around the waist. The miracle fibres such as Lycra and nylon hold your curves with just as much devotion but without the same inconveniences.'[54] For the unglamorous or invisible, as for the visible components of dress, new materials offered an alternative to the well-established natural fibres (in this case to horsehair, buckram and cotton wadding).

Conclusion

In the post-war years, the French fashion press overtly championed the keen, mutually supportive relationship of couture and French textiles, giving an impression of a stable world of luxury. During this time, however, both couturiers and manufacturers had to adapt to changing social mores and overseas competition. They faced the challenge resolutely, working in their parallel spheres to reach out from the base of couture to wider markets. Just as couturiers sought and found salvation in ready-to-wear, so, too, did textile manufacturers seek and find salvation, in sales to new clients, both at home and abroad, as well as in involvement in other branches of the textile trade, in furnishings, or in new fibre technologies.[55]

The career of Joseph Brochier, the second generation of a silk manufacturing family in Lyons, sums up this adaptation. A member of the Syndicat des Fabricants de Soieries et Tissus de Lyon, the silk manufacturers' trade body in Lyons, he headed one of 184 firms that worked in high-fashion textiles.[56] He pooled his resources with a number of fellow manufacturers in 1947 when he joined the newly formed Groupement des Créateurs de Haute Nouveauté (Group of Creators of High Fashion) which in 1955 went into partnership with the major local chemicals company, Rhodacieta.[57] In fashion history, he is known for his commitment to plain, printed and woven high-fashion fabrics made using both old and new technologies.

However, Brochier also involved himself in seven other categories of manufacture: classic textiles of silk, dyed in the piece or hank; classic rayon textiles, dyed in the piece or hank; textiles for special purposes (including industrial); knitted textiles; furnishing textiles for cars; fashion accessories (scarves, handkerchiefs, etc.); and factory production. He had diversified from 1946 so that, in the year of Dior's New Look, his major achievement lay in two radically different high profile outcomes: white silk for the wedding dress of Princess Elizabeth, and the material that protected the oil pipeline between Paris and Le Havre.[58] Brochier's experience and textiles epitomize modernization in post-war France, yet suggest allegiance to earlier craft traditions. In this period, such flexibility was surely the only possible route to 'perfect harmony' in the 'marriage of design and material' in couture and to economic survival.

5.16 Advertisement for machine-embroidered velvet by Abraham of Switzerland. Evening dress by Christian Dior. *Vogue* (British edition), December 1958

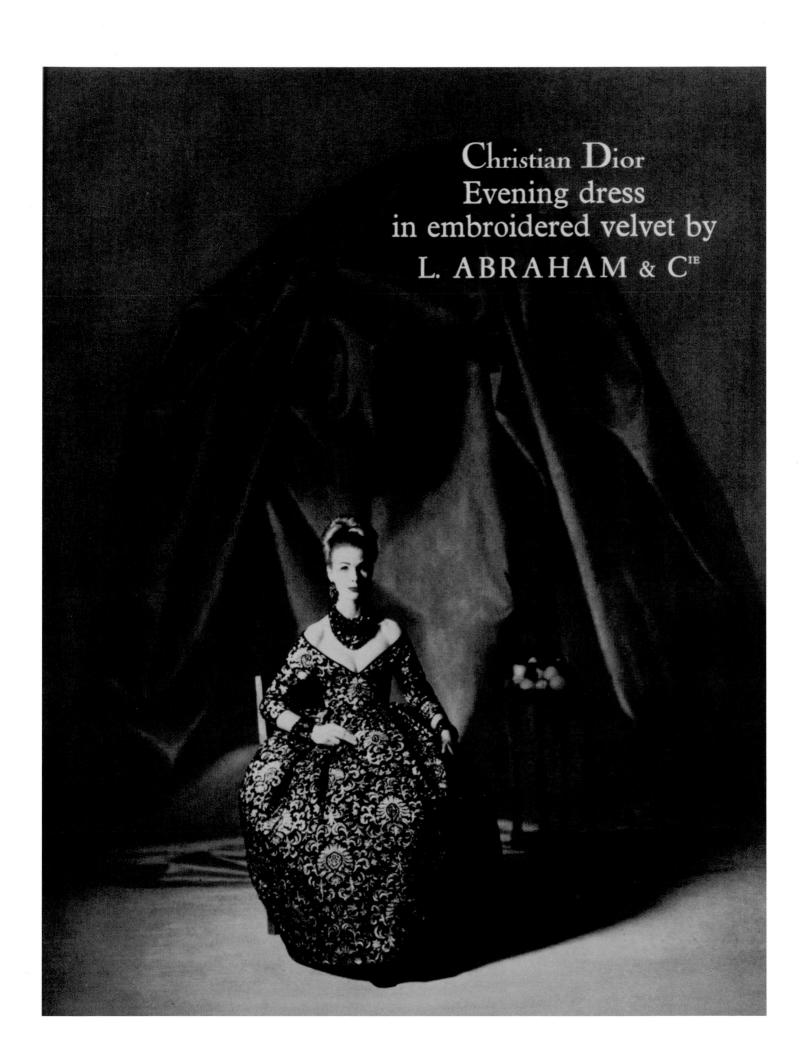

Christian Dior
Evening dress
in embroidered velvet by
L. ABRAHAM & C^{IE}

Embroidery

CLAIRE WILCOX

A network of specialized workshops supplied the embellishments and accessories that made haute couture stand out, such as gloves, silk flowers and buttons. At their peak, over 40 Parisian embroidery ateliers – many employing over 100 people – worked tirelessly to provide a range of designs for the couture houses. Most notable were the master embroiderers such as Lesage, Rébé, Vermont and Brossin de Méré in Paris. In London, Norman Hartnell had in-house embroideresses while other London couturiers sent work out to Paris House in Mayfair. François Lesage created roughly 300 samples for each season. These would first be rendered as sketches, then take the form of a precise line drawing which would be pierced through tracing paper. Attached to the fabric, this served as a stencil through which a fine powder could be sifted to mark the outline of the design. The fully embroidered design was shown to the couturiers; if selected, it remained for the exclusive use of the designer. Hubert de Givenchy wrote that often these samples served 'as the springboard to creation'.[1]

Formal evening wear gave free rein to the embroiderers' imagination: this was the time of day and type of occasion at which it was permissible for the couture customer to sparkle. The embroiderers used a variety of natural and man-made materials that gave an added dimension to the fabric: precious and semi-precious stones, crystal, metallic thread, sequins, beads, feathers, raffia and even plastic were used. Dresses selected for embroidery were usually of simple cut and reliant on sumptuous surface detail to bring them to life. Dior's 'Bosphore' evening dress of 1956 is short and strapless in midnight-blue velvet with delicate embroidery by Rébé which, on closer inspection, reveals velvet birds' nests with clusters of pearl eggs. Couturiers would work with different embroidery houses according to each garment's needs. Dior's formal gown from the 1954 'H' line collection has a formal all-over design of interlocking hexagons worked in couched gilt and silver thread by Brossin de Méré (see pl.2.1). Other designs were bold and dramatic. Lanvin Castillo's cream silk evening gown of 1957 has Lesage chenille-work embroidery in shades of mauve with sequins, beads and stones focused on the bodice, creating a lower, *trompe l'oeil* neckline and leaving the full skirt quite plain.

The consummate skill of the master embroiderers could give the impression that they had scattered gems across the surface of the textile without taking away from its delicacy. Balmain's 1950 evening dress in fine silk organza is sprinkled with silver sequins by Lesage, Swarovski cut crystals and fronds of ostrich feathers by Lemarié. Such a dress would go from one workshop to another, first to be embroidered and then finished with feather-work, a process which could take up to a month. These gowns were seen at their best by artificial light and in grand settings such as the opera or at state occasions. All, however, required meticulous technique and patience, for as Christian Dior explained, 'a ball dress may be entirely covered with millions of *paillettes*, or pearls, each one of which has to be put on separately'.[2]

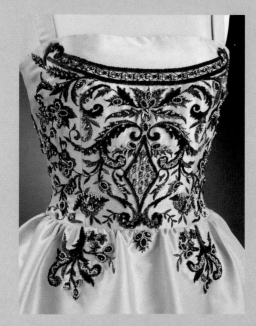

5.17 Evening dress by Lanvin Castillo. Silk with embroidery by Lesage, 1957. Given by the Countess of Drogheda, V&A: T.284–1974

5.18 'Bosphore', cocktail dress by Christian Dior (detail). Velvet with embroidery by Rébé, 1956. Worn by Mrs Stavros Niarchos and given by Mr Stavros Niarchos, V&A:T.119–1974

5.19 Advertisement for Rébé embroiderers. *Vogue* (French edition), March 1952

5.20 Evening dress by Pierre Balmain. Silk organza with embroidery by Lesage, early 1950s. Given by Miss Karslake, V&A: T.176–1969

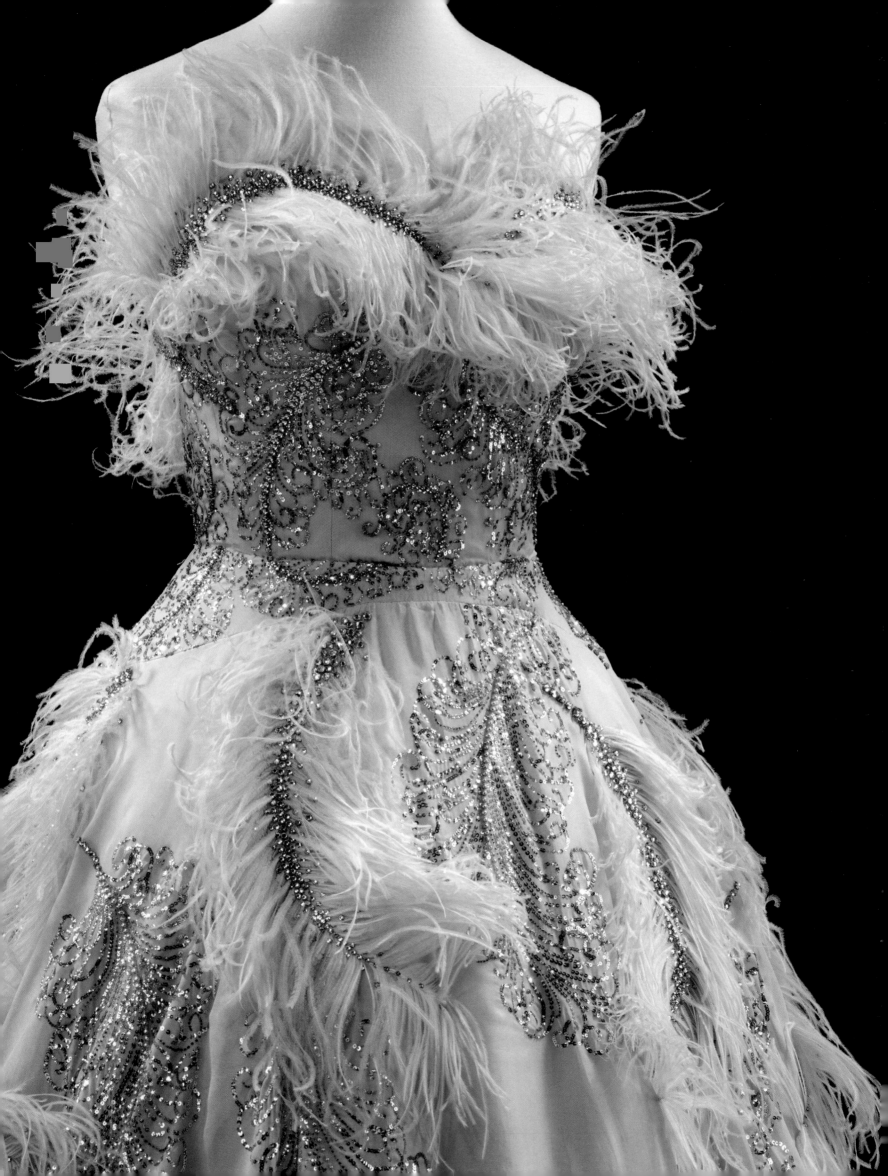

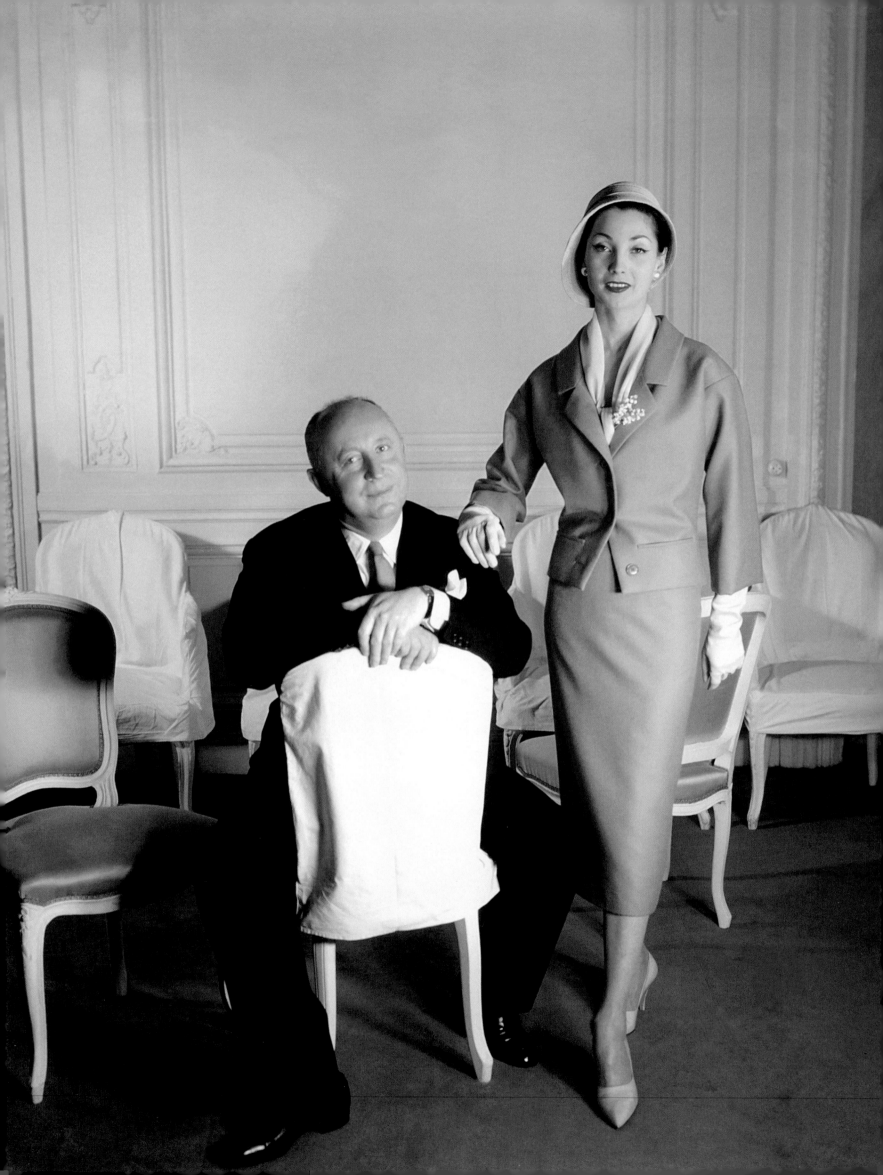

DIOR and BALENCIAGA
A Different Approach to the Body

CATHERINE JOIN-DIÉTERLE

The early days

While Balenciaga's vocation had been evident from childhood, Dior came to the profession more by chance. 'But I never dreamed of being a couturier!',[2] he would say. It could well have been that the family fortune, founded on his father's fertilizer factories, would have been enough to support the lifestyle of this sophisticated *bon viveur* indefinitely – although he was drawn to the arts, there was little urgency for him to choose a career. As a young man during the Roaring Twenties, Dior had ample time and opportunity to make friends among the writers, artists and musicians of the Parisian avant-garde, and in fact he did eventually decide to open his own gallery. However, this congenial way of life was abruptly brought to an end in 1931 by the collapse of the family business as a result of the Depression. For the first time, Dior experienced poverty, then fell ill, but with the support of loyal friends he managed to pull through. He began to scrape a living sketching designs for dresses and hats, and was successful enough eventually to land a job as a design assistant with Robert Piguet in 1938. He then moved on to work with Lucien Lelong in 1941, which proved an excellent apprenticeship.

Dior had at last found his metier. At the age of 41, following the example of Balmain, he decided to set up his own fashion house at 30, avenue Montaigne. He may have conceived this as a modest affair, but it soon grew into an empire. He was fortunate enough to meet textile manufacturer Marcel Boussac who agreed to invest 60 million francs in the launch of this new fashion house.[3] From then on, fashion became his principal interest – 'my whole existence revolved around dresses'[4] – a late but not exclusive vocation for a man who took an interest in everything, and who also found time to develop an enthusiasm for gardening.

The early career of Balenciaga was entirely different, and reads like the stuff of legend. He was born and grew up in Guetaria on the Basque coast. His mother was a seamstress and he developed a passionate interest in fashion from an early age. When still a boy, he made a copy of a suit belonging to the Marquesa de Casa Torres who was on holiday there, and so impressed this kindly aristocrat that she became his benefactor, enabling him to take up an apprenticeship with a tailor when his father died. Balenciaga was only 11.

Like Worth in his time, Balenciaga made his way slowly up the professional ladder. As a young man he worked as a fitter in the atelier of the Grands Magasins du Louvre in San Sebastian, and he went on to open his own fashion house there and afterwards in Madrid, only to face ruin when the new Spanish Republic deprived him of his aristocratic client base. So he left for London in 1937 before finally settling in Paris, sensitive to the reception accorded to foreign couturiers and skilled craftsmen. By the time Dior opened his fashion house nine years later, on 15 December 1946, Balenciaga – his elder by ten years – was already famous.

Two very different men

Although Dior and Balenciaga maintained great humility in their profession, their differences in temperament cannot be emphasized enough. Dior, an intuitive man, developed an extraordinary sensitivity to the climate of the day. Although shy and nervous of his own daring innovations, he moved quickly, almost as though he foresaw the end of his short career (only ten years separate the triumph of the New Look and Dior's death). The fanfare with which his first collection was met, on 12 February 1947, set the designer on an upward-spiralling path upon which innovation was vital in order to maintain media interest – it was American journalist Susan Train's observation that 'Dior's intelligence, at a time when fashion developed in small stages with each collection, lay in jumping forward three stages.'[5] A vision propelled by change was not unique to the couturier. The same approach can be seen with Picasso, for example, who constantly challenged his own art. Paradoxically, as a man, Dior was quite conservative.

In his studio, Dior encouraged a family atmosphere within which everyone's opinion counted – even if it was the master who had the last word (pl.6.3). Furthermore, from the moment he opened his fashion house, even as profits grew, he understood the fragility of the economy of haute couture and the need to adapt to the American market, opening the door to the structural transformations of the fashion world. From 1948 he combined two roles, a top couturier in Paris, and a designer of luxury ready-to-wear in New York. Soon, on the advice of his financial director, Jacques Rouet, he began issuing increasing numbers of licences. Balenciaga, in contrast, was resistant to the idea of producing luxury ready-to-wear on the grounds that only haute couture, to which he was totally dedicated, could meet his own exacting standards. He was a traditional man who built his work gradually, developing his ideas over two or three years.[6] He would also return to some of his designs after a considerable interval, especially those that had become established among his fellow couturiers.

6.3 Christian Dior in the fitting rooms with his models during a show, 1950

In Balenciaga's studio the atmosphere that prevailed was one of concentration – which left its mark on his assistants, Courrèges and Ungaro – and silence, which is probably the reason for the mystery that surrounds the man and his art. The importance of this has been exaggerated, however. Admittedly silence attended his fashion shows,[7] and his relations with the outside world, and unlike Dior, Balenciaga did not give interviews [8] or lectures [9] and refused to publish his life story.[10] Explaining himself was alien to him; he loved life but for him, discretion was paramount.

Despite their very different approaches to their profession, both men contributed to the elevation of the status of the fashion designer, one by his silence and his innovations,

the other by his spectacular media-seeking creations. It was Dior's opinion that '…couture, after a prolonged period of being an almost anonymous craft industry, has today become the expression of a personality: that of the head of the fashion house'.[11] He explained that couturiers 'owe this largely to the fact that they embody one of the last refuges of the fabulous'.[12] And although both men selected their clients, they always aspired to meeting their wishes.[13] Balenciaga never forgot that he had to dress three generations of women, so he employed older models to help him in this.[14] Dior, however, hired the most beautiful models,[15] which proved to be excellent publicity for the fashion house.

The spirit of their design

Dior's models were based on his intense vision of femininity – a nostalgic vision that took its inspiration from the eighteenth and nineteeth centuries and its various forms, with delightful and charming updates on the style of Madame de Pompadour (1721–1764) and Empress Eugénie (1826–1920) (pl.6.5). Like no other, he recreated the body language of a bygone era, whose myth and sophistication were perfectly conveyed by photographers who embellished the women but placed them in another, far-distant place. Balenciaga, for his part, intended his designs to be for women of natural elegance; he did not believe that his dresses, however beautiful, could transform just any woman. He was not seeking beauty but style, and preferred the austere grandeur of the seventeenth century to the charm of the rococo. Over time, he built up an image of woman inspired by Zurbarán and Goya, although initially it was very much of his own time (pls 6.4 and 6.6). He expected the greatest loyalty of his clients, since this was

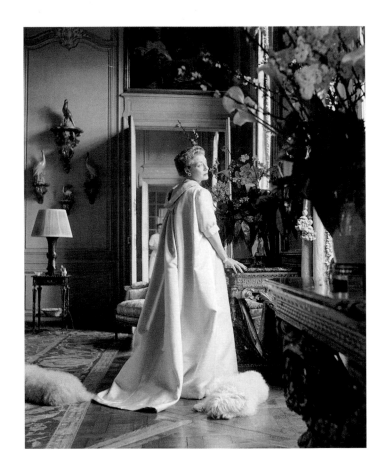

not an image that could change with a woman's mood. How was he to understand that there were those who might dress themselves from more than one fashion house? The attention he lavished upon his clients was suddenly undermined when, attracted by the New Look, several of them abandoned him for a time. Hurt, he stopped going to see them during fittings[16] (which Dior had already decided to do for diplomatic reasons).[17]

Although both designers possessed a demanding and rigorous nature – devoting much time, for example, to choosing exactly the right materials – each developed it in an original way, as illustrated in the manner in which they went about producing their collections.

Shut up at home, Dior frenetically produced a series of drawings that would form the basis of the collection. Then the role of the studio was to deal with the following phases, with everyone participating calmly in the process. Dior, seated, did not work directly on

6.4 Countess Mona Bismarck in a *déshabillé* by Cristóbal Balenciaga, Hotel Lambert, Paris, 1955. Photograph by Cecil Beaton

6.5 Dress by Christian Dior. *L'Officiel*, March 1957. See V&A: T.122–1974

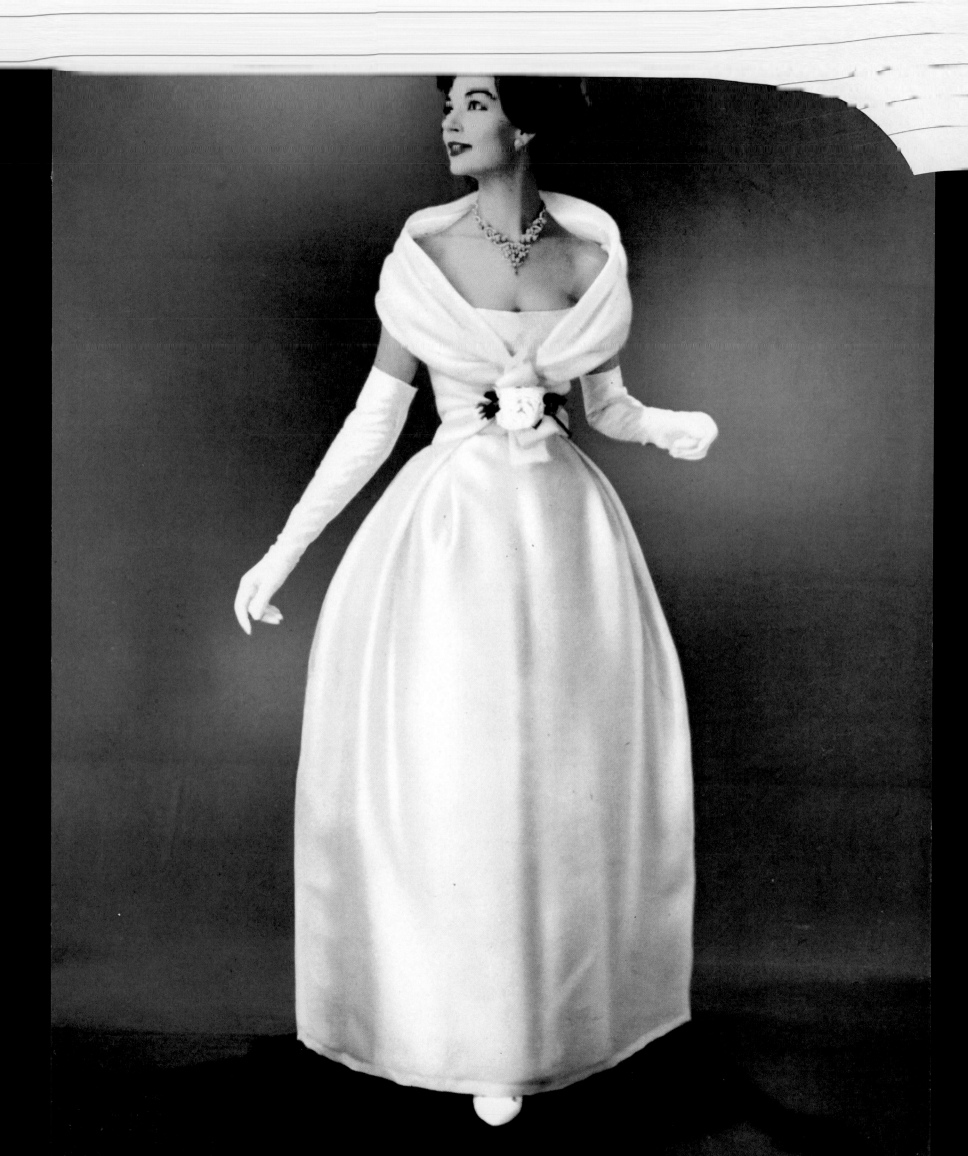

the dresses but oversaw the effect. With his stick, like a turn-of-the-century maestro, he would direct the changes, trusting in his eye and his taste (pl.6.9). Balenciaga, although he was not blessed with Dior's skills as a draughtsman, also supplied the designs but played a more active role in developing the following stages. It was not unusual for him to oversee a hundred fittings a day, changing the fabrics. It is this mastery of his profession that gave him his undoubted superiority over his competitors. Indeed, he had initially endeavoured to learn the techniques of Parisian couturiers by taking apart the *modèles* he bought every year in Paris during the inter-war years so that he could understand the cut; and we must not forget, either – as the Spanish fashion journalist María Pilar del Comín has suggested – the debt he owed to English tailoring.[18] Not only was he a genius of exceptional skill and intuition, qualities first noted so importantly by the Marquesa de Casa Torres, but he also devoted himself to incessant research. This supreme ability, comparable to perfect pitch in a musician, allowed him technical and aesthetic freedom, the importance of which has perhaps never been properly gauged, but which took him many years to achieve. In fact, if only his pre-war designs had remained, the designer would barely have stood out from his fellows. After 1945, Balenciaga took less and less interest in current trends, from which he selected only the main lines. However, unlike Madeleine Vionnet or Mme Grès, also originators of a personal design, Balenciaga expanded the field of possibilities for over 20 years.

Cut and construction

As Marylène Delphis-Delbourg pointed out in the catalogue to the Balenciaga exhibition in Lyons, the innovations that Balenciaga began to make after 1939 were mainly in cutting techniques. In this, she classed him as a genius: 'one who shows himself capable of rearranging a whole system from something very small but with strong transformative potential. With Balenciaga it all started with a sleeve. A square sleeve cut in one piece with the yoke, half with the front, half with the back. This innovation, hardly sensational in itself... led to a series of consequences that together created something beyond its original cause.'[19] The setting-in of sleeves remained one of his obsessions (pls 6.7 and 6.8).[20] Balenciaga, as we have seen, did not confine himself to traditional techniques when a new solution might produce a better result. This research encouraged him to design dresses that demanded extraordinary technical skill; he constantly challenged himself both practically and mentally, but the results, nevertheless, had nothing ostentatious about them. Examples can be seen in two dresses in the collections of the V&A and the Fundación Balenciaga in Guetaria in Spain.[21]

It is undeniably in the construction of the garments and in their relationship to the body that these two couturiers differ most.[22] For seven years, whilst emphasizing the female figure, Dior remodelled the body into two main silhouettes, the 'Corolle' (corolla) and the 'Fuseau' (spindle) shape, achieved by inserting stiffeners, fitted into tulle, the 'foundation' that was the basis of his masterpieces. Upon this armature, an evocation

6.6 Evening gown by Cristóbal Balenciaga, modelled by Dovima. *Harper's Bazaar* (British edition), December 1950. Photograph by Richard Avedon

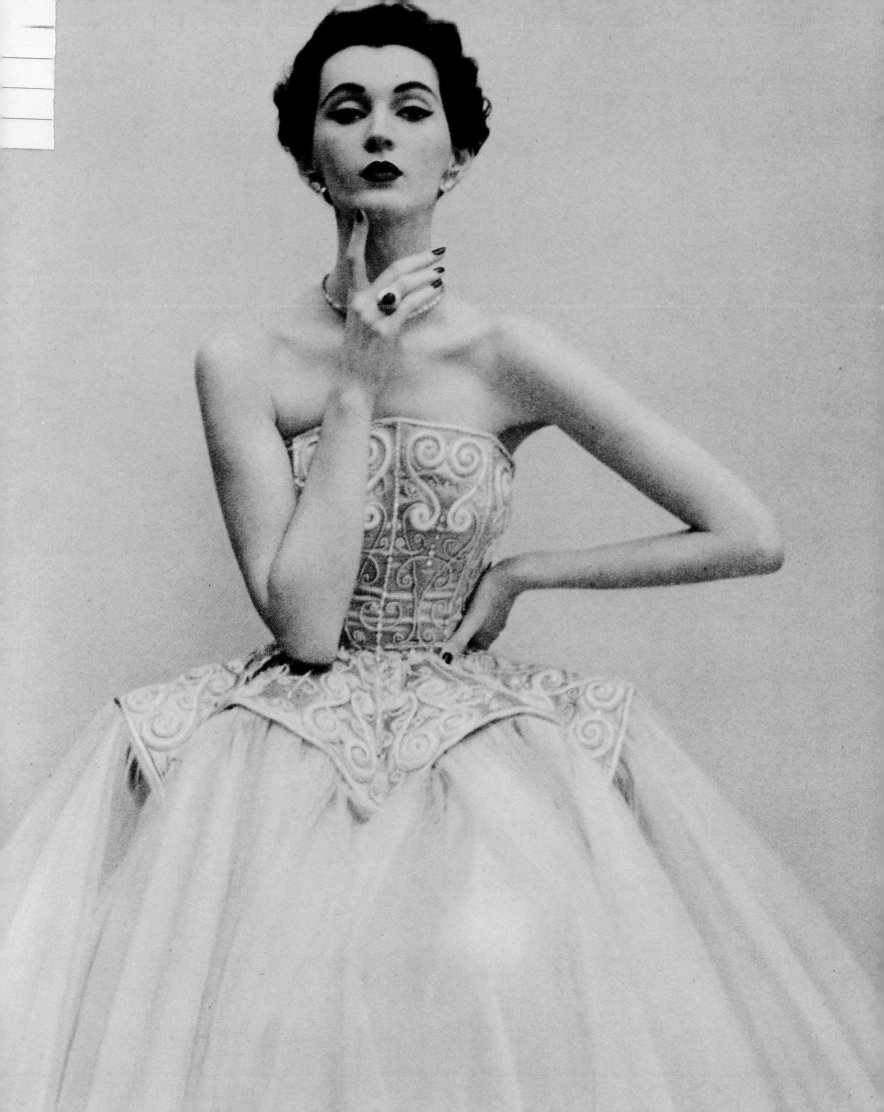

6.7 Perfect seams on a jacket by Cristóbal Balenciaga. *Vogue* (French edition), September 1951. Photograph by Henry Clarke

of the eighteenth-century costume ('armour costume') beloved of the poet Mallarmé,[23] the designer elaborated his construction, but 'the woman could bid farewell to freedom of the body...'.[24] To better express his design, the studio used a traditional technique, lining the garment with interfacing to stiffen it. The reason for these secondary structures was not to hold the weight of the dress but to create a perfect line or curve such as a detached *décolleté* or basque. This concern for detail then prompted the studio to work the fabric so that the darts could be removed, and to devise – for example, to conceal the slits of skirts – a taffeta backing edged with a strip of the same fabric as the skirt. He thus developed sculptures – sometimes lively with movement, sometimes more still, with the dress or suit made from stiffened fabrics to recreate an imaginary body.

In contrast, Balenciaga worked from the body. He knew all its failings and how to

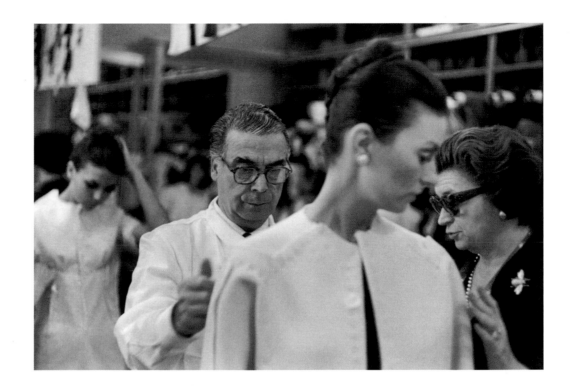

6.8 This rare, behind-the-scenes photograph of Balenciaga was taken in the 1960s.

6.9 Christian Dior inspects an evening gown prior to a new collection. Paris, 1957

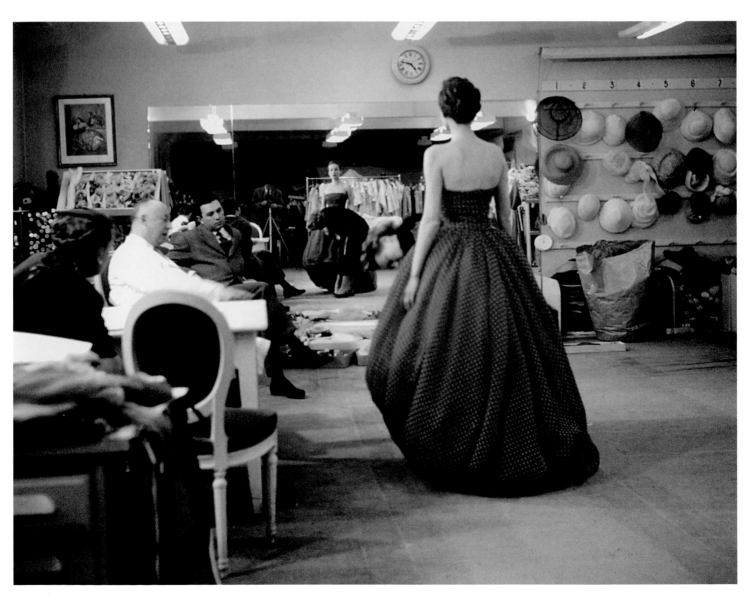

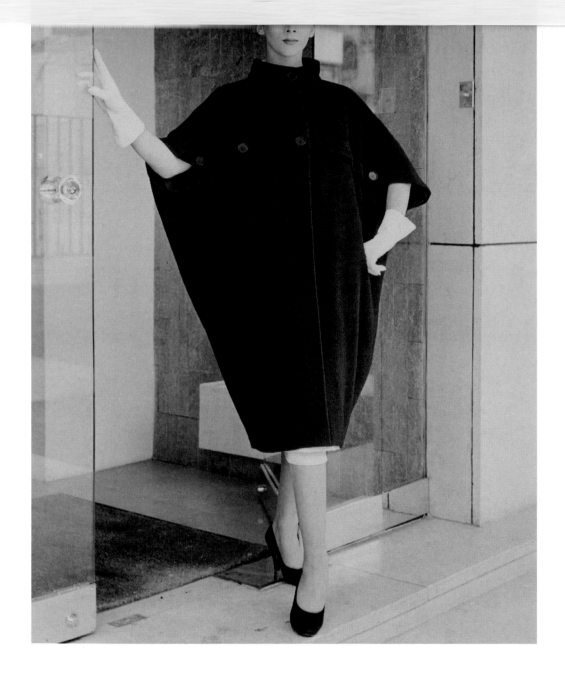

6.10 Coat by Cristóbal Balenciaga. Black wool, 1957. Photograph by Seeberger

6.11 'Ecarlate', cocktail dress by Christian Dior. Red silk grosgrain, Autumn/Winter 1955–6. Christian Dior Archive. See V&A: T.25–2007

distract from them.[25] It is said of him that he liked a bit of stomach; just as with Zurbarán's female saints, this stomach was the source of the tilted line that recurs in his dresses and suits from 1952 onwards. Nor did he shy away from a slightly rounded back; he knew how to straighten it, to tilt it slightly backwards and restore a look that women lost as they aged. The shoulders and the pelvis, the only points of support, were sufficient for the construction of his garments. Unlike Dior, who relied on the bust and waist, he had no need for a framework and refused to use padding, which he believed straitjacketed the woman. The structure lay in the dress itself. Rejecting the stiffeners used by Dior, he preferred to add interfacing to the dress where necessary so that it kept

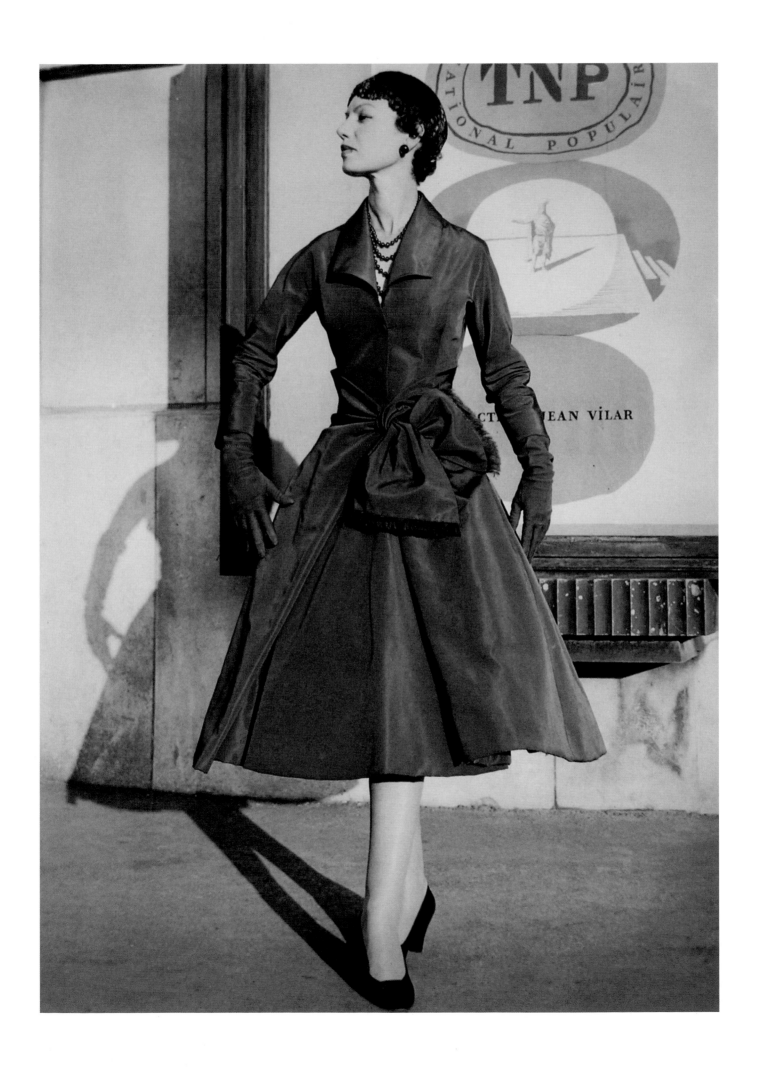

its shape when the wearer moved: comfort and flexibility were the dual imperatives of Balenciaga's designs. Thus he designed suits in which a finger's breadth was left between the garment and the skin, one of the little 'tricks' that he devised as his career developed. The lightness that he cultivated soon became a feature of the period. His colleagues, including Dior in 1954 with his 'French bean' line – a vertical, flattened look – soon followed suit.

Are we do deduce from all this that the creations of these two fashion designers had very little in common? This is actually not the case. Both played with scale and used gigantic elements: examples include the pointed collar reaching down to the skirt of a Dior summer coat of 1950, the huge pointed collar on his winter coat of the same year (see pl.8.10), and Balenciaga's faille bow concealing the bodice of his 1951 guipure lace dress. Similarly, geometric shapes soon became common features of both couturiers' creations, which were probably an unconscious echo of developments in contemporary architecture. In Dior's case, the names he gave his collections after 1954 – 'Figure 8', 'Vertical', 'Oblique', 'Oval' – reflect this, especially in his dress of very pure geometric lines, 'Promesse', in 1957. In Balenciaga's case, this liking for geometric forms, especially the sphere,[26] inspired him to make the garment a kind of envelope separate from the body, an approach that established a connection between his designs and the costumes of the Far East (pl.6.10). Through his avant-garde approach, he opened the way for couturiers such as Courrèges and paradoxically eased the introduction of Japanese designers into France.

However, Dior's search for freedom of movement was a powerful impetus, and was a factor again reflected in the names of some of his collections – 'Flight', 'Zigzag', 'Winged', 'Cyclone' – but this movement is a suspended movement, inherent in the garment, an extraordinary and spectacular swirl highlighted by pleats that often cross over one another (pl.6.11). Leaving aside his 'gypsy' dresses,[27] Balenciaga did not seek motion for its own sake; on the contrary, he was interested in the response of the garment when a woman walked, as can be seen in his 1951 dress with scarves that took flight with the slightest movement. Unlike Dior, whose models viewed in profile were so lively, Balenciaga, who liked to surprise, highlighted the back of his clothes, as is evident in the semi-fitted look of his 1951 suits, and panels that were sometimes detached, sometimes fastened in.

Two very different men, two very different ways of conceiving the creative process and envisaging fashion, according to sensitivities that were, always, of their time. Dior constantly played the fashion game, intuitively understanding the art of staying ahead. Balenciaga's work, on the other hand, bore a sense of eternity, of the reconciliation of past and present.

6.12 Dress with scarves by Cristóbal Balenciaga. Satin and chiffon, 1951

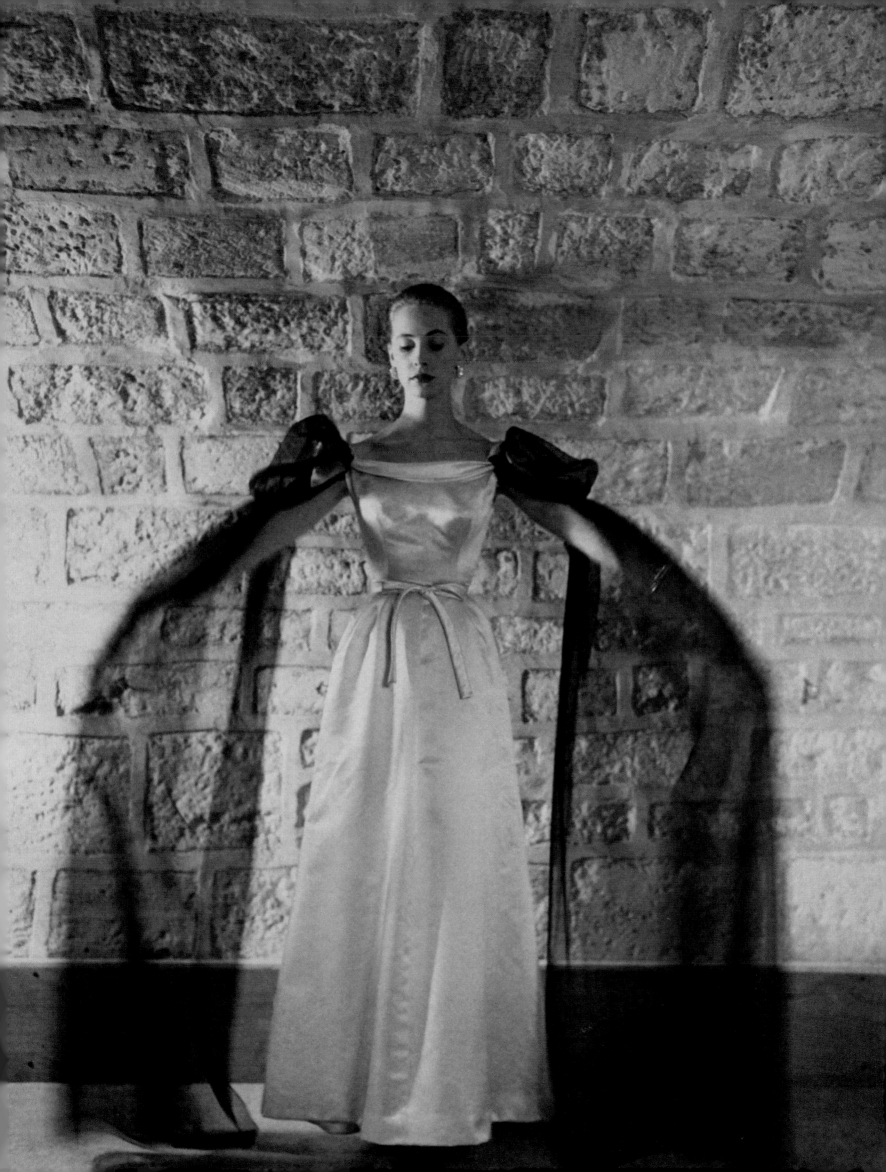

Balenciaga: master tailor

LESLEY ELLIS MILLER

In *A Guide to Elegance*, Geneviève-Antoine Dariaux, *directrice* of the couture house Nina Ricci, wrote: 'A suit is the foundation of a woman's wardrobe... if you have taken care to select a model that is in the long-range general fashion trend rather than a passing fancy, a well-made suit is often wearable for five years or more – especially the Balenciaga models, which are at the same time in advance of the mode and independent from it.'[1]

From 1947 Balenciaga offered two styles: the first fitted and in line with the hourglass shape of Dior's famed 'New Look', the second semi-fitted or loose, an easy alternative that became increasingly fashionable towards the end of the decade and was undoubtedly a precursor of 1960s couture. Balenciaga's perfect little suits commanded high prices: a woollen suit in the early 1950s cost around 110,000 francs.[2] The two suits illustrated are semi-fitted, although constructed in different ways. Both have slim-fitting skirts with a kick pleat that allows ease of movement, and jackets that are broad across the upper body and easy around the waist, based on what fashion journalists called the 'barrel' line.

The first (Winter 1950, no. 24), longer in line than the second, tapers into the hem while the second (Winter 1954, no. 55, made in Henri's workshop for the model Yvonne) is indented at the waist in front but flares out at the back. Both presaged the famous tunic line of 1955 as well as the sack of 1956 (in its ease at the back). Other characteristics are typical of Balenciaga's fascination with cut and construction, as well as his mastery in manipulating firm fabrics. He was adept at creating different types of sleeve and sought perfection in each: the earlier jacket shows Magyar sleeves cut in one with the body while the second has the traditional inset sleeves, made to lie smoothly in exactly the right position on the wearer's shoulder. Balenciaga was renowned in the trade for inspecting and resetting sleeves that were not perfect – even after the garment had been shown in a collection or was being worn by a client. He acquired these exacting standards during his training as a tailor (*sastre*) in San Sebastian: travel guides of this period state appreciation for the skill of Spanish tailors – and the cheapness of their products in comparison with those of the French.

Tweed was a sturdy woollen fabric that appealed to Balenciaga because of the optical illusions created by the two colours in the indistinct flecked pattern. In particular, he was fond of white with brown or black, or even brown and black together, 'the colours of the Spanish earth'. He carefully selected fabrics from the top manufacturers, and for tweeds and woollen fabrics patronized the best in France and Scotland. Although tweed was usually considered appropriate for autumn, these suits had different overtones: the earlier one, with its long sleeves and double-breasted fastening, was far more suitable for outdoor life than the other, whose jacket falls to just below the waist, and whose three-quarter length sleeve allowed ease of movement. The collar is cut away from the neck to let the wearer's pearls breathe.

6.13 Suit by Cristóbal Balenciaga, modelled by Dovima. *Harper's Bazaar*, September 1950. Photograph by Richard Avedon. See V&A: T.128–1970

6.14 Suit by Cristóbal Balenciaga. Tweed, 1950. Given by Mrs Catherine Hunt, V&A: T.128–1970

6.15 Suit by Cristóbal Balenciaga (detail). Tweed, 1954. Worn by Mrs Opal Holt and given by Mrs D.M. Haynes and Mrs M. Clark, V&A: T.128–1982

6.16 Suit by Cristóbal Balenciaga. *Vogue* (French edition), September 1954. See V&A: T.128–1982

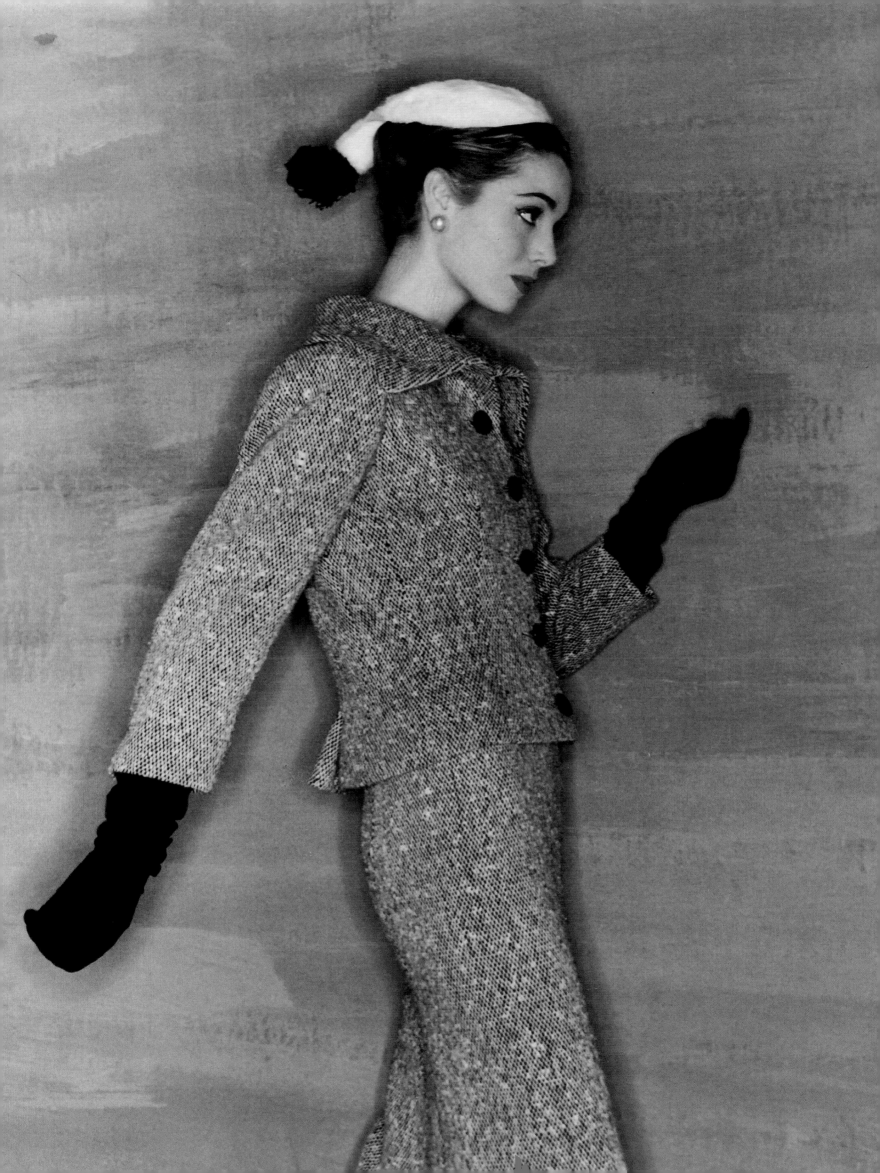

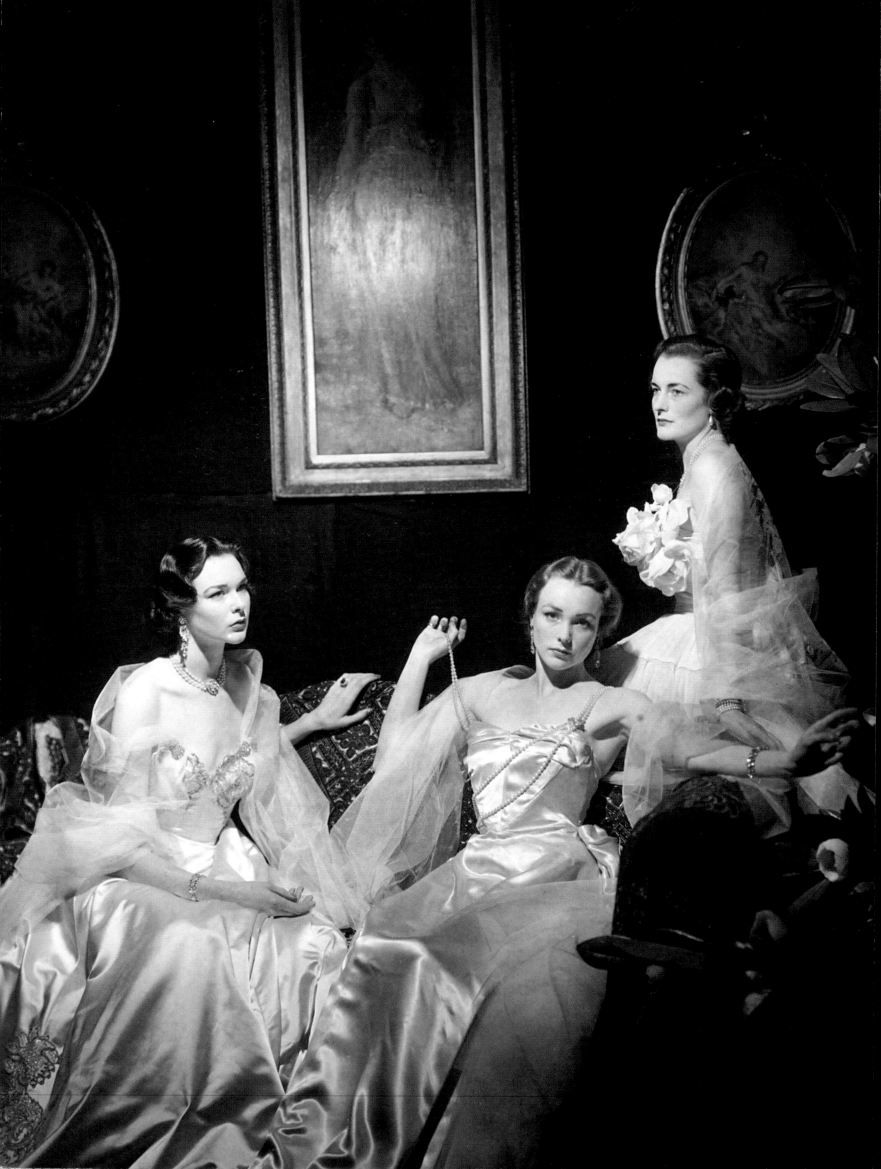

CECIL BEATON
and his Anthology of Fashion

HUGO VICKERS

Dear Cecil,

*Let me know when you come to
Paris and I will show you what
I have! Wonderful idea – it is all
vanishing so quickly!*

Love Mary.

BARONESS ALAIN DE ROTHSCHILD, APRIL 1970

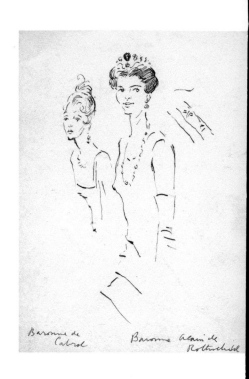

B Y THE 1970S, there were said to be less than 100 women left in the world who commissioned haute couture clothes. Cecil Beaton knew most, if not all, of them, and many were close friends. Thus he was the perfect man to co-ordinate an exhibition of contemporary dresses at the Victoria and Albert Museum in 1971, 'Fashion: An Anthology'. And he went further than that, by creating a permanent collection of couture dresses for the Museum.

Beaton was primarily a photographer, but style was a vital ingredient in every aspect of his work, as important as – and running parallel to – his love of theatre. His involvement in fashion was a close one. It is not every curator who, as an undergraduate, has adorned himself as a woman of style for a theatrical performance at the Cambridge Footlights, who spent much of his youth in fancy dress, and who then went on to dress some of the most elegant women of the day in ballet or theatrical costume. Not for nothing did Beaton's friend, Stephen Tennant, describe him as 'unique in his approach to high fashion… a worldly Peter Pan'.[1] When he dressed Audrey Hepburn for the film *My Fair Lady* (1964), he was aware that normally Hubert de Givenchy dressed her, in life as in previous films such as *Funny Face* (1957) and *Breakfast at Tiffany's* (1961). When Givenchy visited the set of *My Fair Lady* in Hollywood, he amused Beaton by declaring: 'Quel travail! It's like half a dozen collections!'[2]

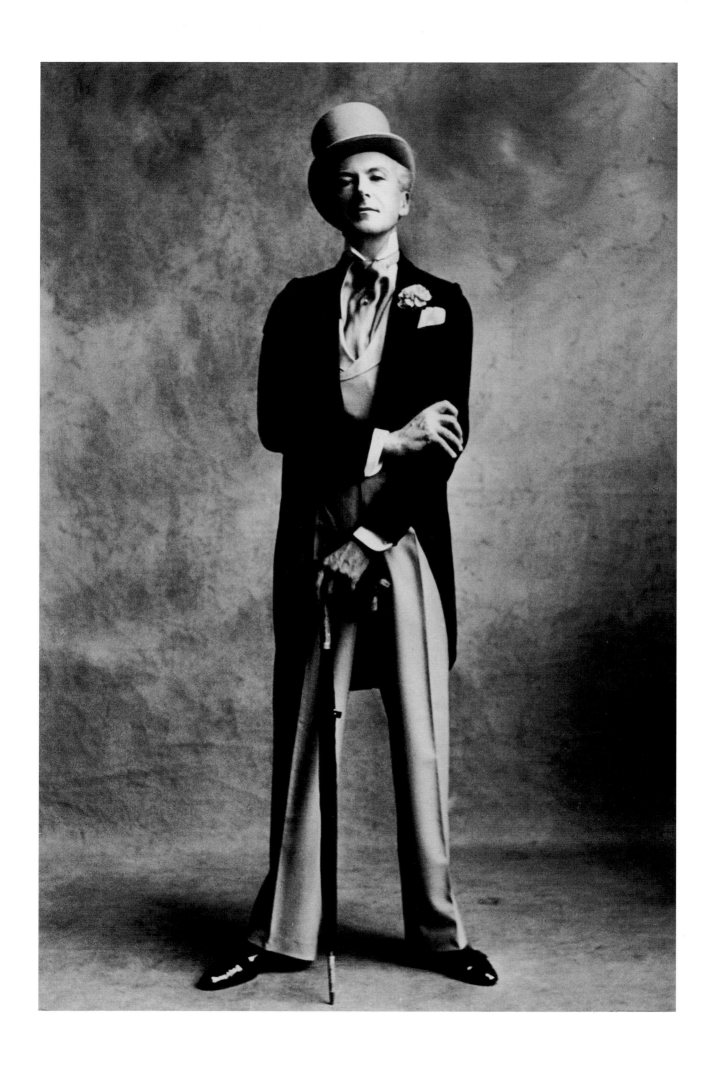

The 1971 exhibition came about as the result of a random *place à table* at a dinner in New York in 1969 (pl.7.4). Beaton was seated next to John Pope-Hennessy, the Museum's Director. Balenciaga dresses were then the vogue, and Pope-Hennessy told Beaton that he was surprised they were not collected like other works of art, especially since all great collections of art were formed and informed by individual taste. Beaton was a neighbour of the Museum, living just a few streets away at 8 Pelham Place. He immediately offered to form such a collection. An exchange of letters set matters in motion. In October 1969 Beaton wrote to Pope-Hennessy: 'I have decided that I would like to make a collection of the best of women's fashions of today.'[3] He was interested in what couture clients did with luxurious clothes after they had worn them a few times. He thought that these women should be invited to give their dresses to him, but as ever where Beaton was concerned, the highest standards needed to be maintained:

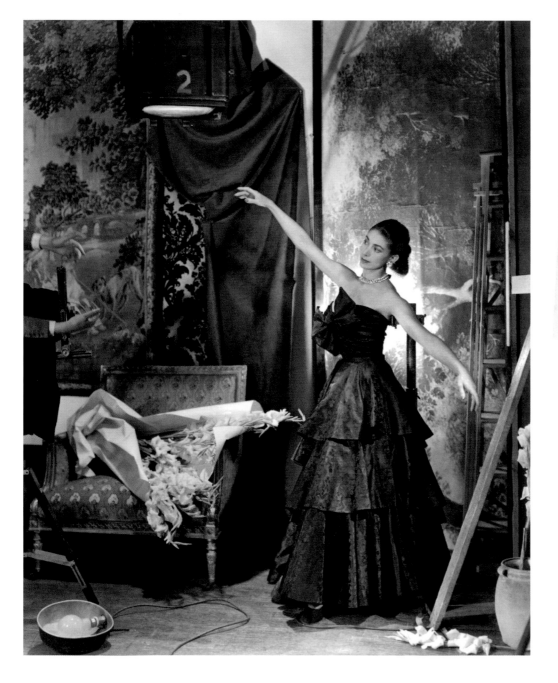

7.4 Invitation to 'Fashion: An Anthology by Cecil Beaton', V&A, 1971

7.5 Margot Fonteyn in a dress by Bianca Mosca, 1949. Photograph by Cecil Beaton

Unlike most collections that are the result of people offering what they can spare, I would hope to flatter the donors by only asking for specific garments that I had seen or admired: and would be very selective in anything that was merely 'offered'.[4]

Pope-Hennessy accepted with relish: 'It would be a marvellous thing to form, and would be a great enrichment of this Museum. *Please* go ahead.'[5]

Beaton began with a general letter: 'I wonder if you would feel inclined to help me in my effort to make a collection of fashions of our day? …Already several ladies, whose taste and discrimination in their clothes I admire, have contributed dresses that I consider should be preserved as historical documents.'[6]

By November 1970 he had been to Paris and obtained 'an overwhelming haul of

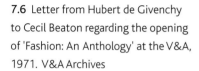

7.6 Letter from Hubert de Givenchy to Cecil Beaton regarding the opening of 'Fashion: An Anthology' at the V&A, 1971. V&A Archives

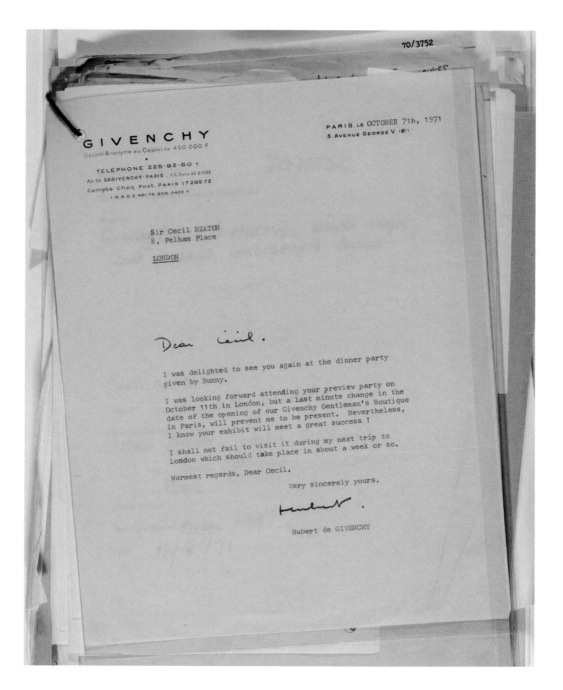

marvellous fashions',[7] including dresses from Margot Fonteyn and the Duchess of Windsor (pls 7.5 and 7.7). By this time, the idea of a collection had burgeoned into a proposed exhibition at the Museum, the emphasis of which was not to be fashion as such but 'dresses shown as works of art' chosen by Beaton.[8] By January 1971 a budget had been fixed and the search for a designer for the show had begun.

Beaton sought examples of dresses that were important in the history of fashion design. His yardstick was the designer, but he also considered the importance of the owner, and on certain occasions, the circumstances in which the outfit was worn. It was a theme well explored in his 1954 book, *The Glass of Fashion*, in which he celebrated

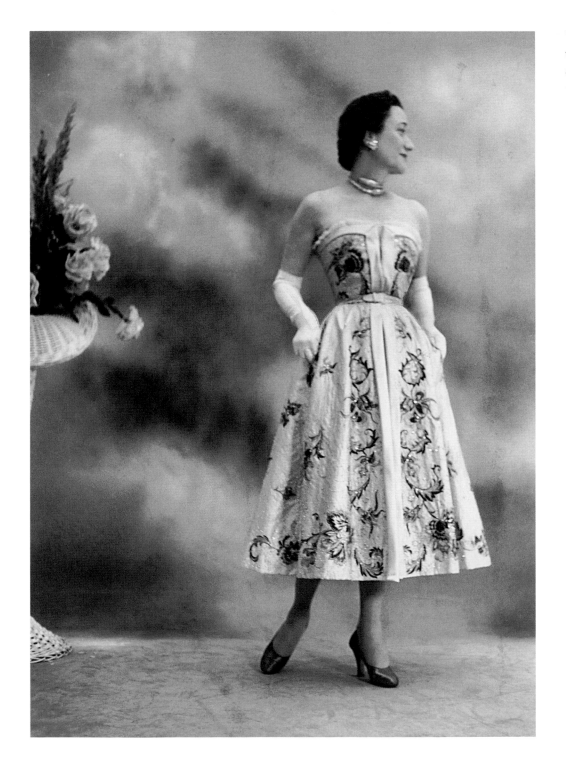

7.7 The Duchess of Windsor wearing a strapless gown and diamond choker by Christian Dior, 1951. Photograph by Cecil Beaton

the style and impact of certain figures on international taste. The fashion expert Ernestine Carter commended Beaton as 'the first to write about the people who make fashion rather than only about fashion itself'.[9] However, not all those hailed as trendsetters in *The Glass of Fashion* were household names, and this was reflected too in the list of donors and lenders to the 1971 exhibition. In the introduction to the catalogue, Beaton wrote of these women with admiration:

> Fashion is a mass phenomenon, but it feeds on the individual. The true representatives of fashion are often those whose surprising originality leads them to a very private outward expression of themselves. In some given decade they appear somewhat outré, they may border on exhibitionism, or even eccentricity, but their means of self-expression curiously corresponds to a need in others who, in a modified way, copy them. Thus they create taste.[10]

Beaton prised dresses from the collections of a great number of well-dressed society ladies whom he admired. So persistent and successful was he that Princess Lee Radziwill,[11] Jacqueline Onassis's sister, complained that after a visit from Beaton, she had nothing left to wear.

Beaton collected 450 pieces for the exhibition, and many more for the Museum's collection. It was a haul that was not only impressive in its scale, but also in its scope. One of the earliest pieces was a dress worn by Winifred, Duchess of Portland at the 1897 Devonshire House Ball.[12] Sylvia Henley, daughter of Lord Stanley of Alderleigh, gave Beaton a 1918 dress that Chanel had made for her to attend the Peace Conference in Paris. There followed flapper dresses and designs by Poiret and Callot Soeurs. The American actress Ruth Ford gave him some much-loved Schiaparellis, including gloves designed by Salvador Dalí and given to her by Edward James, the Surrealist collector, during his unlikely and ultimately fruitless courtship of her. However, Beaton had an eye on the contemporary, too, and brought the collection up to date with a mini-skirt from the Sixties model, Jean Shrimpton ('The Shrimp') and some faded jeans given to him by a collaborator, Robert La Vine, to represent the daily attire of the average young American.

It is interesting that Beaton amassed his collection at the beginning of the 1970s, just after the explosion of youth culture in the 1960s, which the artist Michael Wishart so memorably described as 'the Peacock Revolution'.[13] Although Beaton thought that the Paris designers still held the field, the influence of Mary Quant and Carnaby Street, Pop Art and comic strips was strong; despite the fact that the creativity of the time was undeniable, trends veered towards the mass-produced. This was, therefore, the perfect time to look back to a 'golden age' of greater – not to mention more expensive – elegance.

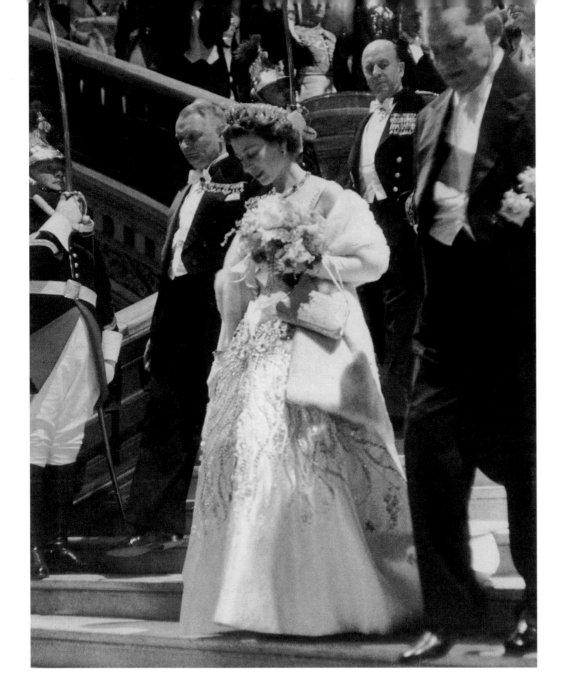

7.8 Queen Elizabeth II arrives at a state reception in Paris wearing 'Flowers of the Fields of France' evening gown by Norman Hartnell, 1957. See V&A: T.264–1974

This publication covers the fascinating decade from 1947 to 1957. It began when Christian Dior sprang to fame with his first show. It ended abruptly while Dior was taking a cure in the spa of Montecatini in the autumn of 1957 and suffered a fatal heart attack at the age of 52. Its designers remain by and large well-known household names, yet some of the women who wore them have now retreated into obscurity – except in that rarefied world in which Beaton lived. Having moved for over a quarter of a century in Beaton's shadow as his biographer, I am able to apply *The Glass of Fashion* formula to some of the clients whose clothes are represented in the present collection, having been fortunate enough to meet quite a few of them myself. The donors come in various categories, starting with the unassailably famous.

Her Majesty The Queen donated a 1965 Hardy Amies day ensemble[14] and, to avoid causing ruptures in the world of couture, the Norman Hartnell dress from the April 1957 state visit to Paris, at which Beaton had been a guest (pl.7.8). He had been invited by Lady Jebb (later Lady Gladwyn), wife of the British Ambassador in Paris, to sketch the return state banquet at which the Queen had entertained President René

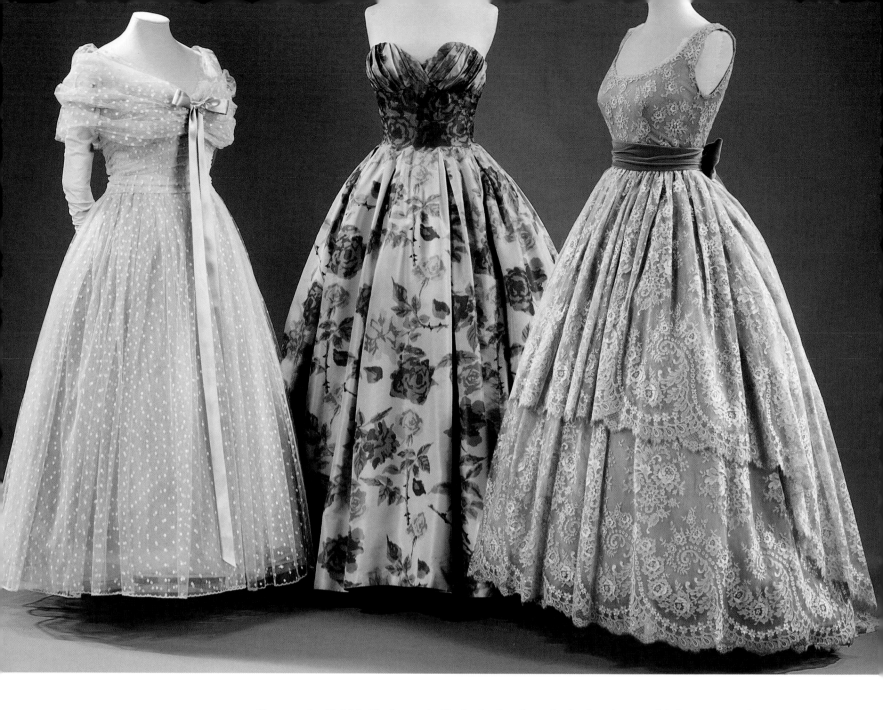

7.9 Evening dresses worn to the Queen's state visit to Paris. Left to right: 'Belgique', evening dress by Christian Dior. Spotted silk tulle, Spring/Summer 1957. Given by Baroness Alain de Rothschild, V&A: T.121–1974; evening dress by Pierre Balmain. Printed and appliqué silk, 1957. Given by Lady Diana Cooper. V&A: T.50–1974; evening dress by Jacques Fath. Lace, 1957. Given by Lady Gladwyn, V&A: T.173–1974

Coty at the British Embassy in Paris. At the time, he had written to his hostess, saying 'The Queen triumphed over Hartnell's bad taste.'[15] Despite this, he was delighted to accept the ivory satin evening dress, encrusted with beads, brilliants and gold. Beaton succeeded in acquiring several other dresses worn during the same visit. Lady Gladwyn donated the lilac lace evening dress by French designer, Jacques Fath.[16] Lady Diana Cooper, Lady Gladwyn's (and Beaton's) great friend, donated a strapless Balmain gown of appliqué printed silk satin. Baroness Alain de Rothschild (Mary Chauvin de Treuil), the wife of one of the Rothschild banking brothers, gave a white spotted tulle dress by Dior (pl.7.9).

Other British society women included Lady Dacre (1907–97), from whom a great number of dresses came, accompanied by enthusiastic correspondence on every aspect of them. She was the daughter of Field-Marshal Earl Haig and wife of the historian, Hugh Trevor-Roper (see p.172). She offered a Jacques Fath gown which she had worn when Princess Elizabeth visited Paris in 1948, more Faths, and two Schiaparellis. She also offered, but did not give, a Lanvin dress made specially for her for the Coronation of King

Mahendra of Nepal in Sikkim in May 1956. She informed the Museum that it was because of her personal introduction that Cynthia Jebb (Lady Gladwyn) had become a client of Jacques Fath. Such recommendations were a quite usual introduction to a couture house and, in accordance with protocol, Lady Gladwyn would then have shared the same *vendeuse* as Lady Dacre. Both ladies moved to Lanvin following Fath's death. The Duchess of Windsor (1896–1986) sent a favourite dress[17] – 'I always had a good time in it so I would like it to live on.'[18] The Duchess of Devonshire (b. 1920), the former Deborah Mitford and last survivor of the famous Mitford sisters, sent a 1953 Schiaparelli.[19]

In addition to the English establishment there were also the Americans, who arrived like swallows at the beginning of the English social scene in early summer before departing for Europe at the end of July. When at home, they were an integral part of the Washington political scene. Evangeline Bruce (1914–95) was the elegant and much-liked wife of the American Ambassador, David Bruce (pl.7.10). She had the best set at London's Albany – overlooking the courtyard to the front, where she entertained elegantly. In later life she wrote an acclaimed biography of Napoleon and Josephine. She sent a very important New Look Dior dress called 'Maxim's' after the famous Belle Epoque Paris restaurant frequented by the cream of society.[20]

Ana Inez ('Chiquita') Astor (1918–92) was the alluring daughter of a post-war Argentinian Ambassador, Miguel Carcano. Like her sister, she married into the British aristocracy, becoming the wife of Nancy Astor's son, the Hon. John ('Jakie') Astor, himself an MP. She worked in set design and theatrical costume and was a contributing editor to *Vogue*.[21] She gave two tight-fitting evening gowns by Jean Dessès, one from 1948 in black velvet and another in pale pink net from 1950. Her sister Stella ('Baby') Ednam gave part of the outfit in which she was married to Viscount Ednam (the present Earl of Dudley) in 1946. Balmain wrote in his autobiography, *My Years and Seasons*, that 'this was the first society marriage for which I designed the bride and bridesmaid's dresses'.[22] She also gave another Balmain, a 1950 crimson velvet evening gown trimmed with sable,[23] and a 1957 Lanvin Castillo polka-dot dress (see pl.2.16).[24] Their mother, Mme Miguel Angel Carcano, gave,

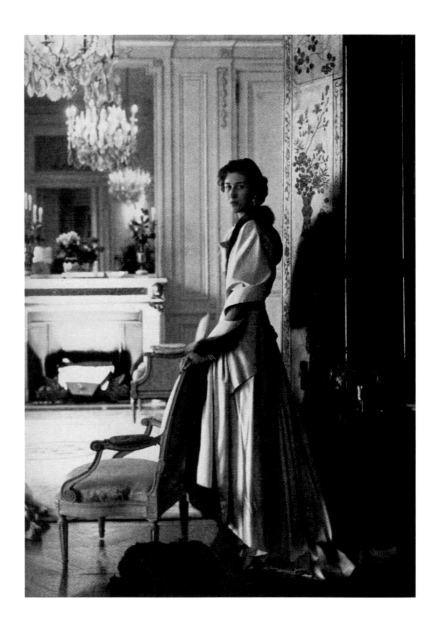

7.10 Evangeline Bruce in the American Embassy in Paris, wearing an evening dress by Christian Dior. *Vogue* (French edition), May 1950. Photograph by Cecil Beaton

amongst some earlier pieces, a rare 1946 beaded white satin jacket by Balenciaga.[25]

The story of the Countess of Drogheda (d. 1989) can never fully be told. The former Joan Carr, a talented pianist, looked like a fragile bird, had been a foundling (with no date of birth in her passport), and the mistress of Edgar Wallace. The Droghedas were involved in a curious incident, only publicly revealed years later. When Lady Drogheda was touring America during the war, a Frenchman by the name of Roget fell in love with her. When she was joined by her husband in Washington, this distraught

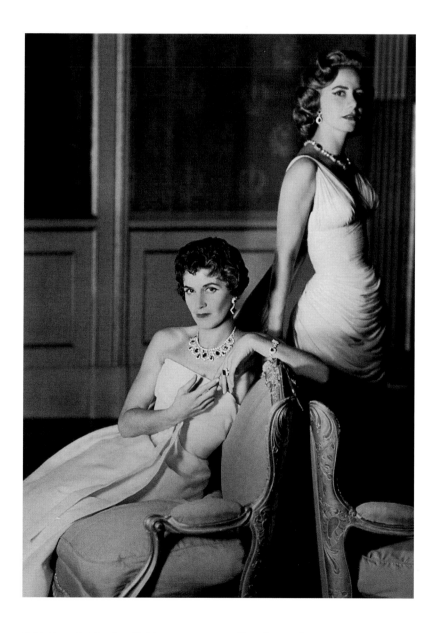

7.11 Eugenia Niarchos (left) wearing an evening dress by Christian Dior, and Athina Onassis, later Marchioness of Blandford, wearing a gown by Jean Dessès. *Vogue* (French edition), January 1957. Photograph by Henry Clarke

man appeared in the hotel, threatening to stab himself if Lord Drogheda did not allow his wife to go away with him. Drogheda explained that this was out of the question, 'Whereupon, to my astonishment, he drew a knife from his pocket – and stabbed himself in the chest.' He added: 'I had never previously, nor have subsequently, had to contend with such melodramatic behaviour.'[26] When her husband was variously Chairman of the *Financial Times* and the Royal Opera House, Covent Garden, Joan Drogheda was a prominent figure in society. She gave Beaton a 1957 Lanvin,[27] which she described as 'white satin with purple embroidery on the bodice – sounds rather hideous but is in fact pretty [see pl.5.17].'[28]

Lady Elizabeth von Hofmannsthal (1916–80) was one of the Paget sisters, daughter of the 6th Marquess of Anglesey, a Maid of Honour at the 1937 Coronation, and like her aunt, Lady Diana Cooper, one of the most beautiful women in England in her day. She married Raimund von Hofmannsthal (son of Hugo von Hofmannsthal), with whom many English girls were in love. She gave her yellow Balmain evening dress of 1956,[29] and a black Balmain cocktail dress of 1957.[30] After her death her son, Octavian, donated a beautiful

Cartier make-up case monogrammed with her initials.[31] It still contains blusher.

Eugenia Niarchos (1926–70) was one of the Livanos sisters, married to the Greek ship owner, Stavros Niarchos (pl.7.11). She was the perfect couture client – beautiful, stylish and exceedingly rich. Beaton had written to Pope-Hennessy that Mme Stavros Niarchos was 'about the only person who could afford to order one of the incredibly beaded dresses that Dior has designed'.[32] Beaton did indeed manage to persuade her to donate her Dior dresses, which thankfully she had 'never had the heart to throw away',

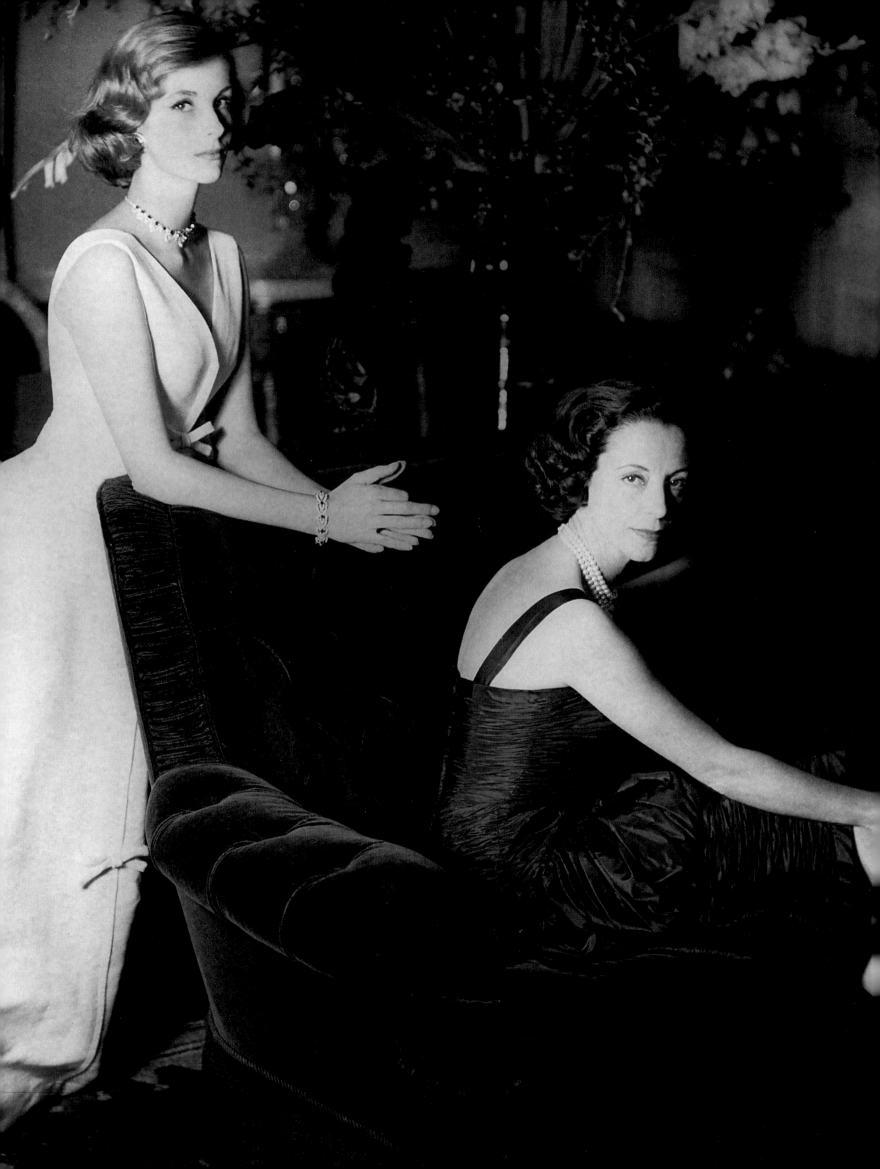

7.12 Mrs Loel (Gloria) Guinness with her daughter Mrs Patrick (Dolores) Guinness, both wearing dresses by Cristóbal Balenciaga. *Vogue* (French edition), January 1957. Photograph by Henry Clarke

7.13 Three of the dresses given to the V&A by Mrs Loel (Gloria) Guinness. Left to right: evening dress by Jeanne Lafaurie. Printed silk with sequins, 1950s. V&A: T.281–1974; evening dress by Christian Dior. Organza with ribbon work and beading, 1954. V&A: T.133–1974; evening dress by Marcelle Chaumont. Hand-painted organza, 1949, V&A: T.92–1974

although she added, 'but I'm afraid they ain't too fresh-looking'.[33] She died on the island of Spetsopoula in May 1970 in mysterious circumstances, and Niarchos then married her sister Athina, later Marchioness of Blandford. After Eugenia's death, Niarchos honoured her promise to Beaton and handed over 19 items, including pieces by Balenciaga, Courrèges, Dessès, Dior, Roger Vivier and Ungaro – most notably Dior's intricately embroidered 'Bosphore' dress of 1956 (see pl.5.18).[34] When I visited Beaton's 1971 exhibition as a youngster, I remember being struck by how small she must have been. The clothes made her sad story seem all the more real.

Mrs Loel Guinness (1913–80) had an extraordinary life. Born in Mexico as Gloria Rubio, her first husband was a Count Furstenberg, to whom she was married at the behest of the German art collector, Freddy Horstmann. Her second husband was an Egyptian by the name of Fakhry, and her third husband, the banker Loel Guinness. In many ways she was unhappy as his wife, as she loved to party and he did not. She gave an enormous number of items from Balenciaga, Dior, Courrèges, Lanvin Castillo, Givenchy, Hellstern and Jeanne Lafaurie, proving that she spread her commissions amongst many different couturiers. Among the 17 outfits, 12 hats and pairs of shoes that

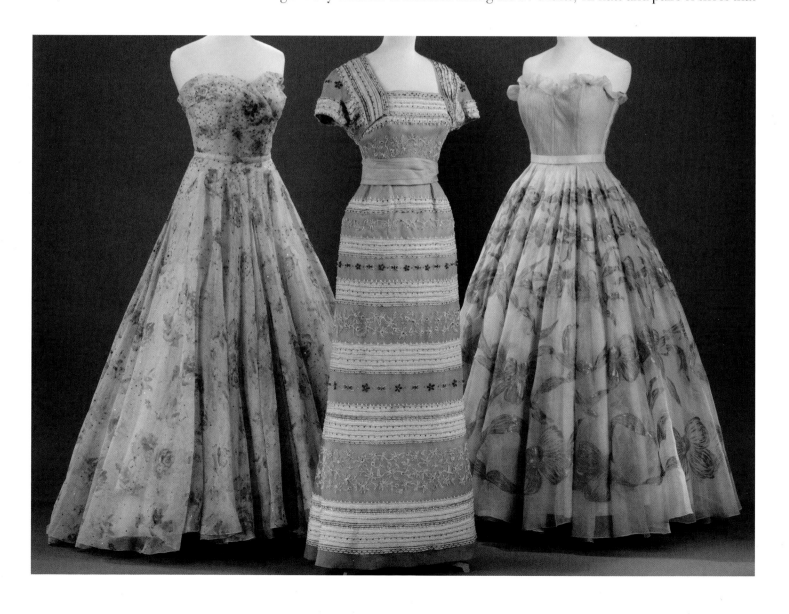

*'I thought you would like to know
that the King was surprisingly
interested in your fashion
display and liked it very much.'*

she donated were a 1948 Balenciaga evening gown of organdie with flock flowers,[35] a 1949 hand-painted evening gown by Marcelle Chaumont, and a 1950s evening gown by Jeanne Lafaurie, the only dress by that designer in the V&A's collection (pl.7.13).

The very rich Edwina d'Erlanger (d. 1994) was also the wife of a banker – Leo d'Erlanger (pl.7.14). In 1974, when Denis Healey was Chancellor of the Exchequer and introducing Draconian taxes, the d'Erlangers retreated from their house in Upper Grosvenor Street to live in Switzerland. It was at this point that Beaton took away a great cache of Paris dresses to add to the Museum's collection, including a 1955 little black dress of spotted net by Grès.[36] Sometimes it was a great designer who donated. Cecil Beaton found Madame Grès 'still romantic and remarkable'[37] in 1970, and comparing well to the younger generation of designers. Grès went to the trouble for Beaton of exactly reproducing her famous 1955 draped cream jersey evening dress.[38]

The exhibition 'Fashion: An Anthology' opened on 13 October 1971 and closed on 16 January 1972. Eighty thousand people saw it, and most of them (including me) enjoyed it hugely. But not everyone was happy. Yves Saint Laurent complained via Pierre Bergé that while there were 22 Givenchys and 31 Balenciagas on show, he was represented by a mere 6. Lord Mountbatten had loaned his wife Edwina's 1922 wedding dress, a lamb jacket, and 10 ostrich fans of different colours. The day Mountbatten attended the exhibition he had lunched with King Gustaf VI Adolf of Sweden and they went on to the Museum together, expecting to see these items – but none had found its way into the exhibition. Mountbatten later complained to Beaton, but conceded: 'I thought you would like to know that the King was surprisingly interested in your fashion display and liked it very much.'[39]

7.14 Mrs Leo d'Erlanger wearing a hat by Vernier. *Vogue* (British edition), June 1949. Photograph by Cecil Beaton

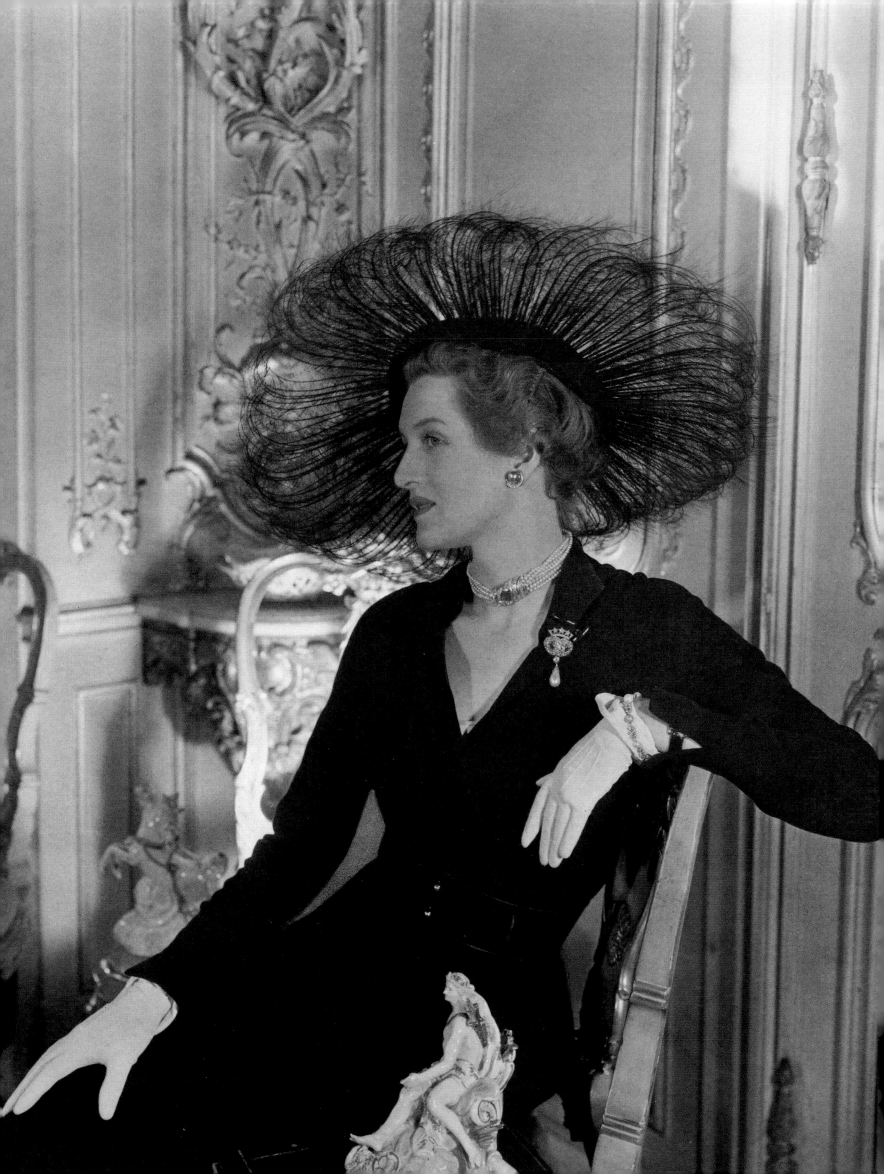

Lady Alexandra

ELERI LYNN

Lady Alexandra arrived in Paris in 1948 as the wife of Captain Howard-Johnston, Naval Attaché to the British Embassy from 1948 to 1950.[1] As an embassy wife she would be expected to attend many dinners and balls for which she would need a glamorous wardrobe, and it was in every couturier's interest to see his clothes represented at these society functions. Jacques Fath was one of the couturiers who most pursued this form of promotion, and he invited Lady Alexandra to be fitted for two complimentary evening dresses and day dresses each season. 'If there was a Fath dress I wanted to keep, I could pay sale price at the end of the season. I was not allowed to go to any other couturier, but I did not want to – Fath was perfection.'[2]

For Lady Alexandra the luxury of Paris was like a fairy tale. She had almost forgotten about fashion during the war, and the rationing that still continued in London. In Paris she could immerse herself in the beauty and bustle of Fath's salon on avenue Pierre 1er de Serbie, where her own *vendeuse*, Madame Dufy (the painter's sister), would attend to her. Not least, she was dressed personally by Fath, who would drape fabric around her, moulding garments to her shape and creating 'the loveliest dresses she had ever worn'.[3] The great event of Lady Alexandra's time in Paris was the official visit of the Princess Elizabeth and

the Duke of Edinburgh in May 1948, for which Fath lent her a sumptuous gown made of cream satin embroidered with amber stones. Arriving at the Théâtre de L'Opéra with her husband, she recalled, 'We started to climb the marble staircase which was lined by the Garde Nationale [when] they suddenly sprang to attention and I realized they had mistaken us for the Princess and Duke. I hurried up the stairs as fast as my dress would allow. That was the effect made by my splendid Fath.'[4]

Lady Alexandra was fortunate enough to share the physique of Fath's models, and she was given some original dresses to wear. One such was a day dress in varying shades of grey, which she wore to the unveiling of a statue in honour of her father, Field-Marshal Earl Haig, in Montreuil-sur-Mer in 1950. The dress was only altered by Fath in order to fit Lady Alexandra during one of her pregnancies. Another dress that Fath created for her was in the Johnston tartan. Fath was well known for his daring use of pattern and colour, and the fabric suited his designs well. Perhaps Lady Alexandra's most precious Fath dress, however, was her wedding outfit in brown wool with gold Lurex threads, created especially for her marriage to Hugh Trevor-Roper in 1954. It was the last dress Jacques Fath made for her, and she wore it for many years afterwards.

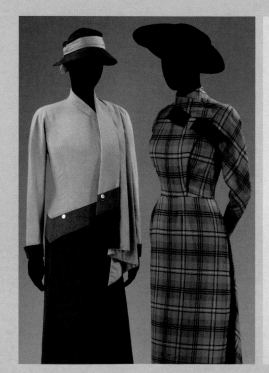

7.15 Two wool day dresses. Left: 1949, V&A:T.180–1974; Right: 1950, V&A:T.182–1974

7.16 Letter from Lady Alexandra to Cecil Beaton, 1974. V&A Archives

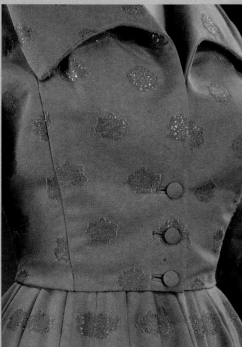

7.17 Lady Alexandra's wedding dress (detail), 1954. V&A:T.178–1974

7.18 Lady Alexandra in her 1948 state dress by Jacques Fath. Private collection. See V&A:T.184–1974

8

INTOXICATED
on IMAGES
The Visual Culture of Couture

CHRISTOPHER BREWARD

*'the whole world holds its breath,
and scraps of information appear
each day, with little sketches
supplying detail or atmosphere…'*

CELIA BERTIN

THE BEGUILING SURFACES of fashion drawings and photographs produced during the 1940s and '50s provide a rich and justly celebrated iconography of luxurious dressing in the 'golden age' of couture. But beyond the realm of surfaces, as Roland Barthes remarked in his classic thesis on the representation of fashionable dress, until the democratizing trends of the 1960s suggested other modes of operation, such images also played an active role in constituting the 'system' of fashion itself.[1] Their glossy perfection disguised the part they played in ensuring that elite visions translated into wider commercial worth. The standard literature on fashion photography has tended to avoid any consideration of Barthes' insistence on the centrality of image-making to the success of couture as an 'industrial' endeavour, characterizing this material through the art-historical prism of authorship and style. There are any number of beautiful books celebrating the achievements of individual photographers and magazines available, but these will often attempt, intentionally or not, to disguise the 'dirty debt' of their material to fashion's internal structures.[2] By way of redress, in this chapter I depart from such reifying approaches and draw on the published memoirs of those involved in the couture and magazine trades to get a fuller sense of the integral place taken up by image-makers (a term that includes the important interpretative work of editors and art directors) in a complex trade whose deft negotiation of the borderline between reality and dream deserves closer scrutiny.

8.2 Cocktail dress by Robert Piguet,
modelled by Dorian Leigh in Helena
Rubinstein's apartment. Paris, 1949.
Harper's Bazaar (American edition),
October 1949. Photograph by
Richard Avedon. V&A: PH.15–1985

The Image in Couture

The slick perfection of the editorial photographic commission in such magazines as *Vogue* or *Harper's Bazaar* may be the most familiar visual production associated with couture, but it is not the only one. Drawings and photographs were generated through every stage of the couture process, from inspirational sketch to promotional advertisement, underlining the truth that this was a business obsessed with making images. In order to set the celebrated photographs of Richard Avedon, Irving Penn or Cecil Beaton in context, it is necessary to reconstruct this evolutionary progression, which began with the simplest pencil mark.

In his autobiography Christian Dior provided a rare description of the creative practice of producing a collection, in which the designer's sketch takes prominence as the inspirational seed from which everything grows:

> I scribble everywhere, in bed, in my bath, at meals, in my car, on foot… by day and by night. Bed and bath, where one is not conscious, so to speak, of one's body, are particularly favourable to inspiration; here one's spirit is at ease. There is also the element of chance inspiration – stones, trees, human beings, mere gestures or a sudden ray of light, may be bearers of little whispered messages… My dresses take shape around me, as my fancy works on whatever it happens to see.

For Dior, the act of sketching becomes a way of progressing ideas swiftly and then editing them down. He continues:

> Little by little the pile of drawings grows, demanding new treatments capable of exploring all their potentialities… Then I behave like a baker who knows when to leave a well-kneaded pastry alone. Now that the line from which the new fashion can emerge is determined, I stop… I examine all my sketches from the first, which are scarcely more than rough outlines, to the last born, where the shape is more clearly defined. The selection takes place more or less automatically.[3]

From these initial 'scribblings', Dior then produced a second tranche of slightly more finished drawings that were handed over 'piping hot' to the workrooms. At this stage they formed the basis of a series of conversations that aided the translation of the couturier's ideas into three dimensions. Dior elaborates:

> My preliminary sketches, which in the charming if archaic language of couture, are still called '*petites gravures*', have been simply scrawled down, and do not give the details of a toilette … As they are passed from hand to hand, I comment on them and fill in the picture with the help of a few purely technical explanations, about the cut or the lay of the material. This is the first step in the metamorphosis of the sketch into the dress.[4]

'I scribble everywhere, in bed, in my bath, at meals, in my car, on foot… by day and by night.'

CHRISTIAN DIOR

From this point on design ideas were expressed through the calico of the *toile* on the body of the mannequin, rather than on paper, although the expressive medium of drawing still informed decisions about cut, drape and proportion.[5] Dior argued that although 'the couturier is naturally anxious to cut and sew well, he feels all the time this desire to express himself. For all its ephemerality, couture constitutes a mode of self-expression which can be compared to architecture or painting.' His '*première*' seamstress, therefore, was expected to effect a smooth transition from 'plan' to '*modèle*', or from 'cartoon' to 'canvas':

> [She] examines her appointed sketch, pulls it to pieces, takes it away with her, gets the feel of it, and finally drapes her *toile* around a dummy figure. Then she steps back, examines the effect, corrects it, balances it, and often entirely destroys it… After several fruitless attempts, the exact meaning of the material becomes apparent to her and the dress starts to take shape. Little by little the pile of sketches diminishes.[6]

As the shrinking pile of Dior's sketches implies, once the design had been fleshed out in fabric, the paper inspiration was redundant and few such drawings have survived beyond their moment of usefulness. A series of annotated drawings of dresses designed for Princess Margaret in the late 1940s by the London couturier Norman Hartnell do, however, suggest something of Dior's insistence that couture was a craft that relied on the traditions of two-dimensional rendering, even though their careful delineation and colouring hint that their purpose was more presentational than inspirational.[7] That the designer's drawing somehow embodied the essence of a collection's inspiration, suggesting (to use Dior's words) 'both attack and allure … a living line … redolent with movement', also partially explains the resistance of many couturiers to handing over ownership of a collection's original meaning to the press, where their ideas would be reinterpreted by illustrators and photographers, almost competing with the designer's talents as a draughtsman and stylist. But that level of professional suspicion was, as we shall see, a necessary motor for further creative expression.

Once *toiles* had been converted into the final collection, the next moment of engagement with the practices of visual representation came at the press showing of the new season's garments, where the concept of recording via line and shade became the focus of a rather defensive stance on the part of the couture houses. International journalists, whose approval was essential to the success of a collection, were admitted to the shows only under the tightest security, and drawing or photographing the new dresses was strictly forbidden. The only forms of reporting allowed were written descriptions and a form of 'very vague sketch' known as a '*tendance*', produced after the event from memory.[8] As American journalists Mary Brooks Picken and Dora Loues Miller explained in their guide to the couture system:

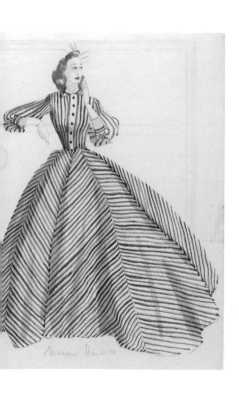

8.3 Norman Hartnell, design for an evening dress for Princess Margaret. The dress is in the collection of the Museum of Costume, Bath. V&A: E.623–1972

an innocent person, especially a student, might try to sketch a dress that appealed to her. Her paper will be taken from her and in some houses dramatically torn up before the entire audience to show that sketching is not allowed. Cameras worn as wrist watches or around the neck as a pendant ornament or on the ankle have also been discovered and the culprit ejected at once.[9]

Aside from increasing the mystique of the industry, such regulations were imposed in order to prevent the copying of collections by counterfeiters and the subsequent undermining of profits. In the three weeks between the first press showings and the publication of reports and images in the media, the couture houses and their buyers were vulnerable to piracy. This level of control extended to the production schedules of the press itself, for as French writer Celia Bertin explained: 'As the result of an agreement between the couturiers and the buyers, who do not want the new features of the models to be revealed by the newspapers before they themselves have taken delivery, no photographs may appear in the Press before a certain date fixed by the Chambre Syndicale de la Couture.'[10]

Images did slip through the net, however, informing the work of copyists on New York's Seventh Avenue and elsewhere. As Picken and Miller reported, 'people with false press cards often operate successfully because they have what is known as a photographic eye. After each collection they are capable of drawing the garments which have just been shown.' Organized into bands, the spies would divide their labour in a perversion of the specialisms of the couture workroom: 'One sketches the front of a garment, the second the back, a third the sleeves, and a fourth the trimmings. These can then be assembled and quickly sent by airmail to feed the nefarious business of copying.'[11] For bona-fide reporters, the barely repressed levels of paranoia that built up during this enforced period of silence were a quintessential component of the couture experience, and integral to its meaning and status. Celia Bertin put it very well when she described how 'the whole world holds its breath, and scraps of information appear each day, with little sketches supplying detail or atmosphere… while the publicity department is invaded by the press'.[12]

It was in the negotiation of set-piece editorial photographs for the key magazines, taken during this three-week embargo, that the relationship between the couture houses

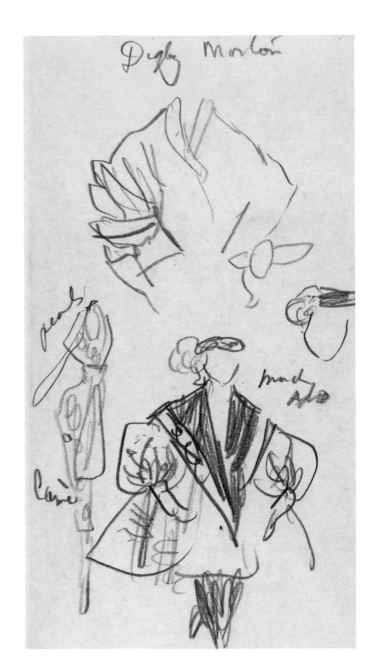

8.4 Francis Marshall, catwalk sketch of Digby Morton's 1952 theatre ensemble. See V&A: T.277–1975. V&A: AAD

and the press was often most fraught. And it is no coincidence that this was the moment when the designer's hold on the interpretation of the garment was finally forced to loosen. Some couturiers were more amenable to the incursion of journalists and photographers into their world than others. Bettina Ballard, fashion editor of American *Vogue*, recalled:

> …the publicity department of Dior was, and is, the most obliging in Paris, making it possible for pictures of Dior clothes to be the best and most plentiful in the press. I remember the summer of 1955 when their desire to please reached such heights that it was impossible to pass a street corner within walking distance of Dior's… without seeing Japanese, Scandinavian, Italian, American, German, English and various South American photographers and reporters snapping pictures of mannequins in exaggerated inhuman poses wearing Dior dresses.'[13]

8.5 Francis Marshall drawing model Barbara Goalen, watched by the fashion editor of *The Daily Mail*, Iris Ashley. Photograph by John French. V&A: AAD

And Dior himself recognized the value of such openness, although he tempered his comments with a defence of the creative rights and superior status of the designer:

If the new line is diffused too widely, too quickly, the collection loses much of its novelty and therefore also of its commercial value… [The] influence of the magazine on the couturier is essentially different in Europe and America. In the USA the Press is treated as an accomplice in the world of fashion, whereas in France it is either ignored or feared. The French couturier tends to blame the Press for indiscretions and bringing down the value of the models. In my opinion he is wrong to do so because the picture of a dress in a magazine can inspire a woman to buy it, and whatever the skill and accuracy of a drawing or photograph, nothing can compare with the model itself.[14]

Others were not so accommodating. Ballard was frank about Balenciaga's antipathy to journalists, complaining that 'he makes life as difficult as possible for them… The more journalists plead for stories, for clothes to photograph, the more the entire house of Balenciaga draws itself into its shell. He would like to exclude the Press entirely and one day he probably will… There is something of sadism in this. The Press grovels at the front desk… top editors are kept waiting for one dress which, mysteriously, can never be found.'[15] Charles James went to the other extreme, making intolerable interventions during photographic sittings: 'He would always arrive with the clothes, fussing over the way a dress fitted the mannequin, telling… whoever was photographing, how to pose and how to light the girl, and generally driving everyone mad… He couldn't help it. His creations were his life's blood… the outpourings of his soul.'[16]

English couturier Hardy Amies recognized the pressures of conflicting demands that caused such frustration on both sides, with designers requiring crisp verisimilitude, while '*Vogue* and *Harper's*, of course, want elegant and pretty pictures and are sometimes prepared to sacrifice the dress to obtain them'.[17] For Ballard, the divide was insurmountable, and with typical directness she bemoaned the fact that 'the charm that Avedon and other photographers try to capture by bringing as much of Paris as possible into their pictures… is lost on the couturiers, who feel that too much atmosphere takes away from the blueprint showing of their dresses. Deep in their hearts they prefer the straight, seam-showing photographic clarity that the *Officiel de la Couture* uses in its magazine, which is the bible of little dressmakers all over the world.'[18] That slightly dismissive reference to *L'Officiel*, with its obvious 'seams' and 'little dressmakers', marks

8.6 Newspaper cutting featuring Digby Morton's Autumn/Winter 1952–3 collection. V&A: Digby Morton Archive

8.7 Theatre ensemble by Digby Morton. London, 1952. Photograph by John French. V&A: AAD. For the ensemble, see V&A: T.277–1975

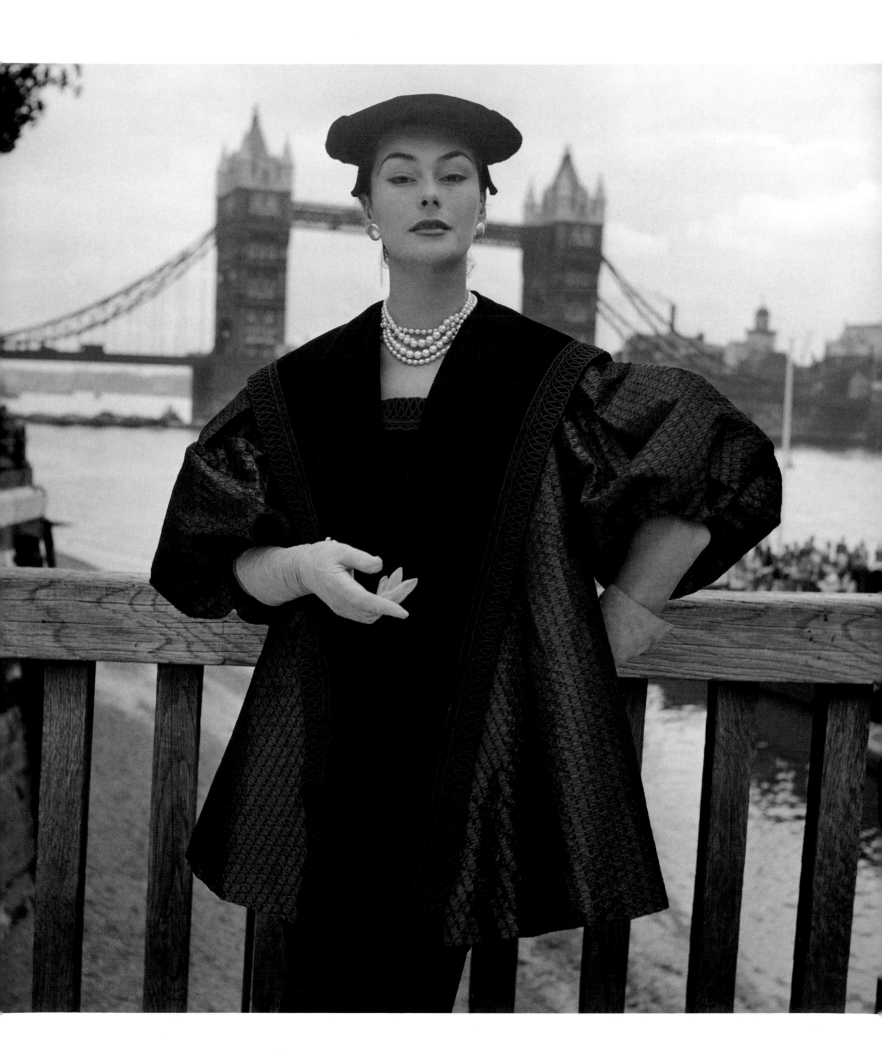

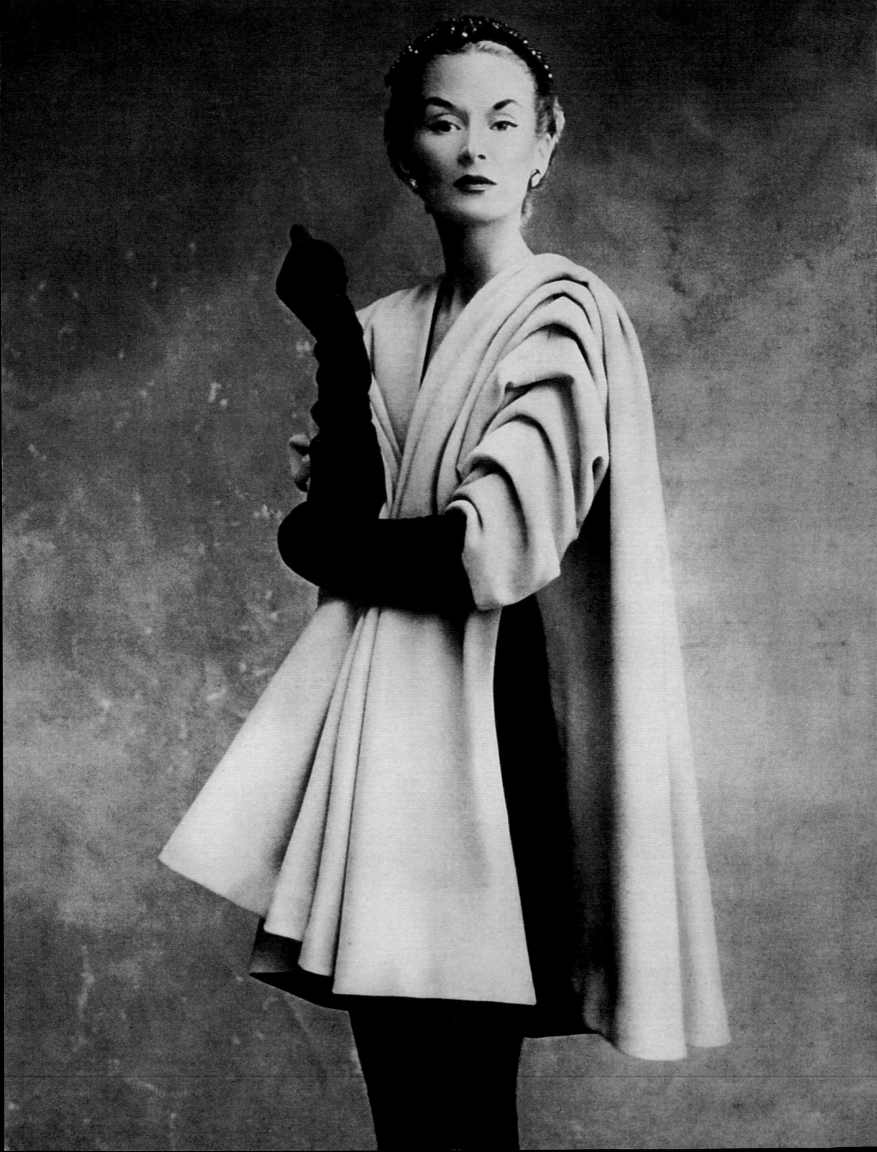

the defining difference between what was widely recognized as the prestigious in-house magazine of French couture ('an ambassador of Fashion of Parisian creation' to use Picken and Miller's awe-struck phrase),[19] and the far more progressive creative stance of the American journals which, in effect, were responsible for redefining fashion photography in the period – in spite of all the obstacles that couture houses placed in their way. Irving Penn captured the strange juxtaposition of expanding opportunities and constraining protocol in his description of his first Paris studio shoot:

Always sensitive to possibilities, Alexander Liberman [Art Director of American *Vogue*] arranged for me in Paris the use of a daylight studio on the rue de Vangirardon on the top floor of an old photography school. The light was the light of Paris as I had imagined it, soft but defining. We found a discarded theatre curtain for a backdrop. As it turned out, 1950 was the only year we were able to have couture clothes during daylight hours at the height of the collections. Clothes were hurried to the studio and back to the salon by cyclists. In the excitement of the time even Balenciaga was amenable to having us photograph his designs at our studio on our own choice of models [pl.8.8].[20]

Fashion illustrators arguably fitted more easily into the routines and expectations of couture than photographers – an ease that perhaps arose from the fundamental role played by drawing in the couturier's craft (as outlined by Dior) and a corresponding sense of shared values. Whatever the status of the fashion drawing in the world of publishing (which was perceptibly fading as photographs gained more prominence in post-war magazines), the relative adaptability and minimal equipment of the draughtsman meant that he could slot into the collection schedules with little disruption caused. A *croquis*, or preliminary sketch, could be taken in a few moments after the fashion show or between fittings. Indeed, as the English illustrator Francis Marshall suggested, any inconvenience was often borne by the long-suffering artist: 'The first few years at Dior were pandemonium, clothes were snatched off the mannequin's backs by frantic buyers. No sooner had you started sketching her than she was rushed off somewhere else. There was no room to draw and four artists might be working on the landing of a staircase constantly buffeted by *vendeuses* or even Dior himself running up and down stairs [pl.8.5].'[21]

Marshall's story of Dior, frantically running through the couture house at this crucial moment of the year, weaving through models, buyers, journalists, photographers and artists, provides a vivid illustration of the symbiotic relationship that existed between idea, object and image in the system of couture, a relationship that Dior himself likened to 'a never-ending love affair, renewed each season, involving endless intrigues and reconciliations'.[22] The final reconciliation, which took place at the end of the collections, was that moment of reflection when the images themselves hit the news-stands. Now, in

8.8 Coat by Cristóbal Balenciaga, modelled by Lisa Fonssagrives. *Vogue* (French edition), 1950. Photograph by Irving Penn

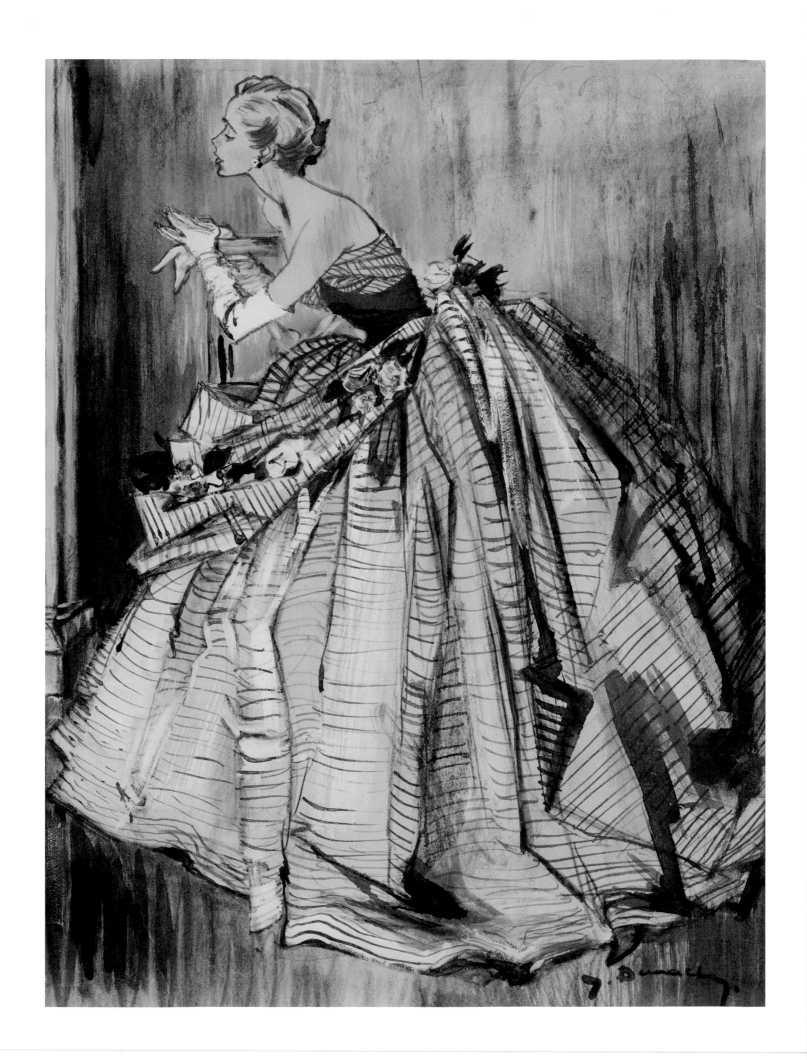

a process that echoed the theories of Barthes, the photograph and the drawing at last came into their own. Their powerful content imbued the subjects depicted with the 'spirit' of fashion in a manner that even the couturier (in this case Dior) found hard to resist:

> The weeks which follow the first showing have a decisive influence as the collection which follows is yet to be born. It is then that I perform my ritual self-criticism, in which I am assisted by the photographs or drawings published in the papers which often present me with an entirely new light on my creations. A detail which I had inserted without thinking, and which had become lost in the course of the execution of the dress, will emerge miraculously under the pencil of the artist or through the objective lens of a camera, as a result of a curious angle or unexpected lighting. Perhaps these revelations are a proof of the independence of my creations from their creator.[23]

Couture in the Image

How, then, was this final process expressed in the surfaces of the image? Henry Yoxall, the plain-speaking head of *Vogue*'s London office in the 1950s, held little truck with the romantic ideals of the couture houses or the pretensions of their protaganists and collaborators, but he did have an aptitude for summarizing, with tongue in cheek, the creative concerns of the industry within which he worked. In his description of what he termed 'the curious caste of photographers', he provides as useful a guide as any to the developing iconography of fashion imagery in the post-war years:

> De Meyer's swirling crepuscular backgrounds gave way to decors of Louis Quinze salons. Then came stark settings against white paper (in one of Cecil Beaton's periods, dirty white paper, preferably torn). Next emerged 'location' work, in Paris bistros, in the corrals of a stud farm, down a coal mine even – the last two preferably for evening dresses. Then there was the travel phase of photography. At first this was a legitimate move of consideration for the unfortunate mannequins who had to pose shivering in bathing suits in the North Sea in March; it was only fair to take them to Cannes as an insurance against pneumonia.[24]

Yoxall's approach may have been satirical, but he still captures the dominant representational styles taken up by illustrators and photographers in the 1940s and '50s. All are characterized by a directness and vitality that contrasted with the Hollywood-inspired photography more prevalent in the inter-war years. Then photographers including Horst P. Horst pioneered their practice 'in the studio with a big cumbersome camera… Elaborate sets were built as backgrounds, often designed by such famous decorators as… Jean Michel Frank.' As Bettina Ballard commented '[in the 1950s] it is

8.9 Evening gown by Lanvin, c.1950. Illustration by De Marché for *Harper's Bazaar*. V&A: E.685–1997

easier to transport small cameras and lights to interesting locations, to someone's well-decorated house, or to a museum or shop.'[25]

The studio tradition still continued after the war, but the approach taken seemed sharper, with a pure focus on the subject – what might be termed a form of couture 'still-life'. Irving Penn was a master in this respect, bringing to his compositions a stillness that was perfectly attuned to the precision of the couture object. Describing his working methods in 1946, Penn recalled how 'in my windowless New York studio I designed a bank of tungsten lights to more or less simulate a skylight… I found this to be an agreeable light for the formalized arrangements of people and still lifes I meant to photograph. A drawback… was the considerable heat of the bulbs and the long exposure times required… sometimes hours long.'[26] Such a setting produced Penn's celebrated food studies (pl.8.12), reproduced in *Vogue* in 1948, whose concentrated rendering of texture and feel for compositional balance translated directly into his fashion shoots, such as the tarot reading scene of 1949 (pl.8.11). Liberman argued that it was 'superb ornamentation, striking cut' and 'the fashion designer's play with a woman's body' that stimulated Penn's 'eager search for the exacerbating recording of extremes'. And in this image, the violent diagonal of the models' poses and the abstraction of their hats are certainly reduced to their decorative essence along similar lines. Other photographers were also inspired by the formal qualities of couture. The Italian Frank Horvat was as particular as Penn in his meticulous staging of garments as sculptural pieces, frozen in time. 'The word "order"', he insisted, 'is certainly one of my key words. I feel deeply threatened by the idea of entropy, by the lack of order in general.' And this sense of control informed his attitude to his craft, which he described as 'the art of not pressing the button, of refusing an infinite number of possibilities, expressions, angles, lighting effects, which do not coincide exactly with my accumulated expectation.'[27]

Cecil Beaton, one of the most celebrated British fashion photographers, also emerged from the established traditions of studio photography. Indeed, his earlier career in the 1920s and '30s was based almost entirely on the construction of elaborately theatrical settings in which portrait sitters became players in a series of glamorous tableaux, their shimmering ambience conjured out of the inventive use of mirrors, tulle and cellophane.

Paris is marking time. No drastic changes. Instead, the interest of developments and variations—which are as proper to fashion as to music. There is no single silhouette; indeed, considerable diversity, which springs mainly from diversity of detail. Skirts range from Dior's full stiff uneven hemlines (p. 46) to Fath's test tubes; waists from Directoire to normal. The back-dipping trend in skirts, capes and jackets is symptomatic of a transitional, experimental fashion stage.

Paris has made up its mind on some counts. Skirts are shorter; few day skirts less than thirteen inches from the ground; many late-day dresses no longer (see page 51). Hips are emphasized; by peplums, by trimming (such as the buttons, opposite), by pockets. Sleeves are wrist-length, even on late-day dresses (page 50). Materials are heavy, rich and good; hardly a light-weight fabric to be seen anywhere.

Paris points up detail … Wonderful wing-back decolleté of the Dior dress, opposite. Huge flapping cuffs like seals' fins. Shelf-back cut on coats, suits, dresses (p. 47). Forward-jutting collars (p. 46). Wide leather belts, deep swathed cummerbunds. Cape collars, double or single. Fur linings. Innumerable leopard touches, day and night.

Paris shows enchanting accessories. Stoles that wrap like stoles (p. 51). Stoles that wrap like saris (p. 49). Ubiquitous boots, ankle to hem-height (pp. 46, 48). Feet gloved in gaiters (p. 48). The outstanding hats are the cloches, in fabrics from suède to satin, and shown with everything. They give a round firm head outline. There are Directoire hats; Venetian bicornes and tricornes; diagonal melon-slice hats. Jewels have Byzantine magnificence.

Paris has important neckline news. Opposite: Dior's wing-back decolleté on a back-buttoned wool dress worn with a close velours cloche. Right: Legroux's long jersey stole, worn chin-high, and partnered by the simplest jersey cloche.

COFFIN

Eric

8.10 Above: Illustration by Eric. Right: dress by Christian Dior, 'Zigzag' collection, Autumn/Winter 1950–1. Photograph by Clifford Coffin. The two images formed a double-page spread in *Vogue* (British edition), October 1948

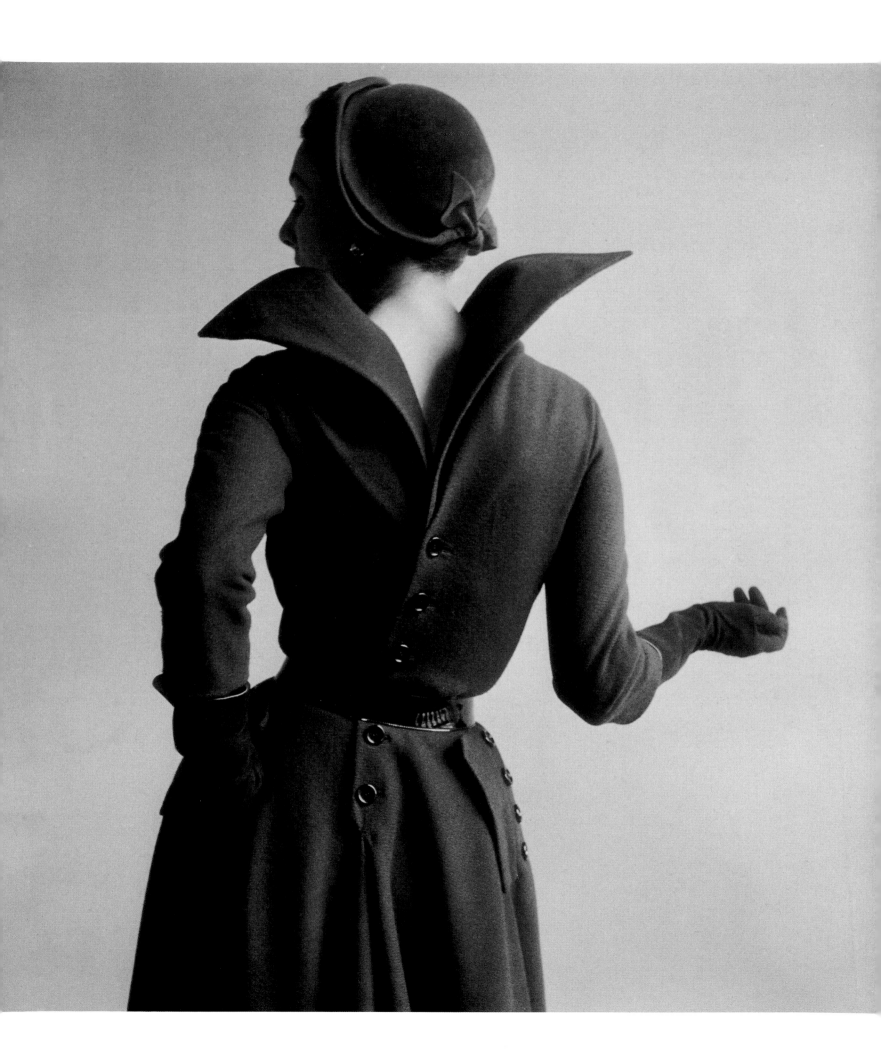

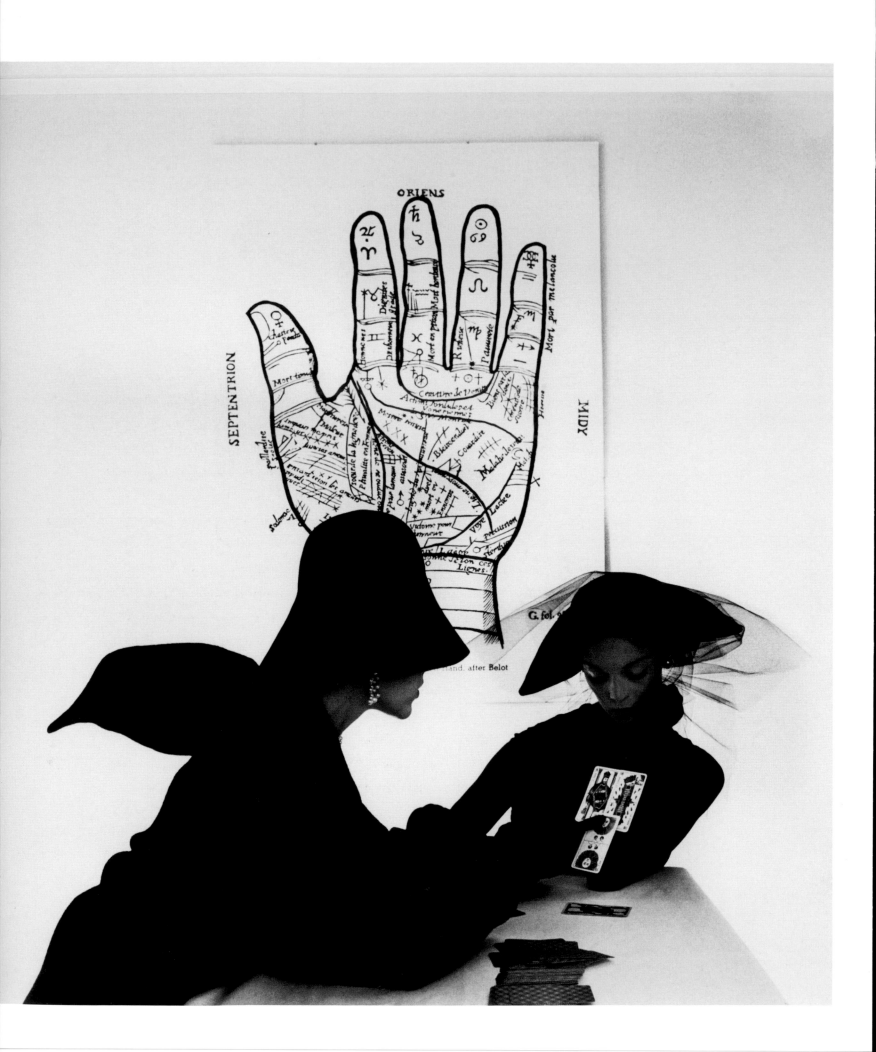

However, an interlude working for the Ministry of Information in the 1940s brought a new realism to Beaton's work, and when he returned as a contract photographer to Condé Nast in 1945 his fashion images reflected a changed professional, social and physical landscape. Models dressed in the neatly tailored couture of the Incorporated Society of London Fashion Designers moved through the bombsites of the capital as if surveying the ruins of that older schema of elegant escapism (see pls 1.2 and 2.2).

The use of the city street as a backdrop was an important theme for several photographers in the late 1940s, and in Paris it was a genre pioneered by Richard Avedon. His pictures of models mingling with the proletarian crowds in the Marais of 1947 and '48 capture the mood of couture at its most bohemian. In one, the notorious aesthete artist Christian (Bébé) Berard, whose word according to Beaton 'could make a hatshop or break a dressmaking establishment',[28] disports playfully with a poodle and the model Renée, swathed in furs and a Dior suit, while in another Elise Daniels, in Balenciaga, strikes a pose that is as contrived as that of the contortionist whose act she has infiltrated (pl.8.13). It is as if the whole carapace of couture's promotional culture is being 'burlesqued', exposed as the performative charade it really is. Beyond bohemian masquerade, these carefully orchestrated *mise-en-scène* representations also expressed something of the economic and psychological investment Americans made in Parisian couture at this time. Historian Anne Hollander identifies in them 'the Jamesian two-way thrill of the American presence in the Old World, Avedon's models in Paris all look like candid Daisys and Isabels... It goes very well with the nineteenth-century flavour of Dior's new designs. Avedon was rendering the haute couture human in the style of great fiction.'[29]

8.11 'The Tarot Reader'. *Vogue* (American edition), October 1949. Photograph by Irving Penn. V&A: PH.929–1987

8.12 'Salad Ingredients'. *Vogue* (French edition), January 1947. Photograph by Irving Penn. V&A: E.1526–1991

Out of doors this arch masquerade of realism gained some representational power from the combination of grey urban setting and attenuated sartorial elegance: an alchemical reaction where 'Avedon took the bitter French doctrine that life had to be lived for its own sake and applied it to the overabundant American culture of Seventh Avenue, creating in the process a new imagery of the bonheur de vivre.'[30] But once moved inside, the *cinéma-vérité* approach took on further layers that were more directly suggestive of the themes of luxury and artifice that lay at the heart of the couture project. Fashion illustrators were particularly skilled at conjuring up an unsettling world of sensual excess, which

> *'Avedon was rendering the haute couture human in the style of great fiction.'*
>
> ANNE HOLLANDER

hinted at the dark secrets of the pornographic novel with its fetishistic details.[31] René Gruau's 1949 drawing for *Fémina*, of a supremely supercilious model in black Balenciaga, imperiously balancing one gloved arm on a luxuriously upholstered golden chair while her scarf trails artfully to the floor, is a typical example, infused with the taut anxiety that often accompanies privilege and elegance (pl.8.14). While illustrations such as this looked back to the powerfully erotic graphic devices of Max Klinger and Aubrey Beardsley, during the 1950s photographers combined this sexualized repertoire with references to filmic melodrama. Avedon's image for the September 1954 edition of *Harper's Bazaar* shows the model Sunny Hartnett in a white jersey Mme Grès evening dress, leaning over the gaming tables at Le Touquet (pl.8.1). In discussing the work, the photographer acknowledged the influence of the classic Hollywood productions of Fred Astaire, but besides the nostalgia, there are also references (perhaps slightly cynical ones) to the artificial mystique of femininity, a mystique that couture deliberately fostered and sought to impose.

It was in the most controversial and avant-garde category of iconographic themes that the visual culture of couture could most profitably engage in the promotion of a mystique that Barthes might otherwise have termed 'fashion'. A tendency towards abstraction in the 1950s was particularly suited to filtering the visual characteristics of couture down to their most concentrated form. For some industry commentators, this trend was unwelcome. Ernestine Carter of *The Sunday Times* regretted that what photographers of the period had striven 'to do was shock and excite, be damned to the clothes they were supposed to be reporting'. For her, 'to photograph a dress so that it is distorted or impossible to see not only betrays the unfortunate designer but denies the equally unfortunate reader the right to be informed' – the ultimate destination of the

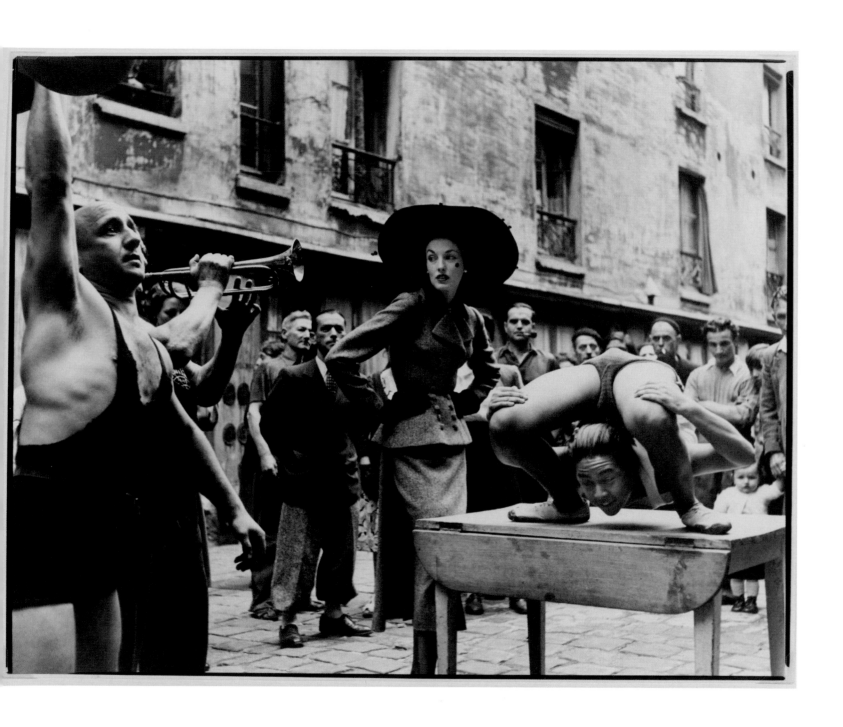

8.13 Suit by Cristóbal Balenciaga,
modelled by Elise Daniels.
Le Marais, Paris, 1948. *Harper's
Bazaar* (American edition), October
1948. Photograph by Richard
Avedon. V&A: PH.13A–1985

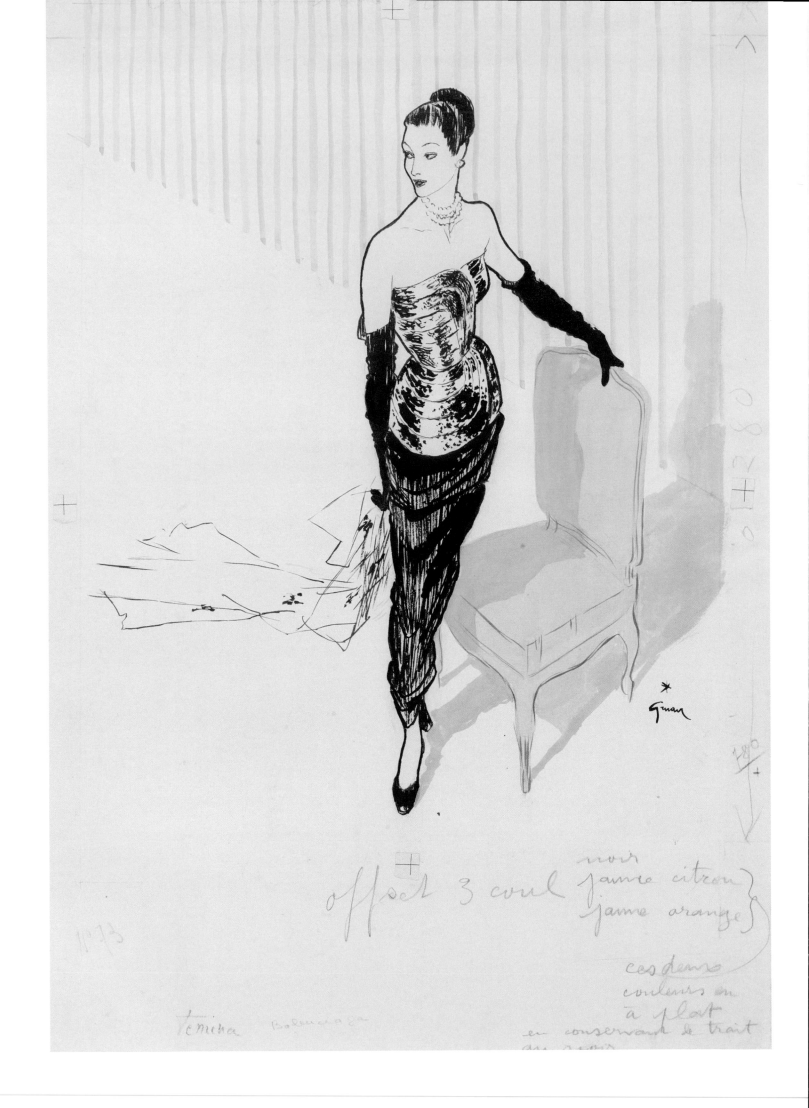

directions first taken up by Avedon and his generation had resulted in the (to Carter) ridiculous situation whereby 'if a social historian of the future were to attempt to reconstruct our way of life in the mid-sixties with fashion photography as his only guide, he might well conclude that we had been a race of zany acrobats.'[32]

What Carter failed to recognize was the way in which this new style of fashion photography captured the essence of modernity, or contemporaneity, in a manner that was out of reach of the more straightforwardly representational approaches that she preferred. In Avedon's work this held direct relevance for the fomenting of new attitudes towards femininity and its fraught relationship with commercial culture. For example, in his image of Elise Daniels in a Paulette turban of 1948, what looks like a fleeting snapshot freezes the defining elements of post-war beauty – the nails, lips and eyebrows – in all their fragile glory, producing an effect that is both vulnerable and empowering (pl.8.15), whilst also echoing the polished perfection of a Gruau lipstick advertisement (pl.8.16). Noting that the launch of Dior's New Look, the publication of Simone de Beauvoir's *The Second Sex* and the exposure of Avedon's work in *Vogue* all took place in 1947, Hollander observes that:

> In their reflexiveness, [Avedon's] fashion photographs seem to acknowledge how hard it is for a woman to become self-aware and self-possessed...
> He demonstrates that a designer can give her great visual means, and a photographer can hold his canny mirror to show that clothes and mirrors are always her allies; but mainly Avedon shows that the quality of the performance depends on her and springs from within.[33]

The *Harper's Bazaar* photographer Lillian Bassman took the effect one stage further, paraphrasing the essential components of fashionable femininity through technical means (exposing the negative through a tiny hole cut in a piece of card and ensuring that only some areas burnt onto the photographic paper in an approximation of freehand drawing), so that what remained were the joyful outlines of modishness. Her editor, Carmel Snow, famously hated the results, admonishing the hapless Bassman with the warning that 'You are not here to make art, you are here to show buttons and bows (pl.8.17).'[34] In reference to Avedon's work, Adam Gopnik argues that the unreality of his vision 'tends towards an ideal... femininity, style, is something constructed – worked for, tweezed and modelled and highlighted into being, the labour of it is always there, but also the fun of it, the affirmation of life'.[35] The observation rings even truer for Bassman, whose 'oblique but atmospheric photographs placed the expression of mood or emotion above describing detailed fashion information'. This may have infuriated the likes of Snow and Carter, but as Martin Harrison states: 'even the most extreme of her experiments... succeed in conveying the essence of fashion with considerable dash and fluency'.[36]

8.14 Evening dress by Cristóbal Balenciaga. *Fémina* magazine, 1949. Illustration by René Gruau V&A: E.397–1986

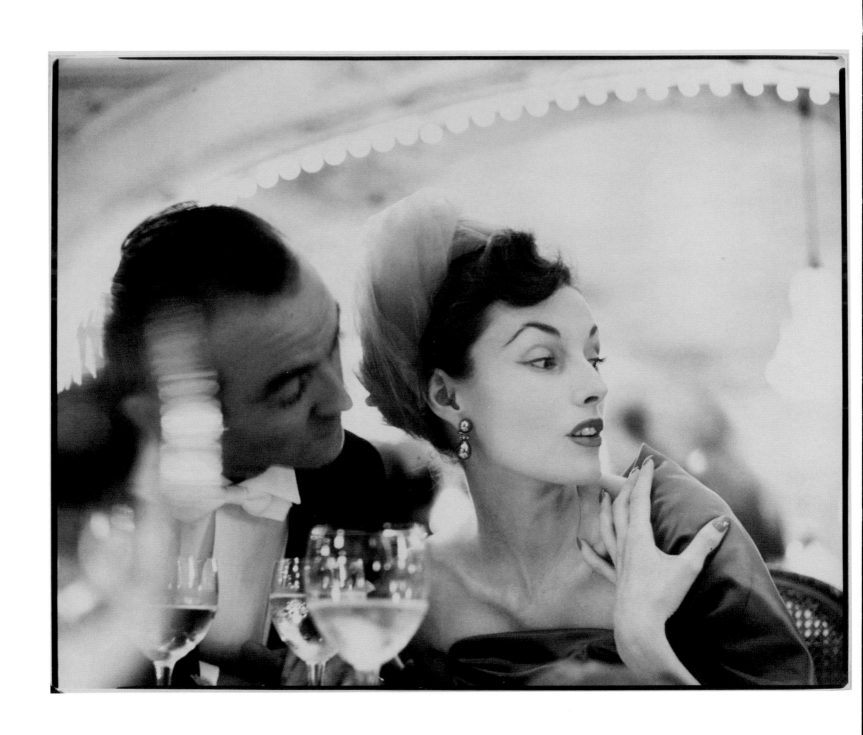

8.15 Hat by Paulette, modelled
by Elise Daniels. Paris, 1948.
Photograph by Richard Avedon.
V&A: PH.19–1985

8.16 Advertisement for Rouge
Baiser lipstick, 1949. Illustration
by René Gruau. V&A: E.395–1986

It is a supreme irony that it should have been couture, a cultural and industrial
phenomenon most often associated with the constraints of tradition, that gave rise to
the intoxicating and forward-looking imagery of Avedon, Bassman and the rest. But
couture was always riven with ironies. As Celia Bertin noted in 1956:

> Couture is something quite different from the idea of it given by the newspapers,
> which can only convey its most superficial, its least true aspect. Above all the
> conventional language used still further distorts the impression. An art which is
> extremely difficult to describe, and by its very nature inimitable, has to be
> interpreted... and thus conveyed by isolated examples, to women all over the
> world... It must never be forgotten that the effort to find new markets and
> outlets for this most individual industry makes it essential to maintain popular
> interest in a luxury art.[37]

The drawing and the photograph offer powerful evidence of the productive tensions that
existed at the heart of the idea of couture as it reached its most illustrious phase – tensions
between the status of the auratic, hand-crafted masterpiece and its mass-reproduction.[38]
They disseminated a tantalizingly accessible version of Parisian splendour to an

8.17 Dress by Jacques Fath, modelled by Barbara Mullen. *Harper's Bazaar* (American edition), March 1950. Photograph by Lillian Bassman

8.18 Silk evening dress (designer unknown), modelled by Barbara Goalen. Autumn 1954. Photograph by John French. V&A: AAD

international audience; they supported and reflected a system of bespoke production that had remained almost unchanged for at least a century; and they anticipated the emergence of new methods and markets, more attuned to fresh notions of the 'popular'.[39] In this sense, the visual culture of couture aptly vindicates Barthes' influential claim that 'the description of fashion… is a social fact, so that even if the garment of fashion remained purely imaginary… it would constitute an incontestable element of mass culture, like pulp fiction, comics and movies.'[40] We may never come close to touching, wearing or owning the material stuff of couture, but through the work of the photographer and the illustrator we can at least lose ourselves in its almost tangible sense of romance.

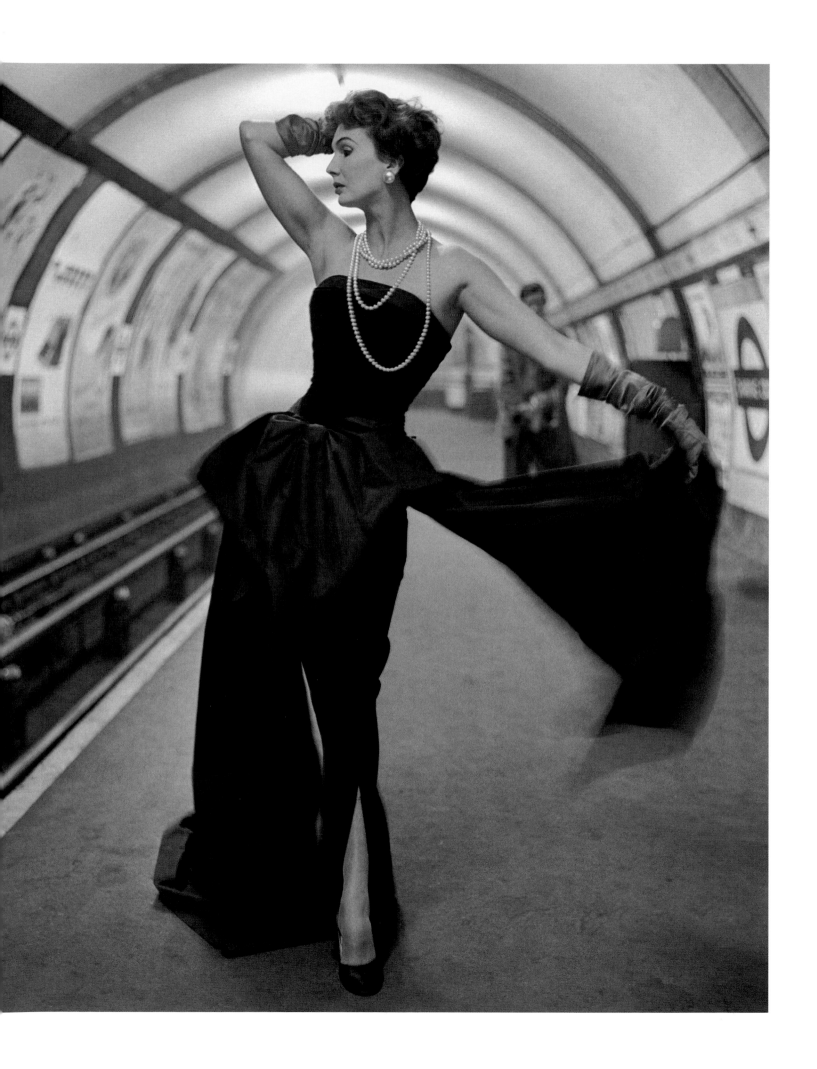

Richard Avedon

ABRAHAM THOMAS

Richard Avedon photographed the model Suzy Parker wearing a Christian Dior grey faille evening dress for the October 1956 issue of American *Harper's Bazaar*. He was regularly sent to Paris to document new collections and had the use of a photography studio on the rue Jean-Goujon, which was directly behind the House of Dior. Avedon would later recall that during photo-shoots he was able, from the balcony, to wave to the Dior seamstresses. The previous tenants of the studio – photography luminaries such as Baron de Meyer, George Hoyningen-Huene and Louise Dahl-Wolfe – had left the skylight covered with tar paper and plaster. One day, Avedon decided to rip away these layers of masking material, allowing daylight to pour into the studio space for the first time in years. The natural light here creates an even, diffused illumination that softens shadows and depicts the folds of the dress as delicate, fragile lines. Intentionally creating a schism between himself and his predecessors, Avedon moved away from the tradition of theatrical sets, studio lighting and extraneous props to a more pared-down, lithe approach to *mise-en-scène*.

Parker stands under the flood of daylight above her and, for one moment, the luxury of the woven silk fuses with the cheap felt background cloth, the folds of which echo those created within the stole as she gently pulls it around her body. The similarity in shade between gown and backdrop allows Parker to dissolve into the wall of cloth behind her, with only her face, neckline, white gloves and a glimpse of shoe floating to the surface in sharp relief. Avedon later spoke about his choice of backdrop: 'A dark background fills, a white background empties. A grey background does seem to refer to something – a sky, a wall, some atmosphere of comfort and reassurance – that a white background doesn't permit. With the tonal background, you're allowed the romance of a face coming out of the dark.'[1]

At first glance, through coincidences of fabric texture and dimensions, Parker seems to be pulling down the backdrop cloth from behind her, perhaps presenting some sort of equivalence with Avedon's heretical stripping of the skylight coverings earlier. Avedon captures the energy of Parker's gestures by preserving the blur of the stole to the right of the photograph. This dynamism would have been encouraged by Avedon's mentor, Alexey Brodovitch, who served as artistic director on *Harper's Bazaar* from 1934 to 1958. Avedon and Brodovitch believed that the synthesis of image and text was the crucial end-product within the pages of the fashion magazine. By carefully juxtaposing images with inventive experiments in typography, and presenting a narrative through photographic sequences inspired by cinematic montage, they ensured that the status of the fashion photograph as discrete illustrative entity was no longer valid. The *Harper's* double spread, which eventually featured a different photograph from this Parker/Avedon sitting, shows how Brodovitch employed a system of visual choreography to create a conversation between the two images that faced each other across the spine of the magazine.

8.19 Evening dress by Christian Dior, modelled by Suzy Parker (left). Paris, 1956. *Harper's Bazaar* (American edition), October 1956. Photographs by Richard Avedon

8.20 The reverse of 8.21, with Avedon's comments and stamps

8.21 Photograph by Richard Avedon. V&A: PH.24–1985. See V&A: T.124–1974

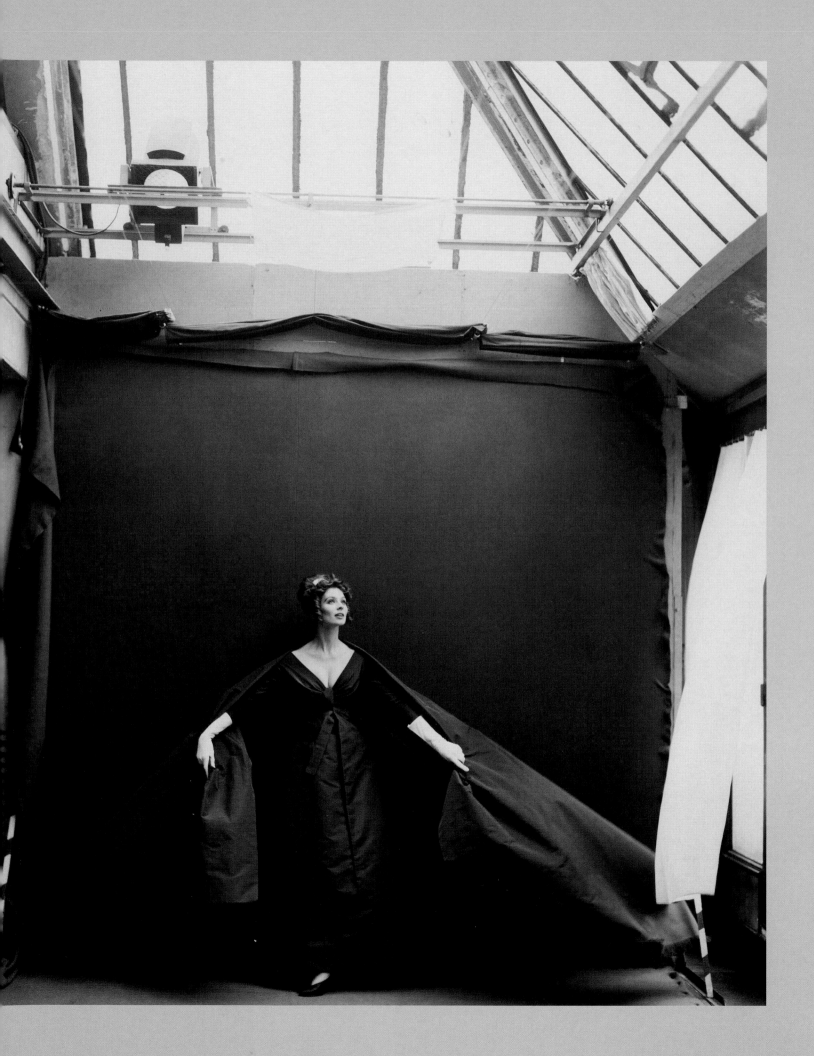

Erwin Blumenfeld

ABRAHAM THOMAS

Erwin Blumenfeld said that he experienced a greater sense of creative freedom when he was depicting accessories and beauty products on mannequins rather than on real women. In 'Décolleté', which appeared on the cover of American *Vogue* on 15 October 1952, he approaches his subject as one would a still-life study, using a formal, static composition to portray the live model as passive mannequin, reducing his subject to an archetypal distillation of female beauty: red lips, exposed neck and *décolletage* framed by folds of the Jacques Fath dress. Blumenfeld's background in Berlin as an apprentice dressmaker informed his understanding of how clothes could transform the female body. He used cloth to delicately orchestrate curves and shadows; here, it forms a sensuous rebuttal to the pale pink flesh of the *décolletage* and the violent gloss red of the lipstick.

Blumenfeld had emigrated to New York from Paris during the Second World War, and worked for *Vogue* in the key years when fashion magazines provided a point of convergence and site of incubation for pioneers in graphic design, illustration and photography. His timing proved fortunate — American women had become tired of the austere fashions demanded by government restrictions on materials throughout the war years. They yearned for imagery and ideas that offered escapism, which Blumenfeld provided willingly. He was already familiar with the fashion inferences of Surrealism from his time spent amongst avant-garde artists in Europe, and this, combined with his early experiments in Dadaism, brought a unique level of ingenuity to his work. Upon arrival in New York, Blumenfeld reluctantly moved from the 9 x 12 cm format camera to the 8 x 10 inch American format of the studio camera. Any problems arising from working in these new proportions were tempered by the fact that he tended to shoot using a wide angle. This he did to allow himself the freedom and flexibility to crop the picture with extreme precision during the printing process. Many of Blumenfeld's fellow photographers considered the full frame of the negative to be sacred, believing that cropping was a sin. Blumenfeld, however, understood the image-enhancing capabilities of cropping to create dramatic compositions and narratives. His formal economy combined with his strong sense of graphic design resulted in an unparalleled level of aesthetic purity and restraint, which is reflected in numerous memorable and hard-hitting *Vogue* covers.

Advertisers regularly saw Blumenfeld's photography within the editorial pages of *Vogue* and noticed his close attention to detail regarding the female face and hair. He was a natural choice for cosmetics photography and went on to win lucrative advertising contracts with firms such as Elizabeth Arden. Such cosmetics firms swiftly became the most powerful group of advertisers in fashion magazines, and 'Décolleté' is testament to how the 'face', as opposed to the complete figure, became the dominant image on magazine covers during this period.

8.22 'Blue eyed look for Spring'. *Vogue* cover (British edition), April 1951. Photograph by Erwin Blumenfeld

8.23 *Vogue* cover (British edition), January 1955. Photograph by Erwin Blumenfeld

8.24 *Vogue* cover (American edition), October 1952. Photograph by Erwin Blumenfeld

8.25 Dress by Jacques Fath. Photograph by Erwin Blumenfeld. V&A:PH.229–1985

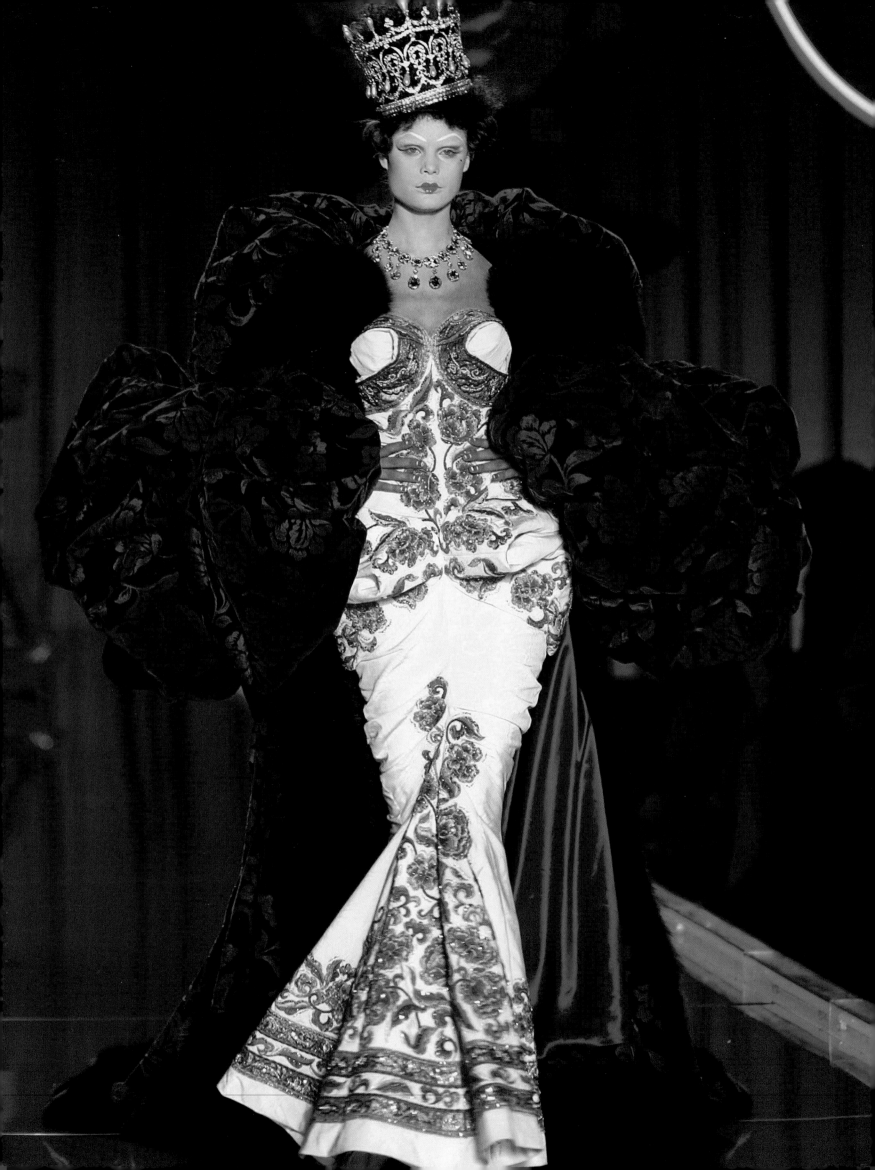

9

THE LEGACY OF COUTURE

CLAIRE WILCOX

'In fashion we've reached complete freedom of expression. There is a spirit of total liberation and freedom.'[1]

YVES SAINT LAURENT

WHEN *QUEEN* MAGAZINE announced the death of couture in 1964 with fictional obituaries of Balenciaga and Givenchy, and Brigitte Bardot remarked that 'couture is for the grannies', the demise of haute couture certainly seemed imminent.[2] The revolution in fashion emanating from London saw an increasing emphasis on a younger and less wealthy clientele, driven by the emergence of ready-to-wear designers of great individualism, such as Mary Quant and Ossie Clark, and Paris-based Emmanuelle Khan and Sonia Rykiel. Mass production and mass appeal went hand in hand and couturiers soon seemed out of touch with the dominant youth culture. The number of couture clients inexorably decreased and mothers no longer habitually introduced their daughters to their personal *vendeuses*. While young society women may have still commissioned wedding dresses and ball gowns from a couturier, many preferred the freedom of ready-to-wear for everything else they chose to wear.

The survival of great institutions such as Dior lay in their existing wealth and lucrative licensing arrangements, while many other couture names, such as Nina Ricci, became increasingly identified with perfume sales. Most leading couturiers had in-house boutiques that sold accessories, gifts and separates requiring only one fitting. However, under pressure from a changing market, couturiers began to show both haute couture creations and ready-to-wear collections. In the 1960s, the Chambre Syndicale stipulated

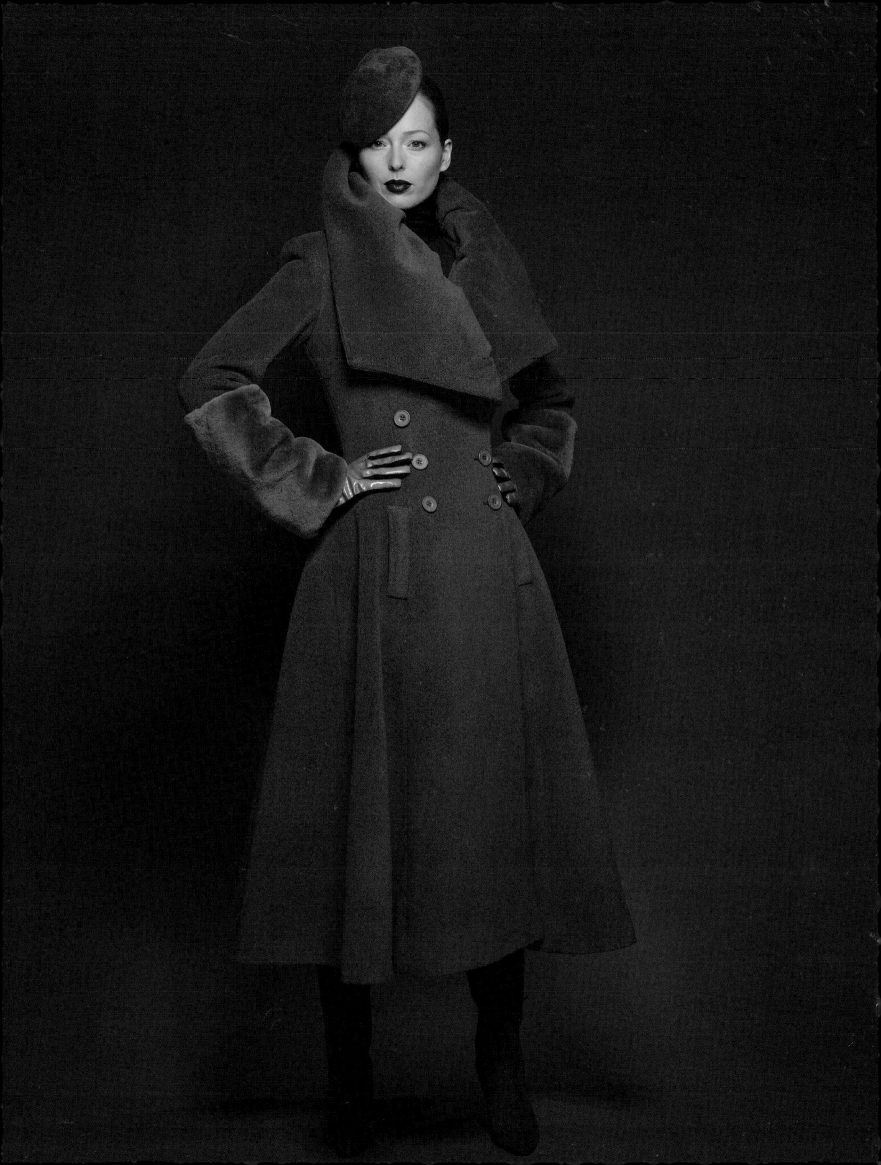

9.3 Givenchy (Riccardo Tisci), haute couture collection, Spring/Summer 2007

that the couturier's ready-to-wear collections should not be sold at any outlet other than their own boutique, in order to keep Paris fashion as exclusive and grand as possible. Failure to comply with couture regulations still resulted in expulsion from the Chambre Syndicale, but for some couturiers the consequences were no longer deemed important. Pierre Cardin, for example, initiated a contract with the department store Printemps, and was debarred. It was impossible to hold back the democratization of fashion. In 1966, Dior opened its 'Miss Dior' boutique which sold inexpensive youthful designs; in the same year Yves Saint Laurent opened his 'Rive Gauche' boutique on Paris's Left Bank and in 1967 Courrèges launched his boutique, 'Couture Future'.

London's great strength remained in its tailoring traditions. The transformation of Carnaby Street from unremarkable thoroughfare to home of the 'mod' look and, in the 1960s, a mecca for fashion's bright young things was propelled by tailors and boutique owners such as John Stephen who helped to create London's 'Peacock Revolution'.[3] In Savile Row, the couture and tailoring house Hardy Amies survived the 1960s by diversifying into accessories and off the peg menswear lines which married good cut with modern fabrics. Today it remains the sole surviving English house from the post-war decade to create couture – both dressmaking and men and women's tailoring – for private clients in an environment unchanged in spirit since the house's foundation in 1946. Amies's protégé Ian Garlant said of British couture 'it is not about reinventing yourself, but about making you the best kind of you that you can be. Strengthening your own identity.'[4]

9.4 Christian Lacroix, haute couture collection, Spring/Summer 2007

9.5 Jean Paul Gaultier, haute couture collection, Spring/Summer 2003

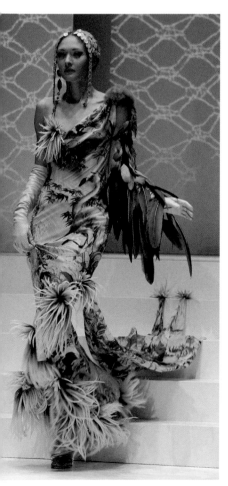

The synergy between the two cities of Paris and London in the post-war decade was based on an exchange of skills and trade in textiles. It has continued in recent years with the appointment of British designers like John Galliano who have reinvigorated Paris couture, just as incomers such as Balenciaga and Dessès did in 1937. With his appointment to Givenchy in 1996, Galliano became the first British designer since Worth to lead a French haute couture house, soon succeeded by Alexander McQueen, then Julien MacDonald. Chief designer at Dior since 1997, Galliano's virtuoso theatricality has provided the perfect vehicle to demonstrate the technical and stylistic resources that the house can still draw on. In recent years, French-born designers have also become members of the Chambre Syndicale, such as Christian Lacroix in 1987 and 'enfant terrible' Jean Paul Gaultier, eventually accepted as a permanent member in 1999. Honorary non-Paris based members include Italian couturiers Armani and Valentino, while guest designers including British designer Vivienne Westwood have shown at the couture collections by invitation.[5]

Two of the most important surviving Paris houses from the pre-war period, Chanel and Balenciaga, thrive today by employing different approaches. The cogency of Chanel's brand, based on the designer's original philosophy of function married to exclusivity, has been stabilized and elaborated upon by Karl Lagerfeld since 1983. In recent years, Chanel has purchased several of the most important surviving Parisian workshops that still supply its trademark buttons, camellias and braid, including the embroidery company Lesage and costume jeweller and button-maker Desrues. After years of neglect, the grand house

of Balenciaga has been revived by the appointment of Nicolas Ghesquière in 1997, through the medium of stylish ready-to-wear rather than couture.

The legacy of Dior's 'golden age' is manifold. The rarefied skill of couture in the post-war years set a standard for high dressmaking that has never been surpassed, while the economic and social forces that shaped its production created a sophisticated marketing model that insisted on fashion's constant renewal. Post-war couture is indelibly associated with the New Look, a style that influenced popular fashion in a way that was unprecedented in fashion history, and sixty years on its memory still has great potency. Breathtaking image-making by the great photographers of the time, and the emergence of notable fashion models characterized by their elegance and flawless faces, epitomise an era of heightened

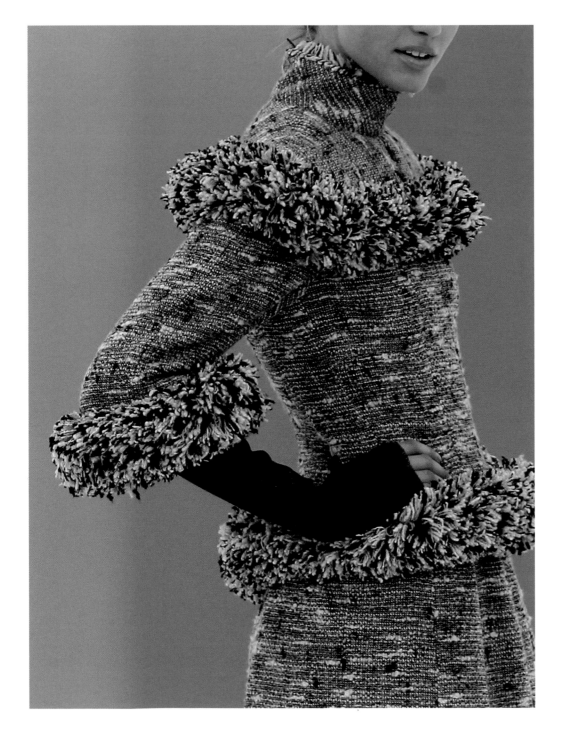

9.6 Chanel (Karl Lagerfeld), haute couture collection, Autumn/Winter 2006–7

femininity. Today, the couture collections are still shown in Paris; often extreme and extravagant, their role is to garner publicity and provide inspiration. Only a small group of loyal clients are still able to afford couture and most of the audience are press, or celebrities who may be lent 'red carpet' dresses for special occasions, while many of the gowns are destined for archive or museum collections. In a discipline where craftsmanship is key, couture's painstaking techniques and anachronisms have been continually passed on, in workshops and cutting rooms and from designer to designer. The metier survives today in a handful of fashion houses, where once there were hundreds, representing a symbolic commitment to artistry and handcraft, that captures in its complexity all the skill and fantasy of the old world of Christian Dior and his contemporaries.

9.7 Givenchy (Alexander McQueen), haute couture collection, Autumn/Winter 1997–8

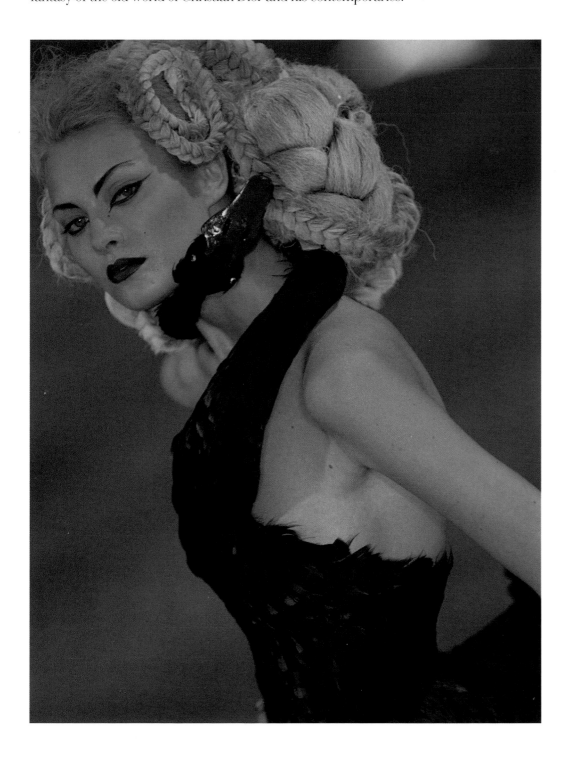

Notes

1 Introduction

1 Bertin (1956), p.236.
2 Stéphane Mallarmé, from 'La Dernière Mode' in D.L. Purdy, *The Rise of Fashion* (Minneapolis and London, 2004), p.224. Dior notes that some archaic terms such as '*petite gravure*' (sketch) were still used. Dior (1956), p.15.
3 'They had to have certain standards before a fashion house would be accepted as a member of the Chambre Syndicale. They had to have their own house... a minimum number of employees... make a collection twice a year of a minimum number of garments... employ about 200 people... you would find certain fashion houses who were not allowed, not admitted... perhaps they had outworkers, their work... might be cut in a workroom, in a small boutique or one or two storey house, and then somebody would come in the evening, pick up the cloth and take it home and sew it at home and then bring it back. And they were not considered eligible to be members of the Chambre Syndicale de la Couture.' Percy Savage, The British Library Sound Archives, London, C1046/09. Savage worked as press officer for first Nina Ricci then Lanvin Castillo in Paris, 1947–74.
4 Veillon (2002), p.90.
5 Ibid., p.86.
6 Germaine Beaumont quoted in Veillon (2002), p.89.
7 Alison Settle (1891–1980), journalist and editor of *Vogue* (British edition). Alison Settle Archive, Design Archives, University of Brighton: Settle B40S.38.
8 Savage, British Library Sound Archives, C1046/09.
9 For further detail on haute couture, see Palmer (2001).
10 Spanier (1959), p.179.
11 Bertin (1956), pp.71–2.
12 D. Tomlinson, *British Cotton Couture 1941–1961* (Manchester, 1985), p.3; for Paris statistics see Veillon (2002), p.90.
13 Alison Settle Archive: Settle B40S.5.
14 Ibid.
15 Savage, British Library Sound Archives, C1046/09.
16 Ibid.
17 Alison Settle Archive: Settle B40S.38.
18 Bertin (1956), p.33.
19 Join-Diéterle (1991), p.59.
20 Savage, British Library Sound Archives, C1046/09.
21 See Miller (2007).
22 Beaton (1954), p.263.
23 Vickers (1985), p.372.
24 J. Pope-Hennessy, foreword to Beaton (1971), p.5.
25 Beaton (1954), p.4.
26 Lady Alexandra Dacre, *Memoirs* (private collection: unpublished).
27 *Time* magazine, 18 August 1947.
28 V&A: T.24–2007. Dior named each individual garment; his references were often cultural. I am grateful to Charles Villeneuve de Janti for pointing out that this design was named after the eighteenth-century opera *Zémire et Azor* (Beauty and the Beast) first performed at Fontainebleau in 1771, perhaps inspiring the garment. Interestingly, in Dior's charts in the Dior Archive, Paris, the name Fontainebleau has been crossed out and replaced with Zemire.
29 In conversation with the author, April 2007. Sekers was a member of the British Associated Haute Couture Fabrics Company, with a Paris office after 1950.
30 Dior Archive, Paris. The mink was supplied by EMBA, the American mink breeders association, according to the collection programme, Autumn/Winter 1954–5.
31 Film at the Gaumont Pathé Archives, St Ouen; *Vogue* (British edition), September 1954, p.126 and *L'Officiel*, September 1954, p.26b; *Vogue* (British edition), November 1954, p.97. Savage recalls:
 'Susan Small always had a little assistant designer who came along and sat in the second row, she would copiously make notes, and then as soon as the collection was over she'd go outside and sit in a café and do sketches, sketches, sketches, sketches of everything she'd seen. Oh, they were an important client, they were a very good quality house. And, they would sell their clothes to Harrods. So they would sell what they called line-for-line copies, not necessarily in the same material, and they would not be allowed to use the name of the designer in a label, but they could use the name of the designer in any advertising they did. So they would take quarter-page ads in newspapers or full-page ads in *Vogue* and say, "Susan Small at Harrods, designed by Lanvin" or Nina Ricci or so on.'
 The original would have been closer to 500 guineas.
32 V&A: S.1443–1984.
33 Chase and Chase (1954), p.323.

2 Dior's Golden Age

1 Dior (1957), p.33. The autobiography, *Christian Dior et moi*, was written in 1954–5, published in French and German in 1956 and then in English, Dutch and Spanish in 1957.
2 Quoted in *Time* magazine, 13 August 1956.
3 *Time* magazine, 21 August 1939.
4 Chase and Chase (1955), p.277.
5 Vickers (1985), p.291.
6 Steele (1997), p.6.
7 *Time* magazine, 21 August 1939.
8 Alison Settle was sent a document entitled *Notes, Documentaires et Etudes* by the French ministry in 1946, which analyzed the influence of fashion on the 'French balance of payments', its aims, fabrics, accessories, the home market and the problems of expansion. She wrote: 'The Ministry added that if other countries turned against creative fashion, then France had all the means and ability to develop a modern industry of mass manufacture by modernisation of textile machinery.' Alison Settle Archive: Settle, B40S.5.
9 *Vogue* (British edition), March 1943, pp.55, 80.
10 Veillon (2002), pp.87, 91, 99.
11 *Time* magazine, 11 September 1944.
12 Buckle (1979), p.151.
13 Mme Massigli was the wife of the French ambassador to London, 1944–54. Lynam (1972), p.139.
14 *Great Britain and the East Textile Supplement*, April 1945, p.xix.
15 Steele (1997), p.8.
16 Alison Settle Archive: Settle, B40S.5.
17 Ibid.
18 *Time* magazine, 11 September 1944.
19 *Time* magazine, 24 December 1945.
20 *Life* magazine, April 1946.
21 Buckle (1979), p.159.
22 Chase and Chase, p.275.
23 Dior (1957), p.21.
24 *Vogue* (French edition), March/April 1947, p.60.
25 Ballard (1960), p.231.
26 Steele (1997), p.28.
27 Dior (1957), p.21.
28 Lynam (1972), p.153.
29 Mulvagh (1988), p.180.
30 Cited in Breward and Steele (2005), vol.1, p.367.
31 Dior (1957), pp.21–2.
32 *Vogue* (British edition), April 1947.
33 Chase and Chase (1955), p.323.
34 Breward and Steele (2005), vol.1, p.253.

35 Jebb (1995), p.44. Cynthia Gladwyn was the wife of Sir Gladwyn Jebb, diplomat, and ambassador to the United Nations, then France.
36 Alison Settle Archive: Settle, B40S.5.
37 Jebb (1995), p.50.
38 Minassian cited in Lynam (1972), p.147.
39 *Time* magazine, 16 August 1948.
40 Dior (1957), p.49.
41 From *Women's Wear Daily*, cited by Richard Martin, *New York Times*, 9 January 1957.
42 Freddy (as told to J. Carlier, trans. K. Black), *Flying Mannequin – Memoirs of a Star Model* (London, 1958).
43 *Time* magazine, 13 August 1956.
44 Archives Nationales de France, Paris, F/12/10.505.
45 *Time* magazine, 4 March 1957.
46 Bertin (1956), p52.
47 *Time* magazine, 4 March 1957.
48 Jebb (1995), p.119. Mme Auriol was the wife of President Auriol of France, in office 1947–54.
49 Hardy Amies observed that currency restrictions benefited London designers. Amies (1954), p.221.
50 Buckle (1979), p.297.
51 C. Bricker, 'Looking Back at the New Look', in *The Connoisseur*, April 1987, p.143.
52 Savage, British Library Sound Archives, C1046/09.
53 Ibid.
54 Giorgio Bernini, 'Protection of Designs: United States and French Law' in *The American Journal of Comparative Law*, vol.1, no.1/2 (Winter/Spring), pp.133–7.
55 Alison Settle Archive: Settle, B40S.5.
56 Jacques Fath, in *Fodor's Woman's Guide to Europe* (1960), p.92.
57 *Life* magazine, 25 April 1949.
58 *Fodor's Woman's Guide to Europe* (1960), p.94.
59 Bertin (1956), p.207.
60 With thanks to Laurent Cotta of the Musée Galliera for drawing my attention to this.
61 Archives Nationales de France, Paris, F/12/10.505.
62 Guillaume (1993), p.184.
63 Savage, British Library Sound Archives, C1046/09.
64 *Vogue* (French edition), November 1957, p.33, trans. Charles Villeneuve de Janti.
65 *Time* magazine, 10 February 1958.
66 Ibid.
67 'This amusement was rather more than encouraged by American big business. They wanted to give a filiip to the sales of her

famous "Chanel 5" perfume.' *Daily Mail*, 6 February 1954.
68 Ballard (1962), p.64.
69 Dior (1957), p.30.
70 Ibid., p.49.
71 See note 1 above.

The New Look
1 Jebb (1995), p.35
2 Dior (1957), p.21.
3 Carter (1974), p.75.

3 Inside Paris Haute Couture
1 Dawnay (1956), p.77.
2 Mrs Robert Henrey, *A Month in Paris* (London, 1954), p.135.
3 For more on this, see Palmer (2001), pp.3–12, and Palmer, 'Haute Couture' in Breward and Steele (2005), pp.186–9.
4 Alison Settle Archive: Settle, AS A47.29: 'Paris Gambles on Luxury Modes' in *The Observer*, 10 August 1947.
5 Alison Settle Archive: Settle, AS AA2.
6 Spanier (1959), p.166.
7 Archives Nationales de France, Paris, F/12/504.
8 Alison Adburgham, 'The Weather in the Salons' reprinted from *Harper's Bazaar*, June 1960, in Adburgham (1966), p.15; Lesley E. Miller, 'Paris-Lyon-Paris: Dialogue in the Designs and Distribution of Patterned Silks in the Eighteenth Century', in R. Fox and A. Turner, eds, *Luxury Trades and Consumerism in Ancient Régime Paris, Studies in the Skilled Workforce* (Oxford, 1996); Carolyn Sargentson, *Merchants and Luxury Markets. The Marchands Merciers of Eighteenth Century Paris* (London, 1996).
9 Alice K. Perkins, *Paris Couturiers and Milliners* (USA, 1949), pp.11, 16, 20, 22; Miller and Picken (1956), pp.100–1; Ballard (1962), pp.228–30; *Paris et sa proche banlieue*, fifth edition, recast by Georges Monmarché (Paris, 1955), pp.cxxxi–cxxxii.
10 Perkins, op. cit., pp.16, 34.
11 Dior (1957), pp.37–8; Palmer (2001), pp.58–9.
12 Miller and Picken (1956), p.96; Perkins, op. cit., pp.11–12; Palmer (2001), pp.183–94.
13 Clare Haru Crowston, *Fabricating Women: the seamstresses in old regime France, 1675–1791* (Durham and London, 2001), pp.2–3, 31–6.
14 Alison Settle Archive: Settle, AS 48.10: *Yorkshire Post*, 18 February 1948.
15 Miller and Picken (1956), p.148.

16 Between 1935 and 1939 Christian Dior sold designs to Agnès, Balenciaga, Paquin, Piguet, Nina Ricci, Maggy Rouf, Schiaparelli, Molyneux, Worth. See de Marly (1990), p.10.
17 Dior (1957), p.99.
18 *Artisans de l'élégance* (Paris, 1993), pp.171–6; François Lesage, interview with the author, Paris, 20 May 2006; Jean Vermont, interview with the author, Paris, 21 May 2006.
19 François Lesage, interview with the author; Jean Vermont, interview with the author.
20 Archives Nationales de France, Paris, F12/10.505; Palmer (2001), p.17; Geneviève Perreau, *Portrait of Christian Dior* (Paris, 1953), quoted in Miller and Picken (1956), p.148.
21 Bertin (1956), p.77; Joelle Anne Roberts, interviews with Sophie Gins and Brigitte Tortet, *vendeuses*, 12 February 2005. Seamstresses Rita Saidy, Lucy Poulou, Vionette, Georgette Blanchard and Raymonde Blanchard, Josette Lefin.
22 Paule Boncourre, interview with the author, Paris, 20 May 2006.
23 Dior (1954), p.59.
24 Dawnay (1956), pp.67–8.
25 François Lesage, interview with the author.
26 Dior (1954), p.65.
27 Dior (1957), p.173.
28 Joelle Anne Roberts, interviews with Sophie Gins and Brigitte Tortet, *vendeuses*, 12 February 2005. Seamstresses Rita Saidy, Lucy Poulou, Vionette, Georgette Blanchard and Raymonde Blanchard, Josette Lefin; Jean Vermont, interview with the author; see also Dior (1957), p.176, where he describes the relationship between garments and workers as 'solicitude for their own particular dresses'.
29 Dior (1957), p.174; Ginette Spanier, *directrice* of Balmain, wrote that 'mannequins invariably identify themselves with the clothes they show. The dress is theirs...', Spanier (1959), p.204.
30 Bettina, *Bettina*, trans. Marguerite Barnett (London, 1963), p.49.
31 Madame Burait of Nina Ricci, interview with the author, Paris, 26 April 1991; Geneviève Perreau, n.p.
32 Spanier (1959), p.173.
33 Alison Settle Archive: Settle, AS L60.3. Madame Burait, at Nina Ricci interview with the author, Paris, 24 April 1991.
34 Leonora Curry, interview with the author, London, 18 May 1992.
35 Bernard Roscho, *The Rag Race. How New York

and Paris Run the Breakneck Business of
Dressing American Women (New York, 1963),
p.162; Alison Settle Archive: Settle, AS L50.6,
1952 report.
36 François Lesage, interview with the author,
Paris, 20 May 2006; Olivier Seguret and Keiichi
Tahara, Haute Couture: tradesmen's entrance
(Paris, 1990), p.30; Jean Vermont, interview
with the author.
37 Miller and Picken (1956), p.5.
38 Bertin (1956), pp.109–10; Stanley Karnow,
Paris in the Fifties (New York, 1997), p.260.
39 Paul Gallico, Mrs 'Arris Goes to Paris (New York,
1957), p.96.
40 Ballard (1962), p.114.
41 Gallico (1957), p.63.
42 Madame Burait, interview with the author;
Dior (1957), p.168.
43 Amies (1954), p.82; Dior (1957), p.168; Miller
and Picken (1956), p.23. Bertin (1956),
pp.55–70.
44 Sophie Gins, interview with the author, Paris,
20 May 2006.
45 Gallico (1957), p.155.
46 Spanier (1959), p.182.

Jean Dessès
1 Vogue (French edition), December 1939, p.16.

Jacques Fath
1 Bertin (1956), p.210.
2 Equivalent to just under $100,000 in 2005,
using the Consumer Price Index. Professor
Samuel H. Williamson, 'Five Ways to Compute
the Relative Values of a US Dollar amount,
1790–2005' (www.measuringworth.com,
consulted April 2005).
3 Life magazine, 19 April 1948.
4 André Ostier, 'Jacques Fath Recalled', in Lynam
(1972), p176.
5 Classification Couture – création applications.
Archives Nationales de France, Paris,
F/12/10.505, cited in Palmer (2001), p.17.

4 Material Evidence
Money comparisons have been kindly
provided by the Bank of England. In 1946 £1
was equivalent to £27.01, in 1951 to £21.75
and in 1954 to £18.98, in relation to £1 in
August 2006.

1 'The London Way', Vogue (British edition),
March 1950, p.77.
2 INCSOC Annual Report 1950, V&A Archives.

See also Palmer (2001).
3 Gordon Beckles, 'These Men Have Flair', The
Strand, June 1946, p.65.
4 'Haute Couture in London', The Economist, 4
August 1951, p.270.
5 Ibid.
6 Richard Collier, 'The Fashion Story (3): Eleven
Designing Men', Housewife, July 1952, p.99.
7 Amies (1954), p.186.
8 Richard Collier, 'The Fashion Story (3): Eleven
Designing Men', Housewife, July 1952, p.99.
9 'Haute Couture in London', The Economist, 4
August 1951, p.270.
10 Amies (1954), p.176.
11 Ibid., p.201.
12 Ibid., p.54.
13 Alison Settle Archive.
14 Amies (1954), p.239.
15 Ibid., p.241.
16. V&A: T.226–1984.
17. V&A: T.214–1976.
18 'Dress Bravely advises designer Paterson',
Swindon Evening Advertiser, 21 April 1955
(Paterson Archives, V&A: AAD).
19 V&A: T.312–1987.
20 V&A: T.292–1984.
21 Lilian Hyder, 'Secrets of Fashion No.4: Victor
Stiebel and Peter Russell', Woman's Own,
3 April 1952, p.23.
22 Ibid.
23 Lilian Hyder, 'Secrets of Fashion No.1: Norman
Hartnell', Woman's Own, 13 March 1952, p.12.
24 V&A: T.192–1973.
25 V&A: T.250–1979.
26 Lindsay Evans Robertson, interview with the
author, 16 March 2006.
27 Hartnell (1955), p.101.
28 Video interview with M. Markham, courtesy of
The Royal Ceremonial Dress Collection,
Historic Royal Palaces.

John Cavanagh
1 The Coronation took place on 2 June 1953.
Lady Cornwallis also wore the green and
yellow striped Victor Stiebel dress from 1947
described on p.101. In 1948 she married her
second husband, Sir Wykeham Stanley
Cornwallis, second Baron Cornwallis
(1892–1982), and wore a blue-grey figured
silk gown by Molyneux, which was also
donated to the museum (V&A: T.295–1984).
2 For more on the Countess's dress, see De la
Haye, Taylor and Thompson (2005), pp.146–7.
For further details about Oliver Messel, see
Vogue (British edition), April 19536, pp.132–3.

3 Lindsay Evans Robertson, interview with the
author, August 2006.
4 John Cavanagh, interview with the author,
Winter 1996, printed in De la Haye (1997).

5 Perfect Harmony
1 Dior (1957), p.73.
2 Ibid., p.68.
3 Exceptions to the rule for couture textiles are:
Mendes (1987); Valérie Guillaume's brief
article 'Haute couture: reconquête et "new
look"', in Philippe Gumplowicz and Jean-
Claude Klein, eds, Paris 1944–1954: artistes,
intellectuals, publics: la culture comme enjeu
(Paris, 1995), pp.96–105; a chapter in
Susannah Handley, Nylon: the manmade
fashion revolution (London, 1999); and
Florence Charpigny, 'L'étoffe de la mode:
soierie lyonnaise et haute couture, l'exemple
de la maison Ducharne' in Danielle Allérès, ed.,
Mode: des parures aux marques de luxe (Paris,
2005), pp.30–1.
4 Note in particular the work of Charpigny,
Vernus, Blum, Guillaume, Join-Diéterle and
Jouve; J.P.P. Higgins undertook interviews for
Cloth of Gold: a history of metallised textiles
(London, 1993), chapters 7 and 8, as did Pierre
Vernus for his unpublished doctoral thesis
'Bianchini Férier, fabricant de soieries
(1888–1973)', Université Louis-Lumière
(Lyons II), 1997.
5 Alison Settle, 'BACKGROUND OF "NEW
LOOK" Bid to Focus All Eyes on French Textile
Trade', The Scotsman, Wednesday, 18 February
1948, p.6. A New Look cocktail dress might
require 13.5 metres (15 yards) of fabric, while
the alternative, slimmer tunic line of the mid-
1950s required between 3.5 and 5 metres for
a day suit for autumn or for a short summer
dress. The suit was made in 140 cm wide
jersey or wool in 'Les Patrons de Vogue', in
Vogue (French edition), October 1955,
pp.134–5, and a short-sleeved, full-skirted
dress in 90 cm wide cotton in 'Les Patrons de
Vogue', in Vogue (French edition), August
1956, p.104.
6 Approximate metrage (V&A: T.24–2007).
Technical analysis of the textiles undertaken
by Marion Kite, Textile Conservation and
Science Conservation at the V&A.
7 Such as the International Wool Secretariat and
the Cotton Board.
8 This is such recent history that very little has
been written on the industry. A useful

contextualized introduction is to be found in Pierre Vernus, 'Bianchini Férier, fabricant de soieries (1888–1973)', criticism cited in Taylor and Wilson, (1989), pp.145–51.

9 Often *Vogue* patterns suggested the best textile to buy. For example, 'Les Patrons de *Vogue*' recommended Rodier's jersey for a winter dress in October 1956, and Boucart's real Alsace poplin for a summer dress in August 1957 (*Vogue* [French edition], October 1956, p.128 and August 1957, p.143). In March/April 1957 it even listed all the manufacturers whose textiles could be bought for their patterns in the department store Au Printemps. A number of sampling houses operated from Paris, supplying manufacturers with information about the textiles that were new or proving popular with couturiers and the trade. In this period, from 1949, they included: Textile Paris Echo, 12 rue Gaillon; Claude Frères et Cie., 10 rue d'Uzès; Société des Nouveautés Textiles, 47 rue de Paradis, and Bilbille et cie., rue Réamur.

10 For further insights, see Carlo Poni, 'Fashion as flexible production: the strategies of the Lyon silk merchants in the eighteenth century' in C.F. Sabel and J. Zeitlin, eds, *World of Possibilities: flexibility and mass production in western industrialization* (Cambridge, 1997), pp.37–74; Sabel and Zeitlin, 'Historical Alternatives to Mass Production: politics, market and technology in nineteenth-century industrialization' in *Past and Present*, no.108, August 1984, pp.133–76; Nancy Green, *Ready-to-Wear and Ready-to-Work: a century of industry and immigrants in Paris and New York* (Durham and London, 1997); Rioux (1989).

11 Veillon (2002), pp.69–83; Vernus, op. cit., pp.362–3; Rioux (1989).

12 From *Le Mercure Galant* in the late seventeenth century to the wartime and post-war press. See Jennifer Jones, *Sexing La Mode. Gender, Fashion and Commercial Culture in Old Regime France* (Oxford, 2004); for nineteenth-century, see Elizabeth Ann Coleman, *The Opulent Era* (London, 1989) and Henri Pansu, *Claude-Joseph Bonne: soierie et société à Lyon et en Bugey au XIXe siècle*, tome 1 (Lyon, 2003); and Veillon (2002) on the role of the press during the war.

13 Join-Diéterle (1991), p.59.

14 The sum averaged out at 200 million francs in this period, having started at a high of 395 million in 1952. Grumbach (1993), pp.48–9, 53.

15 *The Ambassador*, 1950, no.2, p.106; no.3, p.104; and no.4, pp.120–7. From the Spring collections Schiaparelli, Molyneux and Fath had favoured English woollens and worsteds, Dior and Balmain, English jersey, Balmain, heavy English rayon coating, Fath shantung and nylon from Zurrer Silks (Darwen) Ltd, Dior, Fath, Balenciaga, Dessès, Schiaparelli, Paquin, Rochas and Lanvin silk brocades and novelty fabrics including woven nylon sheer.

16 *Vogue* (French edition), March/April 1947, p.93.

17 *Vogue* (French edition), October/November 1948, pp.137ff.: Léonard, Lesur, Moreau, Perrot, Pierre Besson, Rodier, Sinclair, Tissus Raimon for woollens, with Rodier having a special interest in jersey; Bianchini Férier, Bucol, Chatillon Mouly Roussel, Ducharne, Guillemin, Staron for silks. *Vogue* (French edition), September 1952, pp.102ff.: the new names were for woollens – Dormeuil frères, Meyer; for woollens and silks, Mougin-Roubaudi-Olré, for new fibre mixes with artificial materials, Guitry, Hurel, Rémond, Robert Perrier, Coudurier-Fructus-Descher. *Vogue* (French edition), November 1953, pp.111ff.; *Vogue* (French edition), September 1957, pp.200–6.

18 Based on a sampling of *Vogue* (French edition) for this decade and on information from the Balenciaga Archives: Balenciaga first bought from Ascher in 1952, from Sekers in 1951 and from Abraham in 1948. Sekers also formed an association, Associated Haute Couture Fabrics, with three other British manufacturers – Otterburn, Jerseycraft and Wain Shiell/Shielana.

19 Letter from Mr Sekers to Werner Stocker, Whitehaven, 10 December 1949. I am grateful to Alan Sekers for coming forward with this evidence.

20 *Vogue* (French edition), December/January 1947–8, p.51. Suppliers of Biki, Casa Rina, Fabro, Fiorani, Gambino Sorelle, Marucelli, Trinelli, Vanna, etc.; *Vogue* (French edition), April 1950 and February 1955, p.25. Nicola White, *Reconstructing Italian Fashion: America and the development of the Italian fashion industry* (Oxford, 2000), in particular, pp.19–31.

21 *Vogue* (British edition), December 1958, p.17.

22 Grumbach (1993), p.49.

23 Dior (1957) p.99; Join-Diéterle (1991); Guillaume (1993), etc.

24 De la Haye and Tobin (1999), p.36. *Vogue* (French edition), July/August 1947, p.4 and October/November 1947, p.21; Chapter 3 of this book. One fashion historian has commented that the extravagance of the New Look was surely motivated by Boussac's desire to sell textiles. The fashion journalist Anny Latour told a tale of the grey cotton dresses of summer 1952. They 'appeared because Boussac had a pile of grey cotton material left in his warehouses', Latour (1958), p.219.

25 A tradition that stretched back to the eighteenth century and continues into the twenty-first. Nicolas Joubert de l'Hiberderie, *Le dessinateur pour les étoffes d'or, d'argent et de soie* (Paris, 1765), Introduction; Latour (1958), p.217.

26 Balmain to Hureau, 11 July 1960, cited in Vernus, op. cit., p.393; Vernus, op. cit., p.394.

27 Dior (1957), p.69.

28 Golbin (2006), p.18; Charpigny, op. cit., pp.29, 32.

29 Blum and Haughland (1997), pp.125, 263–4. Charpigny, op. cit., p.33.

30 Join-Diéterle (1991), p.62.

31 Higgins (1993); Golbin (2006), p.98.

32 V&A: T.24–2007. Dior's 'Zemire' bears the name Sekers on the label and Lady Sekers' son, Alan, confirms the close friendship of Miki Sekers and Dior; Demornex and Jouve (1988), p.107.

33 Cited in Handley, op. cit., pp.79, 82.

34 Faith Shipway, 'Nylon News in Lace and Lingerie', *Skinner's Silk and Rayon Record*, November 1951, p.1572.

35 Ducharne, cited in Charpigny, op. cit., p.31.

36 Latour (1958), p.218. According to Latour, the couturier's choice was protected for six months, during which time he had exclusive use of a particular textile.

37 Charpigny, op. cit., p.30.

38 Ducharne thought that eight colours were quite sufficient (Charpigny, op. cit., p.34), but this is three to four colours more than what is normally used today for commercial prints.

39 Dior (1957), p.69.

40 *Almanach ou Annuaire commercial de Paris*, 1947–55.

41 Grumbach (1993), p.47. As distinct from the Sentier where the suppliers of textiles for ready-made clothing were located.

42 In the Post Office Directories they featured variously under the rubric of textile manufacturers, agents or merchants (*Post Office Directories*, 1953 and 1957). They were: Coudurier, Fructus et Descher, Dormeuil frères, Ducharne (E.) et cie., Dumas et Maury, Hurel,

Léonard (W.), Meyer (E.), Rodier, and Staron.

43 As early as 1898 Bianchini Férier had opened its first branch in Paris. The success of that office led to the establishment of others in other fashion capitals: in London (1902), in New York (1909), in Montreal (1922), in Brussels and Geneva (1931), and in Dusseldorf (1940). By 1947 the firm had added Buenos Aires to the list. Other manufacturers followed suit. Henriette Pommier et al., *Soierie Lyonnaise* (Lyons, 1980), p.63, and Vernus, op. cit.

44 Lou Taylor, 'De-coding the Hierarchy of Fashion Textiles', in Taylor (2003), pp.67–79. She uses Pierre Bourdieu's seminal framework from *Distinction: a social critique of the judgement of Taste* (1979).

45 Geneviève Antoine Dariaux, *A Guide to Elegance* (reprinted edition, 2003), pp.83–97, 182. It was originally published in 1964, but based on the mores of the previous decade.

46 Blum (1997), p.251; Mendes (1987), p.106.

47 'Trademark of the Dow Badische Company for its metallic fibre yarn, which was introduced during the 1940s. Woven or knitted with cotton, nylon, rayon, silk or wool fibres, Lurex is made into dresses, cardigans and sweaters. It is particularly suitable for eveningwear and was popular until the 1970s.' *Thames and Hudson Dictionary of Fashion and Fashion Designers* (London, 1998).

48 *Vogue* (French edition), October 1956, advertisement (opening pages).

49 Guillaume, op. cit., p.101.

50 'Featherweight Tweed Weights Capture World Markets', *Daily Telegraph*, 21 October 1947; 'New York Turns on the Heat', *Glasgow Evening News*, 17 October 1947; R.M.S. Nairn, 'New Look Line and Shape Opportunity for Scotch Tweed Trade', *The Scotsman*, 14 April 1948.

51 Mendes (1987), pp.112–19.

52 *Vogue* (French edition), September 1953.

53 Mendes (1987), p.108.

54 Dariaux, op. cit., p.100.

55 Such as the department store Galeries Lafayette and ready-to-wear manufacturing firms. Grumbach (1993), pp.54–5; Florence Charpigny and Michèle de la Pradelle, 'La fabricaton du luxe: l'exemple de Bucol, maison de soierie lyonnaise', in *Les Cahiers de la Recherche. Luxe-Mode-Art*, no.2, 2003, pp.31–7.

56 The Syndicat comprised 429 individual firms in total. Syndicat des fabricants de soieries et tissus de Lyon, *Compte rendu 1956* (Lyons, 1956), pp.9–11.

57 Bernadette Angleraud and Catherine Pellissier. *Les Dynasties Lyonnaises, Des Morin-Pons aux Mérieux du XIXe siècle à nos jours* (Paris, 2002), p.652. Rhodacieta had made enormous strides during the war in the development of new synthetic fibres. This partnership lasted into the early 1970s.

58 Ibid., p.658.

Embroidery

1 Palmer-White (1987), p.12.

2 Ibid., p.79.

6 Dior and Balenciaga

1 Hubert de Givenchy, interview with the author, April 2006.

2 Dior (1951), p.19, cited in Musée Christian Dior (2005).

3 For the financial aspect of haute couture, see Grumbach (1993).

4 Dior (1956), p.75.

5 Comment by Susan Train, quoted by Pochna (1994), p.176. American journalist Susan Train worked for both French and American *Vogue* from 1947, and was awarded the Chevalier of the Order of Arts and Letters in 1990.

6 Miller (1994), p.26.

7 A silence that is due as much to his character as to a marketing policy; see Miller (1994), p.14.

8 The only interview Balenciaga granted was with Prudence Glynn, a journalist at *The Times* in August 1971.

9 *Conférences écrites par Christian Dior for the Sorbonne, 1955–57* (Institut Français de la Mode: Paris, 2003)

10 Ibid., note 2. Interviews published by *Elle*.

11 Ibid., note 4, p.27.

12 Ibid., note 10, p.235.

13 Unlike Dior who, in his youth, moved in the same circles as some of his future clientele, Balenciaga arrived in Paris knowing nothing of the clothing habits of ski enthusiasts, and would sit for hours in the Palace de Saint-Moritz watching the fashionable set, then spend the night in the station before returning to Paris. Hubert de Givenchy, interview with the author, April 2006.

14 He said to Hubert de Givenchy, who expressed surprise at his choice of models, 'Show me a bent back, I'll unbend it!'. Hubert de Givenchy, interview with the author, April 2006.

15 Balenciaga said to one of his models, 'You are too beautiful'. Hubert de Givenchy, interview with the author, April 2006.

16 Hubert de Givenchy, interview with the author, April 2006.

17 'I made it a rule never to set foot in my salons, never to intervene directly in the business, to see my customers only rarely. One's closest friend... is thus free to order or not.' Dior (1956), p.172.

18 Ibid., note 6, p.35.

19 *Dépêche commerciale*, 1939, cited in Flory (1986), p.61.

20 When he didn't like the armhole on friends' clothes, Balenciaga often took to dismantling the sleeves; see Demornex and Jouve (1989), p.74; Givenchy also experienced this on several occasions, Hubert de Givenchy, interview with the author, April 2006.

21 V&A: T.234–1982.

22 I do not share the view expressed by Garnier (1987): 'Both vigilantly practised the art of remodelling the body through the impeccable architecture of their garments.' This article also contains a very interesting comparison between the forms of the dresses and those of certain insects.

23 The poet Stéphane Mallarmé, owner and editor of a fashion magazine, wrote 'this armour bodice was already introduced a year ago'. *La dernière mode*, September 1874.

24 Flory (1986), p.25.

25 There are even those who have implied that Balenciaga 'detested the woman's body and concealed it. He dressed them all like old women'. Alex Liberman, cited in Pochna (1994), p.232.

26 For example, the 1950 'balloon' dress and cape, and the 1957 designs.

27 For example, the dress designs of 1951.

Balenciaga: master tailor

1 Dariaux, op. cit., pp.83–97, 182.

2 Taken from a bill from the Phoenix Museum of Art gallery guide, March 1950.

7 Cecil Beaton

1 Vickers (1985), p.xxiii.

2 Ibid., p.471.

3 Cecil Beaton to Pope-Hennessy, 14 October 1969 (V&A Archives).

4 Beaton to Pope-Hennessy, 14 October 1969 (V&A Archives).

5 Pope-Hennessy to Beaton, 17 October 1969 (V&A Archives).

6 Draft letter, undated, but 1969 (V&A Archives).

7 Beaton to Pope-Hennessy, 11 November 1970

(V&A Archives).

8 Pope-Hennessy to Beaton, 7 December 1970 (V&A Archives).

9 Ernestine Carter, *The Magic Names of Fashion* (London, 1980), p.2.

10 Beaton (1971), p.7.

11 Princess Lee Radziwill gave 13 outfits and seven hats.

12 V&A: T.464–1974.

13 Michael Wishart to the Hon. Stephen Tennant, letter in possession of the author.

14 V&A: T.4–1974.

15 Jebb (1995), p.206.

16 Although Jacques Fath died in 1954, his business survived for a few years, managed by his widow Geneviève.

17 A 1958 Yves Saint Laurent cocktail dress for Dior, entitled 'Bal Masque', V&A: T.125–1974.

18 Duchess of Windsor to Beaton, 17 July 1971 (V&A Archives).

19 V&A: T.397–1974.

20 V&A: T.116–1974.

21 V&A: T.113–1974, T.114–1974.

22 V&A: T.46–1974.

23 V&A: T.48–1974.

24 V&A: T.52–1974.

25 V&A: T.15–1974.

26 Lord Drogheda, *Double Harness* (London, 1978), p.92.

27 V&A: T.284–1974.

28 Countess of Drogheda to Beaton, April 1971 (V&A Archives).

29 V&A: T.49–1974.

30 V&A: T.51–1974.

31 V&A: T.62–2004.

32 Beaton to Pope-Hennessy, 14 October 1969 (V&A Archives).

33 Mme Stavros Niarchos to Beaton, Villa Marguns, St Moritz, 9 April 1970 (V&A Archives).

34 V&A: T.119–1974.

35 V&A: T.16–1974.

36 V&A: T.245–1974.

37 Vickers, Hugo, ed., *The Unexpurgated Beaton* (London, 2002), p.117.

38 V&A: T.246–1974.

39 Lord Mountbatten to Beaton, 2 November 1971 (V&A Archives).

Lady Alexandra

1 Lady Alexandra Haig (1907–97) was the daughter of Field-Marshal Earl Haig. She married, firstly, Captain (later Rear-Admiral) Howard-Johnston in 1941. Following their divorce in 1954 she married the historian Hugh Trevor-Roper, who was created Baron Dacre of Glanton in 1979.

2 Lady Alexandra Dacre, *Memoirs* (private collection: unpublished), p.328.

3 Ibid., p.327.

4 Lady Alexandra Dacre, family letter, 1994.

8 Intoxicated on Images

1 Barthes (1990).

2 See, for example, Devlin (1979); Nancy Hall Duncan, *The History of Fashion Photography* (New York, 1979); Martin Harrison, *Appearances: fashion photography since 1945* (London, 1991).

3 Dior (1957), pp.60–1.

4 Ibid., pp.61–2.

5 See Jean Dawnay, *How I became a Fashion Model* (London, 1958), pp.50–1, for a description of Dior at work during this stage of the design process.

6 Dior (1957), p.63.

7 Dior may have insisted on the importance of drawing to the craft of couture, but as Claire Wilcox has pointed out, Balenciaga took the opposite view and followed Madeleine Vionnet's practice of three-dimensional rendering.

8 Francis Marshall, *Fashion Drawing* (London, 1955), p.60.

9 Miller and Picken (1956), p.144.

10 Bertin (1956), p.35.

11 Miller and Picken (1956), p.145.

12 Bertin (1956), pp.35–6.

13 Ballard (1960), p.236.

14 Dior (1957), p.117.

15 Ballard (1960), pp.122–3.

16 Ibid., p.170.

17 Amies (1954), pp.215–16.

18 Ballard (1960), p.265.

19 Miller and Picken (1956), p.149.

20 Irving Penn, *Passage: a work record* (London, 1991), p.80.

21 Marshall, op. cit., p.62.

22 Dior (1957), p.28.

23 Ibid., p.57.

24 Henry Yoxall, *A Fashion of Life* (London, 1966), p.101.

25 Ballard (1960), p.47.

26 Penn, op. cit., p.26.

27 Martin Maux Evans, ed., *Contemporary Photographers* (New York, 1995), p.511.

28 Beaton (1954), p.221.

29 Richard Avedon, *Woman in the Mirror* (New York, 2004), p.239.

30 Adam Gopnik, 'The Light Writer' in Mary Shanan, ed., *Richard Avedon: Evidence 1944–1994* (New York, 1994), p.111.

31 The uniquely sensual quality of the fashion drawing was sometimes also emphasized through its reproduction on textured or coloured paper, differentiating it from other sections of the magazine.

32 Carter (1974), pp.113–14.

33 Avedon, op. cit., p.239.

34 Martin Harrison, 'A Life in Images' in Catherine Chermayeff, Kathy McCarver Munchin and Nan Richardson, eds, *Lillian Bassman* (Boston, 1997), p.53.

35 Gopnik, op. cit., p.111.

36 Maux Evans, op. cit., p.60.

37 Bertin (1956), p.42.

38 Such tensions are also compellingly represented in the inevitable triumph of the more democratic photograph over the traditional illustration in magazines by the end of the 1950s.

39 See Gilles Lipovetsky, *The Empire of Fashion: dressing modern democracy* (Princeton, 1994), pp.80–1.

40 Roland Barthes quoted in Michael Carter, *Fashion Classics: from Carlyle to Barthes* (Oxford, 2003), p.149.

Richard Avedon

1 From Richard Avedon, 'Borrowed Dogs', printed in *Grand Street* (Autumn, 1987), pp.52–64. The essay is adapted from a talk delivered by Avedon at the Museum of Modern Art, New York, 27 September 1986.

9 Legacy

1 Lynam (1972), p.241.

2 Ibid., p.242 and Taylor and Wilson (1981), p.177.

3 See Chapter 4 in this book, p.163.

4 In conversation with the author, April 2007.

5 'Guest' designers, who may not meet the strict requirements for entrance to the Chambre Syndicale de la Couture Parisienne, are annually invited to participate in the shows. The list varies from year to year.

Further Reading

Adburgham, A., *View of Fashion* (Leicester, 1966)

Amies, H., *Just So Far* (London, 1954)

Amies, H., *Still Here* (London, 1984)

Baillen, C., *Chanel Solitaire* (London, 1973)

Ballard, B., *In My Fashion* (London, 1962)

Balmain, P., *My Years and Seasons* (London, 1964)

Barthes, R., *The Fashion System* (California, 1990)

Baudot, F., *Elsa Schiaparelli* (New York, 1997)

Beaton, C., *The Glass of Fashion* (London, 1954)

Beaton, C., *Fashion: an anthology* (London, 1971)

Benaïm, L., *Grès* (London, 2003)

Bergé, P., *Yves Saint Laurent* (London, 1997)

Bertin, C., *Paris à la Mode: a voyage of discovery* (London, 1956)

Blum, D., *Shocking! The Art and Fashion of Elsa Schiaparelli* (London, 2003)

Blum, D. and Haugland, K.H., *Best Dressed: fashion from the birth of couture to today* (Philadelphia, 1997)

Bolton, A. and Koda, H., *Chanel* (London, 2005)

Breward, C. and Steele, V., eds, *The Encyclopaedia of Clothing and Fashion* (Michigan, 2005)

Brighton Art Gallery, *Norman Hartnell* (Brighton, 1985)

Buckle, R., *Self-Portrait with Friends: the selected diaries of Cecil Beaton, 1926–74* (London, 1979)

Carter, E., *With Tongue in Chic* (London, 1974)

Carven, Join-Diéterle, C. and Saillard, O., *Madame Carven, Grand Couturier* (Paris, 2002)

Cawthorne, N., *The New Look: the Dior revolution* (London, 1990)

Charles-Roux, E., *Chanel and her World* (London, 1981)

Charles-Roux, E., Lottman, H.R. and Garfinkel, S., *Théâtre de la Mode, Fashion Dolls: the survival of haute couture* (revised second edition, Oregon, 2002)

Chase, E.W. and Chase, I., *Always in Vogue* (London, 1954)

Dars, C., *A Fashion Parade: the Seeberger collection* (London, 1979)

Dawnay, J., *Model Girl* (London, 1956)

De la Haye, A., *The Cutting Edge: 50 Years of British Fashion, 1947–1997* (London, 1997)

De la Haye, A., Taylor, L. and Thompson, E., *A Family Of Fashion, The Messels: six generations of dress* (London, 2005)

De la Haye, A. and Tobin, S., *Chanel: the couturière at work* (London, 1994)

De Marly, D., *Worth: father of haute couture* (New York, 1980)

De Marly, D., *Christian Dior* (London, 1990)

Demornex, J., *Madeleine Vionnet* (London, 1991)

Demornex, J. and Jouve, M-A., *Balenciaga* (Paris and New York, 1989)

Devlin, P., *Vogue Book of Fashion Photography* (New York, 1979)

Dior, C., *Je suis couturier: interview with Elie Rabourdin and Alice Chavanne* (Paris, 1951)

Dior, C., *Talking about Fashion to Elie Rabourdin and Alice Chavanne* (London, 1954)

Dior, C., *Christian Dior et moi* (Paris, 1956)

Dior, C., *Christian Dior and I* (New York, 1957)

Dior, C., *Dior by Dior* (London, 1957)

Duras, M., *Yves Saint Laurent and Fashion Photography* (Paris, 1999)

Edwards, A., *The Queen's Clothes* (London, 1977)

Etherington-Smith, M., *Patou* (London, 1983)

Flory, E., *Hommage à Christian Dior 1947–1957* (Paris, 1986)

Galante, P., *Mademoiselle Chanel* (Washington, 1973)

Garnier, G., *Cristóbal Balenciaga* (Tokyo, 1987)

Giroud, F., *Dior* (London, 1987)

Giroud, F., *Dior: Christian Dior 1905–1957* (New York, 1987)

Golbin, P., *Fashion Designers* (New York, 2002)

Golbin, P., *Balenciaga Paris* (Paris and London, 2006)

Grumbach, D., *Histoire de la Mode* (Paris, 1993)

Guillaume, V., *Jacques Fath* (Paris, 1993)

Haedrich, M., *Coco Chanel: her life, her secrets* (London, 1972)

Hartnell, N., *Silver and Gold* (London, 1955)

Hartnell, N., *Royal Courts of Fashion* (London, 1971)

Healey, R., *Balenciaga: masterpieces of fashion design* (Victoria, 1994)

Jebb, M., ed., *The Diaries of Cynthia Gladwyn* (London, 1995)

Join-Diéterle, C., *Givenchy, 40 Years of Creation* (Paris, 1991)

Kamitsis, L., *Lesage* (Paris, 1999)

Keenan, B., *Dior in Vogue* (Ottawa, 1981)

Kirke, B., *Madeleine Vionnet* (California, 1997)

Koda, H. and Martin, R., *Haute Couture* (New York, 1995)

Koda, H. and Martin, R., *Christian Dior* (New York, 1996)

Längle, E., *Pierre Cardin: fifty years of fashion and design* (London, 2005)

Latour, A., *Kings of Fashion* (London, 1958)

Leymarie, J., *Chanel* (New York, 1989)

Liaut, J-N., *Hubert de Givenchy: entre vies les légendes* (Paris, 2000)

Lynam, R., *Paris Fashion: the great designers and their creations* (London, 1972)

Mackrell, A., *Coco Chanel* (London, 1992)

Madsen, A., *Living for Design: the Yves Saint Laurent story* (New York, 1979)

Madsen, A., *Coco Chanel, A Biography* (London, 1990)

Marquand, L., *Chanel m'a dit* (Paris, 1990)

Martin, R., *Charles James: a fashion memoir* (London, 2004)

Measham, T., *Christian Dior: the magic of fashion* (New South Wales, 2000)

Meek, J., ed., *Yves Saint Laurent Retrospective* (New South Wales, 1987)

Mendes, V., *Ascher: fabric, art and fashion* (London, 1987)

Mendes, V., *Pierre Cardin: past, present, future* (London, 1990)

The Metropolitan Museum of Art, *The World of Balenciaga* (New York, 1973)

The Metropolitan Museum of Art, *Yves Saint Laurent* (New York, 1983)

Milbank, C.R., *Couture: the great designers* (London, 1985)

Miller, D.L. and Picken, M.B., *Dressmakers of France: the who, how and why of French couture* (New York, 1956)

Miller, L., *Cristóbal Balenciaga* (New Jersey, 1993)

Miller, L., *Cristóbal Balenciaga* (revised second edition, London, 2007)

Morand, P., *L'Allure de Chanel* (Paris, 1976)

Morht, F., *The Givenchy Style* (London, 1998)

Mulvagh, J., *Vogue History of 20th-Century Fashion* (London, 1988)

Musée Christian Dior, *Christian Dior... Man of the Century* (Granville, 2005)

Musée de la Mode et du Costume, *Hommage à Schiaparelli* (Paris, 1984)

Musée des Arts de la Mode, *Yves Saint Laurent* (Paris, 1986)

Musée historique des tissus de Lyon, *Hommage à Balenciaga* (Lyon, 1985)

Palmer, A., *Couture and Commerce: the transatlantic fashion trade in the 1950s* (British Columbia, 2001)

Palmer-White, H., *Elsa Schiaparelli* (London, 1986)

Palmer-White, H., *The Master Touch of Lesage: fashion embroidery* (Paris, 1987)

Pochna, M-F., *Christian Dior* (Paris, 1994)

Pochna, M-F., *Christian Dior: the man who made the world look new* (London, 1996)

Pochna, M-F., *Dior* (London, 2005)

Rawsthorn, A., *Yves Saint Laurent* (New York, 1996)

Rethy, E. and Perreau, J-L., *Christian Dior: the founding of his fashion house* (London, 2001)

Rethy, E., *Christian Dior: the early years 1947–1957* (New York, 2002)

Rioux, J-P., *The Fourth Republic 1944–1958* (Cambridge, 1989)

Rochas, M., *1925–1950, vingt-cinq ans d'élégance à Paris* (Paris, 1951)

Salvy, G-J., *Balmain* (Paris, 1996)

Schiaparelli, E., *Shocking Life* (London, 1954)

Sirop, D., *Paquin: une rétrospective de 60 ans de haute couture* (Musée Historique des Tissus: Lyon, 1989)

Skrebneski, V., *The Art of Haute Couture* (New York, 1995)

Spanier, G., *It Isn't All Mink* (New York, 1959)

Steele, V., *Women Of Fashion: twentieth-century designers* (New York, 1991)

Steele, V., *Fifty Years of Fashion, New Look to Now* (New Haven and London, 1997)

Taylor, L., *Disentangling Textiles* (London, 2003)

Taylor, L. and Wilson, E., *Through the Looking Glass: a history of dress from 1860 to the present day* (London, 1981)

Teboul, D., *Yves Saint Laurent: 5 Avenue Marceau, 75116 Paris, France* (New York, 2002)

Troy, N., *Couture Culture: a study in modern art and fashion* (Massachusetts, 2003)

Utz, L.L., *The Great Paris Designers* (Texas, 1992)

Veillon, D., *Fashion under the Occupation* (Oxford and New York, 2002)

Vickers, H., *Cecil Beaton* (London, 1985)

Walker, M., *Balenciaga and his Legacy* (London, 2006)

Wilcox, C. and Mendes, V., *Modern Fashion in Detail* (London, 1991)

List of Collections

The following museums and galleries hold examples of haute couture in their collections. Please see the websites listed for further details.

**Furniture, Textiles and
Fashion Department
Victoria and Albert Museum**
South Kensington
London SW7 2RL
www.vam.ac.uk

Museum of London
London Wall
London EC2Y 5HN
www.museumoflondon.org.uk

Royal Ceremonial Dress Collection
Kensington Palace
London W8 4PX
www.hrp.org.uk

Brighton Museum & Art Gallery
Royal Pavilion Gardens
Brighton BN1 1UE
www.brighton.virtualmuseum.info

Museum of Costume
Bennet Street
Bath BA1 2QH
www.museumofcostume.co.uk

Gallery of Costume
Platt Hall
Manchester M14 5LL
www.manchestergalleries.org

National Museums of Scotland
Chambers Street
Edinburgh EH1 1JF
www.nms.ac.uk

Musée Christian Dior
Villa 'Les Rhumbs'
50400 Granville
France
www.musee-dior-granville.com

Musée de la Mode de la Ville de Paris
10 Avenue Pierre 1er de Serbie
75116 Paris
France
www.paris.fr

**Musée de la Mode et du Textile
Les Arts Décoratifs**
107 Rue de Rivoli
75001 Paris
France
www.lesartsdecoratifs.fr

**Musées des Tissus et des Arts
Décoratifs de Lyon**
34 rue de la Charité
F-69002 Lyon
France
www.musee-des-tissus.com

**Fundacion Cristóbal Balenciaga
Fundazioa**
Parque Aldamar 6
20808 Getaria
Spain
www.fundacionbalenciaga.com

Museo del Traje
Avenida Juan de Herrera, 2
Madrid 28040
Spain
http://museodeltraje.mcu.es

Royal Ontario Museum
100 Queen's Park
Toronto
Ontario M5S 2C6
Canada
www.rom.on.ca

**The Costume Institute
The Metropolitan Museum of Art**
5th Avenue
New York City
New York 10028-0198
USA
www.metmuseum.org

Fashion Institute of Technology
Seventh Avenue at 27 Street
New York City
New York 10001-5992
USA
www.fitnyc.edu

Kent State University Museum
Rockwell Hall
Kent
Ohio 44242-0001
USA
www.kent.edu/museum

Los Angeles County Museum of Art
5905 Wilshire Blvd
Los Angeles
California 90036
USA
www.lacma.org

Maryhill Museum of Art
35 Maryhill Museum Drive
Goldendale
Washington 98620
USA
www.maryhillmuseum.org

Museum of Fine Arts
Avenue of the Arts
465 Huntington Avenue
Boston
Massachusetts 02115-5597
USA
www.mfa.org

Philadelphia Museum of Art
Benjamin Franklin Parkway
Philadelphia
Philadelphia 19101-7646
USA
www.philamuseum.org

Phoenix Art Museum
Central Avenue & McDowell Road
1625 N. Central Avenue
Phoenix
Arizona 85004-1685
USA
www.phxart.org

Texas Fashion Collection
University of North Texas
School of Visual arts
Denton
Texas 76203-5100
USA
www.tfc.unt.edu

Kyoto Costume Institute
103 Shichi-jo
Goshonouchi Minamimachi
Kyoto 600-8864
Japan
www.kci.or.jp

Powerhouse Museum
500 Harris Street
Sydney
NSW 1238
Australia
www.powerhousemuseum.com

Index

Illustration Credits

Images and copyright clearance have been kindly supplied as listed below. Unless otherwise stated below or in the captions, images are © V&A Images.

2.7, 2.25, 8.1, 8.2, 8.13, 8.15, 8.20: Copyright © 2007 The Richard Avedon Foundation

1.6, 4.11, 7.14: Cecil Beaton/Vogue © The Condé Nast Publications Ltd

2.26: Christian Bérard. © ADAGP, Paris and DACS, London 2007/Vogue Paris

2.3, 2.4, 2.5, 3.18, 6.10: Bibliothèque nationale de France

8.22, 8.23, 8.24, 8.25: Blumenfeld/Vogue © 1952 Condé Nast Publications Inc.

4.3: Bouché/Vogue © The Condé Nast Publications Ltd

2.16: Henry Clarke © ADAGP, Paris and DACS, London 2007/Vogue Paris

2.18 CORBIS/Henry Clarke © ADAGP, Paris and DACS, London 2007

Front jacket/cover, 1.2, 8.10: Clifford Coffin/Vogue © The Condé Nast Publications Ltd

1.10: Clifford Coffin © Vogue Paris

7.11: © Condé Nast Archive/CORBIS

3.6, 3.19, 6.2, 6.3: © Bettmann/CORBIS

3.22: © Genevieve Naylor/CORBIS

2.20, 6.1, 6.12, 7.5, 7.12, 9.5, 9.7: CORBIS

8.10a: Eric/Vogue © The Condé Nast Publications Ltd

9.3, 9.4, 9.6: Firstview.com

2.8: Horst © Vogue Paris

5.8: Keogh © Vogue Paris

8.8: Balenciaga Mantle Coat (A), Paris, 1950 (renewed 1978) © Condé Nast Publications Inc. Irving Penn © Vogue Paris

8.12: Salad ingredients, New York, 1947, Copyright © 1947 (renewed 1975) Condé Nast Publications Inc.

1.11: Vernier/Vogue © The Condé Nast Publications Ltd

p.8, 1.13, 2.10, 2.19, 2.24, 3.1, 3.3, 3.4, 3.10, 3.12, 3.15, 3.19, 5.2, 6.8: Time Life Pictures/Getty Images

2.6: Laurent Sully Jaulmes, courtesy of Maryhill Museum of Art

Jacket/cover spine, 2.29: Willy Maywald. © Association Willy Maywald/ADAGP, Paris and DACS, London 2007

1.7, 4.13: National Portrait Gallery, London. © Norman Parkinson Archive

p.2: Norman Parkinson Archive

3.11: POPPERFOTO/Alamy

1.14: Queen Magazine

1.1, 2.2, 6.4: Sotheby's Picture Library, London